UNIVERSITY OF KANSAS

THE FRANKLIN D. MURPHY LECTURE SERIES

Secrets

of the

Sacred

..

Empowering Buddhist Images
in Clear, in Code, and in Cache

..

HELMUT BRINKER

SPENCER MUSEUM OF ART
UNIVERSITY OF KANSAS, LAWRENCE

in association with

UNIVERSITY OF WASHINGTON PRESS
SEATTLE AND LONDON

The Murphy Lecture Series is sponsored by the Spencer Museum of Art, the Kress Foundation Department of Art History at the University of Kansas, and the Nelson-Atkins Museum of Art. The lectureship was established in 1979 through the Kansas University Endowment Association in honor of former chancellor Dr. Franklin D. Murphy.

Designed by Ashley Saleeba | Composed in Minion Pro and Gotham
Printed in the United States of America
15 14 13 12 11 5 4 3 2 1

SPENCER MUSEUM OF ART

The University of Kansas
1301 Mississippi Street
Lawrence, KS 66045-7500 USA
www.spencerart.ku.edu

UNIVERSITY OF WASHINGTON PRESS

P.O. Box 50096
Seattle, WA 98145 USA
www.washington.edu/uwpress

LIBRARY OF CONGRESS
CATALOGING-IN-PUBLICATION DATA

Brinker, Helmut, 1939–
Secrets of the sacred : empowering Buddhist images in clear, in code, and in cache /
Helmut Brinker. — 1st ed.
p. cm. — (The Franklin D. Murphy lecture series)
Includes bibliographical references and index.
ISBN 978-0-295-99089-7 (hardback : alk. paper)
1. Buddhist art and symbolism. 2. Idols and images. 3. Gautama Buddha—Relics.
I. Helen Foresman Spencer Museum of Art. II. Title.
BQ5105.B75 2011
294.3'437—dc22 2011000186

In memory of Washizuka Hiromitsu (1938–2010)

CONTENTS

ACKNOWLEDGMENTS

My debt for intellectual guidance and inspiration is to teachers and friends, the late Dietrich Seckel (1910–2007), Roger Goepper, John Rosenfield, and Jan Fontein. The subtitle of my lectures was inspired by an unpublished paper of David N. Keightley, professor emeritus of the University of California, Berkeley. The paper, "In Clear and in Code: Pre-Classical Roots of the Great Tradition in China," was prepared for the "The Formation of 'Great Traditions'" panel of the annual meeting of the College Art Association in New York City, 16 February 1990. In another essay, Keightley wrote: "Such coded art, in fact, functioned precisely as the Chinese writing system was to do in later times; it served as an esoteric system of symbols that, for those who had been educated to read the symbols, conferred privileged access to material and spiritual resources. The medium—the use of the coded characters—was indeed part of the message" (1996: 89).

It appears to me that the Esoteric Buddhist faith and its art functioned in a similar way; the use of coded imagery was part of the message. The coded currency of the iconographic system makes it likely that the *Secrets of the Sacred* would have empowered "Buddhist images in clear, in code, and in cache" rather than "challenged the ideological and symbolic role of the canonical art with which [they were] so closely allied" (Keightley 1996). My lectures at the University of Kansas, "From Image to Icon: Unseen Caches for Animating the Sacred" and "Mysteries of Buddha Relics and Esoteric Divinities," attempted to dem-

onstrate how the images and symbols of ordinary and sophisticated Buddhist divinities could be expressed by creating simple or complex codes.

I am particularly grateful to Marsha Haufler and Linda Stone-Ferrier, Kress Foundation Department of Art History, University of Kansas, Lawrence; to Andrea Norris, former director of the Spencer Museum of Art, and Marc Wilson, director of the Nelson-Atkins Museum of Art, Kansas City, for inviting me in 1999 to be their twentieth Franklin D. Murphy Lecturer. I should like to thank all the other colleagues in the department and at the museums for their hospitality and generous support during my visits to Lawrence and Kansas City. I am especially indebted to Amy McNair, who graciously offered to copyedit my manuscript, and my thanks to Sherry Fowler in the Kress Foundation Department of Art History, as well as to the graduate students at the University of Kansas who participated with inspiring enthusiasm in my courses. Bernard Faure, Columbia University, and James Robson, Harvard University, also generously shared their expertise.

Grateful acknowledgment for generous support goes to the late Washizuka Hiromitsu (1938–2010), former director of the Nara National Museum; Okada Ken, Tōkyō National Research Institute of Cultural Properties; Alexander Koch, director of the Historisches Museum der Pfalz, Speyer; and Jorrit Britschgi, Museum Rietberg Zürich, who supplied most valuable research and photographic material. Lei Congyun, Yang Yang, and their colleagues at Art Exhibitions China, Beijing, gave me an opportunity in the fall of 1997 to study the famous—and at that time newly restored—Famensi silver bodhisattva in the flesh. The advice and comments of many other friends and colleagues have been invaluable in bringing the lectures to this published version. I also wish to thank editor Marilyn Trueblood, designer Ashley Saleeba, and other members of the University of Washington Press staff who managed this volume with extraordinary skill.

The text of my lectures has gone through a number of incarnations. For its final reincarnation, I am deeply grateful to Naomi Noble Richard who, with her painstaking prudence, patience, and unfaltering sense of humor, read through the entire text several times, alerting me to countless errors in content, language, and style; her suggestions substantially improved my work. Long before my memorable stay at her home in Yorktown Heights, New York, in the spring of 2001, I had come to admire her precision and sharpness in understanding my intentions. Although I am ultimately responsible for whatever errors and inadequacies remain, I am particularly proud of one of Naomi's written comments: "You have destroyed my cherished belief that authors make poor proofreaders of their own work. But I suspect you of being a *myōō* who chooses to manifest from time to time as an author" (in a letter of 27 April 1998).

H. B.

Zürich | *January 2011*

Secrets

of the

Sacred

1

FROM IMAGE TO ICON

Unseen Caches for Animating the Sacred

.

Traditional Buddhist texts abound in speculations about and comments on the actual and spiritual presence of divinities in images made by human hands. Theologians and pious believers alike were deeply concerned with the degree of reality and potency dwelling in a pictorial representation. Again and again they raised the question, How and when does a motionless image transform from mere material form into a sacred icon? How and when does a statue or a painting of a divinity become more than just an inanimate piece of wood or stone, or colors on silk or paper? How and when is an icon an animated manifestation of the divinity complete with body and spirit, presence and power?[1]

In the earliest canonical scriptures, however, remarks on the practice of making and using images of the Buddha contain no traces of any such intellectualist approaches. There is not a word about transcendental existence or phenomenal manifestation, about "Two Bodies" (C: *ershen*; J: *nishin*) or even "Three Bodies" (C: *sanshen*; J: *sanjin*) of the Buddha, no reference to *trikāya* or *trayah kāyāh*.[2] We may safely assume that images of the Buddha were being made before the abstract concept of two or three essentially identical bodies of the "Original Honored One" came into existence. The oldest surviving translation of the "Practice of the Way of Perfect Wisdom Scripture" (C: *Daoxing banruo jing*; J: *Dōgyō hannya kyō*), allegedly completed by Lokaksema (C: Zhiloujiachen; J: Shirukasen) in 179 CE, informs us that the Buddha's spirit is *not* present in his image.[3] The bodhisattva Dharmod-

gata explains in one of his teaching sessions with the bodhisattva Sadāprarudita the nature of the Buddha's body and the rationale for making an image of it:

> The Buddha's body is like the images which men make after the Nirvāna of the Buddha. When they see these images, there is not one of them who does not bow down and make offering. These images are upright and handsome; they perfectly resemble the Buddha and when men see them they all rejoice and take flowers and incense to revere them.

> O Noble One, would you say that the Buddha's spirit is in the image?

> *The Bodhisattva Sadāprarudita replied:*
> It is not there. The image of the Buddha is made [only] because one desires to have men acquire merit.

> *Dharmodgata said:*

> You do not use one thing to make the image of the Buddha nor do you use two. There is gold and also a skilled artisan. If there is a man who has seen the Buddha in person, then after Nirvāna he will remember the Buddha and for this reason make an image, because he wants men in this world to revere the Buddha and receive the merit of the Buddha.

> *Bodhisattva Sadāprarudita said:*

> It is because of the Nirvāna of the Buddha that one makes images?

> *Dharmodgata replied:*

> It is just as you say, the constitution of the perfect Buddha's body is thus, you do not use one thing nor even two, but rather tens of thousands of things, including the practice of the Bodhisattva and his original seeking for the Buddha [or Buddhahood]. If men constantly see the Buddha performing meritorious deeds, then they too will constitute a perfect Buddha body, and be endowed with wisdom, the [power of bodily] transformations, flying and in sum all the auspicious marks of a Buddha. The constitution of a perfect Buddha body is like this.[4]

This informative discourse leaves no doubt that the nature of the Buddha body and the notion of an animated image of it, the question of transcendental identity of real and ideal, of form and spirit, had not been contemplated with any sophistication in doctrinal Buddhism in its initial stage. The vital issue of non-duality of the outer form and the inner principle was taken up somewhat later,

for example, by Huiyuan (334–416 CE)—one of the most illustrious figures in the early history of Buddhism in China—who entered into a doctrinal discourse with the celebrated Central Asian missionary-translator Kumārajīva (344–409 [or 413] CE).[5] In a panegyric on a Buddhist icon allegedly completed in 375 CE and highly esteemed by his master, he wrote:

> Now form and principle are distinct, yet they pass one into the other as do steps into a highroad. The fine and the coarse are truly different, yet to the enlightened they also are interrelated. So it is that to represent a supernatural model prepares the heart for its final crossing [into salvation]. An icono-graphically correct form divinely imitated opens the way to an understand-ing of all wisdom. It enables those who cherish the profound, to discern the invisible root in the disclosure of a leaf; and those wrapped up in the near, to construct for themselves a rewarding destiny for many aeons to come. Though the achievement was human, it is like Heaven's own art.[6]

Kūkai (774–835), the eminent founder of the chief Esoteric Buddhist school in Japan, the Shingon school, expressed a slightly different conclusion to the intri-cate philosophical problem of transcendental identity, or ultimate oneness, of all existences in their essential nature. The "Non-Duality of Principle and Wisdom" (J: *richi funi*)—that is, that the reality principle is illuminated by wisdom—is a recurrently expounded theme in his major works of the early ninth century:

> *Though raindrops are many, they are of the same water;*
> *Though rays of light are not one, they are of the same body.*
> *The form and mind of that One are immeasurable:*
> *The ultimate Reality is vast and boundless.*[7]

In other words, like raindrops and rays of light, principle and wisdom take separate forms but partake of the same essence. In Kūkai's view the production of an icon was a pious act and the installation of such icons a ritual procedure. He considered art mainly an auxiliary medium through which the meaning of sacred texts could be conveyed and expounded.[8] In his *Shōrai mokuroku*, "Memorial on the Presenta-tion of the List of Newly Imported Scriptures," of 806 he reported to the Emperor Heizei (r. 806–809) on the results of his studies and activities in China:

> The Dharma is beyond speech, but without speech it cannot be revealed. Suchness transcends forms, but without depending on forms it cannot be realized. Though one may at times err by taking the finger pointing at the moon to be the moon itself, the Buddha's teachings which guide people are limitless. Extraordinary feats which may dazzle another's eyes, however, are not valued at all. The Buddha's teachings are indeed the treasures which help pacify the nation and bring benefit to people.

Since the Esoteric Buddhist teachings are so profound as to defy expression in writing, they are revealed through the medium of painting to those who are yet to be enlightened. The various postures and mudrās [depicted in maṇḍalas] are products of the great compassion of the Buddha; the sight of them may well enable one to attain Buddhahood. The secrets of the sūtras and commentaries are for part depicted in the paintings, and all the essentials of the Esoteric Buddhist doctrines are, in reality, set forth therein. Neither masters nor students can dispense with them. They are indeed [the expression of] the root and source of the ocean-like assembly [of the Enlightened Ones, that is, the world of enlightenment].[9]

Sculptural and painted Buddhist images were not valued primarily as works of art; they were installed as focal points of veneration and of cults.[10] Nevertheless, it was recognized in India, early in the history of the creed, that works of art, in addition to communicating and explicating principles of the faith, can also contribute to creating an ideal environment and receptive atmosphere for such a communication between the divine power and the worshipper. The main object of veneration, or prime image worshipped in a particular ritual or enshrined in a Buddhist monastery building, has been called *benzun* (J: *honzon*), the "Original Honored One."[11] *Zun* is an archaic generic term for a ritual vessel. The character was already used in the late Shang dynasty (thirteenth/twelfth century BCE) in the short dedicatory inscriptions cast on bronzes. In its conventional Buddhist sense of a venerated icon, the ancient term for sacrificial vessel connotes a sacred bodily vessel that ideally contains the essence of its live entity. Other key terms frequently found in Chinese Buddhist writings employ the character 像 *xiang* (J: *zō*, "image" or "portrait"), in combination with qualifying terms. Together with the classifier for human being, *xiang* contains an element that refers to images, heavenly patterns, constellations, or portents manifested in earthly objects. One of these terms is *xingxiang* (J: *gyōzō*, "form image"), which emphasizes the visible appearance, the formal likeness, and the iconographic appropriateness of the represented divinity.[12] *Yingxiang* (J: *yōzō*, literally, "shadow image") is the translation of the multilayered Sanskrit term *bimba* or *pratibimba*. It characterizes the image as an ultimately illusory reflection without inherent reality, and it is regularly used to designate the visualized image of a divinity and its pictorial representation: *yingxiang* is the other face of *benzun*.

From Image to Icon

Among all schools of Buddhism, the ritual procedure of transforming an image into an icon consists of a consecration ceremony; the form of the ceremony varies from one school to another.[13] Ultimately the image is given its meaning as a religious icon through worship by the faithful. The visionary Buddhist "dream-

keeper" Myōe (1173–1232), master of the Kegon school and leader of a movement to revitalize traditional Buddhism in Japan, responded to this question of animated presence of a sacred icon with the succinct statement:

> Every time you enter the practice hall, imagine that the living Buddha is there; and, in the presence of the living Tathāgata, set straight your aspirations. When you think of an object carved of wood or drawn in a picture as a living being, then it *is* a living being.[14]

Between Kūkai, who viewed images as an "auxiliary medium," and Myōe, for whom the image could be thought into life, a seismic shift in thinking has occurred. This shift may be related to the movement of Buddhism in the direction of a salvific faith. In such icons the sacred essence of the creed was visualized; religious ideas and ritual conceptions found their sublime expression. Icons were the perceptible bodies of divinities, empowered to act and respond on their behalf, and they were a means to the fundamental goal of every devoted Buddhist, "becoming a Buddha in this very body" (J: *sokushin jōbutsu*), as one of the essential Shingon doctrines proposed. Especially sculptural images, with their three-dimensional physical presence, were far more than mere visualizations of Buddhist divinities and reminders of the Sacred Law. At times, they were literally animated by the presence within them of a consecrated and thus supposedly live entity or its representative symbols. These secret and sacred caches incorporated for animation functioned to establish a response to the quest for intimacy with the unseen sacred. Interior adornment of statues was an attempt to overcome the sense of inaccessibility of the sacred, its distance, or even its absence.

Such secret and sacred "caches inside images" are known in Japanese as *zōnai nōnyūhin*.[15] Besides precious relics in brocaded silk bags and small reliquaries in the shape of "Five-Ring Pagodas" (J: *gorintō*), ritual implements, holy scriptures, and pictures, as well as printed or written magic spells, were frequently deposited in special cavities or in the hollow interior of the sculptures before these received their finishing touches and their initial consecration. When the practice began, however, seems yet to be ascertained. The "Scripture of Measurements for Making [Buddhist] Images" (C: *Zaoxiang liangdu jing*) was translated and annotated by the Manchu prince Gongbu Chabu in 1742. In this rather late text—though certainly based on much older traditions—we find under the "Outline for the Adornment of [Interior] Treasuries" the following statement:

> Both doctrines, the Exoteric and the Esoteric, discuss the usage of adornment of the [concealed] treasuries [of Buddhist images], and the term generally used is "relic" [S: *śarīra*; C: *sheli*; J: *shari*]. Central are two kinds of relics or, some say, four kinds. The first [and more important] is the use of "Dharma-Body relics" [C: *fashen sheli*; J: *hosshin shari*; i.e., the Buddha's body in the form of the teaching as it is presented in sacred writings], and the second

[less important] is that of "corporeal relics" [C: *shengshen sheli*; J: *shōjin shari*]. Therefore, in the Western regions the "Dharma-Body relics" were used to a greater extent. Those in which the Five Great *Dhāraṇī* occupy the upper rank contain the essence of all the scriptures [C: *Yiqie jing*; J: *Issaikyō*] and *mantras*. . . . Therein single "seed syllables" [S: *bīja*] are in miscellaneous use. Especially the "seed syllables" of the primordial Five Tathāgatas and the Six Great Bodhisattvas have the fundamental magical power of enlightenment.[16]

The sophisticated idea of two kinds of Buddha relics, those of the "Dharma Body," which is synonymous with the "True Body" (C: *zhenshen*; J: *shinshin*), and those of the "Transformation Body" (C: *huashen*; J: *keshin*), was already set forth by Wei Shou (506–572) in his "History of the Wei [Dynasty]" (C: *Weishu*):

The Dharma Body (*Dharmakāya*) of the Buddha has two meanings: first, the true and real; second, the temporary and associate. As for the True and Real Body, it is said to be the utterly supreme form; mysteriously free from hindrances and bonds, and unable either to be limited to place or restricted to shape. When there is a stimulus it responds, [but] its form is ever pure. As for the temporary and associate body, it is said to deign to join with the Six Paths and to share the many forms of worldly existence. . . .

It is clear that a Buddha's birth is not a real birth, and his death is not real death. When the Buddha left the world, his corpse was burned with fragrant wood. His divine bones broke up into bits the size of grains, which could not be crushed by blows or scorched by fire. At times, they had a gleam indicative of their divinity. In the foreign language they are called *sheli* [*śarīra*]. The disciples received them respectfully and placed them in a precious urn. They paid them honor and respect with incense and flowers, and erected [for them] a building called a *ta* [*stūpa*]. *Ta* too is a foreign word [signifying something] like an ancestral shrine, so that people call [them] *ta*-shrines. A hundred years after this a certain king Aśoka by his royal power divided the Buddha-relics among the spirits and divinities to build [for them] 84,000 stūpas as gifts to the world. All were completed on the same day. Modern Luoyang, Pengcheng, Guzang, and Linzi all had a King Aśokan Monastery and show remains of it. Although Sakya entered the Parinirvāna, he left shadow foot-prints, his nails, and his teeth in India. To this day they are still there. Travellers to and from Madhayadesa all speak of having seen them.[17]

The equation between the Buddha's relics and the True Body may be traced back to early Chinese translations of sacred texts. In the "Scripture of the Golden Light" (S: *Suvarnaprabhāsa sūtra*; C: *Jinguang ming jing*), translated during the Northern Liang dynasty (397–439) by Dharmaksema (C: Tanmochen, 385–433), the Buddha informs his disciple Ananda upon opening the door of a stūpa to

reveal the Seven Treasures casket holding a mysteriously gleaming relic with the words: "This is the relic of True Body of the Mahāsattva."[18]

The multibody theory is also briefly touched on in "Buddha's Discourse on the Scripture of Merit and Virtue of Sprinkling [Water] on Sacred Icons" (C: *Foshuo yuxiang gongde jing*; J: *Bussetsu yokuzō kōtoku kyō*), translated circa 700 by the missionary Ratnacinta (Maṇicinta), known in Tang China as Bao Siwei.[19] Faithful and meritorious adherents of the Law, men and women, are said to venerate the relics by having "shadow images of the Buddha" (C: *foxingxiang*; J: *butsugyōzō*) made for the *śarīra* and pagodas erected for the Buddha's sacred remains. The association of corporeal and textual relics, of *śarīra* and *dhāraṇī*, must have had a long history, for another version of this text, known as "The Scripture of Merit and Virtue of Sprinkling [Water on Sacred Icons]" (C: *Yufo gongde jing*; J: *Yokubutsu kōtoku kyō*), allegedly translated by Yijing (635–713), transmits the Buddha's explanation of this conception in the following words:

> If you wish to venerate the *trikāya* after I shall have entered *nirvāna*, you should venerate my *śarīra*, of which there shall be two kinds: first, the relics of my "corporeal bones" [C: *shengu sheli*; J: *shinkotsu shari*], and second, the relics of my "Dharma hymns" [C: *fasong sheli*; J: *hōju shari*].[20]

The theory of the *trikāya* or "triple bodies" fostered the sacralization of the written word on the one hand and on the other, the textualization of relics. The cult of "Dharma Body relics" was already mentioned by the great Buddhist pilgrim and translator Xuanzang (600–664) in his famous travel narrative, "Record of the Western Regions of the Great Tang [Dynasty]" (C: *Da Tang xiyuji*), completed in 646 with the assistance of his disciple Bianji (ca. 618–ca. 648).[21] Xuanzang relates a devotional Indian custom: Buddhist practitioners would make miniature pagodas of scented clay that contained some sūtra extracts, and when these tiny stūpas had increased in number to a certain amount a larger pagoda would be constructed to house them. In his "Account of Buddhism Sent Home from the Southern Sea" (C: *Nanhai jigui neifa zhuan*) of 691, the Chinese pilgrim monk Yijing gives a slightly different version of this practice:

> [People in India] make [incense] paste caityas [another term in this context for stūpa] and paste images from rubbings. Some impress them on silk or paper, and venerate them wherever they go. Some amass them into a pile, and by covering them with tiles, they build buddha-stūpas. Some erect them in empty fields, allowing them to fall into ruin. Among the monks and laity of India, they all take this as their practice. Furthermore, whether they build images or make caityas, be they gold, silver, bronze, iron, paste, lacquer, brick, or stone; or they heap up sand like snow, when they make them, they place inside two kinds of relics. One is called the bodily relic of the Great Teacher; the second is called the dharma-verse relic on causation. This verse goes as follows:

All things arise from a cause.
The Tathāgata has explained their cause
And the cessation of the cause of these things.
This the great ascetic has explained.

If one installs these two [relics], then one's blessings will be extremely abundant. This is why the sūtras, expanded into parables, praise this merit as inconceivable. If a person builds an image the size of a bran kernel or a caitya the size of a small jujube, and places on it a parasol with a staff like a small needle, an extraordinary means [is obtained] which is as inexhaustible as the seven seas. A great reward [is obtained] which, pervading the four births, is without end. Details of this matter are all given in other sūtras.[22]

Sacred ashes and words offered believers a form of intimacy with the body and speech of the Buddha and his followers. At times, even textile models of human viscera were incorporated to ensure the physiological functioning, hence the life, of the entity. Of this practice, the Kamakura-period portrait statue (thirteenth century) of the Chinese "Pure Land" master Shandao (J: Zendō, 613–681) at Chion'in in Kyōto[23] and the Northern Song Guanyin figure in the Kanagawa Prefectural Museum of Cultural History, Yokohama, are pertinent examples (fig. 1).[24] The Guanyin, an eleventh/twelfth century sculpture representing the Bodhisattva of Great Compassion in the worldly posture of "royal ease," was made in a joined-wood technique. It contained in its hollow interior incense and cloth simulacra of human entrails (fig. 2). Miniature figures of buddhas, bodhisattvas, and other divinities would also be placed in the hollow interior of icons, as integral to their animation, and were thought to enhance the power of the unseen sacred and to increase its degree of presence in the image. The encasing icons and the miniature divinities placed inside them were not necessarily contemporaneous. The latter might be of greater antiquity—auspicious images or precious fragments excavated at a temple site or miraculously found at a monastery and then reused (literally, incorporated) in a newly consecrated icon. The interior of the eighteenth-century seated Yakushi Nyorai at Kaizōji in Kamakura is adorned with a fine Buddha face of the Kamakura period (fig. 3),[25] and the Edo-period Shō Kannon statue at Zennenji in Fujisawa city, Kanagawa prefecture, has a well-preserved smaller entity older by at least four centuries.[26]

The images deposited within are known as "Enshrined Buddhas" (J: *nōnyū butsu*), or as "Buddhas of the Womb's Interior" (J: *tainai butsu*) and thus may be considered to be the essential seed of buddhahood *in statu nascendi*. The main statues encasing them are usually referred to as "Sheath Buddhas" (J: *saya butsu*). These Sheath Buddhas become "figurative reliquaries" or "statuary stūpas," strongly suggesting a divinity's invisible animating presence, although the idea of "enshrinement" implies that the container has the character of a sarcophagus.[27]

The term *lingyan* (J: *reigen*) refers to the mysterious efficacy or responsive power

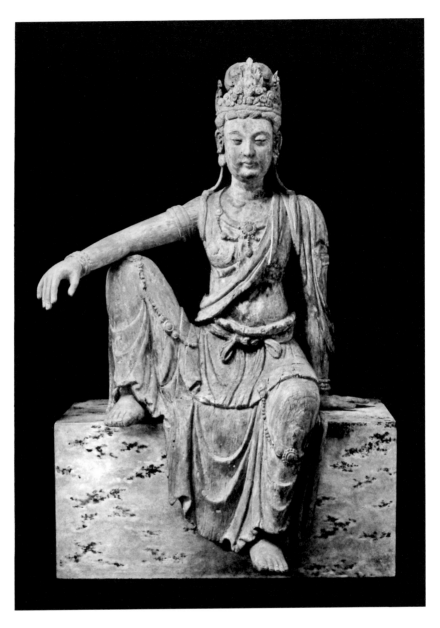

1 Guanyin seated in "royal ease." Northern Song dynasty,
11th–12th century. Wood with traces of polychromy, 99.4 cm. Collection
and photo Kanagawa Prefectural Museum of Cultural History, Yokohama.

that transforms an image into an icon (C: *lingxiang*; J: *reizō*) through the process of animation. Paradoxically, *ling* (J: *rei*) generally connotes death. *Lingjiu* (J: *reikyū*), for example, is a sarcophagus with a corpse inside, and *lingwei* (J: *reii*) a mortuary tablet placed before the coffin to show that it contains a corpse. Notwithstanding this etymology, the substance remains inert and the form a totally worthless

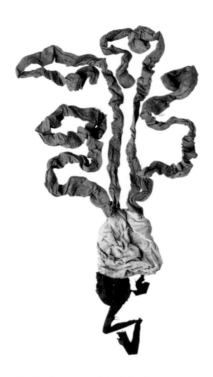

2 Textile simulacra of the "Five Human Intestines
and Six Organs" found inside Guanyin figure (fig. 1).

"shadow"—that is, a mere visual perception—until an image receives its *lingyan*, its
proper spiritual power and enlivenment through consecration in an adequate rit-
ual. Only then does a sculpture change from a lifeless piece of stone, wood, bronze,
clay, or lacquer to an animated icon: only then does it metamorphose from *xiang*
or *zō*, "image," into *benzun* or *honzon*, the "Original Honored One," imbued with
the potency to assist and guide believers on their way to true enlightenment and
salvation. The final step in creating an icon—depicting the pupils of the eyes—was
an act of ritual as well as representation. The practice seems to have been known
in ancient Indian Buddhism as well as in Brahmanism, and it was common cultic
practice along with the "mouth-opening" ritual in ancient Mesopotamia perhaps
as early as the third millennium BCE. Called the "eye-opening" (C: *kaiyan*; J: *kai-
gen*), this ritual is the most important step in consecrating a new image: endowing
it with gaze endows the icon with a sense of life. The comments of an anonymous
Kōyasan priest of the Edo period on paragraph 63 of the "Account of the Secret
Treasury" (J: *Hizōki*), traditionally considered to be Kūkai's recorded memories of
the oral instructions given by his Chinese teacher Huiguo (746–805) on Esoteric
Buddhist principles, elucidate this fundamental problem of material and spiritual
reality as well as the efficacy of Buddhist icons:

As long as the "Eye-Opening" has not yet been performed on an icon of
wood or stone or in painted form, it is still to be regarded in the same way

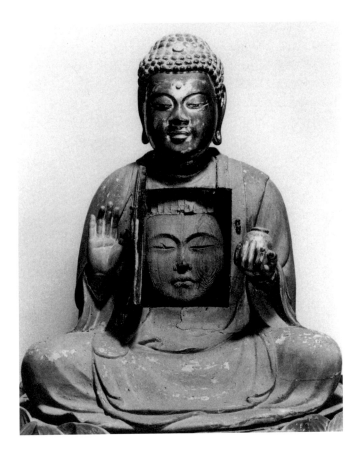

3 Yakushi Nyorai. Edo period, 18th century. Wood with traces of polychromy,
67.3 cm. Buddha head inside. Kamakura period, 13th century. Wood, 18 cm. Kaizōji,
Kamakura. Photo: *Zōnai nōnyūhin: Kamakura o chūshin ni*, no. 3 and front cover.

as inanimate plants or wooden substance. But after the main priest has con-
secrated the image by dotting in its eyes and has bestowed the force of grace
(*kaji riki*) unto it by means of *mudrās*, *mantras*, and meditative vision (*kan-
nen*), the now dignified wooden substance or the plain woven material [of
the painting] has merged inseparably with the "original [absolute] substance"
(*hontai*) of the depicted deity, even though the priest has in no way affected
a change in the [basic material], [i.e.] the wood, the clay, or the stone. Dur-
ing the visualization (*kan*), this [newly emerged substance] is fused with the
Six Great Elements without any hindrance, and they will forever be in cor-
respondence with each other, and the four kinds of *maṇḍala* will not be sepa-
rate from each other. After the "Blessing of the Three Mysteries" (*sanmitsu
kaji*) has been performed, the original substance (*hon*) [of the deity] and its
shadow [image] (*yō*) have become an inseparable unity, and the characteris-
tics of the shadow image will manifest themselves instantly. In the beginning
the buddhas made out of wood, stone, or painted buddhas are mere "Shadow

Images." But after these "Shadow Images" have been blessed with the force of grace of the Three Mysteries and of the Eye-Opening, they have the power to convert the practitioner (*gyōja*) and all other living beings. After such a *kaigen* ceremony has been performed, the "Shadow Images" are respectfully called "Original Sacred Ones" (*honzon*).[28]

Such a *honzon*, believed to be invested with miraculous power, provides the nexus for mystic communication with the unseen sacred. Even when the statue is concealed in a special shrine, in which case it is called a "hidden," or "secret," Buddha (J: *hibutsu*), it nevertheless ensures reciprocal contact, enabling the faithful to reach out for the support and salvific power of the Sacred and allowing the divinity to respond to the address of the worshipper.

Although the rituals that transform an image into an icon are recorded in ancient texts and can be fairly safely reconstructed by analogies with living traditions, it is much harder to disclose the original meaning and function of a particular icon, especially one created by a Buddhist school with strong mystical elements. Such a discovery requires thorough investigation, using modern scientific methods, by conservation specialists, art historians, and Buddhologists. Because of its prime significance, the legendary statue of the historical Buddha Śākyamuni at Seiryōji in the Saga district west of Kyōto has been studied in detail by numerous scholars (fig. 4).

During restoration work a rectangular cavity in the Seiryōji Shaka's back was finally opened toward the end of February 1954, bringing to light a surprisingly large number of valuable documents and objects.[29] The sculpture was made of *Prunus wilsonii koehne*, utilizing a joined-woodblock technique. There is documentary evidence that the highly venerated "Auspicious Shaka Icon" (J: *Shaka zuizō*) was made in China. It is recorded to have been carved at "Opened Prime Temple" (C: Kaiyuansi) in Taizhou (modern Zhejiang province) upon the request of the Japanese pilgrim monk Chōnen (938–1016) by the sculptor brothers Zhang Yanjiao and Zhang Yanxi in 985. On the inside of the removable panel in the back of the sculpture the following inscription was discovered: "Carved by Zhang Yanjiao and his younger brother Yanxi of Taizhou in the land of the Great Song [dynasty]" (C: *Da Song guo Taizhou Zhang Yanjiao bing di Yanxi diao*). The Zhang brothers finished their work within twenty-eight days, from 9 August to 5 September 985. Other details and events of the Japanese delegation's sojourn in Song China may be found in a lengthy itinerary written for Chōnen by a Chinese confrere named Jianduan, who seems to have accompanied the foreign visitors.[30]

In 972 the Tōdaiji priest Chōnen and his young confrere Gizō (950–?) had made an oath to establish a monastery on Mount Atago in Kyōto "with hearts united and strength joined" in order to "raise up the Law left behind by Śākyamuni." They sacrificed the most precious essence of life, sealing their vow with the imprint of their own hands in their own blood, still visible on the hand-

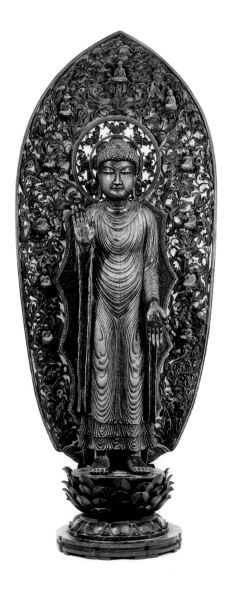

4 Udayana Śākyamuni by Zhang Yanjiao and Zhang Yanxi. Northern Song, dated 985.
Wood with traces of polychromy. 160 cm. Seiryōji, Saga, Kyōto. From the author's archives.

written document.[31] To authenticate one's responsibility for and adherence to
the terms of a document such as a letter, contract, vow, or will by "blood-seals"
(C: *xuepan*; J: *keppan*) was a well-known ceremonial custom in religious com-
munities, but also popular in imperial circles and among the warrior class of
medieval Japan. The tonsured Retired Emperor Go Uda (r. 1274–1287) stamped
his fingerprints in blood drawn from his own fingertips on the will that he
wrote about 1315 to the intent that the Buddhist school of Daikakuji in Kyōto
might flourish and long endure.[32] Chōnen's and Gizō's blood-sealed vow was
discovered inside the Seiryōji Shaka image. It is usually referred to as "letter
with hand-seals to make connection" (J: *kechi'en shūinjō*). In order to ensure the

assistance of the Buddha, a bodhisattva, or other divinity, and to benefit from the divinity's power, the celebrant would establish with it an intimate magical connection, known in Buddhist terminology as (*kezoku*) *kechi'en*. The document, in Chōnen's handwriting, must have been deposited in the statue's interior late in 985 or in 986, at the time of the icon's consecration in China, and remained undisturbed for nearly a millennium.

In 986 Chōnen and his Japanese party returned with their precious Shaka statue to Japan, where the image came to be revered as a genuine lifetime "portrait" of the historical Buddha and a miraculous icon that had been "transmitted across three countries" (J: *sangoku denrai*). The "three countries" refers to an apocryphal story that began to spread throughout Japan about the twelfth century: that the Seiryōji Shaka image was of Indian provenance, temporarily domiciled on Chinese soil, and ultimately brought to Japan by the Buddha's grace and through Chōnen's unfaltering devotion.[33] It occupies a special place in the history of Buddhist art in China and Japan because it "established the notion of an authentic portrait of the living Buddha, verified the magical efficacy of images, and validated the role of art in promotion of the faith. It was also a paradigm for royal patronage of Buddhist art."[34]

King Udayana's "Portrait" of the Buddha

The earliest known reference to the mysterious first genuine Buddha "portrait" and its origin is provided by the "Scripture on the Production of Buddha Images" (C: *Zuo fo xingxiang jing*), one of the oldest extant Buddhist texts in China.[35] The work was translated into Chinese perhaps in the first half of the third century, but virtually no traces are known of its provenance or translators. This short scripture, extremely popular by Tang times (618–907), elaborates in great detail on the marvelous rewards that may be expected in a later life by those who make and commission sacred icons. It relates that the youthful Indian King Udayana (C: Youtian wang; J: Udennō) of Vasta, ruling from the capital Kauśāmbī (present-day Kosam in the district of Allahabad, Uttar Pradesh), was an ardent admirer and pious patron of Śākyamuni. When the Buddha had ascended to the "Heaven of the Thirty-three"[36] in order to give a sermon to his deceased mother, Māyā, the king was deeply distressed by Śākyamuni's absence.

He implored the great Maudgalyāyana (C: Mujianlian; J: Mokkenren), one of the Buddha's disciples renowned for his supernatural powers, to carry a piece of sandalwood to heaven and send along with it thirty-two skilled sculptors so that they might carve a lifelike portrait statue of the Buddha. Each of the artisans would be responsible for producing one of the thirty-two *lakṣaṇa*, the suprahuman marks of the Buddha's body. "In short order the artisans completed their task and the marvelous image was brought back to earth. When Śākyamuni later returned from his sojourn in heaven the image miraculously rose to greet him.

The Buddha then paid homage to the image and prophesied its later importance in spreading the religion."[37]

Several versions of this legend found their way into Chinese sources. The two famous pilgrim-monks Faxian (d. 422) and Xuanzang[38] mention in their travel records a fine, fragrant, sandalwood statue of the Buddha that was made by King Udayana. In his "Record of the Western Regions of the Great Tang [Dynasty]" of 646, Xuanzang recounts his impression of the icon:

> By its spiritual qualities [or, between its spiritual marks] it produces a divine light, which from time to time shines forth. The princes of various countries have used their power to carry off this statue, but although many men have tried, not all the number could move it. They therefore worship copies of it, and they pretend that the likeness is a true one, and that this is the original of all such figures.[39]

No images, however, remain in India that illustrate the iconographic type of the statue preserving Śākyamuni's likeness as we know it in China and Japan. Xuanzang states at the end of his travel diary that among the seven images he brought back to Chang'an in 645 there was a copy of the sandalwood statue of the Buddha carved from life at the order of King Udayana. He also describes the magic self-removal of the venerated original icon from India to Central Asia. After Śākyamuni had attained his final *nirvāna*, people neglected to treat the sacred icon with proper respect. A sandstorm overwhelmed them and the statue transported itself through the air to a town in the region of Khotan. According to older legends and a story told in the *Seiryōji engi* of the Muromachi period, the original sculpture escaped the ravages of anti-Buddhist persecution instigated by King Pusyamitra, whose actual dates are likely to have been 184–149 BCE, but not by its own motive power; it was rescued by a humbler human, though heroic effort. The sandalwood statue is said to have been brought to Kucha by Kumārajīva's father. By day the distinguished aristocrat Kumārāyana carried the statue on his back, by night the statue carried the tired ascetic.

When Kumārajīva was invited to China by the ruler of one of the Sixteen Kingdoms, the famous Kuchean missionary was captured en route by a rogue general named Lü Guang (338–400) and held for nearly two decades in the area of present-day Gansu province. The most precious captured treasure, besides Kumārajīva himself, was the legendary Udayana statue. A new ruler, equally pro-Buddhist, destroyed the rogue general, at least partly in order to secure Kumārajīva's release. Finally, in 402, both the image and Kumārajīva arrived in Chang'an, where the missionary-monk became the *spiritus rector* of one of the greatest Buddhist translation projects of sacred scriptures. After Kumārajīva's death the statue's fate was largely determined by political circumstances. About 417 it was moved to the "Temple of Dragon Radiance" (C: Longguangsi) at Dan-yang (outside Nanjing, Jiangsu province). After Sui troops had captured that

city and set fire to the monastery in the winter of 588/89, the sculpture was rescued from the Longguangsi ruins by a monk named Zhuli. He reinstalled the Buddha image at "Lasting Joy Temple" (C: Changlesi, later "Great Cloud Temple," Dayunsi, and Kaiyuansi) at Yangzhou in Jiangsu. The Japanese pilgrim Ennin (793–864), who kept a detailed diary of his sojourn in China, probably saw it there in 838, after the monastery had been renamed Kaiyuansi. Toward the end of the Tang, the image was rescued again by a courageous monk; in 916 returned to Kaiyuansi; about 940 removed to Jinling (Nanjing), and then to Bianjing (Kaifeng), where it was set up in the new Northern Song capital's "Opening Treasure Temple" (C: Kaibaosi). Upon the order of Song Emperor Taizong (r. 976–997) the legendary statue was transferred to the imperial palace grounds in 964 and given a new home, the "Flourishing Happiness Hall" (C: Zifudian). There the Japanese delegation headed by Chōnen was eventually granted permission to see it in 984.

The six scrolls of the *Shakadō engi*, attributed to Kano Motonobu (ca. 1476–1559) and dated to 1515, present a condensed, vivid account of the Udayana statue's history—from its fabulous origin and its passage through Central Asia and China to its ultimate destination in Japan, the Shakadō, or "Śākyamuni Hall," of Seiryōji.[40] The painter embellished some of the persistent ancient traditions with fictitious detail. By Motonobu's time, the Japanese had long persuaded themselves that *they* possessed the Indian original and not a replica. In this version of the story, the devoted Japanese pilgrim Chōnen requested from the Chinese emperor permission to take the Udayana statue itself home to Japan. The monarch secretly had a replication made, hoping that the foreign monk would be unable to tell the difference. When the Chinese sculpture was completed, the two images were indeed indistinguishable. At night the statues miraculously changed places. Thus the image that Chōnen took home to Japan was the Indian sandalwood original, while the copy, unidentified as such, remained behind in China. The versatile painter of the *Shakadō engi* adapted his style with great skill to the subject matter. He rendered the heavenly sphere of the Buddha and his auspicious likeness with convincingly numinous loftiness, clearly separating those visionary scenes from ordinary settings and activities of this world, and he distinguished the fanciful Indian, Central Asian, and Chinese scenery from his familiar Japanese surroundings.

Many statues of the standing Buddha came to be identified either as the original or as a faithful, equally sacred replication of this "King Udayana Icon" (C: *Youtian wang xiang*), as it was labeled as early as the seventh century in China.[41] A number of distinctive traits were essential to the Udayana type: the rigidly frontal pose; the smoothly rounded facial features, which probably looked rather "exotic" to the Chinese and Japanese; the spiral configuration of the locks of hair on the pronounced *uṣṇīṣa*; the broad-shouldered torso; the right hand forming the *abhaya mudrā* (C: *shiwuweiyin*; J: *semui'in*; "seal of granting the absence of fear") and the left the *varada mudrā* (C: *shiyuanyin*;

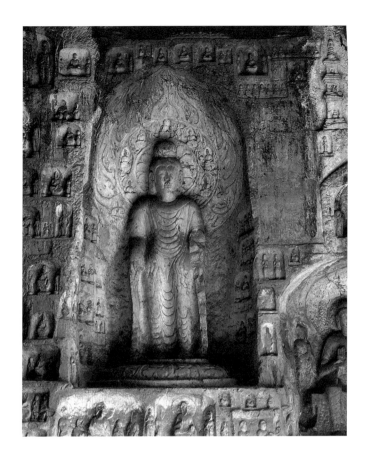

5 Buddha at north wall of Binyang south grotto, Longmen, Henan province.
Tang dynasty, 7th century. From McNair, *Donors of Longmen: Faith, Politics,
and Patronage in Medieval Chinese Buddhist Sculpture*, 102, 5.6.

J: *segan'in*; "seal of the fulfilling of the vow"); the somewhat disproportionate
length of the lower part of the body; the dense concentric-loop folds of the
robe across the chest and belly; and the rhythmically U-shaped pleats of the
drapery over each leg. The peculiar rendering of the clinging drapery espe-
cially was most likely intended to hark back to the Indian origin of the "authen-
tic Buddha portrait," said to have been made from life. The "foreignness" of the
sculptural style assumed the nature of an iconographic trademark in Chinese
and Japanese imagery, and at the same time it purported a claim for authentic-
ity. The stylistic ancestor of this type of Udayana statue "as it first appeared in
China must have had its origin in Northwest India in the Gandhāran region
during its early phases of development."[42] A very large early-seventh century
Buddha image with U-shaped drapery folds on the stout torso standing promi-
nently on the north wall of the Binyang South Grotto (fig. 5) proves that the
"Longmen patrons were probably well versed in the legend of the statue's mak-
ing and were likely familiar with the Seiryōji [proto]type of image."[43]

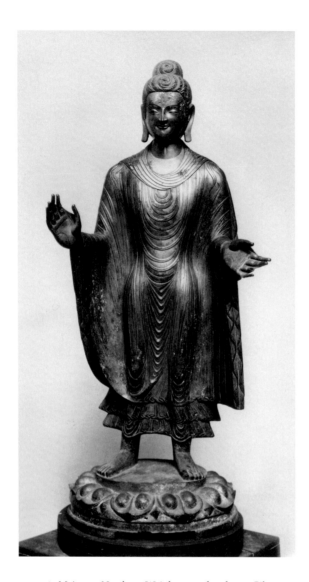

6 Maitreya. Northern Wei dynasty, dated 486. Gilt
bronze, 140.5 cm. Collection and photo Metropolitan
Museum of Art, New York. John Stewart Kennedy Fund 1926.

Quite a few gilt-bronze images of the King Udayana type have survived from
the Northern Wei dynasty (386–534). Well known is the almost life-size statue in
the Metropolitan Museum of Art, New York, identified by an inscription on the
back of the lotus pedestal as Maitreya, Buddha of the Future, and dated to 486
(fig. 6).[44] Prior to the cleaning of the corrosion covering the inscription, the date
of 477 was assigned to the statue. The stately image was made in honor of the
Grand Empress Dowager Wenming (i.e., Lady Feng, 442–490), who ruled over
the Northern Wei dynasty for much of the late fifth century. Additional inscrip-
tions on the base list the names of donors, members of prominent families.

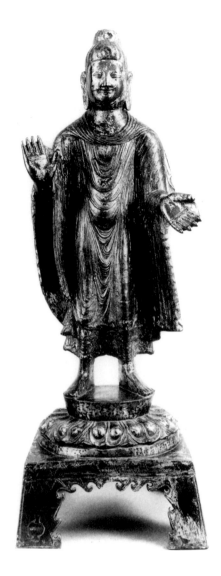

7 Maitreya, commissioned by Wan Shen. Northern Wei dynasty, dated 443.
Gilt bronze, 53.5 cm. The Agency for Cultural Affairs, Tōkyō, on deposit at the Kyūshū
National Museum, Dazaifu. From Matsubara, *Chūgoku bukkyō chōkoku shiron* 1, pl. 23.

A smaller example of this period from Hebei province, commissioned by a certain Wan Shen, was dedicated in 443.[45] The Buddha with beaming countenance and open arms radiates the message of salvation (fig. 7). This image is also identified in the inscription as Maitreya, like several other Northern Wei gilt-bronzes from Hebei that must have been ultimately based on the King Udayana prototype. A small, undated icon inscribed with the name of the donor, a monk named Huibei in the Hamamatsushi Bijutsukan;[46] a somewhat later statue commissioned in 492 by the pious patron Wang Hu, in a Kyōto private collection;[47] and a figure donated in 498 by an ecclesiastic called Pugui, now in the Sen'oku

8 Śākyamuni, commissioned by Zhang Cidai. Northern Wei dynasty, dated 475.
Gilt bronze, 35.2 cm. Found 1967 at Mengcun, Mancheng county, Hebei province.
Hebei Provincial Museum. From *Hebei sheng bowuguan wenwu jingpin ji*, no. 108.

Hakkokan (Sumitomo collection), Kyōto,[48] are all called Maitreya in their
inscriptions. This rather perplexing identification may possibly be explained
by the popularity of the Maitreya cult in that particular region and time. Some
Mahāyāna exegetes had posited Maitreya as one of Śākyamuni's auditors, and
the Chinese fondness for parallelism and cyclical repetition may have nurtured
the belief that the historical Buddha, in his incarnation preceding rebirth as
Śākyamuni was the "Throne-holder of Tusita Heaven." Maitreya was destined to
make the cycle complete. In Martha Carter's view:

So it would not be surprising that Chinese devotees might adapt Maitreya icons from those which had been Śākyamuni models. There may be other factors at work in the transposition of a supposedly Udayana-style Buddha image to that of an identical Maitreya. One fact that seems clear, however, in regard to these . . . fifth-century Chinese bronzes is that, at this period, not all images which we presently label as "Udayana" in style were reserved to portray Śākyamuni.[49]

One very fine gilt-bronze image of Śākyamuni—identified as such in the inscription incised on the back of the pedestal—was found in 1967 at Mengcun in Mancheng county, Hebei province, and is now preserved at the Hebei Provincial Museum.[50] It was made in 475 on behalf of a devotee named Zhang Cidai (fig. 8). The Buddha has a pronounced *uṣṇīṣa*, and the cascading drapery in sharp parallel folds is reminiscent in its general effect of traditional Udayana imagery. The same holds true for an undated bronze Buddha figure in the Social Science Research Institute of Kyōto University (Kyōto daigaku jinbun kagaku kenkyūjo).[51] Nearly vertical loop folds, outlining each of the legs independently, are combined with a dense symmetrical pattern of parallel folds between the legs and on the figure's chest. The small Northern Wei image has a boat-shaped mandorla whose outer perimeter is filled with stylized flames. It may be dated to the fourth quarter of the fifth century.

The King Aśoka Image

Noticeable in Chinese records, however, as well as in excavated Chinese Buddhist statuary, is an association of early Śākyamuni "portraits" with the name of another Indian monarch: Aśoka (ca. 273–ca. 232 BCE). It was presumably the Chinese Buddhist propagandists of the Six Dynasties period who glorified India's first Buddhist ruler not only as a great builder of stūpas (in a pre-iconic period), but (notwithstanding the anachronism) also as prolific maker of Buddha images. "His holy statues had been dispersed all over the world, as part of a divinely sanctioned missionary enterprise. The Chinese had of course received their due share in that remote age, but since the time was not yet ripe these remained concealed for many centuries. At last they began to reappear by various marvelous ways, to begin their task of winning piety and obedience."[52] These "King Aśoka Icons" (C: *Ayuwang xiang*) emerged by the avenues of miracle, "one might say by their own mysterious volition."[53] In chapter 5 of his "Biographies of Eminent Monks" (C: *Gaoseng zhuan*) Huijiao (497–554) relates the miraculous appearance of an Aśokan image in the year 394:

> [Tanyi] continually bewailed the fact that this monastery [Changshasi, in the outskirts of Jiangling] stood and was well provided with monks, but that

its icons were as yet few; saying: "The representations of the countenance made by King Aśoka, with all the holy good fortune [they could bring], were distributed in great numbers in these regions. Why are we so impotent that we receive nothing?" With especial fervor he besought a response to his devotion. Then in [394] on the eighth day of the second month all at once an image appeared north of the city, its radiant body-signs shining skyward. The brethren of Baimasi ["White Horse Monastery"] happened to be the first to go out to welcome it, but they were unable to set it in motion. [Tan]yi then went to adore it, saying to his followers: "This must be a royal Aśokan statue, vouchsafed to our Changsha Monastery!" He directed three of his disciples to pick it up, and it rose as if buoyed on air. It was taken back to his temple, where clerics and laity hastened [to see it] until the rumbling of carriages and horses was everywhere. Later the Kāsmīrī Dhyāna Master Samghananda (C: Chanshi Sengjianantuo) came from Shu [i.e., Sichuan] to the temple and worshipped it. He found on its halo Sanskrit writing and said: "This is a royal Aśokan Image; when did it come hither?" Those who heard him knew that [Tan]yi had not been mistaken. [The latter] died in his eighty-second year. On the day of his death the image's round halo suddenly was dematerialized. No one knew what had become of it; but clerics and laity all said that this was [a sign of Tan]yi's supernatural powers.[54]

The mysterious Aśokan Buddha icon is said to have responded with sweat and tears, and sometimes by walking about, to political upheavals that threatened the Buddhist establishment and the monastery. On auspicious occasions it emitted a bright five-colored radiance. The sacred statue survived the changes of regimes from the (Liu) Song (420–479) to Qi (479–502) to Liang (502–557) dynasties and was still "acclaimed as supreme in the world and first in China" by the time of the restoration of the Changsha Monastery in the third quarter of the sixth century.[55] The reported visit and veneration of the Dhyāna Master Samghānanda from Shu seems to indicate that the celebrated Aśokan icon attracted worshippers from near and far and that it enjoyed exceptional fame of sanctity in what is now Sichuan province. Its popularity in that area continued into Tang times. Daoshi recounts in chapter 14 of his "Grove of Jewels from the Dharma Garden" (C: *Fayuan zhulin*), written in 668, that a monk named Huiyu, of the "Wisdom that apprehends Emptiness Monastery" (C: Konghuisi), had traveled from Yizhou [i.e., Sichuan] to Changsha Monastery in 665 to have the holy gilt-bronze Aśokan Buddha icon copied in a painting.[56]

He (Huiyu) sought out a cunning artist, Zhang Jingyan, and had him purify himself in the proper manner. Six icons were painted without supernatural manifestations. From the seventh, however, a five-colored divine radiance was emitted that gave full illumination inside and out. Far and near all witnessed this, and it lasted for seven days before the light gradually faded. Clerics and laity were astonished and overjoyed beyond the power of words to describe.[57]

Huiyu took a pictorial rendering of the holy gilt-bronze image to Chang'an where the renowned master Fan Changshou completed the painting; he allegedly turned it into an elaborate and representative configuration for a temple hall in the capital. Possibly the influential Aśokan gilt-bronze icon at the Changsha Monastery did not only serve as model for paintings, but also for a number of stone images of the sixth century which have come to light in Sichuan province during the past century. Among these sculptures were two statues whose inscriptions explicitly name them as "King Aśoka Icons." One is a freestanding Buddha torso rendered in an "exotic" Indian style (fig. 9). The statue (WSZ24; h. 150 cm) was recovered in 1954 at the ancient site of the "Myriad Buddha Monastery" (C: Wanfosi) at Chengdu.[58] Its inscription relates that the image was dedicated after the Northern Zhou conquest of Sichuan by the prince Yuwen Zhao, son of Yuwen Tai, who established the Northern Zhou dynasty (557–581): "The Area Commander-in-Chief of Yizhou [Sichuan] and Pillar of State, Duke of the State of Zhao, [Yuwen] Zhao, had this 'King Aśoka Icon' reverently made" (C: *Yizhou zongguan zhuguo Zhaoguogong Zhao jing zao Ayuwang zao xiang yiqu*).[59] According to his biography, the donor Yuwen Zhao held this post and title in Yizhou during the Baoding era, between 562 and 565, and seven years later (572) was assigned a position at court. Therefore the dedication of this "King Aśoka Icon" and most likely the Northern Zhou date of its manufacture may be assigned to the sixties of the sixth century.

A very similar, though slightly taller Buddha torso (WSZ25; h. 165 cm) from the Wanfosi site, without any inscription, is another prime example of the Indianized style (fig. 10).[60] During the reign and under the patronage of Emperor Wu of the Liang dynasty (r. 502–549), "King Aśoka Icons" seem to have become widespread. In his devotion to India's first patron of Buddhism, Emperor Wu strove to emulate the celebrated Aśoka of the Mauryas. He also aspired to be a *cakravartin*, an idealized Universal Monarch described metaphorically as "turner of the wheel [of the Law]." History records that Emperor Wu periodically put on monk's robes and held maigre feasts, thereby echoing Aśoka's total dedication of his empire and himself to the Buddhist order. In Angela Howard's words:

> Thus, legitimacy was conferred on Chinese Buddhist art by its link to India, the holy land, while the patronage of local elites placed it in a Chinese locale. Very likely, the iconography of Aśoka-type Buddha icons originated in Nanjing, the capital of the Southern Dynasties. Because Sichuan became an integral part of the South politically, we may assume that when Sichuan was annexed by the Eastern Jin in 347, Sichuan Buddhist art to some degree reflected the doctrinal choices and aesthetic taste of the southern capital.[61]

The popularity of the "exotic" Aśokan images around the middle of the sixth century in Sichuan is further testified to by an exquisitely carved sandstone Buddha head discovered in 1954 among the sculptural remains of the Wanfosi (WSZ29; h. 35 cm) (fig. 11).[62] It must have once belonged to an imposing statue,

9 King Aśoka Buddha torso (WSZ24), commissioned by Yuwen Zhao. Northern
Zhou dynasty, ca. 562–565. Marble, 150 cm. Found 1954 at Wanfosi site, Chengdu,
Sichuan province. Sichuan Provincial Museum. From Xiaoneng Yang, *New Perspectives
on China's Past: Chinese Archaeology in the Twentieth Century*, vol. 1, 338, 21-6.

well over life-size. The face and its tranquil expression plainly reveal foreign fea-
tures, especially the bulging eyes, the high-bridged nose, the sensuous lips, and
the elegantly curved mustache right and left of the vertical groove on the upper
lip, the pronounced philtrum. These features may be traced back to Mathurān
images. Unlike other Chinese sixth-century *uṣṇīṣa* types the compressed cranial
protuberance covered with spiral curls appears to be reminiscent of the *krobylos*
encountered with [Apollo] statues of classical antiquity.

In May 1995 at Xi'an Road in the center of Chengdu City, not far south of the
Wanfosi site, road construction workers discovered a cache of one Daoist image

10 King Aśoka Buddha torso (WSZ25). Liang dynasty (502–557).
Sandstone, 165 cm. Found 1954 at Wanfosi site, Chengdu, Sichuan province.
Sichuan Provincial Museum. From Tōkyō Kokuritsu Hakubutsukan, Asahi
Shinbun, ed., *Chūgoku kokuhō ten — Treasures of Ancient China* (2000), 175.

and eight Buddhist stone sculptures of the Southern dynasties.[63] A Śākyamuni
figure standing on a round double lotus pedestal is carved completely in the
round (fig. 12). It retains a fragmentary halo behind the head and traces of gild-
ing at the feet. Behind the legs is an inscription panel which identifies the statue
as a "King Aśoka Icon" donated in 551: "On the thirtieth day of the ninth month
in the fifth year of the Taiqing era [i.e., 551, of the Liang dynasty], the Buddha dis-
ciple Du Sengyi had this 'King Aśoka Icon' reverently made to worship the Bud-
dha [on behalf of] her deceased son Li Foshi. . . ." (C: *Taiqing wu nian jiu yue san
shi ri fodizi Du Sengyi wei wang er Li Foshi jing zao Yuwang xiang gongyang*).[64]

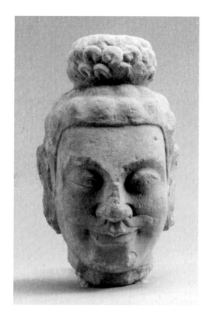

11 King Aśoka Buddha head
(WSZ29). Liang dynasty (502–557).
Sandstone, 35 cm. Found 1954 at
Wanfosi site, Chengdu, Sichuan
province. Sichuan Provincial
Museum. From Tōkyō Kokuritsu
Hakubutsukan, Asahi Shinbun, ed.,
*Chūgoku kokuhō ten — Treasures of
Ancient China* (2000), 174.

The exceptionally well-carved Xi'an Road statue is rendered in almost completely foreign style, inherited from the Mathurā school of the Gupta dynasty (320–647). The Buddha is modest in size but presented in hieratic frontality, stately and imbued with majestic grandeur.[65] His head with its pronounced *uṣṇīṣa* and spiral curls clearly exhibits Gandhāran features and is closely related in style and facial expression to the big Wanfosi head (WSZ29) (see fig. 11). A blissfully withdrawn smile on his face radiates tranquility and salvific certitude. The symbolic gestures of his lost hands (most likely forming the *abhaya* and *varada mudrā*) would have conveyed further reassurance to the devout beholder. On the front of the small aureole fragment, dense chains of pearls outline a rank of miniature Buddha figures known as "Transformation Buddhas" (C: *huafo*; J: *kebutsu*). On the reverse, carved in low relief, a noble assembly of slender female patron and donor figures — perhaps Du Sengyi and her retinue — appears to pay homage. The formulaic drapery of Śākyamuni's clinging robe effectively unfolds in symmetrical arcs across the front of the torso. Conspicuous sharp parallel folds as well as traces of gilding suggest that the sculptor intended to transfer the qualities of a cast metal prototype into stone carving. The Xi'an Road statue seems without doubt a meticulous imitation of a bronze image. For corroboration of this conjecture, we need only compare bronze statues such as the excavated Śākyamuni image from Mengcun dated to 475 in the Hebei Provincial Museum (see fig. 8) or some of the numerous fourth- and fifth-century images of the seated Buddha.

A stately, life-size, gray sandstone torso of a standing Śākyamuni (WSZ1; h. 158 cm) was excavated at the Wanfosi in Chengdu in 1954.[66] It is dated in a rather lengthy inscription of 123 characters on the back of the statue to the first year of the Zhong Datong era of Emperor Wu of Liang (529). The sculptural

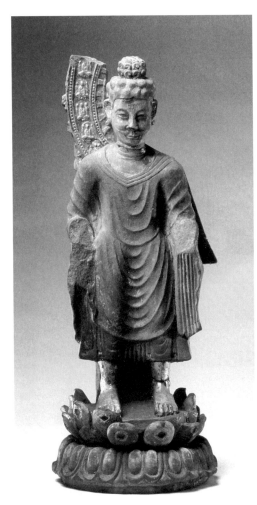
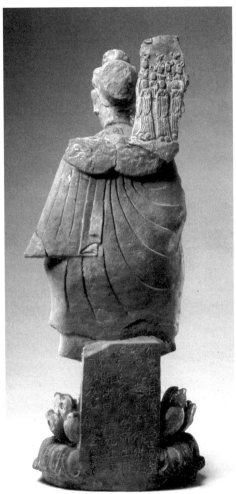

12　King Aśoka Buddha (H1:4), commissioned by Du Sengyi. Liang dynasty, dated 551. Sandstone with polychromy, 48.5 cm. Found in 1995 at Xi'an Road, Chengdu, Sichuan province. Chengdu City Institute of Archaeology. From Watt et al., *China: Dawn of a Golden Age, 200–750 AD*, 228.

treatment of the Buddha's sharply pleated robe undoubtedly descends from Mathurān models. As Howard notes,

> Stylistic innovations from India and Southeast Asia were continually being introduced to Nanjing and would quite naturally have percolated inland (to Sichuan) and northward (to Shandong). The Indianized style derived from Guptan models produced at the artistic centers of Mathura and Sarnath. The Wanfosi Shakyamuni shows a typically Guptan plasticity of form, clearly perceptible beneath the crisply pleated, transparent robe. The prototype is clearly Mathuran, as the pleats form a linear pattern over the entire body.[67]

The inscription confirms the high-level patronage of the image. The Śākyamuni statue was dedicated in honor of a descendant of Emperor Wu, Xiao Fan, Prince of Poyang. Xiao Fan was a son of Xiao Hui, a younger brother of Emperor Wu, and thus a nephew of the Liang emperor. Xiao Hui came into office as fourth prefect (*cishi*) of Yizhou in 514 and was called to the Jiankang (Nanjing) court as palace attendant (*shizhong*) and general of the palace guard (*lingjun jiangjun*) in 518. It seems that Xiao Fan, who inherited the title Prince of Poyang from his father, was on his way westward from Nanjing to Sichuan—most likely for a new appointment as prefect of Yizhou—before 529. In the imperial retinue were the old Lady Daoyou and her two sons Jingguang and Jinghuan, attendants to the Prince of Poyang. Lady Daoyou appears to have been in the courtly coterie or even a relative of Xiao Fan's father, Xiao Hui, and a pious Buddhist devotee. On the occasion of paying homage to the famous nunnery Anpusi [Wanfosi] in Chengdu, Daoyou and members of her family commissioned this Śākyamuni icon in honor of Xiao Fan.[68]

The iconographic and stylistic features of Udayana and Aśoka imagery remained ineluctably exotic—for the most part Mathurān and Gandhāran in origin. They seem to have merged over the centuries, representing in general the Chinese resurgent Indian elements in their own Buddhist sculptural tradition. The actual importation of these Western prototypes probably took place via Chinese pilgrims as well as foreign missionaries and merchants who came along the ancient overland trade routes of Central Asia or by sea around Southeast Asia. Likely they carried with them easily portable gilt-bronze images whose shining surface was intended to reproduce the sunlike radiance of the Buddha's body. Transmitted and acquired inconspicuously, they may have been the models for the life-size or even larger reproductions created by metropolitan Tang sculptors for greater impressiveness.

A reddish limestone statue of a colossal Buddha of the seventh century in the Forest of Stelae Museum, Xi'an,[69] and a seventh- or early eighth-century life-size standing Śākyamuni image of grayish limestone, excavated in 1956 in Liquan county, Shaanxi province,[70] seem to embody this resurgent Indian strain and at the same time the state of sinicization in early Tang Buddha images. In both statues the robe falls symmetrically in harmonious loops over chest and thighs. Two Tang marble statues probably predating the Seiryōji Shaka by more than two centuries present an idealized "portrait" of the historical Buddha in the sculptural Tang language of the mid-eighth century. One has come to light in 1973 at Shahutuo village near Xi'an[71] and the other has been preserved at the Victoria and Albert Museum, London.[72] These forcefully modeled figures, now decapitated, are squatter and less elegant than the earlier gilt bronzes or the seventh-century stone sculptures from Buddhist centers in and around the capital, Chang'an. The robe, draped over both shoulders, hangs in curved regular folds across the chest and in U-shaped folds down each leg. The patterning of the drapery, far less stylized and detailed than on the bronzes, clearly suggests the pectoral breadth and

corporeality, the narrow waist, the hips, and the upper legs via the animated design of assertively three-dimensional elongated pleats. Striving to combine solid volume and majestic dignity, the Tang sculptors imbued the figures with an almost realistic voluptuous fleshiness. The suave, rhythmic drapery patterns follow the form of the substantial body so closely that one senses the texture, weight, and fall of the cloth. The overall rendering testifies to the progressive disuse of exotic foreign stylistic traits in favor of sinicized Buddhist imagery.

Nevertheless, King Udayana's "portrait" of the historical Buddha turned out to be "the most durably persistent iconographic type in the whole history of Buddhism."[73] Such images were produced in China from as early as the fifth century through the Qing period (1644–1911).[74] A remarkable pictorial version by an anonymous artist of the late Ming dynasty (1368–1644) has been preserved on a large stele at "Vulture Peak Meditation Monastery" (C: Jiufengchansi) in Beijing. A long inscription flanking the standing image was written on a "favorable day" of the year 1597 by the patron Shaoqian, a Buddhist monk from Chengdu. It recounts the legend of the sandalwood auspicious Buddha image carved for King Udayana in order to serve as a visual aid during Śākyamuni's temporary absence. Furthermore, Shaoqian pays proper tribute to the distinguished pedigree of the image in China and to the history of imperial patronage. The stele image owes its long life to the fact that "the donors who paid for the stele have earned religious merit for their part in publishing the story of the Udayana Buddha (as has Shaoqian), and the Buddhist clerics and laypeople who visit Jiufeng Temple may have an ink rubbing made from the stele to take away as an object of study or contemplation."[75] One such ink rubbing has been preserved as a hanging scroll in the Field Museum of Natural History in Chicago.[76] The four-character horizontal heading in seal script reads from right to left: "Sandalwood Auspicious Icon" (C: *Zhitan Ruixiang*). Following it is Shaoqian's eloquent eulogy in regular script:

> Record of the Sandalwood Auspicious Image. The image of the Buddha was established in order to contemplate his appearance. The royal virtue [of King Udayana] manifested itself in a material object [the statue of Shakyamuni he commissioned], and its reverent fidelity exhorted the populace to conversion. Since ancient times, there have been many magical images, but the one transmitted from the greatest distance is the sandalwood image of King Udayana. All the records say the Buddha was born in the Western Regions in the 24th year of the reign of King Zhao of the Zhou dynasty [trad. 1029 BCE] and he entered nirvāṇa in the 53nd year of the reign of King Mu [trad. 950 BCE]. After the Buddha had attained complete enlightenment, he ascended to the Trayastrimsha heaven to preach the Buddhist law to his mother. Several months passed, and he had not returned. Because the king had been separated so long from the one he revered, he determined to have an image carved from sandalwood, since he longed to look upon the sacred form of the Buddha. [Buddha's disciple] Maudgalyayana feared the image

would be inaccurate, so by his spiritual power, he took 32 craftsmen up into the heavens. There they observed the special marks on the Buddha's body, and in three tries, they achieved a faithful likeness. When it was completed, the king and his countrymen wished to compare the figure to its inspirations, so the Buddha again descended to the world of men. The king led his subjects out to welcome the Buddha, and the statue rose into the air to present itself to the Buddha. The Buddha laid his hand on the head of the image and said, "A thousand years after my nirvāṇa, you will have gone to China, to make Buddhism flourish there."

Over 1,280 years after the Buddha's nirvāṇa, the image was first transmitted from the Western Regions to Kucha [in modern Xinjiang province]. Sixty-eight years later it went east to Liangzhou [modern Gansu province]. Fourteen years later it went to Chang'an [modern Xi'an]. Seventeen years later it went to Jiangzuo [Yangzi River area]. One hundred seventy-three years after that it went to Huainan [modern Anhui province]. Three hundred and seventeen years later it returned to Jiangnan. Twenty-one years later it went north to Bianjing [modern Kaifeng]. One hundred and seventy-six years later, during the inaugural year of the Shaoxing era of Emperor Gaozong of the Song dynasty [1131], Emperor Taizong of the Jin state welcomed the image to Yanjing [modern Beijing]. He founded a Water-Land Ritual [Hall] and donated the image to the Mingzhong Temple. In the 12th year [1142], Emperor Xizong of the Jin established the Dachuqing Temple. The image was placed in the Jiqing Pavilion. In the 20th year [1150], the Jin Prince of Hailing returned from the south [to ascend the throne], and he returned the image to one of the inner halls of the imperial palace in the capital, where it dwelled for 54 years. In the third month of the *dingchou* year of the Yuan state [1217], there was a fire in the palace, so the minister, Lord Shimo, offered the image to Sheng'an Temple. Nineteen years later, it went to the Yuan [when Yuan conquered Jin]. In the 12th year of the Zhiyuan era of Emperor Shizu of the Yuan [1275], the great official envoy Bole and his entourage, accompanied by Buddhist monks and musicians, offered the image to the throne, and it was kept in the Renzhidian for the next 15 years. In the *dingchou* year [1277], Dasheng wan'an Temple was built. In the 26th year [1289], the image was taken from the Renzhidian and placed in a rear hall of the temple for over 140 years. From there it went to Qingshou Temple, where it remained for over 120 years, until the 17th year of the Jiajing era [1538]. When the Emperor heard a memorial reporting a fire at the temple, he had the image offered to Jiufeng Temple. By now, the 25th year of the Wanli era [1597], it has dwelled here 58 years. From the year King Udayana had the image made, in the 12th year of King Mu [trad. 990 BCE], to the present is over 2,580 years. How extraordinary!

Majestic auspicious image! Glorious golden visage! Revere it, look up to it, as if the Great Sage were immanent. Now when all the Buddhist monks

arrive at the temple and pay their reverence to the abbots and the monks, they say, "we are ignorant of the origin of the Sacred traces." Some visiting lay worshippers also ask about the story of the image's beginnings. Records and chronologies give the dates and places of the auspicious image's travels over the centuries. In addition, Emperor Shizu of Yuan once ordered the Hanlin Academician Recipient of Edicts Cheng Jufu to write the "Auspicious Image Palace Record," and Emperor Taiding [r. 1324–1328] asked the Institute for the Glorification of Literature Academician Tuoyin to have it engraved in stone. These records provide detailed research into the origins of the auspicious image. The period from the image's entry into Shengshou wan'an [Dasheng wan'an] Temple during the Zhiyuan period to the present is also part of its history. This subsequent record I have appended in order to display [Uda-yana's] royal virtue and to illuminate the experience of the masses who come here. If they understand its origin, it will increase their reverence at worship. To proclaim their good deed, the benefactors are listed on the reverse of this stele. The auspicious image will be forever worshipped at Jiufeng Chan Temple in the capital.

Written on a favorable day in the 8th month, in autumn of the *dingyou* year of the Wanli era [1597] by Shaoqian, a Buddhist monk from Chengdu, who also set up this stone.

[Inscriptions at the bottom:]
The Excellent Throne-holder of Tushita Heaven [in Tibetan]; Reengraving of the Excellent Throne-holder of the Tushita Heaven [C: Maitreya].[77]

The Deposits in the Seiryōji Shaka

...

In Japan the late tenth-century Chinese statue at Seiryōji, with its special reputation as an "Auspicious Shaka Icon," became the prototype for numerous replicas.[78] Seiryōji Shaka was most important for its features, significantly less so for its subtle stylistic elements. "All in all, the Seiryōji Shaka must have been seen as an extraordinary icon, replete with unusual powers of great potential benefit to the faithful. And yet these powers—or the claims relating to them—were not sufficient to carry the day; what was needed was a group of dedicated prelates who would convince the faithful of the truth of the claims made of the image."[79] For this purpose the statue's interior adornment and unseen treasury of sacred power may have been piously researched in the thirteenth century, as we shall see.

The extraordinary collection of objects found inside the Seiryōji Shaka statue was tightly packed and wrapped in a cloth. In addition to the handwritten documents mentioned above, 132 coins of the Tang and Northern Song dynasties and a rather thin Chinese bronze mirror with a yellow ribbon and green tassels were

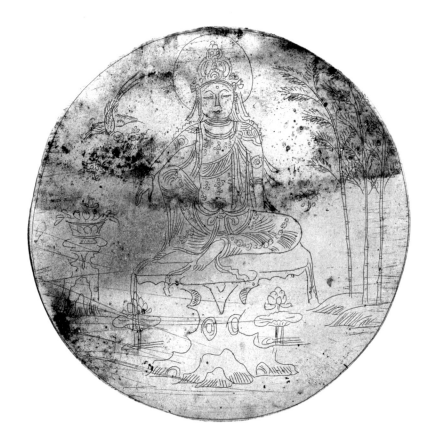

13 Mirror with fine-line engraving of Water-Moon Guanyin. Northern Song, 10th c
entury. Bronze, Diam. 11.4 cm. Found inside Udayana Śākyamuni of 985. Seiryōji,
Saga, Kyōto (4). From Sawa and Hamada, *Mikkyō bijutsu taikan*, vol. 2, plate 176.

found. On the shiny side of the mirror, in a fine-line engraving, is a graceful image
of the "Water-Moon Guanyin" (C: Shuiyue Guanyin; J: Suigetsu Kannon).[80] This
aspect of the "Guanyin of the South Sea" shows the bodhisattva seated at ease near
a bamboo grove on the shore of an island (fig. 13). Blossoming lotuses rise above
the water surface near his rocky throne, which has the typical hourglass shape of
Mount Sumeru. Guanyin is depicted in frontal view, accompanied by a long-tailed
bird and a flowerpot on a rock pedestal to his right. From early times the Chinese
had situated the mythical residence of the bodhisattva Avalokiteśvara—Mount
Potalaka, mentioned in the "Flower Garland Scripture" (S: *Avataṃsaka sūtra*; C:
Huayan jing; J: *Kegon kyō*)—on a small island off the coast of Ningbo in modern
Zhejiang province.[81] The plain style of the delicate line engraving appears to fore-
shadow Li Gonglin's (ca. 1041–1106) elegant "drawing on white," or "plain (pure)
drawing" (C: *baimiao*; J: *hakubyō*), using a technique that renounces all color. As in
baimiao, the line engraving shows a most assured control over the delineation. In
its deceptive simplicity, this Guanyin image more resembles iconographic sketches
and woodblock prints than it does contemporary paintings in color, such as the

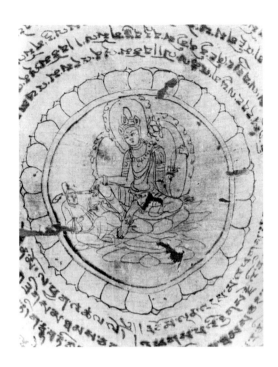

14 Water-Moon Guanyin with donor (detail). Tang dynasty, 9th century.
Found at Dunhuang, Gansu province. Ink on silk, 58.5 x 56.3 cm. Stein Collection,
British Museum, London. From Whitfield, *The Art of Central Asia*, vol. 1, 51.

"Water-Moon Guanyin" from Dunhuang, with worshipping bodhisattvas, pious
beneficiaries, and donors, dated to 13 June 968, in the Freer Gallery of Art, Wash-
ington, D.C.[82] Three other works support this observation. One is a ninth-century
Guanyin image from Dunhuang in the Stein collection of the British Museum,
London, drawn in ink on silk.[83] The bodhisattva is seated at ease on a double lotus
throne (fig. 14). He is accompanied on the left by a small subordinate figure of a
donor. The kneeling worshipper wears an official's cap and holds an incense burner
in his right hand. The two figures are set in a round medallion bordered by a wreath
of lotus petals. The Guanyin image in plain line drawing is the focus and center of
a fragmentary mystic *maṇḍala*: immediately encircling the image is a seven-line
spiral invocation in Tibetan. Beyond the spiral is a square fence of double-headed
vajra tridents, and outside of that several Esoteric divinities and symbols are
depicted according to the "Scripture of the Amoghapāśa Dhāraṇī, The Sovereign
Lord of Spells" (C: *Bukong juansuo tuoloni zizai wang zhou jing*; J: *Fukūkenjaku
darani jizai ōshi kyō*).[84] The second supporting image is a thirteenth-century Japa-
nese ink drawing of Suigetsu Kannon in a rocky cave surrounded by "mysterious"
clouds in the collection of Daigoji, Kyōto,[85] which considerably resembles, in style
as well as in size, Chinese woodcuts of the Song dynasty (fig. 15); and the third is a
Kamakura-period printed Nyoirin Kannon image, dated to 1224, of about the same
size in Gangōji, Nara.[86]

15 Water-Moon Guanyin. Kamakura period, 13th century. Ink on paper, 60 x 33 cm. Daigoji, Kyōto. From Sawa and Hamada, *Mikkyō bijutsu taikan*, vol. 2, plate 177.

Among the holy scriptures recovered from the interior of the Seiryōji Shaka statue is a woodblock print of Song date of the *Vajracchedikā prajñāpāramitā sūtra* (C: *Jin'gang banruo boluomi jing*; J: *Kongō hannya haramitsu kyō*), popularly known as the "Diamond Sūtra." Found in excellent condition, the book, with accordion-folded pages, is 15.7 cm high and has a total length of 820 cm

when unfolded.[87] The frontispiece with the preaching Buddha is partly reminiscent of the same scene in the famous printed late Tang version of the same scripture from Dunhuang, dated to 868, now in the British Library, London.[88] Although the Song book was printed more than a century later, on 20 July 985, the composition is seemingly less advanced and the delineation somewhat cruder, conveying a stronger, if more naive, devotion. Albeit neither highly sophisticated in concept nor expert in execution, this woodcut shows a delightful and refreshing originality. It was commissioned by a man named Wu Shouzhen of Gaoyoujun in present Jiangxi province. Chōnen or a member of his party may have acquired the printed book en route and then donated it for the consecration ceremony of the Shaka image. Thick printed books with accordion-folded pages, containing full-length sacred texts, were often included among the treasures for the interior adornment of Buddhist icons. A number of imported Song examples have been discovered in medieval Japanese sculptures of the Kamakura period.[89] They obviously had a wide distribution, although they may have been printed in limited editions for a pious audience. At least some of the black-and-white frontispieces, rendered in outline only, may very possibly have been modeled after contemporary sūtra scrolls drawn and written in gold and silver on indigo paper. Such luxurious handscrolls were probably commissioned by more affluent adherents of the Law. In 1044, almost sixty years after the printing of the Seiryōji Shaka book, a similarly opulent seven-scroll set of the *Saddharma pundarīka sūtra*, better known as the "Lotus Sūtra," was completed in gold and silver on indigo paper. The set was rediscovered in 1986 in Qingdao, Shandong province.[90]

The Japanese pilgrim Chōnen must have been the first foreigner to receive a complete set of the "Shu" edition of the Chinese *Tripitaka*, whose printing was finished in 983. The edition received its name from its site of production—Chengdu in Sichuan province, an area which had borne the cognomen Shu for over a millennium. On Chōnen's requesting permission to purchase a set of the Buddhist Canon to take home to Japan, Emperor Taizong presented him with a set of the *Dazang jing* (J: *Daizō kyō*).[91] This imprint contained 5,586 fascicles (*juan*).[92] Chōnen further received copies of newly translated scriptures and a copy of the "Imperial Palindromic Hymns of Praise" (C: *Yuzhi huiwen jisong*; J: *Gyosei emon geju*), illuminated with pictures of good portent. The Japanese cargo was remarkable. In addition to the sculpture of the Udayana Shaka, Chōnen had acquired no fewer than 1,124 works (*bu*) in 480 wrappers (*han* or *zhi*) by the time he sailed home from Taizhou to Kyūshū. For Japanese Buddhists of this time, China represented the prime source of sacred scriptures and their commentaries as well as devotional objects. Moreover, a particular aura of authenticity, and hence holiness, surrounded whatever came from the mainland.

Of special interest and quality are four woodblock prints from the cache inside the Seiryōji Shaka statue.[93] They are crisply printed on white paper and were probably intended for a wide distribution in Buddhist communities. In

these prints the designer and wood carver succeeded in creating images of perfect harmony and sacred radiance, effective in addressing the eyes and hearts of pious believers. On three of the prints are short texts in cartouches to be used for recitation, aids to the faithful in their communication with the divinities. All four compositions depict a principal Buddhist divinity frontally, in a severely hieratic pose, with only slight touches of asymmetrical informality. The drawing of the figures is sure and vivid, yet highly elaborate and distinct. Individual forms are defined by a precise, thin line that varies only slightly when indicating a fluctuating contour or tremulous brush strokes. Linear rhythms receive particular emphasis. The austere lineament creates most elegant images of aristocratic refinement, in a style that leads directly into the unadorned Northern Song *baimiao* figure-painting tradition of the eleventh century, epitomized by its pivotal figure, Li Gonglin. In Max Loehr's verdict, "The quality of the Seiryōji prints, at any rate, is such that the items from Tun-huang and Hang-chou are relegated, by comparison, to the level of provincial folk art."[94]

One of the prints is surprisingly large, measuring 77.8 x 42.2 cm. It represents Śākyamuni, on an elaborate throne, expounding the *Saddharma pundarīka sūtra* on the "Mountain of the Efficacious Spirits" (S: Gṛdhrakūṭa; C: Lingshan; J: Ryōzen), popularly called Vulture Peak (fig. 16). In an extremely dense composition a multitude of adherents of the Buddhist Law is depicted in a fantastic landscape setting crowded with sacred beings and surmounted by elevated manifestations of the "Seven Buddhas of the Past" (C: *qifo*; J: *shichibutsu*) in circular halos. Modern scholars usually entitle the print *Lingshan bianxiang* (J: *Ryōzen hensō*). *Bianxiang* (J: *hensō*) literally means "transformed configuration" and denotes the transformation of a verbal into a visual entity—the embodiment of the substance of a text in a picture. *Lingshan bianxiang* refers to just such a transformation of the "Lotus Sūtra," which Śākyamuni preached on the mountain called Lingshan. In China the term *bianxiang* may be frequently encountered in titles of large wall paintings illustrating various holy scriptures. These pictorial renditions based on textual descriptions developed in response to a new kind of piety, ritual, and religious practice. Prints of this sort and size probably served as devotional domestic "wall paintings" in the homes of pious believers, supporting their visualization of principal divinities addressed in the texts they were reciting. From the bottom of the vertical axis of the Seiryōji print rises a seven-story pagoda that is referred to in the cartouche below as "Treasure Pagoda for the Relics of the Complete Body of the Tathāgata Śākyamuni Expounding the *Sūtra of the Lotus of the True Law*"(C: *Miaofa lianhua jing Shijia duobao rulai quanshen sheli baota*; J: *Myōhō renge kyō Shaka tahō nyorai zenshin shari hōtō*).

The other three prints are smaller (54.5 x 28.5 cm, 57 x 29.7 cm, and 57 x 30 cm). They represent three of the most popular bodhisattvas: Maitreya (C: Mile; J: Miroku), Buddha of the Future; Mañjuśrī (C: Wenshu; J: Monju) on his lion; and Samantabhadra (C: Puxian; J: Fugen) on his elephant (fig. 17). In all likelihood they formed a triptych, centered on Maitreya. In the upper corners of the

16 Śākyamuni expounding the *Saddharma puṇḍarīka sūtra* on the Vulture
Peak. Northern Song dynasty, 10th century. Black-and-white woodblock
print on paper, 77.8 x 42.2 cm. Found inside Udayana Śākyamuni of 985.
Seiryōji, Saga, Kyōto (4). From Nara Kokuritsu Hakubutsukan, ed.,
Tō Ajia no hotoke tachi—Buddhist Images of East Asia, 126.

central print, which is framed by a *vajra* border, two unobtrusive vertical car-
touches provide invaluable information about the authorship of the Maitreya
image: *Daizhao Gao Wenjin hua*, "Painter-in-attendance Gao Wenjin delineavit"
(right) and *Yuezhou seng Zhili diao*, "The Monk Zhili from Yuezhou sculpsit"

17 Bodhisattva triptych: Maitreya (*center*), Mañjuśrī (*right*), and Samantabhadra (*left*).
Maitreya by Gao Wenjin. Northern Song dynasty, dated 984. Black-and-white woodblock
prints on paper, *center* 54.5 x 28.5 cm, *right* 57 x 29.7 cm, *left* 57 x 30 cm. Found inside Uda-
yana Śākyamuni of 985. Seiryōji, Saga, Kyōto (4). From Nara Kokuritsu Hakubutsukan, ed.,
Tō Ajia no hotoke tachi—Buddhist Images of East Asia, no. 133, p. 125, nos. 135–36, pp. 127–28.)

(left). To our knowledge this woodblock print, dated to 10 November 984 in the
cartouche at the central left border, is the earliest one to name the artist. Gao
Wenjin has been recorded as an artist from Shu (Sichuan), where his father, Gao
Congyu, and his grandfather were court painters specializing in Daoist and Bud-
dhist subjects. Sometime after Shu surrendered to Song in 965, Gao went to the
capital, Bianliang (Bianjing/Kaifeng, Henan), and joined the Imperial Hanlin
Academy under Emperor Taizong. That is about all we know today of his career
and work. Zhili, the carver of the woodblock, was a monk-artisan who equaled
Gao in perfection and technical skill. He worked in Zhejiang or came from this
region. This might suggest that the actual printing of the Maitreya image—and
most likely also of the other two bodhisattva pictures—was done at a monastery
workshop in the area where the Seiryōji Shaka statue was carved. It is also pos-
sible, however, that the print originated in the Northern Song capital, the center
of Gao Wenjin's activities, where Chōnen was received in audience by Emperor
Taizong shortly after his arrival in China on 26 January 984, and again on 8 April
of that year. After a pilgrimage to the sanctuaries of Mount Wutai and Long-
men, the Japanese delegation reentered Bianjing on 25 July 984, remaining in
the capital until 25 March 985. At any rate, the court painter Gao Wenjin and the

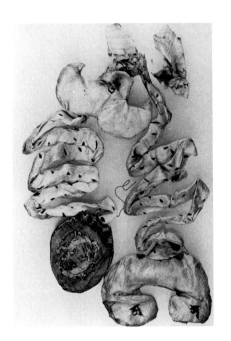

18 Textile simulacra of the "Five Human Intestines and Six Organs." Found inside Udayana Śākyamuni of 985. Seiryōji, Saga, Kyōto (4). From Bunkachō, ed., *Jūyō bunkazai*, special vol. 2, cpl. 10.

monk-artisan Zhili merit our admiration and gratitude for superb examples of a sometimes abused medium of artistic expression—a set of classic black-and-white woodblock prints.

As recorded by Chōnen in his inventory of deposits, the enormous sanctity of the Shaka statue was further emphasized by the miraculous emission of one drop of blood from its back. Also enhancing the organic animation of the iconic body was a group of textile simulacra of human intestines and organs (C: *wuzang liufu*; J: *gozō roppu*), recovered from the sculpture's internal repository (fig. 18). Great care was taken to differentiate the model viscera by shape and also by the textures and colors of the fabrics employed. They were prepared and donated by three pious Chinese nuns of the Miaoshansi and seven other women of Taizhou and inscribed in ink with "seed syllables" that represent the principal divinities of both maṇḍalas, the "Womb World" [of Great Compassion] and the "Diamond World."[95]

Chōnen's auspicious Seiryōji Shaka imported from China was to become one of the most influential Buddhist icons in Japan. The Shaka statue of the Jōraku'in in Kyōto was probably made during the first half of the thirteenth century (fig. 19). Although smaller (h. 97 cm), the polychromed wooden image follows the Seiryōji prototype in its obvious canonical traits. Patron and sculptor must have been bent on accuracy in replication, because the icon corresponds to the Song Chinese original not only in its visible outer appearance but also in the vital components of its unseen *zōnai nōnyūhin*. An X-ray photograph clearly shows that a set of textile replicas of human intestines bearing *shuji*, or "seed syllables," written in ink has been inserted into the figure.[96] These striking parallels cannot be mere coincidence. The anonymous sculptor of the Jōraku'in Shaka statue

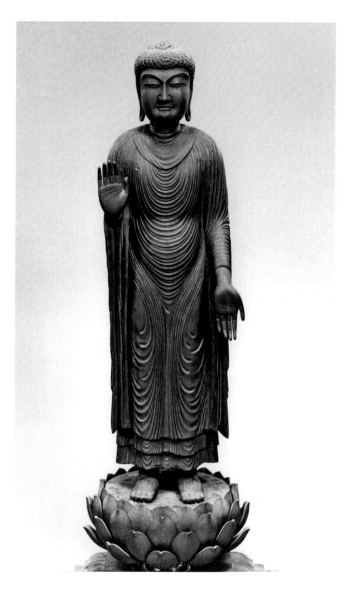

19 Shaka Nyorai. Kamakura period, first half 13th century. Wood with traces
of polychromy, 97 cm. Jōraku'in, Kyōto. From the author's archives.

and those who commissioned it must have been familiar with the organic fea-
tures of the Seiryōji Shaka's iconic body and its specific vitality. That knowledge
could have been available to them either because the celebrated statue at Seiryōji
was opened and investigated during the first half of the thirteenth century, or
because accurate records of the concealed deposits existed other than the ones
inserted in the image itself. These circumstances should alert us to consider that
the custom of ritual animation by inserting textile organs into the iconic body of
divinities may have been more common and essential in medieval sculpture of
East Asia than we presently realize.

The almost life-size Shaka image (h. 167 cm) at Saidaiji in Nara and its Song Chinese prototype (h. 160 cm) in Kyōto were to become two of the most influential extant Buddhist sculptures in Japan. Especially during the Kamakura period, many "portraits" of the historical Buddha were based on the "prime object," whether modeled directly after the famous Seiryōji Shaka or after its copy at Saidaiji (fig. 20). These two icons are the key works in "the Saidaiji lineage of the Seiryōji Shaka tradition."[97] Together with a group of sixteen monks, two carpenters, and nine sculptors headed by Zenkei (1197–1258), who held the honorary ecclesiastical rank of "Dharma Bridge" (J: *hokkyō*), the Saidaiji abbot Eizon (1201–1290) visited Seiryōji in 1249 with the express intent to worship and closely study the divine Buddha image and to have it copied. The master sculptor Zenkei and his highly efficient collaborators completed their assignment within approximately eighteen days.[98] After the polychromy and "cut gold leaf" decoration (J: *kirikane*) was finished, a selection of sacred objects was deposited inside the icon, including the "dedicatory text" (J: *ganmon*) dated to 1248, a set of ten scrolls comprising the "Lotus Sūtra" as well as other scriptures, small paper leaves for ceremonial scattering (J: *sange*), inscribed votive paper sheets known as *shūbutsu* (literally, "printed Buddhas") whose outline was that of a Five-Ring Pagoda, and a fine "rock crystal reliquary" (J: *suishō shariyōki*) in the shape of a *gorintō*. Together with the "Scripture of the Flower of Compassion" (J: *Hike kyō*) in one scroll, the miniature reliquary (h. 3.8 cm) was wrapped in a patterned silk bag (J: *nishiki fukuro*) tied up with a multicolored string.[99] Two days later, on the seventh day of the fifth month in 1249, the "eye-opening ceremony" (J: *kaigen kuyō*) was finally performed to invoke the Buddha and endow his iconic body with life and salvific power. In Eizon's autobiography, usually quoted with its abbreviated title *(Kanjin) Gakushōki* ("Record of Studying the Genuine [of the Receptive Body]"), references are made to the Seiryōji expedition as well as to the various technical and ritual procedures and also to a miracle that occurred upon the completion of the sculpture on the night of the fifth day of the fifth month. The author records that "Buddha relics gushed forth" (J: *busshari yōshutsu*) in two rooms of the monk's quarters.[100] "Eizon must have had great confidence in the efficacy and powers of the image that he had commissioned, and that immediately was divinely recognized."[101]

Eizon was devoted to a variety of Buddhist divinities, in particular to Aizen Myōō, the protective "Bright King of Lust";[102] to Monju Bosatsu, the embodiment of wisdom and the bodhisattva who, in his manifestation as a "Holy Monk," assisted the clergy in spiritual duties and exercises;[103] and—above all—to the historical Buddha Śākyamuni. Instrumental in inspiring Eizon's belief and informing his religious activities—his efforts to revive the original teaching of Buddhism and to counterbalance the enormous influence of the Amidist, or Pure Land schools—

20 Shaka Nyorai by Zenkei (1197–1258) and nine other sculptors.
Kamakura period, dated 1249. Wood with traces of polychromy,
167 cm. Saidaiji, Nara. From *Nara Saidaiji ten*, no. 30, 67.

were the fundamental Precepts of Śākyamuni, as expounded in the "Scripture of
the Flower of Compassion" (J: *Hike kyō*). Versions of chapters 6 and 7 of this scrip-
ture, handwritten on two extremely long handscrolls dated to 1280, formed part of
the interior enhancement of Eizon's portrait statue at Saidaiji. In order to become a
buddha, Eizon believed, one had to live and act like the Buddha, who had not only
founded the religion but also established the monastic discipline (S: *vinaya*).[104]
Thus Eizon matched pious devotion with exemplary conduct. As Śākyamuni was
the source of his belief, he highly venerated the "Auspicious Shaka Icon" at Seiryōji
in the Saga district west of Kyōto. In 1249, therefore, in fulfillment of a vow and
after raising sufficient funds, he made a pilgrimage to that monastery and com-
missioned a replica of its icon for his own institution, the Saidaiji in Nara. Eizon
aspired to live in the presence of Śākyamuni.

21 Shaka Nyorai. Kamakura period, 13th century. Hanging scroll, color on silk, 113 x 53.2 cm. Konrenji, Kyōto. From the author's archives.

Twenty-four years later, in the spring of 1273, another Shaka statue of the King Udayana type was completed by a sculptor named Genkai, who is otherwise unknown. An inscription in ink on the bottom of the base gives not only the date of consecration, but also the information that this image was likewise commissioned by Eizon, to be installed at the Gangōji in Nara.[105] Eizon and his disciples attended the "eye-opening ceremony." Genkai's statue is just half the size (h. 78.8 cm) of its Seiryōji prototype. A technical tour de force, this sculpture, now at the Nara National Museum, relates stylistically directly to Zenkei's Saidaiji Shaka image of 1249 rather than to the imported tenth-century Chinese "prime object" at Seiryōji. Certainly these highly stylized Shaka images are reminiscent of much earlier Indian and Chinese sculptural traditions. The medieval Japanese sculptors, however, turned the cascading drapery folds into abstract pattern and created striations of light and shadow by sharply chiseling the robe furrows. Some of them also concentrated on the intricate openwork pattern of the boat-shaped mandorla and on the distinctive lobed body halo decorated with stylized clouds.

This graphic approach inspired contemporary painters, as evinced by the fine thirteenth-century image in color on silk at Konrenji, Kyōto (fig. 21).[106] The pictorial rendering reflects the standard iconographic traits of the King Udayana imagery, including the peculiar features of the mandorla. But the austerely hieratic qualities of the carved images are absent: in place of the severely frontal stance, the painter has placed the figure in more humanlike three-quarter profile, devoid of all noumenal attributes and any ritual background setting. Thus the representation becomes more a realistic depiction of a sandalwood auspicious sculpture than an awe-inspiring Śākyamuni icon painted in a conventional style. The handling of line and color suggests that the Japanese Kamakura-period master must have been fully conversant with the modes and techniques of late Song Buddhist painting.

Enshrined in the Aizendō at Saidaiji, the monastery where Eizon was active from 1235 until the end of his life, is a highly realistic and expressive portrait sculpture of the abbot (fig. 22).[107] The statue, with Eizon seated cross-legged on a low dais, conveys a strongly individualistic quality. Eizon's remarkably elongated eyebrows attest to the sculptor's keen observation, his sensibility for and delight in extravagant forms. In silhouette the figure is reminiscent of a Five-Ring Pagoda. As suggested by ritual texts, the human body seated erect in meditation seems to be identified in its entirety with the five elements of the *gorintō* (cf. fig. 35). According to documentary evidence, the Eizon portrait was commissioned and sponsored by a multitude of about fifteen hundred devout followers to celebrate the popular abbot's eightieth birthday and to commemorate his sixty-fourth anniversary of receiving the tonsure (J: *teihatsu*) in 1216, the forty-fourth anniversary of his extraordinary "self-ordination" (J: *jisei jukai*) at Tōdaiji in 1236, and the thirty-fifth anniversary of the divine authentication of his special reception of the Buddhist precepts at Kagenji in 1245. A handscroll with a lengthy "Account of the Self-Ordination" (J: *Jisei jukai ki*), dated to 1245 and 1247, was included among the deposits within Eizon's portrait (fig. 23).[108] An inscription inside the statue further states that the *daibusshi* (the "Great Buddhist Master" [sculptor]) Zenshun, with the honorary ecclesiastical rank of *hokkyō shōnin* ("Reverend Dharma Bridge"), completed this work on the twenty-sixth day of the eighth month in the year 1280. He was assisted by members of his atelier named Shunshō, Zenjitsu, and Gyōzen.[109]

The inscription containing all this precise information on the inauguration date, the names of the sculptors, and Eizon's various anniversaries was written in ink by the "Diamond Buddha Son" (J: *kongō busshi*), i.e., the subject himself. It appears to the right and left of an abbreviated maṇḍala of the "Womb World [of Great Compassion] in Seed Syllables" (J: *taizōkai shuji mandara*) outlined in and around an eight-petaled lotus on the inside surface of the wooden statue.[110] The lotus and its "seed syllables" represent the "Court of the Central Dais Eight Petals" (J: *chūtai hachiyōin*), core of the Womb World. The Court of the Central Dais Eight Petals corresponds to the "Assembly of Perfected Bodies" (J: *jōjin'e*), which is the core of the maṇḍala of the "Thunderbolt, or Diamond, World" (J: *kongōkai mandara*). The latter is laid out on the opposite side of the sculpture's inner surface. With the *shuji*, or "seed syllables," embodying the principal divinities of both maṇḍalas in essence and sound, Eizon probably intended to transform his iconic body into an unseen emblematic and phonic maṇḍala. This hypothesis seems to be corroborated by a handscroll in ink on paper, found among the *zōnai nōnyūhin* inside the statue, which depicts both the Diamond World and the Womb World in "seed syllables" and which may also have been executed by the

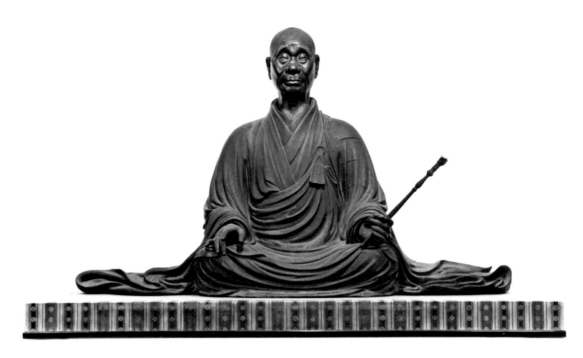

22 Portrait of Eizon (1201–1290) by Zenshun, assisted by Shunshō, Zenjitsu, and Gyōzen. Kamakura period, dated 1280. Wood with traces of polychromy, 91 cm. Saidaiji, Nara. From *Nara Saidaiji ten*, no. 1, 25.

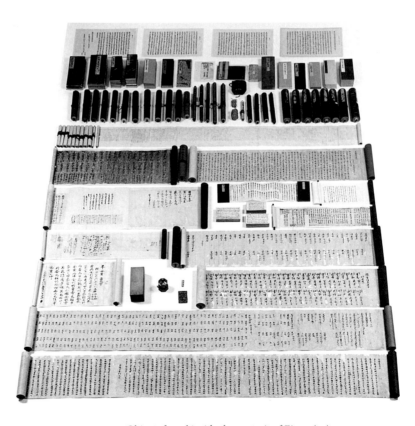

23 Objects found inside the portrait of Eizon (22). Saidaiji, Nara. From *Nara Saidaiji ten*, no. 1, 26.

24 *Ryōkai shuji mandara*: "Seed Syllable Mandala of the Two
Worlds," the "Diamond World" (top) and the "Womb World" (bottom).
Kamakura period, 13th century. Handscroll, ink on paper, 91.1 x 36.9 cm.
Found inside the portrait of Eizon (22). Saidaiji, Nara. From the author's archives.

Saidaiji abbot (fig. 24). Apparently few Buddhist monks in medieval Japan had
acquired any competence in writing Siddhaṃ characters, but Eizon certainly was
one of those few. He wrote this peculiar—for Japanese taste rather "exotic"—type
of the Indian Brāhmī script with utmost skill.[111] The grid of circles and squares
of this "Seed Syllable Mandala of the Two Worlds" (J: *ryōkai shuji mandara*) is
precisely delineated, and the "seed syllables" are executed with great care. In any

case, the hidden diagrammatic layout on the portrait's interior and the elaborate maṇḍala scroll, though secret and silent, offer telling visual testimony to Eizon's belief, cult, and doctrinal concerns.

The most unusual feature of the Eizon portrait, however, is a dense miniature spiral or coil of silver and copper wire installed inside the head at the *ūrṇā* spot. It is mounted on a wooden board whose crescent shape fits the domed cranium.[112] There can be little doubt that the coil was meant to symbolize an *ūrṇā*, the visible sign of the abbot's supreme wisdom and enlightenment; but concealed inside the head, the coil is in fact invisible. One is tempted to explain this seemingly paradoxical feature in the words of Mujaku Dōchū (1653–1744):

> The characteristics of the patriarchs are originally formless (J: *musō*). It is like the Nyorai [S: Tathāgata], whose *uṣṇīṣa* (J: *chōsō*), cannot be seen. Therefore [portraits of patriarchs] are called "topknots" (J: *chinzō*). The *Daihōkyo darani kyō* [Dhāraṇī Scripture of the Torch of the Great Dharma] states: "The *uṣṇīṣa* [J: *chōsō*] of the Nyorai is the [corporeal] protuberance (J: *nikkei*), perfect and complete. It can be seen neither by heavenly nor by human beings."

With these rather cryptic remarks the learned Zen master set forth the semantic ambiguity of the two characters that can be read either as *chōsō*, the cranial protuberance that is a suprahuman mark of the Enlightened Ones, or as *chinzō*, which denotes a painted or sculpted portrait of a Zen master.[113] As one of the thirty-two supreme marks of the imaginary body of the Tathāgata, the *ūrṇā* was originally a white curl in the middle of the forehead, known in Japanese as *miken byakugōsō* ("the mark [S: *lakṣaṇa*] of the white curl between the eyebrows"). The form of the curl was later simplified to a dot, which symbolized the emanation of light that illuminated the world. It probably is no mere coincidence that another thirteenth-century Eizon portrait statue was enshrined at "White Curl Monastery" in Nara.[114] Founded as a Shingon monastery in 715, Byakugōji had declined greatly but experienced a remarkable revival in the Kamakura period, thanks to the initiative of the energetic and influential Ritsu reformer Eizon.

In Eizon's Saidaiji portrait the concealed metal coil constitutes a kind of charismatic focus charged with spiritual energy, just like the *ūrṇā* of the celebrated Seiryōji Shaka, which consists of a circular silver plaque engraved with a seated Buddha figurine. That coinlike insertion may possibly cover or symbolically represent the holy tooth relic that Chōnen, in his inventory of deposits that was found inside the statue, mentions as having been enshrined in the icon's face:

> On the seventh day in the first third of the eighth month in the second year of the Yongxi era [5 September 985], when the image was made, a tooth of the Buddha was installed in its face. Later, the top of the Buddha's back emitted one blood-spot. It is not known what it portended, but the multitude all saw it. Therefore we have recorded it.[115]

Although the "white curl" behind Eizon's forehead was not visible to the eye, it seems likely that the majority of his congregation in Nara who patronized the making of the sculpture was aware of this medieval "high-tech" feature. Those who were present at the consecration ceremony in 1280 might even have learned about it from Eizon himself. It was, after all, their goal to establish a special tie with him in order to receive through him the benefits of the Buddha. The key term for such intimate spiritual connection is (*kezoku*) *kechi'en*. Pious adherents may have directed all their aspirations toward that particular spot, the center of Eizon's sacred emissivity, to receive the Buddhist Law from the master's body and mind with unmediated intensity. It was intimacy that counted. Probably the coil concealed behind Eizon's forehead was conceived of as a high-fidelity transmitter of his charisma. It was most likely installed as ultimate source of the icon's effectiveness, and in fact the icon continued to be revered even after the existence of the coil had been forgotten. But the lasting invisible power of an image cannot be wholly supplied by its spiritual animation. It has to be maintained by a continuous cult tradition and to be generated ever anew by worshippers whose faith enables them to perceive and grasp the unseen sacred.

Found below the coil, i.e., behind the "inlaid jewel eyes" of rock crystal (J: *gyokugan kannyū*), were a handscroll with "ritual formulas in Sanskrit" (J: *bonji darani*) written in ink on paper and one small manuscript fragment attached to a tiny oblong "brocaded pouch" (J: *nishiki fukuro*).[116] The "magical power book" of mystic syllables is dated to 1280. Zenshun and his assistants may have been advised to install the *bonji darani* behind the eyes in order to metaphorically "open the eyes" through the sacred words and the deities embodied in their sounds.

Secret caches and sacred enshrinements, special interior markings and hidden inscriptions transform images into icons. Complex and unique offerings transformed Eizon's portrait statue from its very inception into a powerful iconic body and scriptural corpus. Almost seven centuries later, we have rediscovered its true nature as a figurative reliquary and as a hidden treasury abundantly incarnating Buddhist doctrine and faith.

2

MYSTERIES OF BUDDHA RELICS
AND ESOTERIC DIVINITIES

..

Esoteric Buddhism, also designated as Vajrayāna ("Diamond Vehicle") or Tantric Buddhism, emerged last of the three major doctrinal divisions of the Buddhist faith, the two older being Theravāda ("Teaching of the Elders," also called Hīnayāna, or "Small Vehicle") and Mahāyāna ("Great Vehicle"). In China Vajrayāna became known as *mijiao* (J: *mikkyō*; "Secret Teachings") or *mizong* ("Secret School"). This highly intellectual form of Buddhism, depending largely on "mysteries" (C: *xuan*), was taught and transmitted by Tantric masters. Magic practices and intricate rituals were secrets, to be handed down exclusively from teacher to pupil. Key practices were the veneration of miraculous relics and the use of charms, spells, incantations, secret hand signs, and sacred diagrams to invoke the powers of Esoteric divinities.

Esoteric practices within Buddhism may be traced back to the first century CE, if not earlier. It was, however, only from the fifth century on—and in China especially since the second half of the seventh century—that the new doctrine developed into a most complex religio-philosophic movement. From the very beginning of this development, mysteries were so integral to Buddhist devotion and piety that a governmental "Office for the Illumination of Mysteries" (*Zhaoxuancao*) was established under the Northern and Southern dynasties (386–589) to oversee the activities of the Buddhist establishment. This office is documented since about 460 and was nominally elevated under the Northern Qi dynasty (550–577) to the status of a "court" (*si*). Able ecclesiastics and their lay

secretarial staff dominated this "Court for the Illumination of Mysteries" (*Zhao-xuansi*), which was restricted in its autonomy and redesignated the "Bureau for the Veneration of Mysteries" (*Chongxuanshu*) under the Sui dynasty (581–618).[1]

Esotericism originated in various parts of India: at Nālandā in Bihār; at Vikramaśīla in Bengal; in Kashmir and the Swat Valley; and at Khotan in the Tarim Basin, but it should be noted that some Esoteric texts were already translated into Chinese during the second and third centuries CE. The "Mātaṅgī sūtra," for example, with the Chinese title *Modengqie jing* (J: *Matōga kyō*), is said to have been first translated by a Parthian prince known to the Chinese as An Shigao, who came to Luoyang in 148 CE. A third translation of this scripture was completed in 230 CE by the Indian master Zhu Luyan, or Jiangyan, in collaboration with the Indo-Scythian lay devotee Zhi Qian (act. 223–253).[2] Other early Esoteric texts deal with formal ritual practices and contain *dhāraṇī*, invocatory formulas or magic syllables, usually referred to as "true words" (C: *zhenyan*; J: *shingon*), which epitomize the essence of a sūtra or prayer. *Dhāraṇī* are often thought to possess magic power, and they are also regarded as embodiments of Buddhist divinities and saints in sounds. Indian Tantric theologians and missionaries such as Śubhakarasiṃha (C: Shanwuwei, 637–735)[3] and his Chinese pupil Yixing (683–727) or Vajrabodhi (C: Jin'gangzhi, 671–741) and his disciple Amoghavajra (C: Bukong, 705–774) propagated Esoteric Buddhism in Tang China.[4] There pious pilgrims—Kūkai (774–835), the eminent founder of the chief Esoteric Buddhist school in Japan, Shingonshū; his nephew Enchin (814–891); and the first Japanese patriarch of the Tendai school, Saichō (767–822)—mastered it before returning home.[5]

Born into a family of pronounced Buddhist sympathizers, the notorious Tang Empress Wu (625–705, de facto rule 684–705) made it her priority after ascending the throne in 690 to establish Buddhism as a state religion in place of Daoism. Moved by obviously genuine piety as well as by calculations of policy, she made manifest her determination to firmly implant the Buddhist faith in her empire. She developed a strong attachment to a few select members of the Buddhist clergy. Beyond providing financial support for the translation of Buddhist scriptures by a number of competent ecclesiastics, the empress also honored them by adding personal prefaces. She decreed the establishment of a network of state-supported monasteries, and—again following exemplary models of the past—the dissemination and worship of Buddha relics.[6] It was, however, not until Xuanzong's reign (712–756) that Esoteric Buddhism received official recognition and active encouragement by the court. Sacral arts and architecture were now greatly patronized not only by the Buddhist establishment but also by the empire.

Altars for Esoteric ordinations were set up in some of the large monasteries. Tantric consecrations, known as *abhiṣeka* in Sanskrit (C: *guanding*; J: *kanjō*), literally, "sprinkling water on the head [of a devotee],"[7] were administered to several thousand persons in mass ceremonies. Both Emperor Xuanzong and his

25 *Arghya* pitcher for scented water to be used in the *abhiṣeka* consecration. Tang dynasty, ca. 871–73. Partly gilt silver, 19.8 cm, weight 695 g. Found in 1987 in the crypt of the Famensi pagoda, Fufeng, Shaanxi province. Famensi Museum, Fufeng. From Wu Limin and Han Jinke, *Famensi digong Tang mi mantuluo zhi yanjiu*, 433.

third son, Li Heng (711–762), who succeeded his father on the throne as Emperor Suzong (r. 756–762), received the *abhiṣeka* consecration from Bukong; with the court's blessings, a "baptistry" or *abhiṣka bodhimanda* (C: *guanding daochang*; J: *kanjō dōjō*) was established at the Daxingshansi in 768. The Japanese monk Ennin visited the metropolitan monastery on his pilgrimage in 840 and received baptism there.[8] Tantric practices had much in common with Daoist magic and thaumaturgy, and Xuanzong's fascination with the latter was easily extended to the new Buddhist ideology. Hence Śubhakarasiṃha and Vajrabodhi as well as their disciples Yixing and Bukong were frequently invited to court to perform Tantric rituals that would invoke the powers of various Esoteric Buddhist divinities in order to ward off or reverse disasters – to defeat enemies and protect the empire, to avert or terminate droughts or floods, or to cure sick members of the imperial family.

Bukong's religious heir in the third generation was the eminent Indian priest Prajñācakra (act. 847–882), known to the Chinese as Zhihuilun ("Wheel of Perfect Wisdom"). His name seems to reflect his doctrine of faith: it is an emphatic declaration of his belief in "Perfect Wisdom," *zhihui* (S: *prajñā*), and the power of turning the "Wheel" (S: *cakra*; C: *lun*).[9] He served as "baptismal preceptor" (S: *abhiṣeka ācārya*; C: *guanding asheli*) at the Daxingshan Monastery; in 871 he sponsored the making of one gold and one silver casket for the famous Famensi ("Monastery of the Dharma Gate") relic enshrinement (only nineteen days after the discovery of the relic; figs. 72 and 73), and obviously played a crucial role in devising the iconographic program for the Famensi reliquaries as well as the arrangement of ritual implements and votive offerings in the pagoda's crypt. Zhihuilun donated—among other oblations—a set of four high-footed, long-necked, and spouted *arghya* pitchers (C: *oujiaping*; J: *akabyō*) for scented water to be used in the *abhiṣeka* consecration.[10] The partly gilt silver pitchers are identical in form and decoration (fig. 25). On their bulbous bellies they are adorned with

medallions of pairs of crossed *vajra* tridents. Inside the trumpet-shaped footring of three of them are ink inscriptions specifying their placement in the "northern," "southern," and "eastern" corners of the crypt's rear chamber. Zhihuilun must have given clear instructions for the specific ritual use of his donation at the final enshrinement of the finger-bone relic of the Buddha on 25 January 874.

The Esoteric Images of Anguosi

Of ten images excavated in 1959 in the old Changle ward of the Tang capital Chang'an, at least eight qualify as members of the Esoteric Buddhist pantheon.[11] Eight of the statues are of finely grained white marble with traces of gold and polychromy. The remaining two are of bluish limestone. The bodhisattva Hayagrīva, the "horse-headed" Matou Guanyin (J: Batō Kannon), has three heads and eight arms and is shown sitting on a lotus-and-rock pedestal before an aureole of swirling flames (fig. 26). Two or even three of the images depict the ferocious-looking "Bright King" Acala[nātha] (C: Budong Mingwang; J: Fudō Myōō), the "Immovable One," who was the unshakable, indomitable adherent and protector of the Buddhist Law (figs. 27, 28, and 29). Two other terrifying images on bizarre, layered-rock pedestals represent Trailokyavijaya (C: Xiangsanshi Mingwang; J: Gōzanze Myōō), "Victor over the Three Worlds" (of greed, hatred, and folly) (figs. 30 and 31). One of his characteristic emblems is the magic "thunderbolt" or "diamond sceptre." In one of his emanations Trailokyavijaya has three, sometimes even four, heads and eight arms. His furious, scowling visage, with bulging eyes, bestial fangs, and knotted eyebrows, expresses his holy wrath (S: *krodha*; C: *fennu*; J: *funnu*), while his combative attitude and flaring

26 *(above, left)* Bodhisattva Hayagrīva (C: Matou Guanyin). Tang dynasty, second quarter 8th century. Marble with traces of polychromy, 89 cm. Found 1959 at Anguosi site, Xi'an, Shaanxi province. Xi'an Forest of Stelae Museum. From the author's archives.

27 *(above, right)* Bright King Acala[nātha] (C: Budong Mingwang). Tang dynasty, second quarter 8th century. Marble with traces of polychromy, 62 cm. Found in 1959 at Anguosi site, Xi'an, Shaanxi province. Xi'an Forest of Stelae Museum. From the author's archives.

28 *(below, left)* Torso of Bright King Acala[nātha] (C: Budong Mingwang). Tang dynasty, second quarter 8th century. Marble with traces of polychromy, 52 cm. Found 1959 at Anguosi site, Xi'an, Shaanxi province. Xi'an Forest of Stelae Museum. From the author's archives.

29 *(below, right)* Bright King Acala[nātha] (C: Budong Mingwang). Tang dynasty, second quarter 8th century. Marble with traces of polychromy, 63 cm. Found in 1959 at Anguosi site, Xi'an, Shaanxi province. Xi'an Forest of Stelae Museum. From the author's archives.

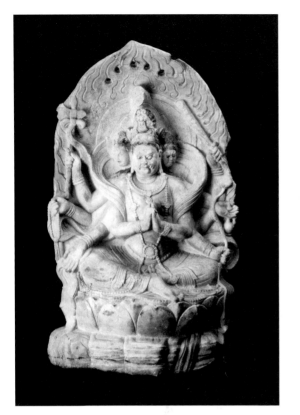 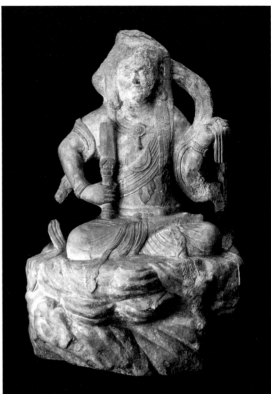

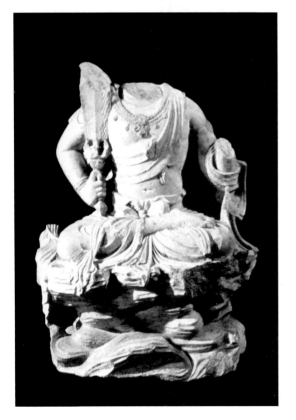 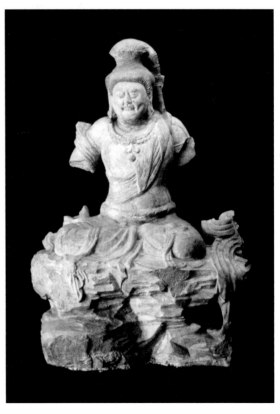

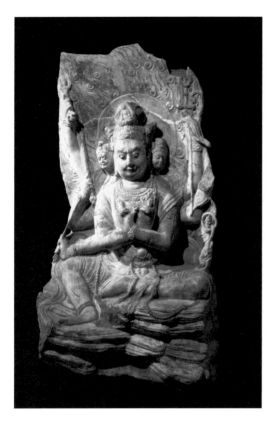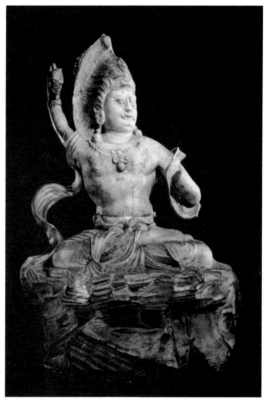

30 Bright King Trailokyavijaya (C: Xiangsanshi Mingwang). Tang dynasty, second quarter
8th century. Marble with traces of polychromy, 76 cm. Found in 1959 at Anguosi site,
Xi'an, Shaanxi province. Xi'an Forest of Stelae Museum. From the author's archives.

31 Bright King Trailokyavijaya (C: Xiangsanshi Mingwang). Tang dynasty, second quarter
8th century. Marble with traces of polychromy, 72 cm. Found in 1959 at Anguosi site,
Xi'an, Shaanxi province. Xi'an Forest of Stelae Museum. From the author's archives.

hair evince his destructive energies and militant opposition to evil, both physical
and spiritual.

Another prominent member of the Esoteric Buddhist pantheon is the mys-
tic Buddha of the South, Ratnasaṃbhava (C: Baosheng; J: Hōshō), "Producer of
Treasures." This unadorned figure, now headless, is seated with legs crossed in
vajrasana pose (legs folded in the "adamant," or unshakable, posture) on a lotus
throne that rests on seven winged horses (fig. 32). The unusual mount establishes
the iconographical identity of the icon, as described in the *Wubu xinguan* (J: *Gobu
shinkan*), a Tang Chinese work of the mid-ninth century based on an older ver-
sion by Śubhakarasiṃha, which presents Esoteric divinities, their symbols, and
their *mudrās* of the "Five Sections Mind Contemplation" (of the Thunderbolt, or
Diamond, World Maṇḍala) (fig. 33).[12] All of these statues and fragments are excep-

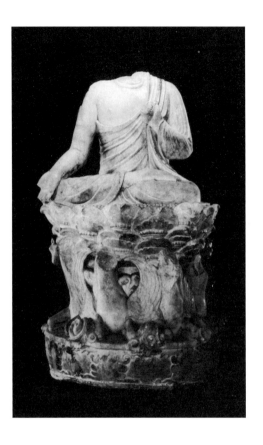

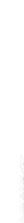

32 Torso of Ratnasaṃbhava
(C: Baosheng), Mystic Buddha of
the South. Tang dynasty, second
quarter 8th century. Marble with
traces of polychromy, 66.5 cm.
Found in 1959 at Anguosi site,
Xi'an, Shaanxi province.
Xi'an Forest of Stelae Museum.
From the author's archives.

tional in their sculptural refinement. Their subtle and elaborate surface treatment, including the original polychromy and gilding, imparts a forceful expressivenes and an extraordinarily lively grace to the works and attests to the artist's or the metropolitan atelier's remarkable sensitivity and technical skill. In their original setting the icons may have constituted a complete *maṇḍala*, perhaps similar to the sculptural installation that has been preserved in the Lecture Hall (Kōdō) of Kyōōgokokuji (Tōji) in Kyōto from about 839. Tōji's group of images is conventionally thought to have been conceived and designed by Kūkai and accomplished after his death by his disciples.

It is likely that the excavated stone sculptures were commissioned for the great Anguosi in Chang'an, which historical records locate in the ancient Changle ward in the immediate neighborhood of the imperial palaces, just outside the northeastern corner of present-day Xi'an, Shaanxi province. In July 1959, local government workers digging for a water conduit discovered the sculptures, several badly damaged, in a small tunnel. They were found buried at a depth of over ten meters.

The Anguo Temple was founded in 710. According to Duan Chengshi's (d. 863) "Notes on Temples and Pagodas" (*Sita ji*), published in 853, the Anguosi Buddha Hall was originally the bed-chamber hall of the future Emperor Xuanzong.[13] The structure was purportedly dismantled and transferred to the temple grounds by imperial decree in 713. Its main image seems to have been a Maitreya

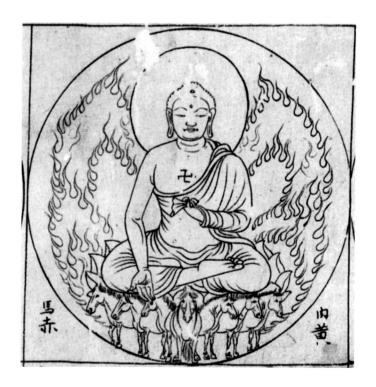

33 Ratnasaṃbhava on throne of seven winged horses from *Gobu shinkan*.
Tang dynasty, early 8th century. Handscroll (detail) with iconographic drawings, ink
on paper, 29.9 x 1808.9 cm. Onjōji, Ōtsu, Shiga prefecture. From the author's archives.

statue that frequently emitted miraculous light. Unfortunately, no other icons
are mentioned. The turmoil accompanying General An Lushan's insurrection
of 755–763 had far-reaching negative effects, not only on the subsequent politi-
cal, economic, and social structure of Tang China, but also on the prestige and
development of the Buddhist establishment and its arts. Probably the Anguosi
sculptures predate this dramatic decline, and thus may have been completed in
the second quarter of the eighth century. As a renowned study center for Esoteric
Buddhism and a colossal monument to piety and the arts in the capital city of
Chang'an, Anguosi was a chief target in the violent anti-Buddhist persecution of
845. Iconoclasts may have buried the sculptures at such a great depth in hopes of
overcoming the magical powers of the terrifying deities embodied in the images,
whose vengeance they feared. By their very act of desecration, they involuntarily
acknowledged the divinities' power.

When Suzong ascended the throne in 756, Bukong was able to strengthen
the links between the Esoteric Buddhist school and the court. After reentering
Chang'an the following year—the old capital city had briefly fallen into enemy
hands during the An Lushan rebellion—Bukong performed Tantric ceremo-
nies to purify the palace and employed Esoteric rituals to consecrate the new

emperor as a Universal Monarch. He was given imperial permission to establish a chapel within the palace precincts for the performance of the *humo* (J: *goma*) ritual, a spectacular fire sacrifice that originated in India and was later adopted by Chinese *mijiao* adherents to symbolize the extinction of defilements, passions, and other evils through the blaze of wisdom.[14] The Esoteric enthusiasm at Suzong's court reached a frenzied pitch, as exemplified by a bizarre religious drama that the emperor ordered to be enacted in 761 at the newly completed chapel in the Hall of the Virtuous Unicorn (Lindedian) of the Palace of the Great Radiance (Daminggong). "His ministers were summoned to render homage to palace attendants who were dressed as buddhas and bodhisattvas, while army officers portrayed the guardian spirits of Buddhism (*jin'gang shenwang*). It is not surprising, then, that with such fanaticism rampant the Empress should show her devotion by offering prayers for her ailing husband by copying sūtras in her own blood."[15] The mere fact that an unbalanced emperor and servile court chose Esoteric Buddhism as the medium in which to express their fantasies reveals the pervasive strength of Esotericism in China at that time.

Esoteric Practice and Icons

Sacred texts offered clear-cut descriptions of the special qualities and appearance of each figure of the enlarged Tantric pantheon, providing a basic assurance of iconographic correctness and conformity. One of the fundamental Esoteric Buddhist scriptures, the *Mahāvairocana sūtra*, known in China under its abbreviated common title *Dari jing* (J: *Dainichi kyō*), or "Scripture of the Great Illuminator," was translated by Śubhakarasiṃha in 724 with his former student and assistant, Yixing, serving as a copyist and commentator.[16] By that time Yixing had become one of the most learned monks of his day, recognized for his valuable scholarly contributions to secular fields such as astronomy and to scriptural exegeses of sacred texts. The *Mahāvairocana sūtra*, surviving only in Chinese and Tibetan translations, seems to have been originally compiled in central India (Nālandā) or in western India (Lāṭa) during the middle of the seventh century. It promoted the primordial cosmic Buddha Mahāvairocana, the "Great Illuminator," as the highest principle, penetrating with his light the darkness of ignorance. The text presents the world as a stage on which Mahāvairocana resides in the absolute epicenter. The Buddha reveals the "Three Mysteries" (C: *sanmi*; J: *sanmitsu*) of the Tantric school, that is, the mysteries of body, mind, and speech, by which every human being is able to perceive the essential identity of his pure innate heart with the enlightened mind of the "Great Radiance of Illumination." The sūtra describes most of the important Esoteric Buddhist divinities in some detail: they were novel and infinitely more varied in their iconography than their traditional counterparts.

Practitioners of the *mizong*, or *mikkyō*, believed that each person's deeds, thoughts, and words—the products of body, mind, and speech, respectively—

were inherently divine and actually those of Mahāvairocana. Through ritual practices, the divinities could be constrained to fulfill their devotees' material and spiritual goals. Correct performance of such rituals was believed to offer access to the power of the expansive Buddhist pantheon. That pantheon was systematically defined and organized into a highly intricate and complex schema, more elaborate than any previously known in the Buddhist world. Picturing that pantheon presented a new challenge to the imagination and skill of Chinese artists of the Tang dynasty.

The "Five-Ring Pagoda"

Of all Buddhist symbols or forms, it is perhaps the "Five-Ring Pagoda" that best epitomizes the purpose and meaning of the fundamental doctrine of the ultimate oneness of all existences, the transcendental unity of macrocosm and microcosm, of human nature and Buddha-nature, of icon and relic, of visible body and unseen presence of the sacred (fig. 34).[17] Its five constituent parts, each a different geometric shape, represent the Five Agents or the Five Substances from which the universe is built: the square base element (J: shōhōkei) symbolizes the earth (J: chidai); over that, the sphere (J: shō'enkei) stands for water (J: suidai); next, the triangle (J: sankakukei) represents the element fire (J: kadai); then a semicircle or crescent (J: hangetsugata or kongōkei) indicates air or wind (J: fūdai); and, at the top, the ogival form (J: dankei or rengeyō) symbolizes the void or ether (J: kūdai). Gorin is equivalent to gotai, referring to five essential components of one's physical body: the head, arms, and legs (knees).

In texts dealing with Esoteric Buddhist rituals, the practitioner is often advised to identify his body in its entirety with the five elements of the gorintō. An illustrated manuscript of the Kamakura period, entitled Taizōkai shidai bunsho ("Notes of What I Have Heard About the Womb World"), in its chapter Rinjū hiketsu ("The Hidden Arrangement at the Time of Death") visually expresses this idea.[18] It projects a frontal image of a human figure seated in meditation onto the geometric outlines of a gorintō (fig. 35). From its center the image seems to emanate a mantric radiance, because mystic Sanskrit "seed syllables" arranged as the core of a maṇḍala transform the erect iconic body into a plane diagram of profound sacred signs and sounds. The whole universe thus becomes manifest in microcosm within the practitioner's body (J: gorin jōshin). In expounding rituals pertaining to the "Scripture of the Great Illuminator," the Shōdai giki gives the following instructions:

> The Shingon practitioner should [first] set up a "round altar platform" (endan) in his "own body" (jitai). From his feet up to the navel he should complete a "great thunderbolt ring" (daikongōrin), and from there up to the heart he should imagine a "water ring" (suirin). On top of the "water ring"

34　Reliquary in the shape of Triangular Five-Ring Pagoda (J: *sankaku gorintō*).
Kamakura period, dated 1198. Gilt bronze, rock crystal, 38.7 cm. Konomiya Jinja, Shiga
prefecture. From Nara Kokuritsu Hakubutsukan, ed., *Busshari to hōju: Shaka o shitau
kokoro—Ultimate Sanctuaries: The Aesthetics of Buddhist Relic Worship*, no. 95, 118.

is a "fire ring" (*karin*), and on top of the "fire ring" is an "air (wind) ring"
(*fūrin*). After that he should from the ground of his memory and apprehen-
sion draw [in his mind] all the "form images" (*gyōzō*) and should extend
those to a degree of [whole] worlds. The Shingon practitioner gathers *sūtras*
everywhere.[19]

In instructions for the installation of Buddhist images in temple halls the same
sequence of five elements is brought to bear with the same vocabulary. Architec-
ture is thought of as a spatial manifestation of the Five Agents within the Five
Rings, a symbol of "the primordial and originally existing stūpa [erected over
Śākyamuni's bodily remains]. . . . The buddhas inside the hall mean that the
Thirty-seven Sacred Beings [i.e., the principal deities of the Kongōkai mandara]
dwell in the 'City of the Mind' (J: *shinjō*). If [the hall] is opened and they become
visible, then one is able to enter, using the 'Portal of Wisdom' (J: *chimon*)."[20]

35 Diagram of human figure seated in meditation and circumscribed by
Five-Ring Pagoda with inscribed seed syllables of Shuji mandara. *Rinjū hiketsu*
section of the *Taizōkai shidai bunsho*. Shōmyōji, Kamakura period, 13th century.
Ink on paper. Collection and photo Kanagawa Kenritsu Kanazawa Bunko, Yokohama.

The Five-Ring Pagoda corresponds in its parts not only to the Five Elements,
their forms, their five "seed syllables" (S: *a-vi-ra-hūṃ-khaṃ*), their five "seals" or
mudrās, and their five colors (J: *goshiki*)—yellow, white, red, black, and blue—
but also to the five corporeal viscera (J: *gozō*), the five senses, the five mental
activities, and the five tastes. The ultimate goal of the practitioner is to attain in
this correlative system the "Five Transcendental Wisdoms" (J: *gochi*) and subse-
quently to achieve sublime harmony with the Five Tathāgatas (J: *gochi nyorai*).
The object of identifying the Self in its totality with the *gorintō* is "to complete the
body with the Five Wisdoms" (J: *gochi jōshin*), to overcome all distinctions that
separate the devotee from the unseen sacred, the Ultimate Truth. Therefore the

gorintō made an apt emblem for the eternal presence of the "Buddha-nature" (J: *busshō jōjū*), i.e., the "Buddha-body" (J: *busshin*) in its essential nature, and for the Buddha's holy relics. Therefore, too, it has become a favorite grave monument in Japan, known as *gorin sotoba*.

The spread of faith in relics, advocated in medieval Japan particularly by Esoteric Buddhist ecclesiastics, inspired an increasing production of reliquaries in the form of various pagoda types. One type is known as "Triangular Five-Ring Pagoda" (J: *sankaku gorintō*) because of the specific shape of its "roof." Two representative gilt-bronze examples have been preserved from the Kamakura period, one at Konomiya Jinja in Shiga prefecture, dated to 1198 and allegedly commissioned by one of the most prestigious clerics of his day, Shunjōbō Chōgen (1121–1206) (fig. 34),[21] and the other at Jōdoji in Hyōgo prefecture.[22] The square inner casket of both *sankaku gorintō* rests on short feet, and its four walls are decorated on the outside with line-engraved images of the "Four Divine Kings" (C: *sitianwang*; J: *shitennō*), who protect the Buddha relics in the four quarters of the world. Each of them is identified by a short inscription in the upper right corner. These guardian images are unseen when the reliquary is properly assembled and closed; the Shitennō function here as secret protective agents.

Ichiji Kinrin

..

One of the most formidable, highly speculative, and least understood transformations of the all-encompassing primordial Buddha is the Dari Jinlun (J: Dainichi Kinrin), the "Golden Wheel of the Great Illuminator," also known as Ekākṣara Uṣṇīṣa Cakra, the "Wheel of the [Buddha's] *uṣṇīṣa* of the Single Syllable." Yet another name for the divinity, Yizi Jinlun [Foding] (J: Ichiji Kinrin [Butchō]), may be translated as the "Golden Wheel [of the Buddha's Cranial Protuberance] of the Single Word." The one syllable that is considered to be imbued with the cosmic Buddha's spiritual essence and potentiality is the "seed syllable" (S: *bīja*) *bhrūṃ*. "It is so powerful that its proper articulation will throw bodhisattvas unconscious to the ground,"[23] and it is supposed to realize "buddhahood in this very body" (*sokushin jōbutsu*), as one of the prime Shingon doctrines proposed. This *bīja* is recited in one of the most secret rituals, believed to be extremely efficacious, in fact so predominant that it can overwhelm other rites and cancel their effects. The power of Mahāvairocana's manifestation as the "Golden Wheel of the Single Word" was said to surpass that of all other divinities. Hence he is worshipped to secure a wide variety of benefits: to ward off evil spirits and danger, to avert illness and epidemics, to prevent disasters such as famine, poor harvests, and torrential rains, to gain worldly objectives, to prolong life and secure well-being, and to attain an exalted state of spiritual awareness. The "Single Word of the Golden Wheel" imagery was based on Bukong's translation of five important texts:

1. *The Rules for an Abriged Invocation of the Golden Wheel King of the Bud-dha's Cranial Protuberance* (C: *Jinlunwang foding yaolüe niansong fa*; J: *Kinrinnō butchō yōryaku nenju hō*);[24]
2. *The Manual of Rituals for Invoking the Single-Word Supreme Wheel King* (C: *Yizi ding lunwang niansong yigui*; J: *Ichiji chōrinnō nenju giki*);[25]
3. *The Manual of Rituals for Meditation on the Mystic Unity with the Single-Word Supreme Wheel King* (C: *Yizi ding lunwang yuqie guanxing yigui*; J: *Ichiji chōrinnō yuga kangyō giki*);[26]
4. *The Manual of Rituals for the Mystic Unity with the Single-Word Supreme Wheel King of the Diamond Supreme Sūtra by Proper Conduct and Invoca-tion of All the Scriptures and the Attainment of Buddhahood* (C: *Jin'gang ding jing yizi ding lunwang yuqie yiqie shichu niansong chengfo yigui*, J: *Kongōchō kyō ichiji chōrinnō yuga issai jisho nenju jōbutsu giki*);[27]
5. *The Recital Regulations and Manual of Rituals for the Single-Word Supreme Wheel King of the Diamond Supreme Sūtra* (C: *Jin'gang ding jing yizi ding lunwang yigui yinyi*, J: *Kongōchō kyō ichiji chōrinnō giki ongi*).[28]

As well described by Mimi Hall Yiengpruksawan:

> In scripture Kinrin is described in terms both frightening and beautiful. The language seems drawn from the quantum realm of particle physics and nuclear forces. Kinrin is a radiant pool of wisdom that binds the universe in a flash of light as pure as the new moon; his body gleams with the gold and white-gold hues of concentrated energy; his very form is the unified field of the absolute Buddha body.[29]

The golden wheel, or *cakra*, indicates Mahāvairocana's supreme hieratic sta-tus as the Universal Monarch, derived from the old Indian *cakravartin*, whose emblem is the golden wheel and whose wisdom, sovereignty, and power extend without limit. The cosmic Buddha's role as the source of all being and of enlight-ening wisdom is further symbolized by the perfectly round solar disc, the "Great Radiance of Illumination" that penetrates the universe in its totality, by his pure white or red robe, and by the Tathāgatas of the Five Wisdoms, contained in the Buddha's *uṣṇīṣa* and usually depicted as five tiny icons in his jewelled crown. The "wisdom-fist gesture" (S: *jñānamuṣṭi* or *bodhyagrī mudrā*; C: *zhiquanyin*; J: *chiken'in*) identifies an image as Mahāvairocana; such an image appears in the top center section of the Diamond World Maṇḍala, the section denominated as the "Assembly of the Single Seal" (C: *yiyinhui*; J: *ichiin'e*). In this distinctive *mudrā* the ultimate axiom of Esoteric Buddhism is epitomized: the gesture in which the right *vajra* fist encloses the index finger of the left *vajra* fist suggests the unity of both *maṇḍala* worlds, that of the Diamond World (*Vajradhātu*) and that of the Matrix (or Womb) World (of Great Compassion) (*Garbhadhātu*).[30] It also conspicuously demonstrates the interactive embracement of the deluded

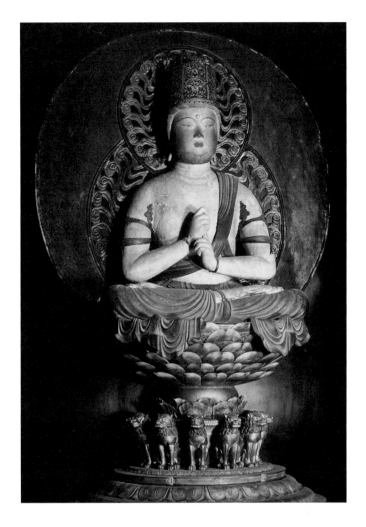

36 Ichiji Kinrin. Heian period, late 12th century. Wood with polychromy, 76 cm. Chūsonji, Hiraizumi, Iwate prefecture. From Sawa and Hamada, *Mikkyō bijutsu taikan*, vol. 2, no. 29, 35.

knowledge of mankind, the noumenal principle *li*, by the Tathāgata's transcendental wisdom *zhi*. Finally, the union of both *vajra* fists lends visual expression to the fundamental Esoteric doctrine of the ultimate non-duality of being and becoming, of essence and substance, of knowledge in the world of illusion and of divine wisdom, summarized in the popular formula: "Principle and Wisdom are not two" (C: *lizhi buer*; J: *richi funi*).

Some extraordinary Ichiji Kinrin representations have survived in Japanese medieval statuary and painting. They served as the focus of rituals (C: *xiufa*; J: *shuhō*) that made them operational. The strikingly well preserved and pretty image at Chūsonji in Hiraizumi, Iwate prefecture, is worshipped as a *hibutsu*, a "hidden, or secret, Buddhist [image]," and thus is seldom exposed to public view (fig. 36).[31] It was commissioned by a member of the Hiraizumi Fujiwara family,

probably Fujiwara Hidehira, toward the end of the twelfth century.[32] The poly-chromed wooden image was constructed using an uncommon *yosegi* technique. Its vivid, painterly surface was created with light colors highlighting a ground of white kaolin on the face and white lead on the torso and arms. Backed by its round halo, the bright Ichiji Kinrin image evokes the shining sun of its iconography. As Yiengpruksawan observes:

> It is likely that the artist responsible for the Chūsonji Kinrin was cognizant of the new continental style as it developed at workshops in Kyoto and Nara. However, a more direct route may account for the Song features of the Kinrin. Possibly the work was based on a painting or drawing brought from China along with the Song canon and Fujian celadons. The medallion format

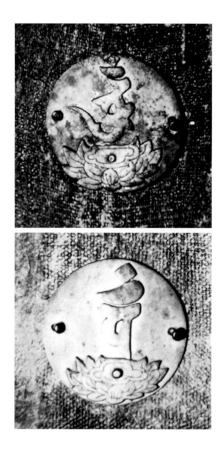

37 Seed syllables *bhrūm* of Ichiji Kinrin (top) and
vaṃ of Kongōkai Dainichi (bottom). Heian period, late
12th century. Gilt-copper reliefs, diam. 4.7 cm. Installed
inside Ichiji Kinrin (36). From Bunkachō, ed., *Jūyō
bunkazai*, special vol. I: *Zōnai nōnyūhin*, no. 75:1–2, 74.

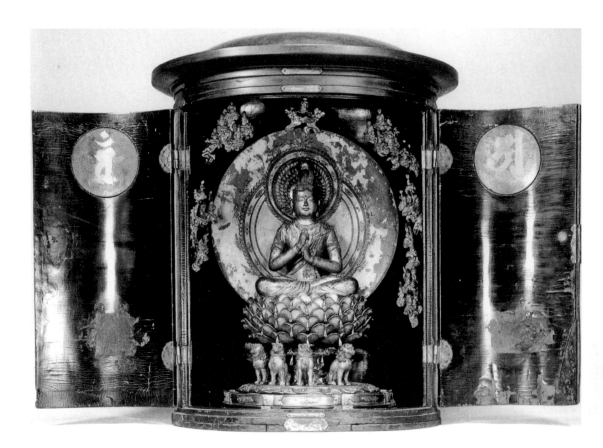

38 Ichiji Kinrin, attr. to Unkei (d. 1223). Heian period, late 12th century. Wood with polychromy, 32.1 cm, 83.7 (shrine). Kōtokuji, Tochigi prefecture. From the author's archives.

encourages such speculation, as does the painterly quality of the surface, and the unusual folds that spill over the dais as if in three-dimensional replication of a swirl of drapery on the surface of a drawing.[33]

Monastery tradition defines the icon as an *ikimi*, a "living body." Essential "chips" for its animation were two tiny gilt-copper medallions (diam. 4.7 cm) installed in the statue's interior. On each of them, rendered in low relief against a flat circular halo or solar disc, is a lotus pedestal upon which rests the icon's mystic Sanskrit "seed syllables," the *bhrūṃ* of Ichiji Kinrin and the *vaṃ* of Kongōkai Dainichi (fig. 37).

Another Ichiji Kinrin statue, most likely contemporary with the famous Chūsonji image, has been preserved at Kōtokuji, Tochigi prefecture (fig. 38). The lacquered wooden sculpture, entirely covered with gold leaf, is said to have been originally enshrined at Bannaji of Ashikaga city, an "ancient monastery" (*kosatsu*) built in the late twelfth century by Ashikaga Yoshikane (d. 1199).[34] Considering

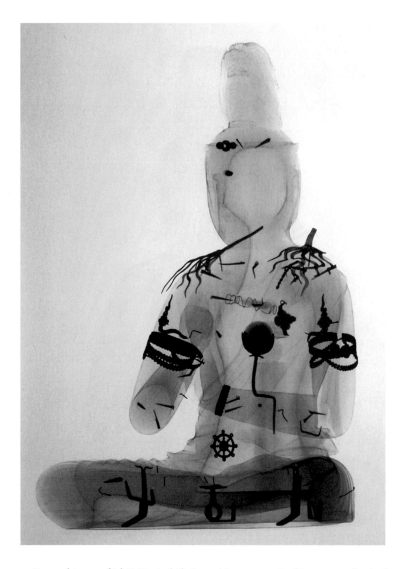

39 Scanned image of Ichiji Kinrin (38). From *Museum*, no. 621 (August 2009): 26, 48.

the close family kinship between the Ashikaga and the Hōjō clans, it has been suggested that the statue could have been carved between 1189 and 1198 by the famous sculptor Unkei (d. 1223), who evidently worked for the Hōjō family. The face of the icon is precisely rendered and the body is well proportioned.[35] Ichiji Kinrin, making his specific hand gesture, is seated cross-legged in the standard posture on an elaborate lotus throne supported by seven lions, of which four are extant. X-ray and recent CT scan examination has revealed that the interior of the statue is adorned with a crystal jewel, a wooden miniature Five-Ring Pagoda (*gorintō*), a human tooth and some other objects (fig. 39). Similar deposits have been recovered from other works by Unkei. Animated by these sacred and secret objects within its body, the icon becomes operational. Since the Esoteric Bud-

dhist teachings are so unfathomable and mysterious as to defy verbal explanation or classification, the innately powerful impact of the visual arts gives them a crucial role in Esoteric practice. The secret doctrines are revealed through iconic and ritual objects, through the medium of sculpture and painting. Icons provide a focal point for pious immersion.

Like Aizen Myōō, the "Bright King of Lust,"[36] Ichiji Kinrin became especially prominent in the secret ritual for achieving "reverence and love" (J: *keiaihō*). The original Sanskrit term for that ritual, *vaśīkaraṇa*, however, lends it the connotation of an "act of subjugating or bewitching." To achieve power and influence over another person, to win that person's love or submission to one's wishes and desires, was the principal goal of these rituals of subjugation and domination. "Most commentaries declare *keiai* as the most effective (*tokushō* or *saishō*) of all kinds of Goma Rites at the fire altar, since it has Non-Duality (*funi*) as its basic aim, especially when performed in an erotic context. Non-Duality as the harmonious blending (*wagō*) of opposites into an all-comprising oneness is one of the basic concepts of Mikkyō, culminating for instance in the famous dictum: *Bonnō soku bodai*, 'The Defilements, they are identical with Enlightenment,' a notion inconceivable in early Buddhism. In this sense *keiai* may also be regarded as the condensation of all other rites."[37] Indeed, *keiaihō* was initially considered so sacred that only the head (*chōja*) of the great Tōji in Kyōto was allowed to officiate at this exceedingly important service.

Ichiji Kinrin is iconographically similar to the Dainichi who appears in the top center square of the Diamond World Maṇḍala. Fine painted Ichiji Kinrin images of the late Heian and the Kamakura period have survived in Japanese temple collections, and also in the Tōkyō National Museum[38] and the Museum of Fine Arts, Boston (fig. 40).[39] In all of these, the divinity is seated in serene frontality on a lotus pedestal surrounded by a flaming mandorla. The entire image is projected on a perfectly round, white, luminous "lunar disc" (*gachirin*), filling almost the whole picture space. Offertory vases, usually called *hōbyō* or *genbyō* (S: *kalaśa* or *bhadra kalaśa*), at the four corners are the precious vessels of divine wisdom, containing the water of principle. Thus they are also referred to as "wisdom vases" or "jewel vases." Flower offerings in bulbous, high-footed vases of this sort would be set up on a Buddhist altar to demarcate and adorn a sacred space for the performance of a ritual. It seems that these decorative elements sometimes replaced the simple *kīlaka*, or "pegs" (C: *jue*; J: *ketsu*), that were erected at the four corners of a consecrated area. Usually a five-colored string connected the pegs, creating a magic boundary intended to protect the main object of veneration against evil influences from without.[40] Although the positioning of the four vases, combined with the lotus pedestal and the lunar disc, lend a certain planimetric character to the picture, it is important to remember that individual divinities such as the puissant Ichiji Kinrin were meant to be visualized as three-dimensional icons actually sitting on those lotus pedestals in front of the lunar discs. These compelling and enigmatic Buddhist paintings are

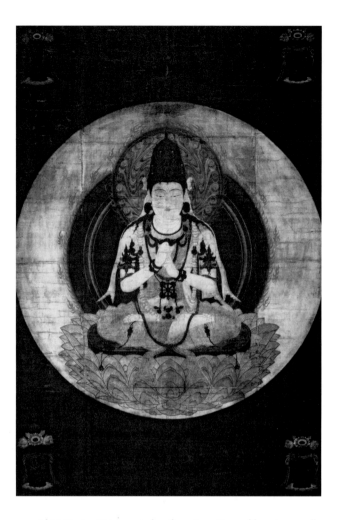

40 Ichiji Kinrin. Heian period, 12th century. Framed hanging scroll,
colors, gold and silver on silk, 125.3 x 79.5 cm. Denman Waldo Ross
Collection, 09.387, acc. no. 11.4039, Museum of Fine Arts, Boston.

intended to represent three-dimensional constructions. Whereas the Diamond
and Matrix World Maṇḍalas are two-dimensional graphic layouts of complex
religious hierarchy, the paintings of Ichiji Kinrin show an individual divinity in
sacred space and atmosphere, that of the "Golden Wheel [of the Buddha's Cra-
nial Protuberance] of the Single Word."[41]

Among the *maṇḍalas* of individual divinities, those featuring Ichiji Kinrin
belong to the category of cranial protuberance *maṇḍalas*. Some of these richly
symbolic *maṇḍalas* centered on the "Great Uṣṇīṣa of Wisdom of the Buddhas"
(J: *Daibutchō mandara*) are based on the *Mahāvairocana sūtra*, others on the
Vajraśekhara sūtra (C: *Jin'gang ding jing*; J: *Kongōchōkyō*), an abbreviated popu-
lar title translatable as "Diamond Tip Scripture." They honor the divine virtues
embodied in the cranial protuberance of supreme and enduring wisdom.[42] One

of the finest examples of an Ichiji Kinrin Butchō Maṇḍala has been preserved in the Nara National Museum.[43] It was primarily used in the rituals intended to appease threatening forces and to halt calamities. These pacifying *śāntika* (C: *xizaifa*; J: *sokusaihō*) are addressed to Ichiji Kinrin to secure his support in eliminating "all hindrances caused by malignant actions or thoughts which afflict the human being in form of defilements (J: *bonnō*; S: *kleśa*) on his way to enlightenment."[44] The primordial Buddha, crowned and bejewelled, is seated on a magnificently appointed lotus base supported by seven crouching lions, each clenching a *vajra* between his teeth. His royal status is further emphasized by the "Seven Treasures" (S: *sapta ratna*; J: *shippō*), signifying the proud possessions of a world ruler and his manifold powers: at the bottom center appears the golden wheel of the Law, "which was originally supposed to have fallen from the skies when a cakravartin was invested with authority."[45] Clockwise follow the sacred wish-fulfilling jewels; the Chinese-garbed ideal minister, representing a good and auspicious government; a winged white horse, as the ruler's noble mount; a white elephant, indicating the irresistible propagation of the Buddhist Law; the king's ideal consort; the perfect military leader, whose fierce appearance and weapons of knowledge fend off all enemies; and finally, to complete the symmetrical structure of a *maṇḍala*, an eighth figure is added, that of Butsugen Butsumo, the "Buddha-Eye and Buddha-Mother" (S: Buddhalocanā or Buddhalocanī). This divinity, usually wearing a lion crown, "symbolizes the divine power of obliterating blind ignorance and seeing through to the essence of things, a power that gives birth to buddhahood."[46]

The Bright Kings

Very conspicuous in the Esoteric pantheon was a class of powerful figures with ferocious facial expressions, several heads and arms, warlike attributes, and militant postures and gestures, encompassed by aureoles of menacing flames, and often seated on formidable mounts. Among these were the "Bright Kings [of Esoteric Wisdom]" (S: *vidyārājas*; C: *mingwang*; J: *myōō*), guardians of the faith and implacable foes of the defilements. Most of these Buddhist divinities had originated in Hinduism and had been adopted into Indian Buddhism. When transported eastward, they were infused with an element of intense ferocity and made agents of the highest-ranking divinities of the Esoteric Buddhist pantheon, the Five Tathāgatas, a class of fully enlightened buddhas. The epithet Tathāgata (C: *rulai*; J: *nyorai*) means something like "he who has thus come," i.e., like other buddhas before him. Each of the Tathāgatas is associated with a cardinal direction: Mahāvairocana (C: Dari; J: Dainichi) rules the center, Akṣobhya (C: Achu; J: Ashuku) the east, Ratnasaṃbhava (C: Baosheng; J: Hōshō) the south, Amitābha (C: Emituo; J: Amida) the west, and Amoghasiddhi (C: Bukong-shengjiu; J: Fukūjōju) the north. Each Tathāgata had as his pair of agents a partic-

ular bodhisattva and vidyārāja, representing his benign (S: *śānta*) and wrathful (S: *krodha*) aspects.

The powerful presence of the "Bright Kings [of Esoteric Wisdom]" in particular, must have overshadowed the appeal of the bodhisattvas, whose prominence they were usurping. The vidyārājas are wrathful deities, terrifying in appearance, as described above, but their anger and ferocity are beneficent. They embody the militant energy and retaliatory power of the Tathāgatas when confronted with such evils as heresy, ignorance, illusion, passion, and other spiritual obstacles. The wrathful manifestation of Mahāvairocana in the center is Acala[nātha], that of Akṣobhya in the east is Trailokyavijaya, that of Ratnasaṃbhava in the south is Kuṇḍalī (C: Junchali; J: Gundari), that of Amitābha in the west is Yamāntaka (C: Daweide; J: Daiitoku), and that of Amogasiddhi in the north is Vajrayakṣa (C: Jin'gang yecha; J: Kongōyasha). In the vast network of correspondences posited by Esoteric Buddhism, the vidyārājas, protectors of the faith, are matched with the Five Tathāgatas, as are the five cosmic elements, the five cardinal points, the five transcendental wisdoms, the five senses, the five colors, the five vitality centers, and the five viscera of the human body. Although the "Five Great Bright Kings [of Esoteric Wisdom]" (C: *wuda mingwang*; J: *godai myoō*), their names, and their functions are of Indian origin, they were probably first conceived as a distinct group of five in Chinese Esoteric Buddhism during the seventh to eighth centuries.

The Four Divine Kings

As fierce emanations of the Tathāgatas, the vidyārājas also functioned prominently as powerful guardians of the peace and prosperity of the country. They protected not only the Buddha's spiritual realm—the Law, the sanctuary, and the congregation—but also the physical land against natural calamities and the empire against enemies. These functions they shared with the "Four Divine Kings," guardians of the four directions: Dhṛtarāṣṭra (C: Chiguotian; J: Jikokuten) the east, Virūḍhaka (C: Zengchangtian; J: Zōchōten) the south, Virūpākṣa (C: Guangmutian; J: Kōmokuten) the west, and Vaiśravaṇa (C: Duowentian; J: Tamonten) the north. The worship of these enraged divinities was propagated by a large body of Esoteric texts, among others by Bukong's influential redaction (765–766) of the "Scripture on Perfect Wisdom (S: *Prajñāpāramitā*) for Humane Kings Who Wish to Protect Their States" (C: *Renwang hu guo banruo boluomiduo jing*; J: *Ninnō gokoku hannya haramitta kyō*).[47] This scripture and its Tantric commentary featuring the Divine Kings were to become one of the most important texts of Esoteric Buddhism. According to Charles Orzech:

> The *Scripture for Humane Kings* was purportedly given by the Buddha to the Indian King Prasenajit for use in the future time of the decline of the teach-

ing (C: *mofa*) and the disappearance of saints. Probably composed in Chinese in Central Asia or North China between 450 and 480, the scripture was based on ideas that flourished in Northwest India in Mahāyāna and proto-tantric circles. . . . The first recorded instance of the scripture's use in China was under Emperor Wu of the Chen in the year 559 CE when a great vegetarian banquet was ordered and, in accordance with the scripture, an altar with one hundred buddha images was constructed and one hundred teachers were called upon to expound its teachings. Probably composed in the aftermath of the persecution of Buddhism under the Northern Wei between 446 and 452, it apparently circulated anonymously until the last part of the century.[48]

The Four Divine Kings originated in old Indian cosmology as protectors of Mount Sumeru at the four quadrants of the compass. Each is accompanied by a retinue of demons and other ferocious assistants who report on the conduct of every single individual. The Four Divine Kings are said to have appeared to Bukong in a monastery in Chang'an sometime around 742, when a rebellion had broken out in the Anxi region and the Tantric master was urgently summoned to court to invoke divine support. Thanks to Bukong's magic skills, his secret incantations, mystic prayers, and fervent sūtra chanting, His Majesty—holding an incense burner—saw an apparition of a powerful army of divine guardians who would defeat the Anxi rebels. A few months later Emperor Xuanzong received the report from his field headquarters that the insurrection had been successfully subdued owing to the miraculous intervention of the Esoteric Buddhist divinities. In logical consequence, Bukong propagated the worship of the Four Divine Kings in China as guardians of the empire and of temples, where their images were installed at the four corners of an altar platform, on all four sides of major temple halls, and in entrance structures, occasionally designated as "Hall of the Divine Kings" (*tianwangtang*). In 765, during the Tibetan invasion, Bukong had the first opportunity to celebrate the Esoteric ritual for the repulsion of enemies according to his new redaction of the "Scripture on Perfect Wisdom for Humane Kings Who Wish to Protect Their States." The ritual was expressly ordered by his patron, Emperor Daizong (r. 762–779), and held at two major monasteries of the capital. Two years later, Bukong "requested an imperial edict to provide for the ordination of monks for the performance of the rite, which was to be used repeatedly as a centerpiece of Bukong's state cult. Thirty-seven monks (the number of deities of the Vajradhātu maṇḍala) were ordained by imperial edict to chant the *Scripture for Humane Kings* and perform the rites on Mount Wutai, to establish the state as a field of merit."[49]

Relics and Esoteric Practice

One of the principal tasks of the Four Divine Kings was the eternal protection of the Buddha's corporeal remains distributed throughout the Buddhist

oecumene. Worship of sacred relics, entombed in stūpas or pagodas as proper places for eternal rest, always occupied a prominent position in Buddhist faith and ritual life. According to ancient tradition, the body of the historical Buddha Śākyamuni was incinerated after he had attained his nirvāṇa. His ashes and corporeal remains were divided with diplomatic skill and interred in eight separate tumulus-like burial mounds, or stūpas. In the third century BCE India's first Buddhist ruler, Aśoka (ca. 273–ca. 232 BCE) of the Mauryas, first reassembled and later dispersed these relics throughout his far-flung kingdom in 84,000 stūpas said to have been erected in one single day. The miraculous division and widespread veneration of the Buddha's remains established a powerful precedent. Continuing division of "authentic" relics — not only of Śākyamuni himself but also of bodhisattvas, of his disciples, and of later saints and patriarchs — created an almost inexhaustible supply of minute holy objects of worship. The number 84,000 was said to be the number of atoms in the Buddha's body and of words in his sacred corpus. Thus, these 84,000 stūpas were intended to symbolically recreate Śākyamuni's physical body and his myriad teachings. The relics and the doctrines of the historical Buddha were considered to be equivalent manifestations of the same reality and sacred presence throughout the Buddhist world. Possessing "authentic" relics ensured a Buddhist institution of a high place in the ecclesiastical hierarchy as well as in society. At the same time it was a powerful instrument of monastic and imperial legitimacy and a guarantee of income through pious donations.[50]

The belief in the relics' magical power to generate wealth for whoever owned them provoked at certain times serious rivalries between institutions and individuals for possession of them — occasionally extending even to theft (or attempted theft). Donations apart, Buddha relics were highly valued because of their wish-fulfilling, life-prolonging, apotropaic, purificatory, and fecund qualities.[51]

In the strict orthodox Buddhist sense the Sanskrit term *śarīra* refers to the pure crystallized grains found after Śākyamuni's cremation; to his ashes and other bodily remains such as teeth, hair, finger-bones, and fingernails, or to the ashes, bones, and similar physical fragments of saints. The body of the Buddha Prabhūtaratna is said to have metamorphosed at his incineration into a single solid rock, a so-called "Complete-Body Relic" (C: *quanshen sheli*; J: *zenshin shari*). Reference to the "Complete-Body Relic" may be found in chapter 40 of the "Grove of Jewels from the Dharma Garden," written by Daoshi in 668.[52] The learned author further explains: "There are three kinds of relics. First is the bone relic, which is white in color. Second is the hair relic, which is black in color. Third is the flesh relic, which is red in color."[53] If "authentic" relics are lacking, Buddhist scriptures allow for tiny grains of precious substance to be venerated as *śarīra*. In chapter 3, "The Wish-Fulfilling Jewel" (C: *ruyi baozhu*; J: *nyoi hōju*), of the "Scripture of the Golden-Wheel Dhāraṇī King's Secret Transformation into a Buddha in This Body Through Turning the Wheel of the Wish-Fulfilling Jewel," the Buddha outlines the proper methods for manufacturing "artificial" relics:

If there are no relics, use gems of gold, silver, lapis lazuli, crystal, agate, glass, and so on to make the relics, and use them for the jewel. If the practitioner has no powers, go to the seashore and pick up pure sand and pebbles to use as relics. Further, use herbs, bamboo, or roots to make the relics. They are to number thirty-two grains [representing the thirty-two supreme marks of the Buddha's body], with seven primary grains. Count them as with eggs, and so make the jewel. The jewel will release light that shines on all poverty-stricken and suffering [beings insofar as] your jewel is no different [from that which would contain physical remains of the Buddha].[54]

Especially in Esoteric Buddhist literature the *śarīra* of the Buddha came to be more and more identified with the fabulous wish-fulfilling jewel (S: *cintāmani*; C: *ruyi baozhu*; J: *nyoi hōju*). Relics so identified were especially treasured (fig. 41). Already in chapter 10 of the "Treatise on the Great Perfection of Wisdom" (C: *Dazhidulun*, J: *Daichidoron*), traditionally attributed to the great Indian saint Nāgārjuna (ca. 150–ca. 250 CE), it is said that "the relics of past Buddhas turn into wish-fulfilling jewels."[55] Various other texts emphasize the metamorphosis of *śarīra* of the Buddhas of old into "diamond wish-fulfilling jewels" (C: *jin'gang ruyi*; J: *kongō nyoi*) for the enabling of all sentient beings to attain supreme enlightenment. These texts go on to associate those diamond-like jewels—and the holy relics of which they are metamorphoses—with grains of rice. In his "Account of the Secret Treasury" (J: *Hizōki*), Kūkai draws attention to the similarities of the two: "In India, in referring to 'rice grains' the word *shari* is used. Buddha relics (*busshari*), furthermore, appear similar to rice grains. Therefore, they are called *shari*."[56] The medieval Japanese Zen master Keizan Jōkin (1264–1325) also attests this supernatural power of transformation and ultimate essential identity of *śarīra*, *cintāmani*, and grains of rice in his *Denkōroku* ("Record of the Transmission of the Light"):

> The wish-fulfilling jewel of the human world is also called a grain of rice. This is called a precious gem. Compared to the jewels in the heavens, this is considered artifical, yet it is called a jewel. Moreover, when Buddhism dies out, the relics of the Buddha will become wish-fulfilling jewels raining everywhere; they will also become grains of rice to help people.[57]

Thus white rice was considered part of Śākyamuni's salvific merits, left for posterity upon his entering nirvāṇa. Inherent in this equation is the regenerating capacity and fertility symbolism of the "relic grains," of simple seeds containing the essence of life. Because pure white grains of rice were endowed with the same supernatural quality as *śarīra* and crystalline jewels, they were assigned the preciousness and perdurability of a diamond. Hence, in the devotional context of popular Buddhism, relics became associated with the unity of both maṇḍala worlds, the generative maṇḍala of the "Womb World [of Great Compassion]"

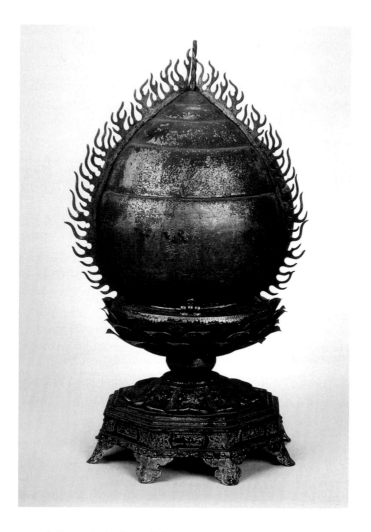

41 Reliquary in the shape of Flaming Wish-Fulfilling Jewel (J: *ka'en hōju*).
Muromachi period, 15th century. Gilt bronze, 52.3 cm. Ninnaji, Kyōto. From
Nara Kokuritsu Hakubutsukan, ed., *Busshari to hōju: Shaka o shitau kokoro—*
Ultimate Sanctuaries: The Aesthetics of Buddhist Relic Worship, no. 62, 90.

(S: *garbhadhātu*) and the ignorance-cleaving maṇḍala of the "Diamond World"
(S: *vajradhātu*).

It should be noted that special acts of relic veneration, dissemination, and
enshrinement were often performed on the Buddha's birthday, the eighth day of
the fourth month; these acts manifestly celebrated the life-generating mystery
of relics. Fertility of the land, prosperity of the state, its rulers, and people arose
and flourished through the creative power of relics. Their religious prestige and
magic aura were partly grounded in their secrecy. Although they were periodi-
cally "resurrected" from their unseen "cryptic" existence, i.e., brought out from
the pagoda's hidden underground treasury and transferred from the monastery

to the imperial palace in the capital in order to benefit the emperor and the state, they were for the most part sequestered from public exposure and circulation. "Relics are, as it were by essence, elusive realities, they are as much an 'ideal,' constructed object, product of the Buddhist imaginaire, as a material given."[58] Without any doubt, they were of primary importance in the process of implanting the Buddhist faith in Chinese soil.

In Japan legends about deeply buried relic treasuries are associated with a number of temple sites. The "Tradition of the Mount Murō Relics" (J: *Murōzan oshari sōden engi*), written in 1302 by a monk named Sōmyō, relates that Kūkai enshrined *śarīra* that he had brought from China in a small seven-storyed pagoda, and then cached the reliquary in a cave on Mount Murō. Hidden relic treasuries actually came to light in 1953, in the process of restoring the thirteenth-century "Maitreya Hall" (J: Mirokudō) of Murōji in southern Nara prefecture. On removing the central statue, a concealed cache of 37,387 small pagodas was discovered. No fewer than 4,334 were painted in the five cosmic Buddhist colors of blue, yellow, red, white, and black.[59] These miniature pagodas probably date from about the fifteenth century. Square, with successively smaller stepped platforms, projecting triangular roof decorations at the four corners and a high finial on top, they were undoubtedly inspired by the traditional Aśokan pagoda-shaped reliquaries popular in China since the sixth century and modeled after actual architectural monuments.[60] They are known as *baoqieyinta* (J: *hōkyōintō*), "Dhātukāraṇḍa Mudrā Pagodas," a denomination that refers to the "Treasure-Casket Seal Dhāraṇī" (S: *dhātukāraṇḍa mudrā dhāraṇī*; C: *baoqieyin tuoluoni*; J: *hōkyōin darani*). In each of the Murōji pagodas a small cavity in the bottom held one or two grains of rice wrapped in printed paper (fig. 42). As befitted the pagoda's special structure and function and in response to the Esoteric Scripture of the "Treasure-Casket Seal Dhāraṇī," the *hōkyōin darani* was printed on the inserted paper slips in Sanskrit, employing three different types of woodblock printing.[61] It is one of the three most powerful formulas recited every day by Shingon and Tendai adherents "as the means to acquire powers of the relics of all Buddhas in the cosmos on behalf of the deceased."[62] Beyond any doubt, the grains of rice enshrined in the miniature pagodas were to symbolize Buddha relics, most likely the vast number of atoms in the Buddha's body as well as the fecund essence of his myriad teachings. This unusual type of wooden miniature pagoda is known in Japan as *momitō*, literally, "rice-grain pagoda."

Beginning in the late Heian period, the cult of relics intensified and the numbers of relics multiplied, owing partly to the fragmentation of existing relics and partly to the creation of new ones through the cremation of venerated persons. Fervor combined with availability made for a wider distribution of relics among the Buddhist centers of Japan, and all three circumstances certainly contributed to the practice—increasing in the Kamakura period—of enshrining sacred objects inside Buddhist sculptures. During the same period the bodhisattva Kṣitigarbha (C: Dizang; J: Jizō; "Earth Repository" or "Earth Womb") emerged

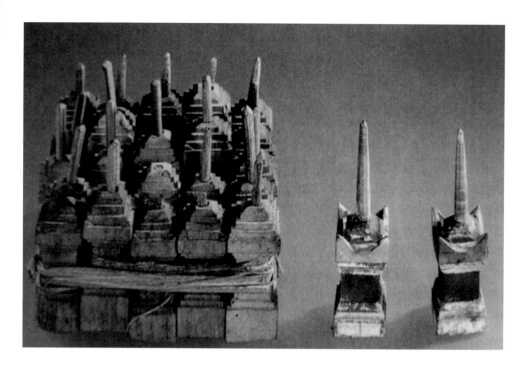

42 "Rice-Grain Pagodas" (J: *momitō*). Muromachi period, ca. 15th century.
Wood, approx. 9 cm. Photograph courtesy of Sherry Fowler.

as one of the most approachable and popular deities in Japanese Buddhism, wor-
shipped as the savior of humankind from suffering and danger, as protector of
the weak and humble, especially children, as redeemer from hell, as guide to
the foolish or wicked on their "Six Paths" (J: *rokudō*) of transmigration. Many
excellent sculptures of Jizō survive from the Kamakura period, witness to the
widespread adoration of this embodiment of divine compassion.[63]

Among the objects discovered in 1969 inside a Jizō statue of the early Kamakura
period (ca. 1200) were a baked-clay tile in the shape of a *gorintō* with impressed
"seed syllables," or *shuji*, for the five elements, and also approximately fifty sheets
of paper with identical woodblock impressions of a Five-Ring Pagoda.[64] Cover-
ing the *gorintō* image is the mystic text of the *Dhātukāraṇḍa mudrā dhāraṇī* in
Sanskrit[65] along with encircled *shuji* corresponding to each part of the *gorintō*.
Within the surrounding frame appear short prayers in Chinese. Across the top
in Chinese characters is the full title of the "Treasure-Casket Seal Dhāraṇī" (C:
Yiqie Rulai xin mimi quanshen sheli baoqieyin tuoluoni; J: *Issai Nyorai shin hi-
mitsu zenshin shari hōkyōin darani*): "The minds of all Buddhas are a mystic
secret; their entire bodies are relics; the *hōkyōin darani* [one of three ritual formu-
las recited daily by devotees of the Esoteric sects] [brings safety and solace to the
living and the dead]." On the right, the text reads, "The sentences and phrases [of
the holy texts] give off great light; they illumine the three lowest stages of rebirth

and destroy completely the suffering that attends them." The text to the left reads, "In sentient beings who are liberated from suffering, the seeds of Buddhahood shall sprout; through their own will [they shall] be reborn in the Pure Lands of the Ten Directions."[66]

The first passage acknowledges the mystic power of the Buddha's "Complete-Body Relic," i.e., the whole corpus of his teachings as it is preserved in the form of sacred texts, especially in the "Treasure-Casket Seal Dhāraṇī"; the second refers specifically to the magic quality of the sacred word; and the third deals with the believers and their auspicious prospects of rebirth and salvation. These aspects are by no means combined at random: they focus on the "Three Jewels" (S: *ratnatraya*, *trīṇi ratnāni*; C: *sanbao*; J: *sanbō*): the Buddha, the Law (S: *dharma*; C: *fa*; J: *hō*), and the community of believers (S: *samgha*; C: *sengjia*; J: *sōgya*).

Already the first pioneering Buddhist missionary in south China, the sinicized Sogdian monk Kang Senghui (first half 3rd century), is said to have relied entirely on the magic power of a Buddha relic when asked by the self-proclaimed emperor of the Wu dynasty, Sun Quan (r. 222–252), to produce convincing evidence for the efficacy and truth of the new religion. Sun Quan offered to build a stūpa if Kang was able to obtain a relic. The anxious propagator of the Buddhist Law set up a bronze phial on a table. After a nerve-racking three weeks of intense prayers and supplications, one night Kang and his monks heard a tinkling sound and were extremely relieved to discover a relic inside the small flask. When it was proudly presented to the court, the relic emitted a five-colored flame; when the phial was emptied into a bronze basin, the basin shattered where the tiny relic struck it. Sun Quan accepted these awesome occurrences as an auspicious omen. Huijiao, who recorded this story in his "Biographies of Eminent Monks" (*Gaoseng zhuan*) of 519, continues by having Kang Senghui self-assuredly come forward, saying to the king:

> "Do not think that the awesome divinity of a relic is limited to the attribute of light. The fires [that consume the universe at the end of] a cosmic cycle cannot burn it; an adamantine mace cannot smash it." Then the king ordered that it be tested, and [Kang Seng]hui again prayed, saying: "When the cloud of the Dharma is overhead, all living creatures look up for its moisture. I beg that once again this divine vestige will condescend to show more widely its awesome power."

So the relic was set on top of an iron anvil, and a strong man was made to strike at it. The anvil was completely shattered, while the relic was uninjured. [Sun] Quan in great delight paid reverence to it, and proceeded to have a pagoda erected. Since this was the beginning of Buddhist temples [there], it was known as Jian-chusi, the "Founding Temple."[67]

In 229 Sun Quan had moved his capital from Wuchang to Jianye, and the "Founding Temple" was allegedly built about 248 in the new capital, the present-day Nanjing. In the sixth century the Luoyang "Monastery of the Dharma

Cloud" (Fayunsi) claimed to possess some of the Buddha's authentic teeth; Yang Xuanzhi visited the place and recorded the claim in his *Luoyang qielanji* ("Record of Buddhist Monasteries in Luoyang"), completed about 547.[68] Yang further related that in Najie, the capital of Nagarahāra (in modern Jalalabad, Afghanistan), the Buddha's teeth and hair received special veneration. The relics "were placed in a jeweled box and worshipped [by the people] day and night." But a century later, when the famed Chinese priest Xuanzang (600–664), who spent seventeen years on pilgrimage in India and Central Asia, reached the city, the teeth were already lost.[69]

Again, Huijiao in his "Biographies of Eminent Monks" describes the supernatural manifestations and mysterious events befalling the penitent monk Huida, who died suddenly. He had been a hunter in Northern China named Liu Sahe and "then had come back to life with the torments of Hell imprinted on his memory; he had been told there that he might escape them, however, if he paid for his sins by seeking out and worshipping certain works of King Aśoka in China."[70] Huida's pilgrimage to one of these famous relic monuments engendered a miracle, as related by Huijiao:

> In the Ningkang era [373–375] of the Jin [dynasty] he reached the capital.
> Just before that time His Imperial Majesty Jianwen [r. 371–372] had had a
> three-storeyed pagoda built at Changgansi [south of Nanjing], which after its
> completion poured forth light every night. Huida climbed onto the city wall
> to see, and observed that the tip of the spire alone had an unusual color. He
> went thither to pay worship, and every morning and night made his prayer;
> until one night he saw that from time to time a light was coming from under-
> neath the spire. When he told, an excavation was begun; at a depth of ten
> feet or so they discovered three stone tablets. Inside the lid of the central one
> was an iron coffer, and in that a silver coffer, which in turn held one of gold.
> Within the last were three relics, and in addition a nail and a hair several feet
> long, which when stretched out would curl again in a spiral form, all of these
> glowing with light and color. This had been one of the 84,000 stūpas erected
> by King Aśoka at the time of King Jing [r. 519–476 BCE] of the [Eastern]
> Zhou [dynasty]. Religious and laity were overjoyed at the miracle. West of the
> old stūpa they set up another pagoda spire to house the relics. In [391] this
> was enlarged to a three-storeyed form by [Emperor] Xiaowu [r. 373–396] of
> the Eastern Jin [dynasty].[71]

Reliquaries: Caskets, Pagodas, and Aśoka Stupas

Whether or not such radiant relics were ever excavated, Huijiao's account illustrates to perfection the contemporary mode of depositing *śarīra* and the persistence of material hierarchy in their consecratory enshrinement. Usually

slabs and caskets of stone, often with inscriptions recording names and dates of temples, monasteries, and donors, held nested caskets of increasingly costly materials: within a wooden box, an iron coffer, and within that a gilt-bronze container, then a silver casket, a golden one, and finally a jade or glass container. Beginning in the tenth century, noticeable changes may be observed, both in the selection of materials, containers, and offerings enshrined and in the way in which they were deposited.

Buddhist history records that Huida excavated on his pilgrimage also a miniature wooden stūpa reliquary which he believed was one of the original 84,000 made by King Aśoka. This legendary box-like reliquary covered with carved figure scenes in an Indianized style, prominent leaf-shaped projections at the four corners, and a central pillar along which are spaced five discs is thought to be the one preserved at Ayuwangsi (Aśoka Monastery) of Ningbo, Zhejiang province.[72]

In 955, Qian Hongchu (r. 948–78), the king of the state of Wuyue, vowed to print 84,000 scrolls with Buddhist texts and to enshrine these sacred words in small Aśoka pagodas. Such domed stūpa reliquaries in carved wood, cast silver, (gilt) bronze and iron have been recently discovered in several pagodas, for the most part under the "heart chamber" (*xinshi*) in a central underground depository usually referred to in Tang texts simply as "stone chamber" (*shishi*) or "stone chamber below the pagoda" (*ta xia zhi shishi*). The terms "underground palace" (*digong*) or "dragon palace" (*longgong*) commonly used for a pagoda's crypt are modern misnomers. Among the treasures of the seven-storyed pagoda of the Ruiguangsi in Suzhou, Jiangsu province, which were recovered in 1978 from the reliquary chamber on the third story, was a gilt bronze Aśoka type reliquary (h. 36.7 cm) dated 955.[73] On the inside of its base the Aśoka pagoda bears an incised inscription identifying it as one of the "84,000 treasure pagodas respectfully made by the king of the state of Wuyue, Qian Hongchu, in the year 955." A somewhat smaller bronze reliquary (h. 18.5 cm) of the same type made under the patronage of Qian Hongchu, with a similar inscription and the same date of 955 found its way to Japan where it has been preserved at Seiganji, Fukuoka.[74] In 1957 no less than fifteen examples (h. 22.6 cm) dated to 955 were found in the crypt of the Wanfo pagoda in Jinhua City, Zhejiang province.[75]

During the second excavation campaign of the Institute of Archaeology of Zhejiang Province in 2001, one of the finest and best preserved examples was unearthed from the crypt of the Leifengta ("Thunder Peak Pagoda") in Hangzhou.[76] The precious Aśoka reliquary (h. 35.6 cm) is of solid silver and partly gilt (fig. 43). It was protected by a square iron coffer with bevelled edges at the top (h. 51.2 cm) and enshrined in the "stone chamber" of the Leifengta. Closely related in style and size is a twelfth-century gilt-bronze Aśoka pagoda (h. 32.2 cm) excavated in June 1976 from the crypt of a pagoda in Qingyang county, now preserved at the Anhui Province Museum in Hefei.[77] The Aśoka pagoda was found inside a silver reliquary casket. An inscribed silver plaque attached to it records the beginning of construction work of the pagoda's crypt in the

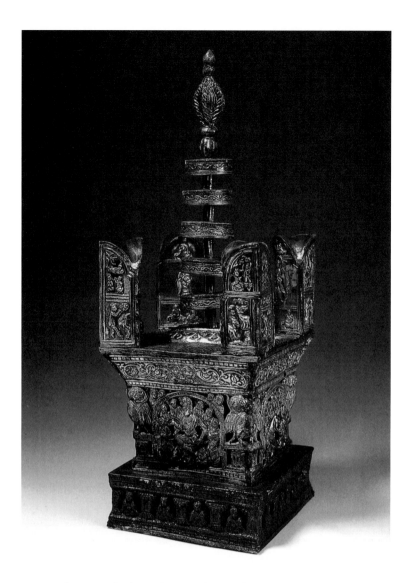

43 Reliquary in the shape of King Aśoka Pagoda. Wuyue kingdom, mid-10th century. Partly gilt silver, 35.6 cm. Found 2001 in the crypt of Leifengta, Hangzhou, Zhejiang province. Zhejiang Province Museum, Hangzhou. From the author's archives.

twenty-fifth year of the Shaoxing era (1155) of the Southern Song Emperor Gaozong (r. 1127–1162).

A prototype of the Aśoka pagoda with stronger reminicences of the original Indian stūpa was discovered in 1972 at the Buddhist site of Gongxian, Henan province.[78] The cylindrical domed miniature building (h. 50 cm) rises from a square stepped base. It has four leaf-shaped projections on top. This bronze stūpa probably predates the Qian Hongchu reliquaries by more than four centuries; it may have been made during the Wei dynasty (386–556).

44 Reliquary pagoda of King Aśoka Pagoda type at the top of a Buddhist stele
(detail). Eastern Wei dynasty (534–550). Limestone relief with traces of polychromy,
310 cm (total). Found 1996 at Longxingsi site, Qingzhou, Shandong province.
Qingzhou Municipal Museum. From the author's archives.

The type of the square single-story reliquary pagoda on a stepped base, with
tiered eaves, domed roof with projecting decorations at the four corners, and a
high finial on top clearly reflects architectural structures of the sixth century.
"The domed stupa was quite prevalent in Buddhist art of the Northern Qi period
[550–577]. It can be associated with officially sponsored projects, and until
recently it was believed to have been only rarely depicted prior to 550. It is inter-
esting, therefore, that in the finds from Longxing Si many examples appear to
be from the Eastern Wei period [534–550]."[79] Among the stunning sculptural
remains from the cache of Qingzhou, Shandong province, discovered in Octo-
ber 1996 at the site of the former Longxing Monastery, the domed stupa may
be found in several Buddha triads (fig. 44). It occurs at the apex of the stele's
pointed leaf-shaped aureole accompanied or carried by heavenly musicians and
flying divinities (S: *apsarases*, C: *feitian*).[80] During the sixth century it figures
prominently as a widely disseminated architectural form and pictorial motif in
the Buddhist arts of the Northern and Southern dynasties, of the eastern coastal
regions of present-day Hebei, Shandong, Jiangsu and Zhejiang,[81] as well as south-
western Sichuan, which was then part of Liang territory (since 347).[82] The square
single-storyed pagoda on a stepped base and with high finials on top is set in
one of the small pictorial bas-relief frames decorating the narrow sides of a sadly
damaged Bodhisattva stele (h. 120 cm) unearthed 1953 at the Wanfosi site in
Chengdu (fig. 45).[83] The Aśoka-type stupa is built on an elevated fenced-in park.
Its entrance and fence are governed by spatial perspective with converging lines,

45 Reliquary pagoda of King Aśoka Pagoda type on the side of Buddhist stele (detail). Liang
dynasty (502–557). Limestone relief, 120 cm (total). Found 1953 at Wanfosi site, Chengdu,
Sichuan province. Sichuan Province Museum, Chengdu. From Tōkyō Kokuritsu Hakubutsu-
kan, Asahi Shinbun, ed., *Chūgoku kokuhō ten — Treasures of Ancient China* (2000), no. 119, 184.

and a lush palm tree on the left and a mountain range in the background con-
vincingly complete the condensed landscape space cell. The small picture recalls
the Buddha's *parinirvana*, while the representations carved in low relief on the
stele's back envision the Pure Land of salvation as an orderly paradisiacal garden
setting surrounded by a fanciful landscape. Here again — close to the left bor-
der — the Aśoka pagoda with four prominent high finials is introduced as clearly
defined architectural structure.

The distinctive shape of the Aśoka stupa even came to have political symbol-
ism hinting at official authority and aristocratic patronage. Foremost, however,
the square Aśoka stupa served as a cache for relics and sacred texts. As a funerary
monument at various burial sites of distinguished Buddhist monks, nuns and
devout lay people it appropriately reminds posterity of the stupa's original signif-
icance. According to Katherine Tsiang, "Although there is no known documenta-

tion labelling the flying domed stupa as specifically Ashokan in the Northern Qi period, circumstantial evidence indicates that they are likely to have been considered as such. . . . Beginning in the fourth century, Chinese Buddhist accounts of the discovery of ancient Ashokan images, stupas and relics on Chinese soil were appearing, and by the sixth century, the sites of nineteen Ashokan remains had been located in China."[84]

Buddhist Relic Caches

The earliest archaeological evidence of Buddhist relic caches in China dates from the Northern Wei dynasty (386–534), whose rulers were lavish patrons of Buddhism. A small stone casket of 453 that had been re-enshrined in the "underground palace" of the Northern Song pagoda no. 5 of the Jingzhi Monastery, the so-called Zhenshen shelita ("Pagoda of the True Body Relics"), was discovered in 1969 at Dingzhou, Hebei province.[85]

In 1960 an inscribed stone slab was excavated from the foundations of the "Iron Pagoda" (tieta) of the Ganlusi ("Monastery of Sweet Dew") at Zhenjiang, Jiangsu province, along with several reliquaries of gold and silver, dating between 824 and 829.[86] The text of the tablet records the removal of relics from the Aśoka pagoda of the Changgan Monastery for the founding of a new reliquary pagoda. Among the devoted patrons and collectors of Buddhist art who managed to protect and promote several sacred works and sites was the grandee and later prime minister Li Deyu (787–849). During his office as civil governor of Zhexi in Runzhou (modern Zhenjiang), he had a stone pagoda built on Mount Beigu to enshrine the śarīra at Ganlusi. In 824 the relics were transferred from Changgansi south of Nanjing to Runzhou, and in 829 also the re-discovered relics of the Chanzhong Monastery were moved to the "Monastery of Sweet Dew" in the provincial capital of Runzhou. It may be safe to assume that new precious relic containers were made for the sacred remains. Among the treasures unearthed from the "Iron Pagoda" in 1960 were two miniature sarcophagi of pure gold (l. 7.9 and 6.4 cm) (fig. 46), a silver casket (l. 11.6 cm), and the outer silver container (h. 12.4 cm) (fig. 47) for the Chanzhongsi relics, all decorated in the opulent Tang style of the early ninth century. Li Deyu's stone pagoda already collapsed in the 870s and was replaced only after two centuries by the "Iron Pagoda" under the Northern Song during the Yuanfeng era (1078–1085). The old Tang reliquaries were placed in a new stone casket dated by an inscription to 1078 and deposited in the foundations of the "Iron Pagoda." At this time, again some sacred objects were made and added as pious offerings, among them a tiny golden sarcophagus (h. 1 cm, l. 2.8 cm) and a silver figure of a dancing infant on a rock (h. 1.7 cm).[87]

It should be remembered that, according to the *Gaoseng zhuan*, Emperor Jianwen had erected a pagoda for the Changgansi śarīra in the 370s, and his successor built another three-story one in 391 to commemorate Huida's miracu-

46 Inner miniature sarcophagus of Changgansi Reliquary. Tang dynasty, ca. 825.
Gold, 2.7 x 6.4 cm. Found 1960 under the Iron Pagoda of Ganlusi, Zhenjiang, Jiangsu
province. Zhenjiang Municipal Museum. From Tōkyō Kokuritsu Hakubutsukan,
Asahi Shinbun, ed., *Chūgoku kokuhō ten—Treasures of Ancient China* (2004), no. 141, 174.

lous discovery and to provide a proper place of enshrinement for the "authentic"
Buddha relics. In token of his total dedication to Buddhism, Emperor Wu of the
Liang (r. 502–549) heaped special favors on the old temple, enlarging its pagodas,
taking the opportunity to open and inspect the celebrated ancient reliquary set of
"Aśokan times" in person, and holding an "unstinted maigre feast" there.[88] After
the fall of the Chen dynasty (557–589), when Nanjing declined from a capital
into a provincial town, the temple site was a deserted ruin. In his brief historical
account of Changgansi,[89] the noted Vinaya master Daoxuan (596–667) related
his personal experiences with the famous relics. In summary:

> When he [Daoxuan] was a monk of Riyansi at Chang'an, under the Sui, he
> remedied that temple's lack of relics by leading a party to Nanjing to exhume
> and carry off the Changgansi set. When Riyansi was abandoned shortly after,
> at the fall of the Sui, the relics were again moved, to the Tang Chongyisi,
> where they were placed under a pagoda southwest of the Buddha hall. The
> high priests of the South continued to believe that it was not the true Aśokan
> relics that had been removed; and Daoxuan admits that the original site was
> still favored by supernatural manifestations.[90]

The founder of the Sui dynasty, Emperor Wen (r. 581–604), was a dedicated
supporter of Buddhism. He initiated a vast range of pious projects to make

47 Outer casket of Chanzhongsi Reliquary. Tang dynasty, ca. 829. Silver, 12.4 cm.
Found 1960 under the Iron Pagoda of Ganlusi, Zhenjiang, Jiangsu province. Zhenjiang
Municipal Museum. From Tōkyō Kokuritsu Hakubutsukan, Asahi Shinbun, ed.,
Chūgoku kokuhō ten — Treasures of Ancient China (2004), no. 139, 173.)

Buddhism the dominant faith of the new dynasty's subjects. One of his most
spectacular initiatives was the distribution of holy relics throughout the empire,
following the model of the great Indian King Aśoka. Near the end of his reign
and upon completing the fifty-ninth year of his life—the sexagenary cycle being
traditionally celebrated in China as a fitting measure of human time—he ordered
the simultaneous enshrinement of *śarīra* on his birthday, at noon on 21 July 601,
in twenty-eight prefectural capitals.[91] At court, Emperor Wen himself in a sol-
emn ceremony placed the Buddhist relics in precious double caskets authenti-
cated with the imperial seal. Then a commission, headed by eminent monks and
escorted en route by secular officials and servants, was dispatched on horseback
to select suitable sites for the construction of the twenty-eight reliquary pagodas.
At the time set for the empire-wide enshrinement of the relics, distinguished
members of the Buddhist community in the capital assembled at court for a reli-
gious service of high solemnity:

> The emperor stood in the main hall of the Daxing palace. Facing west, he
> stood holding the jade sceptre of his exalted rank and welcomed the Bud-

dha images and three hundred sixty-seven monks. With pennons, umbrellas, incense and flowers, with songs of praise and instrumental music, they proceeded from the Daxingshansi and took their places in the great hall of the palace. The emperor burned incense and worshipped. Descending, he proceeded to the eastern verandah of the palace and personally led the various civil and military officials to partake of a vegetarian meal.[92]

Twice more, his strong commitment to Buddhism and his hope for salvation led Emperor Wen to enact similar reliquary installations. The following year, 602, fifty-three more places throughout the empire received imperially encased śarīra, and in 604 the aging ruler gave rein to his religious fervor by entrusting holy Buddhist relics to yet another thirty prefectures.[93]

In recent years several archaeological finds have come to substantiate these events recorded in historical sources. "Surviving inscriptions from the reliquary sites stress the common vow that all beings from the imperial ancestors and the Emperor and Empress down to the humblest creature might one and all attain the blessed fruit of enlightenment."[94] Remains of the third relic distribution, that of 604, were excavated in April 1969 at the Zhaojin commune in Yao county, north of Xi'an in Shaanxi province. A heavy stone casket with double cover contained a cubic bronze case with gilded lid. Nested within was a square gilt-bronze casket containing a small, green-glass bottle, in which the śarīra must originally have been preserved.[95] Centered on its outer cover, the stone casket bears a nine-character inscription: *Da Sui Huangdi sheli baota ming* (Inscription on the Relic Treasure Pagoda of the Emperor of the Great Sui [dynasty]). Apsarases and floral designs in dense fine-line engravings decorate the sides of this outer cover. Engraved on the four sides of the casket are vigorously drawn scenes with such Buddhist figures as the Four Divine Kings.

Of particular interest is the representation on the casket of a globular reliquary embedded in an exuberant lotus blossom, which rises from a wide, flat plate that rests, in turn, on a flaring lotus pedestal. The reliquary is protected by two powerful demonic guardians, whose dramatic postures and swirling scarves enhance their indomitable appearance. They are accompanied by a pair of ferocious lions. Like an amazing array of canopies, pendant flowers seem to protect the scene from above. In structure, form, and style the bulbous flask on its elaborate lotus throne represents a fairly persistent type of Buddhist reliquary that may be found throughout East Asia. Closely related is a three-dimensional version on a gilt-bronze altar representing the Buddha Amitābha and his retinue.[96] This masterwork of bronze casting, discovered in 1974 near the village of Bali in the southeastern outskirts of Xi'an, was commissioned in 584 by the pious Sui general and magistrate Dong Qin. He had "this Amitābha image made—as the inscription further records—so that His Majesty the emperor and his inner circle above and father and mother, brothers and sisters, wife and children below all may perceive the correct Law [of the Buddha]." There follows a panegyric in

48 Inscription on the lid of the inner relic casket: *Da Sui Huangdi sheli baota*. Sui dynasty, ca. 604. Stone, 97 cm. Found 1982 at Hongfan, Pingyin county, Shandong province. From *Kaogu*, no. 4 (1986), 376, 4.

four verses on the prospects of salvation, on the true marks of the Buddha's body becoming manifest, on cause and effect, illusion and rebirth, and finally on salvation in Amitābha's paradise.

The inner lid of the stone casket from Yao county bears a longer inscription than the outer. The text of this inscription refers to the foundation of a pagoda at the Shende Monastery at Yizhou in Yijun county, ordered by the emperor of the Great Sui dynasty for the eighth day of the fourth month in the fourth year of the Renshou era—604—undoubtedly to mark and celebrate the Buddha's birthday. In November 1982 construction workers from the Hongfan commune of Pingyin county, south of the Yellow River in western Shandong province, discovered at a depth of 1.6 m a big cubic stone casket similar to the relic container from Yao county. An inner stone casket within unfortunately contained no relics.[97] Within a square border the bevelled cover of this inner coffer bears an eight-character inscription in two vertical columns: *Da Sui Huangdi sheli baota* (fig. 48). Except for omitting the last character, it is identical with the legend on the outer cover of the stone casket related to the Shendesi pagoda and the enshrinement of relics there by imperial decree in 604.

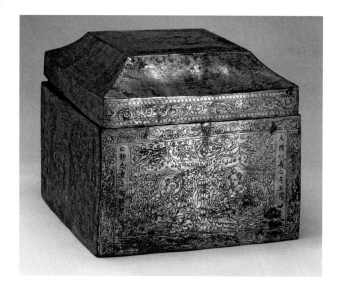

With the Sui imperial promotion of the *śarīra* cult, we may also connect a cubic gilt-bronze casket with bevelled cover dated by inscription to the eighth day of the tenth month of the year 606 (fig. 49). Near the corners on each of the four sides a columnar inscription gives particulars of the original contents and dates of enshrinement. The reliquary came to light in May 1969 from the crypt of the Jingzhisi pagoda, the "Pagoda of the True Body Relics," at Dingzhou, Hebei province.[98] Its surface is covered with elegant figural and ornamental engravings. On each side pairs of worshipping bodhisattvas, each with a round halo behind his head, are shown in three-quarter view on lotus seats. An intricate mandorla of stylized flower, flame, and cloud design surrounds each figure. Centered on the square cover, a circular medallion frames a guardian divinity proudly standing atop a subdued demon. Twelve smaller medallions enclosing strange creatures are set into dense floral and figural patterns and ornamental borders. Motifs and style of this 606 reliquary seem to confirm the Sui designer's indebtedness to Sassanian models. This gilt-bronze reliquary, a stone casket dated to 606, and another dated to the year 453 of the Northern Wei, mentioned above, all of which had had previous interments, were buried in the "underground palace" of the Zhenshen shelita along with many new deposits in early Northern Song, after the reconstruction of the destroyed pagoda was completed in 977. The pagoda's underground chamber also held two late Tang stone "coffins" (*guan*) for relics, one dated to 858 and the other to 889.[99]

Another small cubic stone *śarīra* casket, recently discovered, with bevelled cover and scenes in low relief on all four sides, provides new visual evidence for the distribution of Śākyamuni's relics and the rituals performed in their honor (figs. 50 and 51). The reliquary was found in 1990 on the grounds of a former Tang monastery, the Fachisi, at Caiguai Village in Lantian county, Shaanxi province.[100] The scenes have been connected with early Indian legends

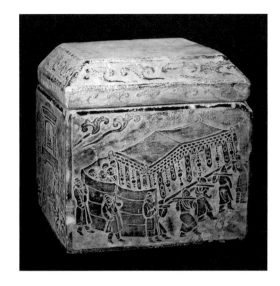

50 Reliquary casket with bevelled cover. Tang dynasty, 7th–8th century. Marble with reliefs, 32 cm. Found 1990 at Fachisi site, Caiguaicun, Lantian county, Shaanxi province. Cultural Relics Center of Lantian County. From *Kyūtei no eiga: Tō no jotei Soku Tenmukō to sono jidai ten—The Glory of the Court: Tang Dynasty Empress Wu and Her Times*, no. 34, 68.

51 Side of Reliquary casket with bevelled cover (50). From *Kyūtei no eiga: Tō no jotei Soku Tenmukō to sono jidai ten—The Glory of the Court: Tang Dynasty Empress Wu and Her Times*, no. 34:3, 67.

of events that occurred in the process of distributing the Buddha's relics, but it would seem just as plausible to assume that they illustrate what happened to the relics in China.

The first scene could be interpreted as the arrival of some of Śākyamuni's sacred corporeal remains in China. In a mountainous area with a Chinese temple building in the background, a group of foreigners on an elephant is awaited by two Chi-

nese emissaries on horseback. The second scene clearly represents the distribution of the *śarīra* from a big jar to six officials seated in dignified poses to the right and left. In an elevated palace building in the center the emperor seems to supervise the ceremony in person. Three standard-bearers on either side flank the scene. The composition, with its unusual orientation on the vertical-central axis, imparts a strong hieratic order to the sacred scenario. In the third scene, the holy relics are being carried in procession in a shrine lavishly decorated with precious pendants and banners. Ten men carry the shrine, which rests on long poles on their shoulders, and several monks follow closely. Only one side of the shrine and the five bearers on that side are on view. A curtain attached to long staffs held up by several men screens the remaining three sides from secular eyes, although the bird's-eye perspective allows a glimpse of several of the monks crowding close behind. The fourth scene probably illustrates preparations for the permanent enshrinement of the *śarīra* (fig. 51). A group of monks and clerics bearing banners, half-visible past a mountain ridge, seems to announce the approaching procession. Before its arrival, a suitably important site for the erection of a relic pagoda had to be selected. An eminent monk, presumably the head of the site-selection commission, is instructing five strong, half-naked workers to move a huge rock to a designated site. A solid rock usually covered the underground relic chamber of a pagoda and served as plinth for its central pillar. All four illustrations may depict specific episodes in the reception and distribution of the relics enshrined in the Fachisi casket from Lantian county. At the same time they vividly recall the reports on Emperor Wen's activities in consolidating the Buddhist faith and worship throughout his empire by numerous repeated reliquary installations.

Empress Wu, in whom Buddhist ardor merged with the avarice of power, identified herself with Maitreya, the redeeming Buddha of the Future, whose terrestrial incarnation she declared herself to be. In the ninth month of 693 she adopted the official title Jinlun Shengshen Huangdi (Sagelike and Divine Sovereign of the Golden Wheel [of the Law]). This curious title "is an unmistakable reference to the Buddhist concept of the idealized Universal Monarch (*cakravartin*, 'turner of the wheel [of the Law]') who rules in accordance with the high ethical principles of Buddhism . . . in the first month of 695 Empress Wu formally added the name Maitreya to her title, thereby combining in her person the secular authority of the Universal Monarch and the religious authority of the Future Buddha."[101] Although she did not grasp the reins of power until 684, she had adopted the unprecedented title Tianhou (Heavenly Empress) in 674 and said: "Buddhism opened the way for changing the Mandate of Heaven."[102] Ideas found in the prophetic *Dayun jing* ("Great Cloud Sūtra") could be employed to legitimize imperial rule by a woman. In celebration and commemoration of this holy scripture's translation into Chinese and its presentation to the throne, she ordered in the tenth month of 690 that a Dayunsi ("Monastery for the Great Cloud [Sūtra]") should be established in each of the prefectures of the empire and in the two capitals.

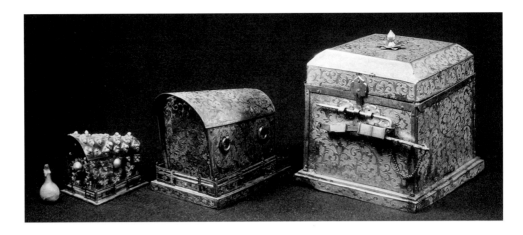

52 Reliquary set of Dayunsi. Tang dynasty, dated 694. Gilt bronze casket, 13.2 cm,
silver outer sarcophagus, 9.3 cm, gold sarcophagus inlaid with pearls, turquoise and
quartz, 6 cm, glass bottle, 2.6 cm. Found 1964 at Shuiquansi, Jingchuan county,
Gansu province. Gansu Provincial Musuem, Lanzhou. From Tōkyō Kokuritsu
Hakubutsukan, et al. eds., *Chūka Jinmin Kyōwakoku Shiruku Rōdo bunbutsu ten—
The Exhibition of Ancient Art Treasures of the People's Republic of China. Archaeological
Finds of the Han to Tang Dynasty Unearthed at Sites along the Silk Road,* nos. 77–80.

Four years later and probably in compliance with the imperial decree, some
sixty donors contributed to the lavish deposit of fourteen *śarīra* grains at the
newly established Dayunsi of Jingzhou (present-day Jingchuan county, Gansu
province). In 1964 these sacred remains were recovered inside an engraved and
inscribed rectangular marble casket (fig. 52).[103] This held a finely ornamented
gilt-bronze cubic casket with bevelled lid, chain, and padlock. Within was a small
silver coffin, which in turn held a miniature gold sarcophagus wrapped in bro-
cade and inlaid with pearls, turquoise, and quartz. Inside the golden coffin was a
tiny glass bottle set on a sandalwood board. It contained the fourteen relic grains
referred to in the imposing title characters on the marble casket's lid: *Da Zhou
Jingzhou Dayunsi sheli zhi hanzong yishisi li* (Casket for the Fourteen Grains, the
Relics of the Monastery of the Great Cloud, [deposited] at Jingzhou [during]
the Great Zhou [dynasty]).[104] By their order of proximity to the relics, the pre-
cious or elaborately decorated materials used as housings reveal their respective
ranks in the hierarchy of devotional estimation and the spiritual value attached
to them: glass, crystal, or jade were more precious or sacred than gold, followed
by brocade or silk, then silver, bronze, copper, iron, (sandal)wood, marble, and
similar stones.

Another notable feature of the Jingzhou Dayunsi reliquary cache is its close
resemblance to secular burials. The stone chamber of the old Dayunsi pagoda
itself, decorated with an engraved figural program, as well as the bevelled lid of

the marble casket, with its title inscription in sixteen large characters and its stylized floral border design, are strongly reminiscent in shape and style of secular sepulchral conventions and implements. So are the miniature gold and silver coffins, which repeat not only the typical multiple encasement within an inner *guan* and an outer *guo*, but also the characteristic shape of a Tang sarcophagus—its stepped base with a railing enclosure and its barrel-vaulted top cover higher at the front end than at the rear. Golden *guan* and silver *guo* were quite a novelty for relic encasements. It appears to suggest that relics were being treated as "bodies" in accordance with popular mortuary practices.

This amalgamation of traditional Chinese burial customs with Buddhist ritual practice may also be observed in a reliquary cache discovered by accident in 1985 at a depth of six meters at the site of the Qingshan Monastery's long-lost pagoda near Xinfengzhen in Lintong county, about forty kilometers northeast of Xi'an in Shaanxi province.[105] According to the eleventh-century "New History of the Tang [dynasty]" (*Xin Tangshu* [ch. 35]), the "Monastery of the Mountain Blessed with Good Luck" near the famous mausoleum of China's First Emperor, Qin Shihuangdi, received its name, Qingshansi, in 686 by order of the superstitious Empress Wu after a miracle occurred there. Its recently excavated crypt, built in 741, closely resembles an aristocratic Tang tomb. Likewise, the relic cache itself is similar to the Dayunsi reliquary of 694 in arrangement, form, and materials. Ten white crystal grains were enshrined in two green glass phials set on lotus-shaped copper pedestals and the whole originally wrapped in brocade. The tiny bottles were found in a nested pair of sarcophagi, one of silver enclosing one of gold (fig. 53), both lavishly decorated with encrusted precious stones and gilded reliefs. Supporting the silver sarcophagus was a gilt-bronze pedestal; this consisted of an openwork base topped by a short course of steps overhung, in turn, by an openwork railing. The resulting waisted, or hourglass, conformation of the pedestal recreated the form of Sumeru, the cosmic mountain that rises through the center of the world. Enclosing this precious reliquary set was a rectangular gray sandstone casket in the form of a traditional Chinese single-storyed pagoda.[106] Lotuses of gilt copper, naturalistically designed, decorate its base at the four corners. They may have been originally connected by a five-colored string in order to establish a magic protective boundary around the Buddha's holy relic. The four miniature blossoming trees of copper and silver on the pagoda's roof presumably symbolize the *śāla* trees under which Śākyamuni is said to have attained nirvāṇa.

All four sides of the outer stone casket are covered with carefully executed carvings in low relief vividly depicting important events in the life of the historical Buddha. The cover, made of two stone slabs, forms a tripartite roof. Gilded phoenix heads, each with a pearl in its beak, adorn the four corners—a purely Chinese decorative element. Crowning the roof's center is a jewel-shaped finial on a lotus throne, an ensemble that is one of the most common forms for Buddhist reliquaries. Centered in the lower register of the front vertical panel of the roof-cover is a two-column inscription flanked by a pair of guardians. Traces of

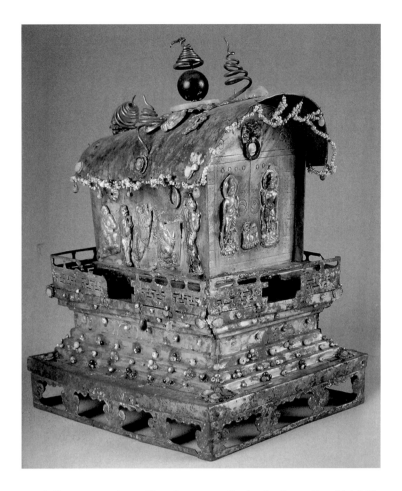

53 Reliquary sarcophagus. Tang dynasty, 741. Partly gilt-silver coffin with inlaid
precious stones, 14.5 cm, gilt-bronze pedestal, 12 cm. Found 1985 at Qingshansi site,
Xinfengzhen, Lintong county, Shaanxi province. Lintong County Museum.
From *Kyūtei no eiga: Tō no jotei Soku Tenmukō to sono jidai ten — The Glory
of the Court: Tang Dynasty Empress Wu and Her Times*, nos. 35–44, 69–83.

gold indicate that the eight characters originally were given special prominence.
They read: *Shijia Rulai sheli baozhang* (Treasure Canopy for the Relics of the
Tathāgata Śākyamuni). We may conclude that *baozhang*, literally, "treasure tent,"
was one term for "relic container" or "reliquary" in Tang times.

Chinese taste and ideas of appropriateness regarding sepulchers informed not
only the housings of Buddhist relics but also their larger architectural context. In
a Chinese pagoda the *śarīra* were usually enshrined in a chamber centrally sited
in the foundation, in the *shishi* or "stone chamber." The crypt of the Qingshansi
was constructed on much the same lines as secular underground palaces for the
afterlife of imperial court members and high officials, which in turn clearly reflect
the axial sequence of long alleys, gates, halls, and courtyards of palace architec-

54 Rubbing of inscription stele with the "Record of the Relic Pagoda
of the Elevated Area" of Qingshansi. Tang dynasty, 741. Stele limestone, 77 cm.
Found 1985 at Qingshansi site, Xinfengzhen, Lintong county, Shaanxi province.
Lintong County Museum. From *Kyūtei no eiga: Tō no jotei Soku Tenmukō to sono
jidai ten — The Glory of the Court: Tang Dynasty Empress Wu and Her Times*, no. 35, 70.

ture aboveground. Access to the reliquary chamber was afforded by a corridor
that sloped from south to north, at whose lower end a level corridor led to an
antechamber. Originally placed in the antechamber was the inscription stele
with the *Shangfang shelita ji* (Record of the Relic Pagoda of the Elevated Area),
which corresponds directly to the epitaph tablet (*muzhiming*) of the deceased
(fig. 54). The long record, in twenty-one columns of regular script, fills the stele's
entire surface and is dated at the end in accordance with Śākyamuni's birthday,
the eighth day of the fourth month (of the year 741). Centered on the stele's semi-
circular top is a two-column superscription: *Da Tang Kaiyuan Qingshan zhi si*
(Monastery of the Mountain Blessed with Good Luck [re-erected during] the
Kaiyuan [era, 713–741] of the Great Tang [dynasty]).[107] A granite door separated
the antechamber from the chamber holding the reliquary. Close to and centered
against the northern wall of the reliquary chamber was the stone pagoda model

containing the relics; the pagoda rested on a flat, lotus-shaped plinth above a seven-stepped pedestal. Thus centered at the farthest point from the entrance to the crypt, the reliquary actually occupied the position of greatest honor and dignity, which in secular burial was reserved for the sarcophagus containing the bodily remains of the deceased.

Sacred Buddhist relic assemblages were mostly found within or on the site of pagodas, which served as monumental architectural reliquaries and usually stood at a prominent place on the monastery grounds. The sealed crypt was not the only customary location for the relics; they might also be enshrined in other parts of the structure, for example, at the base of the mast atop a pagoda, as evinced not only by several rich caches from Chinese monuments, but also from Korean Buddhist sites. In 1959–1960 a reliquary was discovered on the third floor of the three-storyed Western stone pagoda of the Kamunsa in Wolsong of Northern Kyongsang province,[108] and in 1995–1996, when the Eastern pagoda of the same monastery underwent thorough restoration and investigation, another superb reliquary was found in even better condition.[109] The Kamunsa was established by King Munmu (r. 661–680) to commemorate the successful defence of the Eastern coastal region against Japanese pirates. That monarch died before the work was completed, and his son and successor on the throne, King Sinmun (r. 681–691), is said to have finished it in 682. This date has been generally proposed for the enshrinement of the two reliquaries in the Kamunsa twin pagodas.

The reliquaries closely resemble each other in material, size, structure, and style. It is therefore legitimate to assume that they were made in the same workshop and at the same time, shortly before 682. All parts of the reliquaries except the innermost phial containing the relic are of gilt bronze. The outer casket is cubic with a flattened-pyramid roof. Within is the reliquary proper in the shape of a complex Buddhist altar. Its platform is supported by a terraced base with protective figures in two framed recesses on each of the four sides. Overhanging this terraced base is a lotus cornice. Above the cornice a balustrade fences in the sacred space of the altar, enclosing several guardians (among them the Four Divine Kings), monks, musicians, dancers, and four lions. Four slender columns, obviously imitating bamboo, support an elaborate domed canopy. It protects a bipartite gourd-shaped reliquary set in lotus blossoms and topped by a pearl. Within this relic container on the central platform is a tiny rock crystal phial containing the relic.[110] As protectors of the Buddha body, the Four Divine Kings also occupy prominent places on the four sides of the outer casket. They are invariably encountered in association with Korean Buddhist relic caches and precious reliquary sets. The guardians have striking hairdos, pronounced moustaches, and exotic physiognomies that differ markedly from common types of East Asian faces. Equipped with their respective attributes, they stand on animals or on subdued crouching demons. The craftsmanship of the armored relief figures is exquisite and extremely fine and their stylistic treatment reminiscent of Central Asian and Chinese prototypes of the early Tang period.

So important were the Four Divine Kings to the great Japanese statesman and patron of Buddhism, Shōtoku Taishi (574–622), that he had a temple built in their honor, Shitennōji in the vicinity of modern Ōsaka. This he had vowed to do if conservative forces opposing Buddhism were defeated, as they were in 588. Making his vow, he placed "swiftly fashioned images" of the Four Divine Kings in his headdress and pledged: "If we are now made to gain the victory over the enemy, I promise faithfully to honor the Four Kings, guardians of the world, by building for them a temple with a pagoda."[111] Prince Shōtoku, who became regent under Empress Suiko (r. 592–628) in 593, proclaimed Buddhism the official national religion a year later. He declared the firm support of the court for the faith by adjuring reverence for the newly imported religion in his famous "Seventeen-Article Constitution" of 604. The oldest extant representation of the Shitennō in Japan is the set of impressive archaic wood sculptures of the mid-seventh century in the "Golden Hall" (Kondō) of Hōryūji near Nara. These powerful images were carved by a group of sculptors descended from naturalized immigrants from China or Korea.

Reliquary Imagery

It seems that by the mid-eighth century in China the Five Vidyārājas, and more than a century earlier, the Four Guardian Kings, had been accepted as standard groups in ritual context as well as in visual imagery. The Four Divine Kings are depicted as a guardian quartet in high-relief carvings on the sides of a rectangular relic casket in the Cleveland Museum of Art (fig. 55).[112] That white marble casket may have been the outermost container of a seventh- or eighth-century reliquary, holding a nested set of smaller caskets in gilt bronze, silver, gold, and jade or glass. The Bright Kings [of Esoteric Wisdom] appear on several Tang gilt-bronze bells with five-pronged *vajra* handles (S: *ghantā*; C: *wuguling*; J: *gokorei*).

These ritual implements combine two principal aspects of the "Secret Teachings." The ancient Indo-Aryan *vajra*, the magic "thunderbolt" or "diamond scepter" (C: *jin'gang chu*; J: *kongōsho*), symbolizes the diamond-like, indestructible character of the ultimate truth, which can destroy any kind of defilement; the five prongs of the *vajra* represent the "Tathāgatas of the Five Wisdoms" (C: *wuzhi rulai*; J: *gochi nyorai*) and their five-fold spiritual principles. The *vajra* bell provides the resonant sound to invoke the attention and presence of the divinities and to instill the essence of wisdom (S: *prajña*) into the heart of the Esoteric practitioner. Five-pronged *vajra* bells were used by Tantric masters of the highest rank in most of their magic practices and secret rituals. Some of the best examples dating from the late eighth to early ninth century have been preserved in Japan (fig. 56). They were most likely brought from Tang China by Japanese Buddhist priests who had studied there under Tantric masters.[113]

55 Reliquary casket with the Four Guardian
Kings. Tang dynasty, 7th–8th century.
Marble with reliefs, 22.6 cm. Collection and
photograph Cleveland Museum of Art.

56 *Ghantā* with five-pronged *vajra* handle
and reliefs of the Five Bright Kings. Tang
dynasty, 8th–9th century. Gilt bronze, 24 cm.
Tōkyō National Museum. From Nara Kokuritsu
Hakubutsukan, ed., *Tō Ajia no hotoke tachi—
Buddhist Images of East Asia*, no. 84, 88.

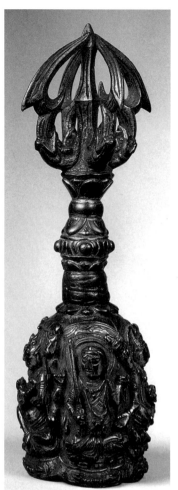

Maṇḍalas

The Tathāgatas of the Five Wisdoms were thought of as spiritual principles con-
stituting the body of the universe; and the relationship among them was clarified
by the use of spiritual diagrams, known as *maṇḍalas*.[114] Such formal geometric
diagrams, depicting Buddhist divinities in a highly abstract theological schema,
originated in India. In China *maṇḍalas* of painted or sculptural images were
employed in liturgies and special rituals, such as ordination and consecration,
and also as aids to private exercises such as the pious invocation or mystic visu-
alization of Esoteric divinities.

In the Maṇḍala of the Diamond World (C: *jin'gang jie da mantuluo*; J: *kongōkai
daimandara*), the central core of divinities is referred to as the "Assembly of
Perfected Bodies" (C: *chengshenhui*; J: *jōjin'e*). This assembly is represented in

repoussé relief on a gilt-silver casket discovered in May 1987 among the treasures of the famous "underground palace" of Famensi ("Monastery of the Dharma Gate") at Fufeng county in western Shaanxi province (fig. 57).[115]

In all, forty-five icons adorn the casket. The most important group, Mahāvairocana surrounded by eight of his bodhisattvas, occupies the square center of the lid. Each of the four sides of the casket holds a configuration of five icons: a Tathāgata in the center with his four bodhisattvas at the corners. These, the twenty-nine principal figures of the Assembly of Perfected Bodies, are depicted in frontal view, each seated on a lotus throne and set off by a double mandorla.[116]

The four bevelled faces of the lid (surrounding the central square with its Mahāvairocana group) contain sixteen smaller and less hieratic images of minor divinities, among them Four Vidyārājas. These figures symbolize various aspects of ritual and veneration. A frieze of tripartite medallions decorates the narrow vertical edges of the lid. Symmetrically disposed and encircled by flames, the frieze comprises *arghyas*, vases for offerings of scented water, flanked on two of the sides by clusters of three fabulous wish-fulfilling jewels, or *cintāmani*, on lotus pedestals and on the other two by pairs of crossed, double-headed, three-pronged thunderbolts. The *arghyas* allude to the *abhiṣeka* ritual, the merit and virtue of sprinkling water on the head of a devotee or sacred icons, and to the "Waters of the Four Seas" (cf. n. 7). On the body of the casket, the panel of divinities on each of the four sides is framed by fourteen three-pronged *vajras*, form-

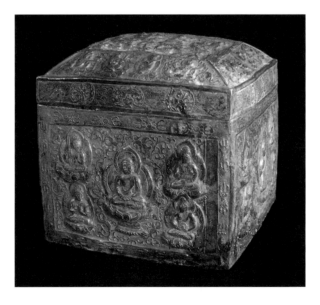

57 Reliquary casket with bevelled cover from five-piece reliquary set, commissioned by Zhiying (59). Tang dynasty, dated 871. Gilt silver with repoussé reliefs. 16.6 cm. Found 1987 in pagoda crypt of Famensi, Fufeng county, Shaanxi province. Famensi Museum, Fufeng. From *Fomen mibao da Tang yizhen. Shaanxi Fufeng Famensi digong*, no. 17.

ing a "thunderbolt fence" (S: *vajra prakāra*; C: *jin'gang qiang*; J: *kongōshō*). As in some painted *mandala*s, the "thunderbolt fence" replaces the five-colored string (S: *vajra sūtra*; C: *jin'gang xian*; J: *kongōsen*) in the *sīmābandha* ritual (C: *jiejie*; J: *kekkai*) for "binding an area," i.e., enclosing a certain space to denote its special sanctity and elevate it above its profane surroundings. This very elementary ritual was employed in Esoteric Buddhist practice since earliest times.[117] It is frequently mentioned in the "Scripture on the Act of Perfection," *Susiddhikara sūtra* (C: *Suxidi jieluo jing*; J: *Soshitsuji kara kyō*) translated into Chinese by Śubhakarasiṃha in 724.[118] He also uses in his translation the term "bordering way" (C: *jiedao*; J: *kaidō*), to indicate the magic boundary of a sacred space. If this symbolic boundary consists of a five-colored string, it is called *wuse jiedaoxian* (J: *goshiki kaidōsen*).

The Maṇḍala of the Diamond World, partially embodied on this lidded casket, was understood by Esoteric practitioners as signifying the process of active creation, the visible, dynamic, and tangible aspect of existence.

At the right border of the side of the casket featuring Amitābha is a narrow vertical cartouche bearing an inscription; it sets forth the purpose and circumstances of the donation of this reliquary:

> Treasure casket respectfully made for the True Body of Buddha Śākyamuni offered on behalf of the Emperor (C: *Feng wei Huangdi jing zao Shijiamouni Fo zhenshen bao han*).[119]

Another inscription, on the underside of the casket gives the name of the donor and the date of dedication (fig. 58):

> On the sixteenth day of the tenth month in the twelfth year of the Xiantong [era] of the Great Tang [dynasty, 1 December 871] this treasure casket was respectfully made by the Dharma disciple, the monk Zhiying, for the True Body relic [of the Buddha Śākyamuni] so that it may be venerated in eternity (C: *Da Tang Xiantong shier nian shi yue shiliu ri yi fa dizi biqiu Zhiying jing zao zhenshen sheli baohan yong wei gongyang*).[120]

The Famensi casket is part of a five-piece reliquary (fig. 59) that is believed to have contained the celebrated "authentic Buddha bone" (C: *zhen fogu*). The relic container was deposited in a "secret niche" (C: *mikan*) beneath the rear north wall of the innermost chamber in the pagoda's crypt. The relic itself was wrapped in gold-lined embroidery and enshrined in a nested pair of miniature coffins. Of these the outer coffin is of rock crystal inset with precious stones,[121] and the inner—just visible through its walls when placed within it—of jade.[122] These two coffins were set in a (now decayed) sandalwood casket with silver fittings, and that was placed inside the gilt-silver casket described above. Enclosing the gilt-silver casket was an iron container which originally bore gold designs on the lid.

58 Inscription on the bottom of reliquary casket with bevelled cover from five-piece reliquary set, commissioned by Zhiying (57). From Wu Limin and Han Jinke, *Famensi digong Tang mi mantuluo zhi yanjiu*, 254.

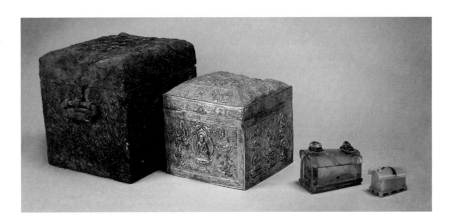

59 Four- (originally five-) piece reliquary set, commissioned by Zhiying (Figs. 57–58). Tang dynasty, dated 871. Iron, ca. 20 cm, gilt silver with repoussé reliefs. 16.6 cm, rock crystal inlaid with precious stones, 7 cm, jade 4.8 cm. Found 1987 in the "secret niche" of pagoda crypt of Famensi, Fufeng county, Shaanxi province. Famensi Museum, Fufeng. From *Fomen mibao da Tang yizhen: Shaanxi Fufeng Famensi digong*, 107.

Such a nested reliquary, incorporating a complex iconographic program, may have been intended to form a three-dimensional *maṇḍala* of powerful Esoteric divinities. Another reliquary set from the Famensi treasury provides a quite astonishing concentration of secret imagery (fig. 60).[123] It consists of eight precious containers placed one within another to enshrine the "finger-bone relic of the Buddha" (C: *fozhi sheli*) (fig. 61). Of the outer, silver-framed, sandalwood casket only small fragments remain. Next in order of size is a gilt-silver casket with an elaborate

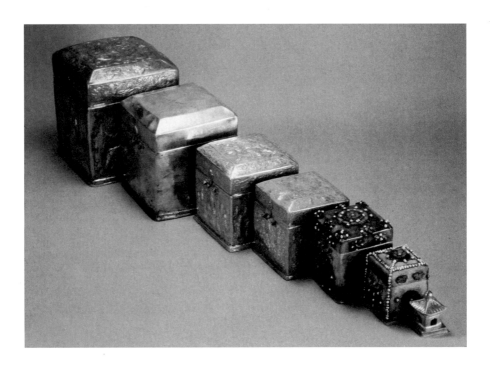

60 Seven- (originally eight-) piece reliquary set. Tang dynasty, 871–73. Gilt-silver
casket with repoussé reliefs, 23.5 cm; plain silver casket, 19.3 cm; gilt silver casket with
repoussé reliefs, 16.2 cm; gold casket with repoussé reliefs, 13.5cm; gold casket inlaid with
pearls and precious stones, 11.3 cm; stone casket inlaid with pearls and precious stones 10 cm;
gold pagoda, 7.1 cm, with silver pillar for hollow finger-bone relic, 4.03 cm. Found 1987 in
pagoda crypt of Famensi, Fufeng county, Shaanxi province. Famensi Museum, Fufeng.
From *Fomen mibao da Tang yizhen: Shaanxi Fufeng Famensi digong*, no. 4.

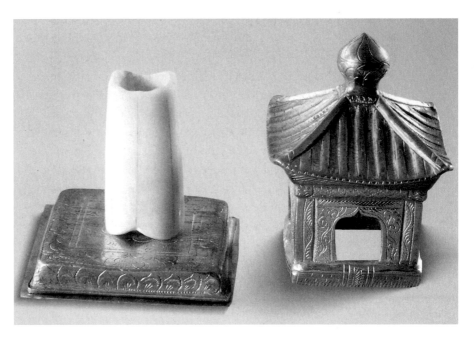

61 Golden miniature pagoda with base for hollow finger-bone relic.
From *Fomen mibao da Tang yizhen: Shaanxi Fufeng Famensi digong*, no. 3.

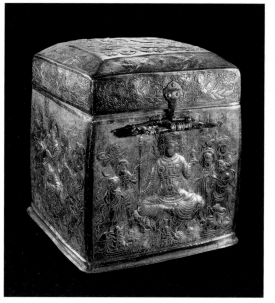

62 Reliquary casket from a seven-piece (originally eight-piece) set. Tang dynasty,
871–73. Gilt-silver with repoussé reliefs, 23.5 cm. Found 1987 in pagoda
crypt of Famensi, Fufeng county, Shaanxi province. Famensi Museum, Fufeng.
From *Fomen mibao da Tang yizhen: Shaanxi Fufeng Famensi digong*, no. 5.

63 Lid of reliquary casket from seven-(originally eight-) piece set. Tang dynasty,
871–73. Gilt-silver with repoussé reliefs, 23.5 cm. Found 1987 in pagoda crypt of
Famensi, Fufeng county, Shaanxi province. Famensi Museum, Fufeng. From Wu
Limin and Han Jinke, *Famensi digong Tang mi mantuluo zhi yanjiu*, 412.

repoussé design on a ring-matted background (fig. 62).[124] The major images on the
four sides are the Four Divine Kings. Each is seated on a pair of crouching demons
and flanked by armed warriors and demonic attendants. They are identified by
short double-column inscriptions in small cartouches. The guardian of the north,
Vaiśravaṇa (here identified in Chinese as Pishamen [J: Bishamon], but known also
in Chinese as Duowentian [J: Tamonten]) appears in the principal position—the
front of the casket below the lock—since in Chinese cosmological thought the
north was the direction of the greatest peril. Virūḍhaka, the mighty guardian of
the south, is depicted on the back. Virūpākṣa, protecting the west, is represented on
the viewer's right side of the casket, and Dhṛtarāṣṭra, guardian of the east, appears
on its left side. The central square face of the lid shows a pair of slender dragons
chasing a flaming jewel amid stylized clouds (fig. 63). Four symmetrically disposed
pairs of running fabulous beasts to the right and left of a flaming pearl embellish
the cover's bevelled edges, and four pairs of suprahuman winged beings, *kinnaras*
or *kalaviṅkas*, amongst floral scrolls decorate the narrow vertical sides of the lid.

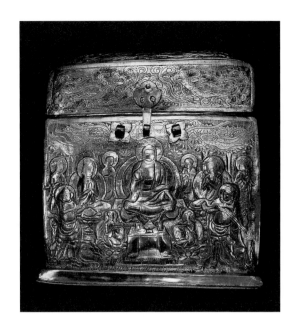

64 Reliquary casket from seven-(originally eight-) piece set. Tang dynasty, 871–73. Gilt-silver with repoussé reliefs, 16.2 cm. Found 1987 in pagoda crypt of Famensi, Fufeng county, Shaanxi province. Famensi Museum, Fufeng. From Wu Limin and Han Jinke, *Famensi digong Tang mi mantuluo zhi yanjiu*, 397.

The third relic container, slightly smaller, is of silver, ungilded and undecorated.[125] It encases another gilt-silver casket of the same shape with a manifold iconographic program executed in repoussé (fig. 64).[126] Hieratic configurations adorn the sides of the container. On the front, below the padlock, is the preaching historical Buddha Śākyamuni, flanked by ten symmetrically arranged attendants. On the back is the crowned primordial Buddha, Mahāvairocana, seated in his heavenly realm under a canopy and before a pair of blossoming trees. He, like Śākyamuni, is expounding the Law, in this case to eight members of his realm. The bodhisattvas Mañjuśrī (C: Wenshu; J: Monju) on his lion and Samantabhadra (C: Puxian; J: Fugen) on his elephant, each with his divine retinue, are represented on the right and left sides. Centered on the lid is an eight-lobed *cakra*, or "wheel of the Buddhist Law," surrounded by four *kalaviṅkas*. A trident occupies each corner of the lid's face. On the upper, bevelled part of the lid are eight phoenixes among flowers. Four pairs of juxtaposed apsarases, or "celestial nymphs," amid stylized clouds decorate the vertical sides of the lid.

Within this container is the fifth casket, of gold worked in a similar technique (fig. 65).[127] Decorating the face of the lid is a pair of confronting phoenixes, with spread wings and long tail feathers, among floral scrolls (fig. 66). Four pairs of mandarin ducks are depicted on the lid's bevelled sides, and sixteen flying ducks appear on its vertical rim. Śākyamuni is shown with his assembly on the viewer's right side of the coffer, and Bhaiṣajyaguru, the "Buddha of Medicine and Healing," is represented in his realm on the viewer's left side. The front features the assembly of the six-armed bodhisattva of great compassion, who perceives the sounds of the suffering world and fulfills all wishes of his devotees with the "wish-fulfilling jewel," or *cintāmani*, and the "wheel treasure [of the Law]" (S: *cakra*; C: *lunbao*; J: *rinbō*). In Sanskrit this Esoteric divinity is known as Cintāmani-Cakra-

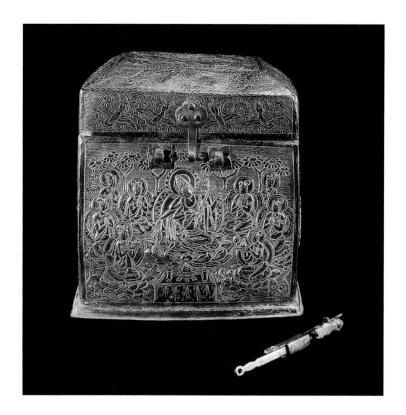

65 Reliquary casket from seven- (originally eight-) piece set. Tang dynasty,
871–73. Gold with repoussé reliefs, 13.5 cm. Found 1987 in pagoda crypt of
Famensi, Fufeng county, Shaanxi province. Famensi Museum, Fufeng.
From *Fomen mibao da Tang yizhen: Shaanxi Fufeng Famensi digong*, no. 11.

66 Drawing of the design on lid of reliquary casket: Pair of confronting
phoenixes, with spread wings and long tail feathers, among floral scrolls.
From *Fomen mibao da Tang yizhen: Shaanxi Fufeng Famensi digong*, 143.

Avalokiteśvara. He resides in the center of the *Guanyin yuan* (J: *Kannon'in*), or *lianhuabu yuan* (J: *rengebu'in*), the "Court of the Lotus Section," in the left half of the Taizōkai mandara.

Cintāmani-Cakra-Avalokiteśvara

In China beginning in the eighth century and in Japan from the ninth, the "Talismanic Wheel Avalokiteśvara" (C: Ruyilun Guanyin; J: Nyoirin Kannon) became the object of great popular devotion.[128] In two of his six hands he bears the attributes from which his name is derived, the *cintāmani* and the *cakra*; in two other hands he holds a rosary and the lotus, which is Guanyin's constant emblem; he touches the fifth hand to his face in a pensive gesture, while the sixth hand rests on his left upper thigh. Ruyilun Guanyin wears a high jewelled headdress. On the Famensi's golden casket he is shown seated atop an elegant lotus pedestal in the "position of royal ease," known as *mahārājalīlāsana* (C: *lunwangzuo*; J: *rinnōza*), in front of a flame-edged circular double halo. Before him is a narrow altar covered with a patterned cloth and furnished with an incense burner and a pair of footed cylindrical vases. Four smaller kneeling attendants flank the bodhisattva on either side, two presenting offerings of a precious rock and a fruit on a tray, while the others turn toward the main image in a posture of prayerful respect. Four blossoming *śāla* trees in the background enhance the sacred assembly's paradisiacal aura.

Cintāmani-Cakra-Avalokiteśvara is fifth of the six "transformed manifestations" (C: *bianhua*; J: *henge*) of Guanyin, who preside over the six stages of rebirth. The religious conception of these six transformed manifestaions is vital to believers who pray for the souls of the deceased. The fifth stage of rebirth is that of devas (C: *tian*; J: *ten*), "celestial" beings with supernatural powers. Ruyilun Guanyin's mystic secret name is Chibao Jin'gang (J: Jihō Kongō), "the *vajra* holding the treasure," and his mystic Sanskrit "seed syllables," or *bīja*, are *hrīḥ, hrīḥ trāḥ trāḥ*. Ruyilun Guanyin is especially worshipped by those seeking relief from hardship and perils such as thunderstorm and torrential rains, illness, and demons; he grants long life and joy. The bodhisattva is often depicted with a distinctly fleshy physique and frankly sensuous appeal, lending a feminine charm to the images. Theologically, however, the bodhisattva remains essentially neuter.

Among the early representations of the Cintāmani-Cakra-Avalokiteśvara is an excellent, well-preserved ninth-century wall painting in cave 14 at Dunhuang.[129] The north wall is decorated in the center of its eastern side with an imposing composition of the six-armed Ruyilun Guanyin. The bodhisattva is surrounded by an assembly of members of his exalted realm, whose four corners are guarded by the Four Divine Kings. During the ninth century Tibetans dominated the Dunhuang region, and the wall painting attests the increasing popularity of Esoteric Buddhism under their dominion. So too does the presence

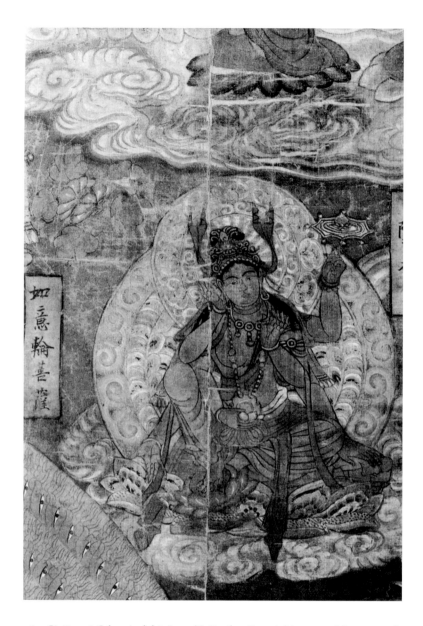

67 Cintāmani-Cakra-Avalokiteśvara (C: Ruyilun Guanyin) in upper right corner of
large banner with Thousand-Armed and Thousand-Eyed Avalokiteśvara (detail). Tang
dynasty, first half 9th century. Colors on silk, 222.5 x 167 cm. British Museum, London
(Stein collection). From Whitfield, *The Art of Central Asia*, 1:I, figs. 18:1, 18:4, 18:6.

of Cintāmani-Cakra-Avalokiteśvara on several silk banners. In the upper right
corner of a large banner whose principal image is a Thousand-Armed and Thou-
sand-Eyed Avalokiteśvara (C: Qianshou Qianyan Guanyin; J: Senju Sengen Kan-
non), Ruyilun Guanyin is identified by a small name label to the left (fig. 67).[130]
He floats on multicolored clouds in front of a magnificent halo. This masterpiece

of Tang Esoteric Buddhist painting in the Stein collection at the British Museum, London, may be safely dated to the first half of the ninth century. Again, in an equally large Dunhuang silk banner depicting the paradise of Bhaiṣajyaguru, the bodhisattva Ruyilun Guanyin is specifically mentioned in the dedicatory inscription, which bears a date in accordance with 836.[131]

Two other late Tang versions of the Cintāmani-Cakra-Avalokiteśvara from the second half of the ninth century have been preserved on silk banners from Dunhuang in the Stein collection. In the rather fragmentary larger of them, the six-armed divinity is the central image, seated on an elaborate lotus throne, surrounded by ornamental halos and accompanied by eight smaller seated bodhisattvas and the Four Divine Kings.[132] In the smaller banner, which has lost much of its original pigments, the graceful bodhisattva figure dominates the picture and almost fills the entire space.[133]

The spread of Esoteric doctrines, as well as the enormous popularity of Avalokiteśvara, ensured that there were many Ruyilun Guanyin images among all mediums employed in the official service of the Buddhist establishment as well as in private devotion. Only a few will be mentioned: an eight-lobed bronze mirror of the late Tang dynasty (8th–9th century) has on its back an engraved design of the six-armed bodhisattva protected by the Four Divine Kings. The mirror was probably brought to Japan by one of the Japanese pilgrims who studied Esotericism in Tang China. It has been preserved in the collection of Daigoji, Kyōto.[134] Probably Japanese student-pilgrims were also the conveyors of a late eighth-century bronze image in the Yamato Bunkakan, Nara,[135] and of a superb sandalwood sculpture of exactly the same size and most likely the same age in Hōryūji, Nara, reflecting the quality of late Tang Esoteric Buddhist statuary at its best.[136] A thin miniature sandalwood relief plaque with a crisply carved Ruyilun Guanyin in the Komatsudera, Ibaraki prefecture, may also have been imported from Tang China (8th–9th century), although some Japanese scholars consider it a Japanese work by a tenth-century Heian sculptor (fig. 68).[137] As opposed to the larger or even monumental statues that were made for installation in temple halls, these images of portable size were used in private devotions. Their easy accessibility engaged the divinity's loving protection at all times. Besides their small size, icons for intimate private worship typically show finesse in execution and a concern to render the divinity as both a comely and a living presence, thus making for an image at once humane and charming.

Japanese statuary of the ninth and tenth centuries is well represented by the famous polychromed "life-size," or tōshin (also tōjin) format, wood statue of the Nyoirin Kannon (first half of 9th century) in Kanshinji, Ōsaka;[138] the image carved from kaya wood (late 9th to 10th century) in the Nara National Museum;[139] the lacquered and gilt-wood sculpture of the Nyoirin Kannon (10th–11th century) in Daigoji, Kyōto,[140] and many other examples.

Notable among painted Japanese images of Nyoirin Kannon is the excellent Heian-period version in the Museum of Fine Arts, Boston (11th–12th cen-

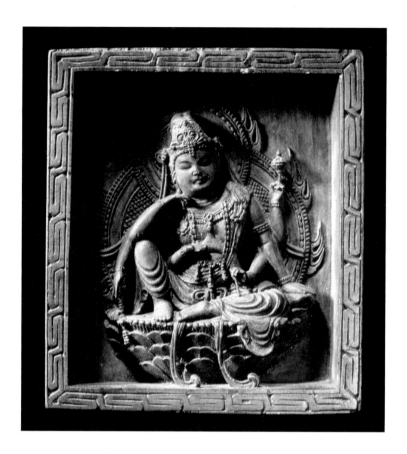

68 Cintāmani-Cakra-Avalokiteśvara (J: Nyoirin Kannon). Tang dynasty, 8th–9th century. Sandalwood relief plaque, 8.4 x 7.6 cm. Komatsudera, Ibaraki prefecture. From Sawa and Hamada, *Mikkyō bijutsu taikan*, vol. 2, no. 163, 156.

tury),[141] as well as the six-armed bodhisattva depicted in a lovely landscape setting (14th century) in the Nara National Museum.[142] Rather traditional in iconography and style is the Nyoirin Kannon by an otherwise unknown painter named Kikukei, whose seal appears in the lower left-hand corner of the scroll (fig. 69).[143] On this painting appears a eulogy, dated in accordance with 1307, written (from left to right) by Yishan Yining (1247–1317). That eminent Chinese Zen master arrived in Japan in 1299 and presided at some of the most distinguished Zen monasteries in Kamakura and Kyōto. The image, which has been preserved at Matsunoodera in Kyōto, shows strong influence of Song painting. The slight shading on the robe and body, and the refined line drawing are unmistakable Song features. Compared with other specimens of Yishan's calligraphy, which are typically extremely fluent, his brush movement here seems rather conservative and somewhat stiff. This difference, however, may reflect a deliberate response of the Zen master to the subject of the painting, that is, a traditional icon of the Esoteric Buddhist pantheon.

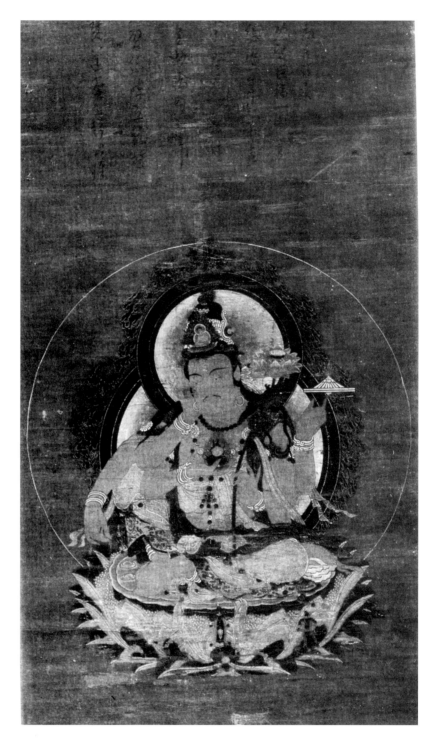

69 Cintāmani-Cakra-Avalokiteśvara (J: Nyoirin Kannon) by Kikukei with
inscription by Yishan Yining (1247–1317), dated 1307. Kamakura period.
Hanging scroll, ink, color, gold pigment, and gold foil on silk, 102.5 x 54.3 cm.
Matsunoodera, Kyōto. From Sawa and Hamada, *Mikkyō bijutsu taikan,* vol. 2, no. 155, 149.

70 Back of reliquary casket from seven- (originally eight-) piece set (60).
Tang dynasty, 871–73. Gold with repoussé reliefs, 13.5 cm. Found 1987 in pagoda
crypt of Famensi, Fufeng county, Shaanxi province. Famensi Museum, Fufeng.
From *Fomen mibao da Tang yizhen: Shaanxi Fufeng Famensi digong*, no. 10.

The back of the golden Famensi relic casket expresses the Esoteric vision of
the generative principle of the universe (fig. 70). With severe frontality and sym-
metry, endowing the image with a hieratic, regal presence, the cosmic Buddha
Mahāvairocana is depicted in his most formidable transformation, that of the
"Golden Wheel [of the Buddha's Cranial Protuberance] of the Single Word."
In the center of the composition Mahāvairocana is seated atop a lotus pedestal
supported by kingly lions, befitting his royal status. This lion throne establishes
the identity of the forceful divinity beyond any doubt. It is corroborated by an
iconographic drawing in a Tang Chinese handscroll containing a multitude of
Esoteric images, known under its Japanese title, *Gobu shinkan* (fig. 71). This
important collection is said to be based on an early eighth-century version by
Śubhakarasiṃha whose portrait appears at the end of the scroll. It was brought
back from China by Kūkai's nephew Enchin (Chishō Daishi), who studied the
Esoteric doctrines and rituals of the Tiantai (J: Tendai) school at the source on
Mount Tiantai. Enchin is the founder of the Jimon branch of the Tendai school.
During his sojourn there between 853 and 858, he collected many scriptures and
much ritual paraphernalia. At the Qinglongsi in Chang'an he received instruc-
tion from the priest Faquan (act. 841–859), who in 855, on the occasion of

71 "Golden Wheel [of the Buddha's Cranial Protuberance] of the Single Word"
(C: Yizi Jinlun [Foding]): Mahāvairocana on lion throne from *Gobu shinkan.*
Tang dynasty, early 8th century. Handscroll (detail) with iconographic drawings, ink on
paper, 29.9 x 1808.9 cm. Onjōji, Ōtsu, Shiga prefecture. From the author's archives.

Enchin's unction ceremony, or *abhiṣeka*, presented him with the extremely long
scroll. The work has been preserved at the headquarters of the Enchin school, the
Onjōji in Ōtsu, Shiga prefecture.[144]

Behind the divinity's head on the Famensi gold casket is a geometrically pre-
cise circular halo edged by flames. Enriching the circle of stylized flames on the
halo's border are six *cakras* of the Buddhist Law, emblems of the divinity of the
"Golden Wheel of the Single Word" and of the Universal Monarch. Concentric
rings form the larger aureole behind his body. Within the inner ring densely
radiating short lines indicate the solar disc, intended to visualize the enlighten-
ing mystic energy of the "Great Illuminator." All attributes convincingly imply
the emanation of extreme supernatural power and the mysterious aura of this
secret divinity. Flanking him on each side are two standing attendants, two
kneeling figures on lotus pedestals presenting offerings, and two armed guard-
ians. Stylized clouds at the bottom of the composition and blossoming *śāla* trees
in the background add to the visionary atmosphere. In Eugene Wang's words,

In combination, the scenes on the four faces of this casket represent an *abhiṣeka* ritual in which a bodhisattva attains the Dharma Body and becomes a buddha. . . . Various Buddhist sects in medieval China based their initiation ritual on the model of a bodhisattva becoming a buddha. The most elaborate enactment is found in esoteric Buddhism, as evidenced by the abundance of ritual prescriptions in its scriptures. . . . Not only does the bodhisattva [Cintāmani-Cakra-Avalokiteśvara] occupy the front face here, but he is also aligned with the Vairocana Buddha. Since the eight caskets present a recti-linear progression, these placements represent a process of becoming. The casket visualizes the final stage of a bodhisattva's transformation . . . the bud-dhas on the two side faces of the casket radiate light beams as the bodhisattva Guanyin (Avalokiteśvara) becomes the Buddha Vairocana.[145]

Within this gold casket are two smaller caskets inlaid with pearls and precious stones, one of gold and the other of stone, and finally a tiny gold stūpa with a silver pillar in which is enshrined the hollow finger-bone relic (fig. 61).[146]

The caskets of the Famensi reliquary with relief decoration described imme-diately above reconcile two somewhat contradictory aesthetic concepts. The main subjects on the four sides are sacred configurations, partly hieratic in their scaling and symmetrical arrangement, and visionary in character, centered around Esoteric divinities of majestic, ferocious, or demonic aspects. The cov-ers offer a striking contrast, in subject matter and in style: their motifs, entirely secular, purely Chinese, and elegant and refined in execution, are redolent of the aristocratic taste of High Tang. This combination of disparate subjects and styles reveals the degree to which Esoteric Buddhist art was able to respond to Chinese sensibilities and to court patronage by the second half of the ninth century.

The Famensi Finger-bone Relic

In all likelihood, this set of eight costly relic caskets was prepared under the patronage of Emperor Yizong (r. 859–873), who embraced the Buddhist faith with enthusiasm. He may have been inspired by the famed precedent set two centuries earlier by the zealously Buddhist Empress Wu. Among her various acts of imperial sponsorship, several sources mention the donation in 660 of a sump-tuous set of nine nested caskets for the Famensi finger-bone. The noted ecclesi-astic, historian, translator, and biographer Daoxuan, for example, records in his "Catalogue of Salvific Influences of the Three Jewels on the Divine Continent" (C: *Ji shenzhou sanbao gantong lu*) of 664 that, upon the reception of the Buddha relic at the palace in the third month of the year 660, Emperor Gaozong's consort commissioned "a marvelous reliquary of nine parts embossed and engraved with an inner coffin of gold and an outer sarcophagus of silver."[147] This reliquary set probably did not survive the destruction, confiscation, and looting of Buddhist

treasures that marred the mid-ninth century. Under Emperor Wuzong (r. 840–846) a severe suppression of Buddhism gathered head from about 841 and culminated in 844–845. When the Famensi relic was rediscovered in 871, it reportedly lacked housings of any sort.

The eight-casket Famensi reliquary, recently excavated, is recorded on one of the two stone slabs that stood before the door to the first chamber. On that large tablet, in fifty-one columns, are no fewer than seventeen hundred characters and the rather lengthy title *Yingcong Chongzhensi sui zhenshen gongyang daoju ji enci jinyin qiwu baohan dengbing xinenci dao jinyin baoqi yiwuzhang* (The Following Inventory Lists the Votive Offerings Carried in the Procession of the True Body [of the Buddha] from the Chongzhen Monastery, besides the Gold and Silver Objects and Reliquaries Donated by His Majesty [the Emperor Yizong] and yet other Precious Gold and Silver Items and Garments Offered Anew by His Majesty).[148] In 874 Famensi, the "Monastery of the Dharma Gate," was officially renamed Chongzhensi, "Monastery of the Renewed Truth [of the Dharma]," undoubtedly with reference to the temporarily lost and now properly re-enshrined Buddha relic. The long title of the inventory, usually abbreviated to *Yiwuzhang*, or simply *Wuzhang*, introduces in great detail the profusion of lavish gifts dedicated to accompany the four finger-bone relics.[149] One of these was apparently regarded as the most sacred of all, as the "authentic" relic of the Buddha. Hence it is called in the inventory and other inscriptions "True Body [of the Buddha]" (C: *zhenshen*); the other three are sometimes referred to as *yinggu* ("shadow bones"). The dedicatory list was compiled by a monk named Juezhi of the Daxingshan Monastery on the fourth day of the first month of the fifteenth year of the Xiantong era, 25 January 874.[150]

The other stone slab records the history of the relic and is entitled *Da Tang Xiantong qi song Qiyang zhenshen zhiwen* (Memorial on Escorting the True [Buddha] Body from Qiyang [to the capital during] the Xiantong [era, 860–874] of the Great Tang [dynasty]).[151] The memorial was written in 874 upon the completion of the re-enshrinement by the eminent Anguosi priest Sengche, who was admired and honored by Emperor Yizong as meditation preceptor and sūtra lecturer in the imperial palace. The memorial as well as several other sources informs us about at least nine occasions on which the finger-bone relic of the Buddha was "resurrected"—taken from concealment in the Famensi crypt for public worship. This happened for the first time in 387 under the newly established Northern Wei dynasty. About two hundred years later Emperor Wen of Sui, one of the most devout among Buddhist rulers, repeated this pious act. All other openings of the "underground palace" were ordered by the Tang imperial court. In 631 Emperor Taizong (r. 626–649) had the relic brought temporarily from Famensi to the palace.

Less than three decades later, in 659, his successor, Gaozong (r. 649–683), made generous grants to the Famensi clergy and in 660 showed his deep devotion to the Buddha relic by worshipping it at court in Luoyang. The sacred relic is

said to have been carried in processions through the streets and to have remained in the capital city for nearly two years. It was upon this occasion, in 660, that Empress Wu commissioned a costly set of gold and silver caskets to enshrine the famous finger-bone. This was one of her first arbitrary religio-political acts, following the stroke that disabled her husband, Gaozong, and the passage of actual power into her hands. Her strong attachment to Buddhism was made further apparent in 704 by her order to transfer the finger-bone relic again from Famensi to the imperial palace at Luoyang, where she payed homage to it at the *mingtang* ("Bright Hall"). The holy relic was returned to Famensi only in 708, after Empress Wu was dead, when Emperor Zhongzong (r. 705–710) ordered it deposited at the Dasheng zhenshen baota (Treasure Pagoda for the True Body of the Great Sage). It was enshrined in a large marble reliquary, known as a *lingzhang* (Spirit Canopy), which occupied almost the entire space of the central chamber in the Famensi pagoda's crypt.[152]

No sooner had Emperor Suzong (r. 756–762) ascended the throne than he was urged to bring the finger-bone to the palace to seek the Buddha's support against the An Lushan rebels. After all, the famous relic was reputed to have magical properties and to work wonders. In 760 Suzong complied with the wishes of his religious advisers and had the Famensi relic installed at the newly erected palace chapel so that several hundred monks could offer their prayers. The seventh transfer of the Buddha's finger-bone from Famensi to the capital was ordered by Emperor Dezong (r. 779–805) in the year 790, and the eighth by the ardently Buddhist Xianzong (r. 805–820). It was suggested to him "that peace and prosperity would prevail throughout the empire provided that the relic was . . . displayed publicly once every thirty years."[153] In 819, just one year before the monarch's death, Śākyamuni's finger-bone was brought from Famensi to the Tang capital in a magnificent procession. Many conservative literati of the day were appalled by the religious frenzy pervading all strata of society. Han Yu (768–824), vice president of the Board of Justice, proposed drastic measures to suppress the enormous influence of the Buddhist establishment. When in the first month of 819 the Famensi finger-bone relic was received by a fervent crowd in Chang'an and temporarily placed on view at the court, the highly respected Confucian scholar wrote a forthright criticism of the fulsome adulation of the Buddha's corporeal remnants. Han Yu presented his startling *Lun fogu biao* ("Memorial Discussing the Buddha's Bones") to the throne. In harsh words he criticized His Majesty:

> I am of the opinion that Buddhism is nothing more than a religion of the
> outlying tribes. . . . The Buddhist religion appeared only in the reign of
> Emperor Ming of the Han [57–75 CE], and Emperor Ming sat on the throne
> for only eighteen years. After him, turmoil and destruction were continuous,
> and fate gave no long reigns. . . .

I recently heard that Your Majesty has commanded a group of monks to welcome the Buddha's bone in Feng-xiang; then, as you watch from an upper chamber, it will be carried with ceremony into the palace precincts. You have also ordered that all the temples take turns welcoming it and paying it reverence. Although I am very foolish, I suspect that Your Majesty has not, in fact, been actually so deluded by the Buddha as to carry out such august devotions in search of blessings and good fortune; rather, at a time when the harvest is abundant and the people are happy, I suspect that you are simply accommodating the hearts of the people by putting on a display of illusory marvels and the stuff of a stage show for the inhabitants of the capital. How could such a sagely and enlightened ruler as yourself bring himself to have faith in this sort of thing?

Nevertheless, the common people are foolish and ignorant, easy to lead into error and hard to enlighten. If Your Majesty behaves like this, they will assume that you serve the Buddha from genuine feelings. All will say, 'The Son of Heaven is a great Sage, yet still he gives Buddha his wholehearted respect and faith. What are we common folk that we should begrudge even our lives?' They will set their heads on fire and burn their fingers. In tens and hundreds they will undo their clothes and distribute coins; and from dawn to dusk they will try harder and harder to outdo one another, worrying only that they are not acting swiftly enough. We will see old and young in a desperate scramble, abandoning their places of business. If one does not immediately strengthen the prohibitions against this, they will pass from one temple to another, cutting off arms and slicing off flesh as devotional offerings. This is no trifling matter, for they will be the ruin of our good customs, and when the word gets out, we will be laughed at by all the world around.

The Buddha was originally a tribesman from outlying regions. His language is incomprehensible to those who inhabit the heartland, and his clothes were of strange fashion. . . .

But now he has been dead for a very long time. Is it fitting that you order his dried and crumbling bone, this disgusting and baleful relic, to be brought into the imperial palace? Confucius said, 'Respect gods and spirits, but keep far away from them.' In ancient times when a member of the great nobility made a visit to a state to offer condolences, he would command a shaman to precede him with a peach branch and a broom of reeds to ward off malignant influences. Only under these conditions would he offer his condolences. Now for no good reason you are receiving this disgusting and decaying object, and you will personally inspect it—but without a shaman preceding you and without using the peach branch and reed broom. Not one of your many officials has told you how wrong this is, nor have your censors brought up the error of it. Of this I am truly ashamed.

I beg you to hand this bone over to the charge of someone who will throw it into fire or water and finish it forever, thus putting an end to the confusions of the world and stopping this delusion in generations to come. This will result in having all the people of the world understand that what a great Sage does infinitely surpasses the ordinary. Wouldn't it be splendid! Wouldn't it feel good![154]

The Re-enshrinement of the Relic

The Famensi finger-bone of the Buddha survived in all its glory and splendor. Reportedly lost in the turmoil of the Buddhist persecution in 844–845 under Emperor Wuzong, the treasured relic was rediscovered by chance on 7 September 871 by a meditation master of Mount Jiuhua named Yigong Zhangwen.[155] He found the sacred Buddha remains in the northwest corner of the old passage beneath the Famensi pagoda after he had asked the court for permission to set up an altar in the crypt. Only twenty days later, on 27 September 871, the first reliquary was completed in the capital: "the Conveyor of the Great Teachings and Tripiṭaka Monk Zhihuilun" (C: *zhuan daxiao sanzang seng Zhihuilun*) donated a plain golden casket with a padlock for "the Buddha's True Body" (C: *fo zhenshen*) and had his pious offering documented by an inscription of fifty-two characters in eleven columns (fig. 72);[156] five days later, on 2 October 871, the devoted monk contributed again to a silver casket for the "*śarīra* of the Buddha's True Body" (C: *fo zhenshen sheli*), which was made under the supervision of the monk Jiaoyuan by the two artisans Liu Zairong and Deng Xingji at the Daxingshan Monastery of Chang'an (fig. 73).[157] The inscription on its front face of 83 characters in ten columns introduces Zhihuilun as "baptismal preceptor" (S: *abhiṣeka ācārya*; C: *guanding asheli*). It should be noted that this double casket for the forthcoming relic enshrinement was obviously made in a monastery workshop at the metropolitan Daxingshansi and not in the imperial "Studios of Refined Ideas" (*wensi yuan*) as several other precious donations were.[158]

It would seem that Emperor Yizong soon made plans to pay homage to the sacred bone at his court in Chang'an, as at least four of his predecessors on the Tang throne had done. Influential ecclesiastics fervently supported his plans. Toward the end of the year 871—a few days or several weeks after the auspicious rediscovery—Zhiying, Zhihuilun, and Dengyi[159] prepared in advance precious treasury caskets of gold and silver for the Buddha's finger-bone relic and dedicated them to His Majesty. Dengyi respectfully gave the emperor on his thirty-ninth birthday a magnificent silver bodhisattva monstrance for the presentation of the sacred relic in the capital city of Chang'an (figs. 74, 75 and 76). The grand vegetarian banquet Yizong held at the palace for some ten thousand monks, after first paying a visit to Anguosi, may have been in anticipation of this felicitous occasion.[160] This was just two years before his death. The young monarch may

72 Two nested reliquary caskets, commissioned by Zhihuilun. Tang dynasty, dated 871. Silver, 27.2 cm, gold, 13.5 cm. Found 1987 in pagoda crypt of Famensi, Fufeng county, Shaanxi province. Famensi Museum, Fufeng. From Wu Limin and Han Jinke, *Famensi digong Tang mi mantuluo zhi yanjiu*, 435.

73 Outer reliquary casket with inscribed front, commissioned by Zhihuilun (72). Tang dynasty, dated 871. Silver, 27.2 cm. Found 1987 in pagoda crypt of Famensi, Fufeng county, Shaanxi province. Famensi Museum, Fufeng. From *Fomen mibao da Tang yizhen: Shaanxi Fufeng Famensi digong*, no. 23.

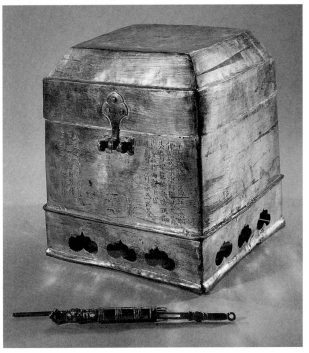

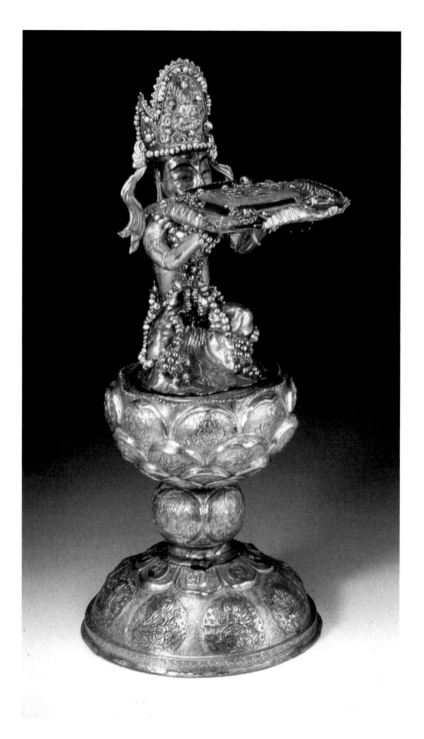

74 Bodhisattva monstrance, commissioned by Dengyi (after restoration).
Tang dynasty, dated 871. Partly gilt and painted silver and pearls, figure 22.3 cm,
weight 894.8 g, with lotus throne 41.7 cm, weight 1982.1 g. Found 1987 in pagoda crypt
of Famensi, Fufeng county, Shaanxi province. Famensi Museum, Fufeng. Photograph
by Hartmut von Wieckowski, Römisch-Germanisches Zentralmuseum, Mainz

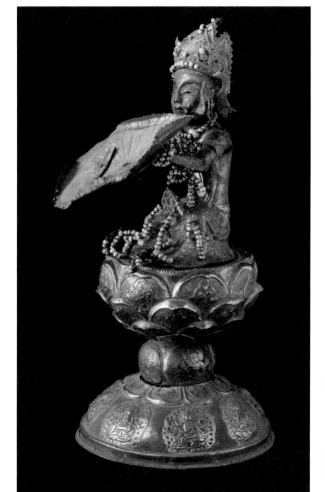

75 Bodhisattva monstrance,
before restoration (74).
Photograph by Hartmut von
Wieckowski, Römisch-
Germanisches
Zentralmuseum, Mainz.

76 Disassembled Bodhisattva
monstrance, during restoration
(74). Photograph by Hartmut von
Wieckowski, Römisch-Germa-
nisches Zentralmuseum, Mainz.

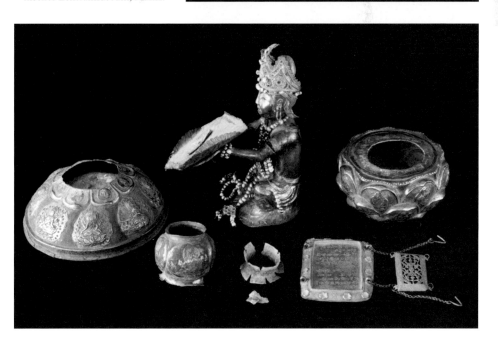

have been already ill, since he expressed the wish to see the Buddha's "True Body" so that he could die without regret. Ignoring the remonstrations of his ministers, Yizong dispatched an imperial delegation to Famensi on 22 April 873 to fetch the celebrated relic. Little more than two weeks later, in a stately and sumptuous procession, the relic reached the capital on the Buddha's birthday, the eighth day of the fourth month (8 May). In Stanley Weinstein's description:

> The splendor of the procession was said to have surpassed even that of 819, when the relic had last been brought to Chang'an. Wealthy families, one vying with the other, erected elegant pavilions along the route providing vegetarian fare for monks and lay worshippers alike. When the procession reached the Palace, Yizong prostrated himself before the relic, tears reportedly streaming down his face.[161]

The official reception for the Famensi relics was witnessed by the writer of "brush notes" (*biji*) Su E (act. ca. 870–890) and recorded in dramatic detail in his "Miscellanea from Duyang" (*Duyang zabian*) of 876:

> On the eighth day of the fourth month of 873, the bone of the Buddha was welcomed into Chang'an. Starting from the Anfu Tower at the Kaiyuan Gate, all along the way on both sides, cries of invocation to the Buddha shook the earth. Men and women watched the procession of the relic respectfully, while monks and nuns followed in its wake. The emperor went to the Anfu Temple, and as he personally paid his respects, tears dropped down to moisten his breast. He thereupon summoned the monks of both sides of the city to offer gifts of varying quantities to it. Moreover, to those venerable old men who had participated in welcoming the bone during the Yuanhe era [806–820] he bestowed silver bowls, brocades, and colored silks.
>
> . . . Those who came to see the spectacle all fasted beforehand in order that they might receive the blessings of the Buddha. At the time, a soldier cut off his left arm in front of the Buddha's relic, and while holding it with his hand, he reverenced the relic each time he took a step, his blood sprinkling the ground all the while. As for those who walked on their ellbows and knees, biting off their fingers or cutting off their hair, their numbers could not be counted.
>
> . . . The emperor welcomed the bone into the palace chapel, where he built a comfortable couch with curtains made of golden flowers, a mat made of dragon scales, a mattress made of phoenix feathers; he burnt incense of the most precious quality, and offered cream made of the essence of milk, all material offered by Lalinga in 868. Immediately after welcoming the bone, the emperor decreed that in the capital and vicinity people were to pile up earth along the roadside to form incense posts to a height of ten to twenty feet. Up to about nine feet they were all decorated with gold and jade. Within the capital, there

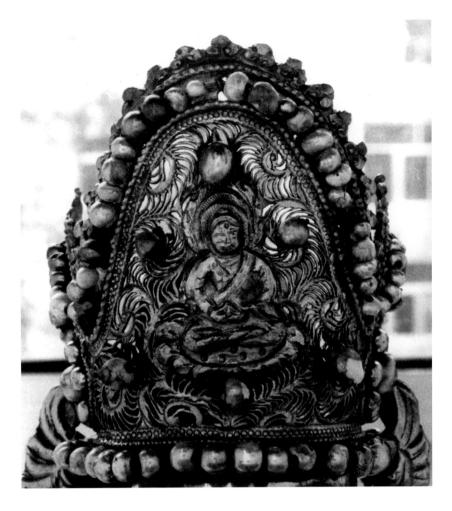

77　Amitābha image in jewelled filigree crown of Bodhisattva monstrance (74).
Photograph by Hartmut von Wieckowski, Römisch-Germanisches Zentralmuseum, Mainz.

were approximately 10,000 of these posts. Legend has it that when these posts
shook, rays from the Buddha and auspicious clouds lighted up the roadside,
and this was regarded repeatedly as a supernatural sign by the happy people.[162]

The sacred finger-bone was kept in the palace chapel, where it could be wor-
shipped by members of the imperial household for three days. In all likelihood,
it was placed on the inscribed golden tray,[163] resting on a lotus leaf held up by
a kneeling bodhisattva. This unique figure from the Famensi treasury may be
safely identified as Avalokiteśvara by virtue of the small Amitābha image in his
jewelled filigree crown (fig. 77).[164] A flat cover with an openwork design of a dou-
ble-headed, three-pronged *vajra* is attached to the tray by four chains; it probably
served to secure the finger-bone relic (figs. 78, 79 and 80). Inscribed on the tray
are sixty-five characters in eleven columns of elaborate homage to the emperor,

78 Profile cross-section of
Bodhisattva monstrance (74).
From Koch, "Der Goldschatz-
fund des Famensi: Prunk und
Pietät im chinesischen Buddhis-
mus der Tang-Zeit," 28, 469.

79 Underside of lotus leaf holding inscribed tray of Bodhisattva monstrance (74).
Photograph by Hartmut von Wieckowski, Römisch-Germanisches Zentralmuseum, Mainz.

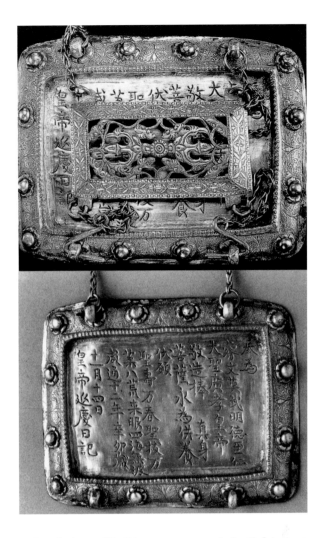

80 Inscribed tray of Bodhisattva monstrance (74) with flat cover in openwork design of double-headed, three-pronged *vajra* attached to the tray by four chains (which probably served to secure the finger-bone relic) dedicated by Dengyi to His Majesty on 29 December 871. Photograph by Hartmut von Wieckowski, Römisch-Germanisches Zentralmuseum, Mainz.

dated to His Majesty's birthday on the fourteenth day of the eleventh month in the twelfth year of the Xiantong era, a *xinmao* year (29 December 871). It proclaims that this bodhisattva was respectfully made for reverent devotion of the Buddha's True Body in eternity:

> Respectfully offered [to His Majesty],
> who is sagaciously wise, heroic, illuminatingly virtuous and most benevolent,
> the great sage, the overwhelmingly pious emperor.[165]
> This bodhisattva is reverently made to hold the [Buddha's] True Body for
> perpetual veneration,

81 Base of tripartite lotus throne of Bodhisattva monstrance with
wreath of eight seed syllables on lotus petals and images of the Eight Great
[Thunderbolt] Bright Kings [of Esoteric Wisdom] (74). Photograph by
Hartmut von Wieckowski, Römisch-Germanisches Zentralmuseum, Mainz.

with the respectful wish
that [His Majesty's] long life will span ten thousand springs and the [impe-
rial] family tree bear ten thousand leaves, [the people] of the Eight Directions
will come to pay their respect, and the Four Seas will be without turbulence.
—RECORDED ON HIS MAJESTY'S BIRTHDAY, THE FOURTEENTH DAY OF
THE ELEVENTH MONTH IN A *XINMAO* YEAR, THE TWELFTH YEAR OF THE
XIANTONG ERA.[166]

According to the Famensi inventory (*yiwuzhang*), the bodhisattva figure was
donated by the monk Dengyi. He is listed among several other high-ranking
celebrities who contributed generously to the Famensi treasure. The partly gilded
and painted silver monstrance is exceptional in many respects, particularly in
its technique and iconography. The silver figure is decked with pearls,[167] and

the lotus throne on which the bodhisattva kneels is engraved with twenty-eight gilded images of Esoteric divinities, their corresponding Sanskrit "seed syllables," and conventional ornamental Tang designs (figs. 74, 75 and 81).[168] Figure and lotus throne are hollow. The work was not cast, but shaped of wrought silver—several thin sheets skilfully hammered into the desired shape and joined by soldering (figs. 76 and 78). Sculptural volume and certain patterns were achieved by raising and embossing the sheet metal in repoussé technique. Linear figural and ornamental details were engraved, punched, or chased. They mostly appear on a dense ground pattern produced by ring-matting. The arms and hands of the bodhisattva were made separately and socketed into the torso and into the forearms. The bodhisattva's crown and the relic display tray were also made separately. Compared with the precision and technical skill of the smithing, the mercury-amalgam gilding appears somewhat slipshod.

The tripartite lotus throne deserves special attention (figs. 74, 75 and 81). Two sheets of silver joined at the foot-rim form the hemispherical base. On its underside—invisible when the throne is upright—a pair of crossed double-headed *vajra* tridents appears in the center (fig. 83). Surrounding this motif, two elongated, fierce, turbulent dragons soar through the firmament, which is concisely indicated by six stylized clouds. The whole design, executed in precisely chased outlines, blends traditional elements of Chinese mythology with a primary Esoteric Buddhist emblem. This manifests the intimate relationship between the symbolic language of the Buddhist establishment and the classical pictorial vocabulary of its imperial sponsors. So sophisticated and complex is the iconographical program of this unique work that one must presuppose close collaboration between the Buddhist patron and the silversmithing workshop to which he entrusted his demanding commission. As we have seen, the monk Dengyi donated the sumptuous bodhisattva to the court on His Majesty's birthday, a clear indication of the patron's close acquaintance with the palace and his encouragement for a quick relic translation.

On the outside of the throne's flaring base is a wreath of eight ring-matted lotus petals in raised relief (fig. 82a). Centered in each petal is a plain, round disc enclosing a "seed syllable." The iconographic reading of these *bīja* is controversial. It has been suggested that their phonetic values represent the "Eight Great Bodhisattvas" (C: *bada pusa*; J: *hachidai bosatsu*): *hūṃ* Vajrapāni, *va* Mañjuśrī, *a* Ākāsagarbha, *saṃ* Kṣitigarbha, *sa* Avalokiteśvara, *mai* Maitreya, *āḥ* (substitute for *yu*) Sarvanivāraṇaviskambhi and *pa* Samantabhadra. Hence they also correspond to the "seed syllables" of the "Eight Great [Thunderbolt] Bright Kings [of Esoteric Wisdom]" (C: *bada [jin'gang] mingwang*; J: *hachidai [kongō] myōō*).

On the other hand these sanctified *bīja* have been identified as phonetic manifestations of the eight divinities who encircle Mahāvairocana in the "Court of the Central Dais Eight Petals" (C: *zhongtai bayeyuan*; J: *chūtai hachiyōin*), the central court in the Maṇḍala of the Womb World [of Great Compassion] (C: *taicangjie da mantuluo*; J: *taizōkai daimandara*). Surrounding the imaginary essence of

East
Ratnaketu

South
Samkusumitarāja

Southwest
Mañjuśrī

West
Amitāyus

Mahāvairocana

Southeast
Samantabhadra

Northwest
Avalokiteśvara

Northeast
Maitreya

North
Divyadundubhimeghanirghoṣa

82a Wreath of eight seed syllables on lotus petals representing Four Directional Buddhas and four attendant bodhisattvas who encircle Mahāvairocana in the central court of the Mandala of the Womb World [of Great Compassion] (74).

East
Ratnaketu

Northeast
Maitreya

Southeast
Samantabhadra

North
Divyadundubhimeghanirghoṣa

Mahāvairocana

South
Samkusumitarāja

Northwest
Avalokiteśvara

Southwest
Mañjuśrī

West
Amitāyus

82b Orthodox arrangement of the Mandala of the Womb World.

83 Underside of lotus throne with pair of crossed double-headed *vajra* tridents, two dragons and stylized clouds of Bodhisattva monstrance (74). Photograph by Hartmut von Wieckowski, Römisch-Germanisches Zentralmuseum, Mainz.

the enlightened nature of the Dharma world, Mahāvairocana, the "Great Illuminator," the Four Directional Buddhas alternate in the traditional layout of the *maṇḍala* with the four attendant bodhisattvas (fig. 82b). On the Famensi lotus throne, however, the *bīja* appear in a different sequence. Beginning with the Buddha of the East and continuing in a clockwise direction, we have the following sequence of "seed syllables" (fig. 82a):

1. *a* for Ratnaketu (C: Baochuang; J: Hōdō; "Jewel Pennant"), the Buddha of the East; he embodies "the perfect mirror knowledge."
2. *aṃ* for Mañjuśrī (C: Wenshu; J: Monju; "Wondrous Felicity"), the bodhisattva of the southwest; he embodies "supreme wisdom, the source of buddhahood."

3. *aṃ* for Samantabhadra (C: Puxian; J: Fugen; "Universal Wisdom"), the bodhisattva of the southeast; he embodies "the pure and innate *bodhicitta*, the seed or aspiration to enlightenment indwelling in each being."

4. *yu* for Maitreya (C: Mile; J: Miroku; "Benevolent"), the bodhisattva of the northeast; he embodies "enlightenment itself."

5. *hāṃ* for Divyadundubhimeghanirghoṣa (C: Tianguleiyin; J: Tenkuraion; "Thunderous Sound of the Celestial Drum"), the Buddha of the North; he embodies the "knowledge of the perfection of action."

6. *sa* for Avalokiteśvara (C: Guanzizai or Guanyin; J: Kanjizai or Kannon; "Freely Contemplating"), the bodhisattva of the northwest; he embodies infinite compassion.

7. *saṃ* for Amitāyus (C: Wuliangshou; J: Muryōju; popularly known as Amida, "Immeasurable Life"), the Buddha of the West; he embodies "the knowledge of profound or subtle insight."

8. *ā* for Samkusumitarāja (C: Kaifuhuawang; J: Kaifukeō; "Opening Flower King"), the Buddha of the South; he embodies "the knowledge that understands the essential equality of all beings."

Below these "seed syllables" on the base are eight images of fierce divinities seated in aggressive postures in front of flaming aureoles: the "Eight Great [Thunderbolt] Bright Kings [of Esoteric Wisdom]" (fig. 84). All are equipped with weapons and other militant attributes and gesture menacingly. Some of them have several heads and arms. They are manifestations of Mahāvairocana's wrath, which conquers such evils as passion, ignorance, and illusion. This group is set forth in the "Scripture of the Great Mystery and the Diamond Scepter," translated in 838 by the Tang master Dharmasena (C: Damoqina) and known under its abriged title *Damiao jin'gang jing* (J: *Daimyō kongō kyō*).[169] As protectors of the faith, these eight vidyārājas are equivalent to the "Eight Great Bodhisattvas;" each of the "Bright Kings" is capable of transforming himself from his ferocious aspect into the benevolent aspect of a bodhisattva and the other way around. Starting at the front of the lotus throne, i.e., from the direction in which the bodhisattva faces, and continuing clockwise around the base, we encounter the vidyārājas in the following order:

1. Hayagrīva (C: Matou; J: Batō) corresponding to Avalokiteśvara (C: Guanzizai, J: Kanjizai).

2. Mahācakra (C: Dalun; J: Dairin) corresponding to Maitreya (C: Cishi, J: Jishi).

3. Acala[nātha] (C: Budong; J: Fudō) corresponding to Sarvanivāranaviskambhi (C: Chugaizhang, J: Jokaishō).

4. Trailokyavijaya (C: Xiangsanshi; J: Gōzanze) corresponding to Vajrapāni (C: Jin'gang shou, J: Kongōshu).

5. Yamāntaka (C: Daweide; J: Daiitoku) corresponding to Mañjuśrī (C: Wenshu, J: Monju).

6. Amrtakuṇḍalī (C: Daxiao [Junchali]; J: Taishō [Gundari]) corresponding to Ākāśagarbha (C: Xukongcang, J: Kokūzō).

7. Aparājita (C: Wunengsheng; J: Munōshō) corresponding to Kṣitigarbha Dizang (J: Jizō).

8. Padanaksipa (C: Buzhi; J: Buchaku) corresponding to Samantabhadra (C: Puxian, J: Fugen).

According to another tradition, the group of Eight Vidyārājas was an extension of the well-known set of Five Great Bright Kings (C: *wuda mingwang*; J: *godai myōō*), who are found immediately below the "Court of the Central Dais Eight Petals" of the *Garbhadhātu Maṇḍala* in the "Court of the Bright [Mantra] Holders" (C: *chimingyuan*; J: *jimyōin*). New in this illustrious ensemble were Ucchuṣma (C: Wushushama or Huiji; J: Usumasa or Eshaku), Hayagrīva (C: Matou; J: Batō), and Aparājita (C: Wunengsheng; J: Munōshō). These divinities were believed to possess the understanding of *mantras*, invocatory sacred formulas or sets of (sometimes nonsensical or meaningless) syllables "recited by the devotee with the intention of compelling the presence of other beings, either human or superhuman, and of coercing their power."[170]

The globular middle, or stem, of the lotus throne is adorned with images of the Four Divine Kings (fig. 85). These armor-clad guardians of the four directions are shown seated in regal, awe-inspiring frontality and may be easily identified by their attributes. Supposedly, the present reconstruction of the icon agrees with the original state: the western guardian, Virūpākṣa (C: Guangmutian; J: Kōmokuten), is facing front, and Dhṛtarāṣṭra (C: Chiguotian; J: Jikokuten), protector of the east, is at the back. Correspondingly, Virūḍhaka (C: Zengchangtian; J: Zōchōten), guardian of the south, is depicted below the bodhisattva's left arm, and Vaiśravaṇa (C: Duowentian; J: Tamonten), protecting the north, below the figure's right arm. Their postures and robust, compact bodies and their rustic facial features and penetrating gaze from wide-open bulging eyes echo the bulky polychrome marble sculptures of the Four Divine Kings that were probably set up, along with other treasures and ritual implements, in their respective positions inside the Famensi crypt's rear chamber and in front of its entrance before the arrival of the Buddha relic and its accompanying precious gifts.[171]

On the silver underside of the lotus blossom itself, that is, the seat on which the bodhisattva kneels—unseen when the whole is properly assembled and soldered together—we find five decorative Sanskrit "seed syllables" carefully inscribed within a double outline (figs. 86 and 87).[172] The central *bīja* symbolizes the mystic sound *vaṃ* of Mahāvairocana. Around it are the mystic "seed syllables" of the Four Directional Buddhas of the Diamond World Maṇḍala: *hūṃ* for Akṣobhya (C: Achu; J: Ashuku) in the east, *trāḥ* for Ratnasaṃbhava (C: Baosheng; J: Hōshō)

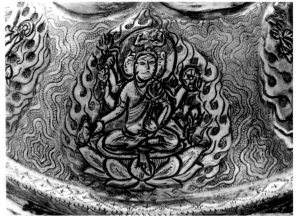

84-1

84 Eight Great [Thunderbolt] Bright Kings of Esoteric Wisdom] on the base of tripartite lotus throne of Bodhisattva monstrance (74): 1. Hayagrīva, 2. Mahācakra, 3. Acala[nātha], 4. Trailokyavijaya, 5. Yamāntaka, 6. Amṛtakundalī, 7. Aparājita, 8. Padanaksipa (*clockwise arrangement*). Photograph by Hartmut von Wieckowski, Römisch-Germanisches Zentralmuseum, Mainz.

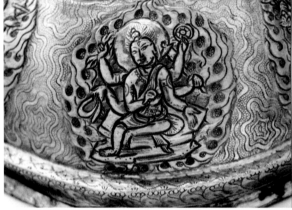

84-2

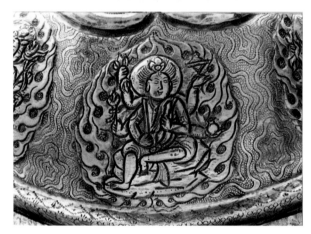

84-3

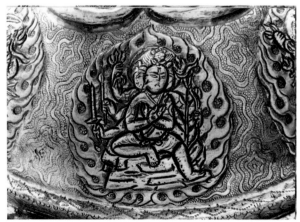

84-4

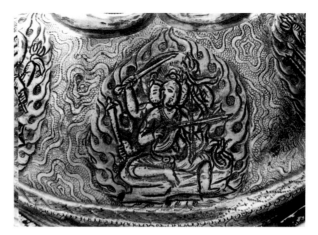

84-5

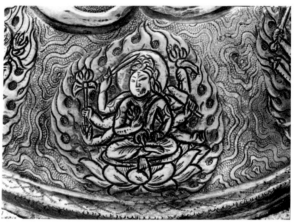

84-6

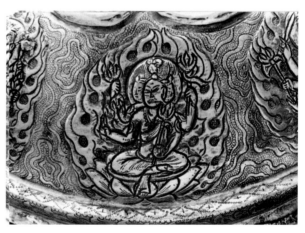

84-7

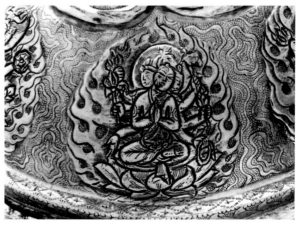

84-8

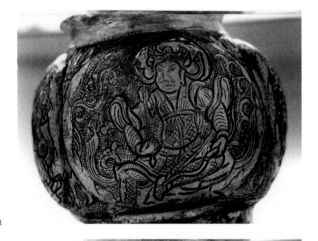

85-1

85 The Four Divine Kings on globular middle of tripartite lotus throne of Bodhsiattva monstrance (74): 1. Virūpāksa, guardian of the west, 2. Vaisravana, guardian of the north, 3. Dhrtarāstra, guardian of the east, 4. Virūdhaka, guardian of the south (*clockwise arrangement*). Photograph by Hartmut von Wieckowski, Römisch-Germanisches Zentralmuseum, Mainz.

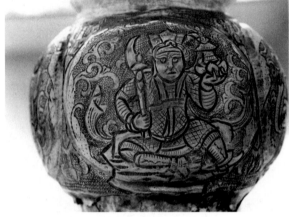

85-2

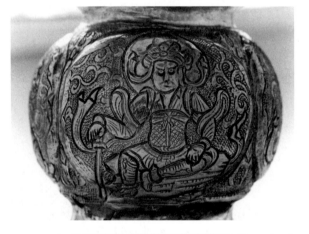

85-3

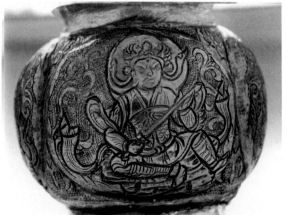

85-4

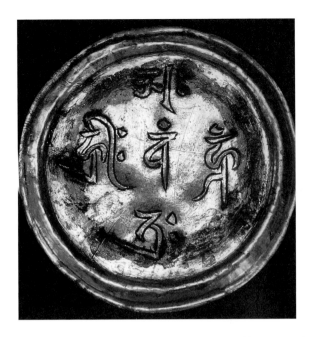

86 Seed syllables of the Five Tathāgatas on underside of lotus blossom seat (on which the bodhisattva kneels, unseen when the whole is properly assembled) (74). Photograph by Hartmut von Wieckowski, Römisch-Germanisches Zentralmuseum, Mainz.

87 Lotus petals of seat on which the bodhisattva kneels (74). Photograph by Hartmut von Wieckowski, Römisch-Germanisches Zentralmuseum, Mainz.

in the south, *hrīḥ* for Amitābha (C: Emituo; J: Amida) in the west, and *aḥ* for Amoghasiddhi (C: Bukongshengjiu; J: Fukūjōju) in the north.

Within the Diamond World Maṇḍala, the central square is called the "Assembly of Perfected Bodies" (C: *chengshenhui*; J: *jōjin'e*), and these Five Tathāgatas constitute the circular core of that central square. They indicate the five directions and dimensions of the all-encompassing knowledge and ultimate truth, the complete and perfect realization of enlightenment through "meditation"

(C: *ding*; J: *jō*), and the supreme adamantine "wisdom" (C: *hui*; J: *e*) of the "Great Illuminator." In the brief note on the "Westerner" (*xiyuren*) Zhihuilun in the "Song Biographies of Eminent Monks" (*Song gaoseng zhuan*) compiled by Zanning (919–1001) between 982 and 988, there is special mention of his instructions on "meditation and wisdom" (*dinghui*) to open the "Dharma Gate" (*famen*) for his students.[173] It is further said that "the Buddhist Dharma he set forth and his school were firmly rooted in Mahāvairocana" (*zhu fofa genben zong hu Dapiluzhena*) and that he "thoroughly understood secret words" (*shentong miyu*). The Indian monk Prajñācakra (Zhihuilun), engaged at the "Monastery of the Dharma Gate" (Famensi), was certainly versed in Sanskrit and familiar with "seed syllables." Is it therefore surprising to find the five hidden *bīja* under the bodhisattva throne focused on the central mystic sound representing Mahāvairocana?

The *Vajradhātu Maṇḍala* provides two gates to the path leading to the attainment of buddhahood: the "Samādhi Gate" (C: *dingmen*; J: *jōmon*) and the "Prajñā Gate" (C: *huimen*; J: *emon*). Samādhi ("meditation") and *prajñā* ("wisdom") are intricately interrelated, as attested by the linkage of the two terms (C: *dinghui*; J: *jōe*). Their manifold aspects are exemplified by two groups of sixteen bodhisattvas, the "Sixteen Sacred Beings of the Meditation Gate" (C: *dingmen shiliuzun*; J: *jōmon jūrokuson*) and the "Sixteen Sacred Beings of the Wisdom Gate" (C: *huimen shiliuzun*; J: *emon jūrokuson*). These thirty-two bodhisattvas are thought of as emanations of the Buddhas of the Four Directions in the Assembly of Perfected Bodies. In a complex interactive system of variations they transmit messages to the initiated adept concerning enlightenment and the attainment of buddhahood. Each of the Four Directional Buddhas is surrounded by his quartet of "individual attendants" (C: *qinjin*; J: *shinkin*).

The Sixteen Great Bodhisattvas in their dual aspects and reciprocal relationship of *prajñā* and *samādhi* are represented on the uppermost part—the lotus blossom itself—of the Famensi bodhisattva's throne (figs. 88 and 89). Four overlapping rows of eight petals each make up the blossom. The thirty-two petals are raised in pronounced relief. Beyond their general significance as a Buddhist symbol of compassion (S: *karuṇā*; C: *bei*; J: *hi*), the sixteen lotus petals in the lower two registers, bearing an ornamental scroll-and-leaf design, appear to signify the mysteries of the Sixteen Sacred Beings of the Wisdom Gate. On the two upper wreaths, each petal's face is inhabited by one of the Sixteen Sacred Beings of the Meditation Gate, all shown seated and with a double halo around head and body. They represent sixteen births or stages on the way to buddhahood as proclaimed and visualized in the Diamond World. In response to Mahāvairocana's revelation of the Sixteen Great Bodhisattvas, this quartet of Directional Buddhas reveals to the "Great Illuminator" in reciprocation the mysteries of the Four Bodhisattvas of "Perfection" (S: *pāramitā*; C: *boluomi*; J: *haramitsu*). They in turn manifest four aspects of Mahāvairocana's perfection of buddhahood:

[upper register no. 1] Vajrapāramitā, "Diamond Perfection" (C: Jin'gang boluomi; J: Kongōharamitsu), in the east;

[upper register no. 2] Ratnapāramitā, "Treasure Perfection" (C: Baoboluomi; J: Hōharamitsu), in the south;

[upper register no. 5] Dharmapāramitā, "Dharma Perfection" (C: Faboluomi; J: Hōharamitsu), in the west;

[upper register no. 6] Karmapāramitā, "Deed Perfection" (C: Jiemoboluomi; J: Katsumaharamitsu), in the north.

In response to the Four Perfection Bodhisattvas dedicated to him by the Directional Buddhas, Mahāvairocana reveals Four Inner Veneration Bodhisattvas (S: *pūjā bodhisattvas*; C: *gongyang pusa*; J: *kuyō bosatsu*). He offers them reciprocally to the Buddhas of the Four Directions:

[upper register no. 3] Vajramālā, "Diamond Necklace" (C: Jin'gang man; J: Kongōman), in the southwest;

[upper register no. 4] Vajranṛtā, "Diamond Dance" (C: Jin'gang wu; J: Kongōbu), in the northeast;

[upper register no. 7] Vajralāsī, "Diamond Joy" (C: Jin'gang xixi; J: Kongōkike), in the southeast;

[upper register no. 8] Vajragītā, "Diamond Song" (C: Jin'gang ge; J: Kongōka), in the northwest.

The Four Directional Buddhas reply to this gift by offering to Mahāvairocana Four Outer Veneration Bodhisattvas:

[lower register no. 9] Vajradhūpā, "Diamond Incense" (C: Jin'gang shaoxiang; J: Kongōshōkō), in the southeast;

[lower register no. 11] Vajragandhā, "Diamond Perfume" (C: Jin'gang tuxiang; J: Kongōzukō), in the northeast;

[lower register no. 13] Vajralokā, "Diamond Lantern" (C: Jin'gang deng; J: Kongōtō), in the northwest;

[lower register no. 15] Vajrapuṣpā, "Diamond Flower" (C: Jin'gang hua; J: Kongōke), in the southwest.

In this continuous interaction of mysterious revelations and offerings among the Five Tathāgatas, the "Great Illuminator" finally presents, in response to the gift of the Four Outer Veneration Bodhisattvas, the quartet of the All-Embracing Virtue, or Attraction, Bodhisattvas:

[lower register no. 10] Vajrāṅkuśa, "Diamond Hook" (C: Jin'gang gou; J: Kongōkō), in the east;

[lower register no. 12] Vajrāveśa, "Diamond Bell" (C: Jin'gang ling;

88-1

88　Eight of Sixteen Sacred Beings of the Meditation Gate: Four Perfection Bodhisattvas and Four Inner Veneration Bodhisattvas on upper wreath of lotus petals of bodhisattva's seat (*counterclockwise arrangement*) (74). Photograph by Hartmut von Wieckowski, Römisch-Germanisches Zentralmuseum, Mainz.

88-2

88-3

88-4

88-5

88-6

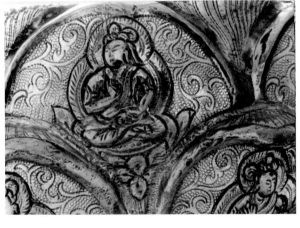

88-7

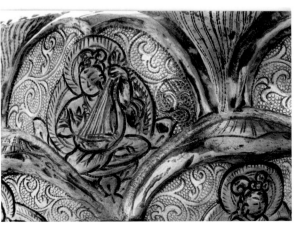

88-8

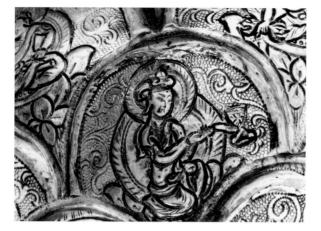

89-9

89 Eight of Sixteen Sacred Beings of the Meditation Gate: Four Outer Veneration Bodhisattvas and Four All-Embracing Virtue (or Attraction) Bodhisattvas on lower wreath of lotus petals of bodhisattva's seat (*counterclockwise arrangement*) (74). Photograph by Hartmut von Wieckowski, Römisch-Germanisches Zentralmuseum, Mainz.

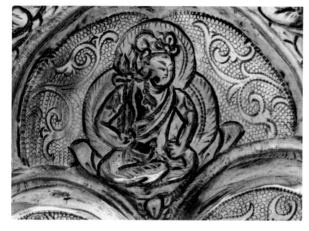

89-10

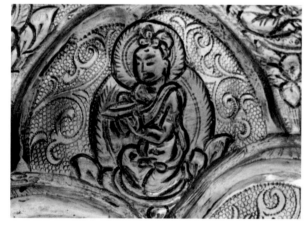

89-11

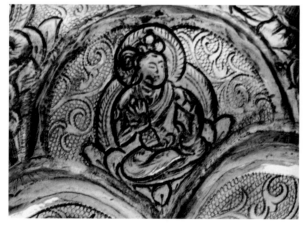

89-12

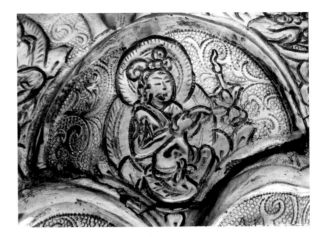

89-13

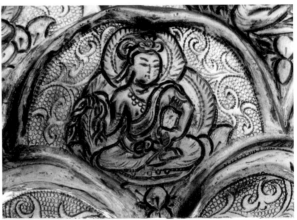

89-14

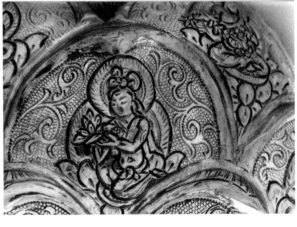

89-15

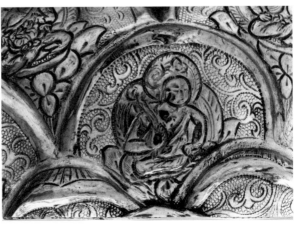

89-16

J: Kongōrei), in the north;

[lower register no. 14] Vajrasphoṭa, "Diamond Chain" (C: Jin'gang suo; J: Kongōsa), in the west;

[lower register no. 16] Vajrapāśa, "Diamond Rope" (C: Jin'gang suo; J: Kongōsaku), in the south.

The lotus throne of the Famensi bodhisattva expounds the unity of both *maṇḍala* worlds (C: *liangjie mantuluo*; J: *ryōkai mandara*), sometimes also called "dual *maṇḍala*" or "twofold *maṇḍala*" (C: *liangbu mantuluo*; J: *ryōbu mandara*). The Four *Pāramitā*, or Perfection, Bodhisattvas and the Four Inner *Pūjā*, or Veneration, Bodhisattvas occupy the uppermost register of lotus petals (fig. 88), while the Four Outer Veneration Bodhisattvas and the Four All-Embracing Virtue Bodhisattvas inhabit the petals of the second wreath (fig. 89). Together these constitute the Sixteen Sacred Beings of the Meditation Gate. In the upper register of the hemispherical base are the eight "seed syllables" of the divinities of the Court of the Central Dais Eight Petals of the Womb World Maṇḍala (figs. 81 and 82a). Images of the Eight Great [Thunderbolt] Bright Kings [of Esoteric Wisdom] encircle the lower register of the base. The Four Divine Kings are pictured on the globular middle part. Together, "seed syllables," Bright Kings, and Divine Kings represent powerful divinities of the Womb World [of Great Compassion] (S: *garbhadhātu*) in sounds and images. The blossom of the lotus presents in a highly sophisticated and secret form the essence of the Diamond World (S: *vajradhātu*), the Assembly of Perfected Bodies, in hidden words and tiny images. Thus the bodhisattva's lotus throne represents the entirety of the Buddhist cosmos, providing an adequate base for the Buddha's "True Body."

The concept of the dual *maṇḍala* is believed to have been devised within the clerical circles of Kūkai's charismatic teacher Huiguo (746–805), the seventh master in the lineage of Esoteric Buddhism, who instructed many diligent disciples. Only when the two are paired does each *maṇḍala* reveal all its mysteries and coded messages. These doctrinal implications became popular in the ninth century, at a time when the monk Dengyi commissioned this masterwork in honor of the Famensi relic and the imperial house; and Zhihuilun expounded his teachings of the powerful "Wheel of Perfect Wisdom" (S: *prajñācakra*; C: *zhihuilun*)—epitomized in his monastic name—through the merit and virtue of the *abhiṣeka* consecration, which he administered to emperors, high ranking eunuchs, and other court officials and which involved the ritual use of secret and sacred *maṇḍala*s.

It seems likely that the intricate iconographic program for the bodhisattva throne was conceived by the two ecclesiastics: Dengyi, the donor, and Zhihuilun, the doctrinal *spiritus rector*. In the few biographical lines of his *Song gaoseng zhuan*, Zanning notes in particular Zhihuilun's fascination with and practice of *maṇḍala*s in the Dazhong era (847–860) (*Dazhong zhong xing Damannaluo fa*). He further identifies him as "Preceptor of the Consecration Ritual [of sprinkling

water on the head of a devotee]," *abhiṣeka ācārya* (*guanding wei asheli*), and explains that "the foundations of his Dharma were *dhāraṇī* (*fa zhi genben zhe tuoluoni shi ye*).[174] Mystic formulas in Sanskrit known as *dhāraṇī* and written in Siddhaṃ (C: *fanwen tuoluoni*; J: *bonji darani*) are believed to sustain the religious life of the writer as well as the reciter. *Dhāraṇī* literally means "that by which something is held up." Around the top surface of the lotus throne, concealed by the kneeling bodhisattva, runs a fifteen-character inscription in Siddhaṃ (C: *xitan*; J: *shittan*), a type of the Indian Brāhmī script that was preserved mainly by Esoteric Buddhist communities in China and Japan (fig. 90).[175] Zhihuilun was certainly familiar with Sanskrit and Siddhaṃ. When the bodhisattva figure is placed on the lotus throne, the inscription, which comprises three formulas of five mystic syllables, is hidden. The syllables *a, ra, pa, ca, na—a, vī, ra, ha, kha— a, vam, ram, ham, kham* appear to have been engraved without any special care,

90 Fifteen-character inscription in Siddhaṃ around top surface of lotus throne (concealed by the kneeling bodhisattva) comprising three formulas of five mystic syllables: *a, ra, pa, ca, na — a, vī, ra, ha, kha — a, vam, ram, ham, kham* (74). From Wu Limin and Han Jinke, *Famensi digong Tang mi mantuluo zhi yanjiu*, 282.

perhaps as a short personal prayer of the pious patron. The three formulas invoke the "Three Bodies" (S: *trikāya*, or *trayaḥ kāyāḥ*; C: *sanshen*; J: *sanjin*) of the cosmic Buddha Mahāvairocana: *Dari fashen zhenyan* (J: *Dainichi hosshin shingon*), *Dari baoshen zhenyan* (J: *Dainichi hōjin shingon*), and *Dari yingshen zhenyan* (J: *Dainichi ōjin shingon*). Sophisticated Mahāyāna doctrines hold that the Buddha exists simultaneously in three essentially identical "bodies." The first is the true "Dharma Body" (S: *dharmakāya*), which transcends personality and the multitude of forms and colors in the phenomenal world. Thus it can neither be depicted nor expressed in words, nor contemplated by the unenlightened human mind. The second is the "Retribution Body" (S: *sambhogakāya*), the Buddha's level of existence upon entering buddhahood as a result of vows, exercises, and religious merits. This aspect may be visualized by enlightened beings. The third, *nirmāṇakāya*, or "Shadow Body," is the Buddha's incarnation for the benefit of unenlightened sentient beings. In this body the devotee is able to perceive him as a human figure, as the person of Śākyamuni.

After the Buddha relic from Famensi had been worshipped in the palace, it was installed for eight months at the Anguosi (and perhaps at several other metropolitan monasteries) for adoration by the general public. Emperor Yizong died at age forty-one, only three months after the arrival of the relic in the capital. On 11 January 874 the relic was finally returned to Famensi, and two weeks later, on 25 January, it was sealed in a solemn ceremony in the crypt of the monastery's pagoda. Obviously, the set of eight nested relic caskets for the Buddha's fingerbone (fig. 60) was made before the final enshrinement at Famensi, and it is reasonable to assume that it (or at least parts of it) was made between 871, when the relic was rediscovered, and Yizong's death in the seventh month of 873.

Facing the approaching end of his life, Yizong may have intended not only to offer his personal ardent devotion toward the Buddha's "True Body," but also to reach salvation through the power of those Esoteric Buddhist divinities surrounding the relic on the protecting caskets. Especially Bhaiṣajyaguru, the Buddha of Medicine and Healing; Cintāmaṇi-Cakra-Avalokiteśvara, the six-armed bodhisattva of great compassion "who perceives the sounds [of the suffering world and fulfills all wishes of his devotees with] the 'wish-fulfilling jewel'"; and the primordial Buddha Mahāvairocana in his most powerful transformation of the "Golden Wheel [of the Buddha's Cranial Protuberance] of the Single Word" were the supreme mystic forces to overcome disease and disaster. "As an adjunct to deathbed *nembutsu*, performance of the Kinrin service will even produce visualization of Amida and promote the blissful mentation that prefigures heavenly rebirth."[176] In fact, the extraordinary iconographic program on the Famensi reliquaries and on the enthroned bodhisattva Avalokiteśvara seems to reveal something of the purpose and occasion of their commission and dedication. The imagery may be interpreted as an impassioned pictorial invocation of divine support. It functioned to establish and reinforce response to the ultimate source of salvation, the Buddha's "True Body."

GLOSSARY

Achu; J: Ashuku 阿閦

Aizen Myōō 愛染明王

Aizendō 愛染堂

An Lushan 安祿山

An Shigao 安世高

Anfu Tower 安福樓

Anguosi 安國寺

Anpusi 安浦寺

Anxi 安西

Ashikaga Yoshikane 足利義兼

Ayuwang xiang 阿育王像

Ayuwangsi 阿育王寺

bada [jin'gang] mingwang; J: *hachidai [kongō] myōō* 八大 [金剛] 明王

bada pusa; J: *hachidai bosatsu* 八大菩薩

Baimasi 白馬寺

baimiao; J: *hakubyō* 白描

Bali Village 八里村

Bannaji 鑁阿寺

Bao Siwei 寶思惟

Baoboluomi; J: Hōharamitsu 寶波羅蜜

Baochuang; J: Hōdō 寶幢

Baoding 保定

baoqieyin tuoluoni; J: *hōkyōin darani* 寶篋印陀羅尼

baoqieyinta; J: *hōkyōintō* 寶篋印塔

baoshen; J: *hōjin* 報身

Baosheng; J: Hōshō 寶生

bei; J: *hi* 悲

benzun; J: *honzon* 本尊

bianhua; J: *henge* 變化

Bianji 辯機

Bianjing 汴京

Bianliang 汴梁

biji 筆記

Binyang 賓陽

boluomi; J: *haramitsu* 波羅蜜

bonji darani 梵字陀羅尼

Bonji shittan jibo hei shakugi 梵字悉曇字母并釋義

Bonnō soku bodai 煩惱即菩提

bu 部

Budaluojia 補怛洛迦

Budong Mingwang; J: Fudō Myōō 不動明王

Bukong 不空

Bukong juansuo tuoluoni zizai wang zhou jing; J: *Fukūkenjaku darani jizai ōshi kyō* 不空
絹索陀羅尼自在王咒經

Bukongshengjiu; J: Fukūjōju 不空成就

busshari 佛舍利

busshari yōshutsu 佛舍利涌出

busshin 佛身

busshō jōjū 佛性常住

Butsugen Butsumo 佛眼佛母

Butuoluojia 補陀落迦

Buzhi; J: Buchaku 步擲

Byakugōji 白毫寺

Byōdōji 平等寺

Caiguaicun 蔡拐村

Chang'an 長安

Changgansi 長干寺

Changle ward 長樂坊

Changlesi 長樂寺

Changshasi 長沙寺

Chanshi Sengjianantuo 禪師僧伽難陀

Chanzhong Monastery 禪眾寺

chengshenhui; J: *jōjin'e* 成身會

Chibao Jin'gang; J: Jihō Kongō 持寶金剛

chidai 地大

Chiguotian; J: Jikokuten 持國天

chimingyuan; J: *jimyōin* 持明院

chimon 智門

chinzō 頂相

Chion'in 知恩院

Chishō Daishi 智證大師

chōja 長者

Chōnen 奝然

Chongxuanshu 崇玄署

Chongyisi 崇義寺

chōsō 頂相

Chugaizhang, J: Jokaishō 除蓋障

Chūsonji 中尊寺

chūtai hachiyōin 中臺八葉院

Cishi, J: Jishi 慈氏

Da Song guo Taizhou Zhang Yanjiao bing di Yanxi diao 大宋國台州張延皎并弟延襲雕

Da Sui Huangdi sheli baota ming 大隋皇帝舍利寶塔銘

Da Tang Kaiyuan Qingshan zhi si 大唐開元慶山之寺

Da Tang Xiantong qi song Qiyang zhenshen zhiwen 大唐咸通啟送岐陽真身誌文

Da Tang Xiantong shier nian shi yue shiliu ri yi fa dizi biqiu Zhiying jing zao zhenshen sheli baohan yong wei gongyang 大唐咸通十二年十月十六日遺法弟子比丘智英敬造真身舍利寶函永為供養

Da Tang xiyuji 大唐西域記

Da Zhou Jingzhou Dayunsi sheli zhi hanzong yishisi li 大周涇州大雲寺舍利之函摠一十四粒

daibusshi 大佛師

Daibutchō mandara 大佛頂曼荼羅

Daienji 大圓寺

Daigoji 醍醐寺

Daihōkyo darani kyō 大法炬陀羅尼經

Daikakuji 大覺寺

daikongōrin 大金剛輪

Daikōzenji 大興善寺

Dalun; J: Dairin 大輪

Damiao jin'gang jing; J: *Daimyō kongō kyō* 大妙金剛經

Daminggong 大明宮

Damoqina 達磨栖那

dankei 團形

Danyang 丹陽

Daoshi 道世

Daoxing banruo jing; J: *Dōgyō hannya kyō* 道行般若經

Daoxuan 道宣

darani 陀羅尼

Dari; J: Dainichi 大日

Dari baoshen zhenyan; J: *Dainichi hōjin shingon* 大日報身真言

Dari fashen zhenyan; J: *Dainichi hosshin shingon* 大日法身真言

Dari jing; J: *Dainichi kyō* 大日經

Dari Jinlun; J: Dainichi Kinrin 大日金輪

Dari yingshen zhenyan; J: *Dainichi ōjin shingon* 大日應身真言

Dasheng zhenshen baota 大聖真身寶塔

Daweide; J: Daiitoku 大威德

Daxiao; J: Taishō 大笑

Daxing palace 大興殿

Daxingshansi 大興善寺

Dayun jing 大雲經

Dayunsi 大雲寺

Dazang jing; J: *Daizō kyō* 大藏經

Dazhidulun, J: *Daichidoron* 大智度論

Dazhong zhong xing Damannaluo fa 大中中行大曼拏羅法

Deng Xingji 鄧行集

Dengyi 澄依

Denkōji 傳香寺

Denkōroku 傳光錄

digong 地宮

ding; J: *jō* 定

dinghui; J: *jōe* 定慧

dingmen; J: *jōmon* 定門

dingmen shiliuzun; J: *jōmon jūrokuson* 定門十六尊

Dingzhou 定州

Dong Qin 董欽

Du Sengyi 杜僧逸

Duan Chengshi 段成式

Duowentian; J: Tamonten 多聞天

Duyang zabian 杜陽雜編

Eizon 叡尊

Emituo; J: Amida 阿彌陀

Emperor Daizong 代宗

Emperor Dezong 德宗

Emperor Gaozong 高宗

Emperor Suzong 肅宗

Emperor Taizong 太宗

Emperor Wu of the Chen 陳武帝

Emperor Wu of the Liang 梁武帝

Emperor Wuzong 武宗

Emperor Xianzong 憲宗

Emperor Xiaowu 孝武帝

Emperor Xuanzong 玄宗

Emperor Yizong 懿宗

Emperor Zhongzong 中宗

Empress Suiko 推古

Empress Wu 武后

Enchin 圓珍

endan 圓壇

Enjōji 圓成寺

Ennin 圓仁

Ensei 圓晴

ershen; J: *nishin* 二身

fa zhi genben zhe tuoluoni shi ye 法之根本者陀羅尼是也

fa; J: *hō* 法

Faboluomi; J: Hōharamitsu 法波羅蜜

Fachisi 法池寺

famen 法門

Famensi 法門寺

Fan Changshou 范長壽

fanwen tuoluoni 梵文陀羅尼; J: *bonji darani* 梵字陀羅尼

Faquan 法全

fashen sheli; J: *hosshin shari* 法身舍利

fasong sheli; J: *hōju shari* 法頌舍利

Faxian 法顯

Fayuan zhulin 法苑珠林

Fayunsi 法雲寺

feitian 飛天

Feng wei Huangdi jing zao Shijiamouni Fo zhenshen bao han 奉為皇帝敬造釋迦牟尼佛
真身寶函

fennu; J: *funnu* 忿怒

fo zhenshen 佛真身

fo zhenshen sheli 佛真身舍利

Foshoujisi 佛授記寺

Foshuo yuxiang gongde jing; J: *Bussetsu yokuzō kōtoku kyō* 佛說浴像功德涇

foxingxiang; J: *butsugyōzō* 佛形像

fozhi sheli 佛指舍利

fūdai 風大

Fufeng county 扶風縣

Fujiwara Hidehira 藤原秀衡

fūrin 風輪

gachirin 月輪

Gangōji 元興寺

Ganlusi 甘露寺

ganmon 願文

Gao Congyu 高從遇

Gaoseng zhuan 高僧傳

Gaoyoujun 高郵軍

genbyō 賢瓶

Genkai 玄海

Gizō 義藏

Go Uda 後宇多

gochi jōshin 五智成身

gochi nyorai 五智如來

gochi 五智

Gokurakuji 極樂寺

Gongbu Chabu 工布查布

Gongxian 鞏縣

gongyang pusa; J: kuyō bosatsu 供養菩薩

gorin jōshin 五輪成身

gorin sotoba 五輪率都婆

gorintō 五輪塔

goshiki 五色

gotai 五體

gozō 五臟

Grand Empress Dowager Wenming 文明太后

guan 棺

guanding; J: kanjō 灌頂

guanding asheli 灌頂阿闍梨

guanding daochang; J: kanjō dōjō 灌頂道場

guanding wei asheli 灌頂為阿闍梨

Guang hongming ji 廣弘明集

Guangmutian; J: Kōmokuten 廣目天

Guanyin 觀音

Guanyin yuan; J: Kannon'in 觀音院

Guanzizai; J: Kanjizai 觀自在

guo 槨

Guzang 姑臧

gyōja 行者

gyokugan kannyū 水晶嵌眼

Gyōzen 堯善

gyōzō 形像

han 函

hangetsugata 半月形

Hangzhou 杭州

Hanlin Academy 翰林院

Han Yu 韓愈

Heizei 平城

hibutsu 秘佛

Hike kyō 悲華經

Hizōki 秘藏記

hōbyō 寶瓶

Hōjō 北條

hokkyō 法橋

hokkyō shōnin 法橋上人

hon 本

Hongfan 洪范

hontai 本體,

Hōryūji 法隆寺

Hōzōji 寶藏寺

huafo; J: kebutsu 化佛

huashen; J: keshin 化身

Huayan jing; J: Kegon kyō 華嚴經

Huibei 慧俻

hui; J: *e* 慧

Huida 慧達

Huiguo 惠果

Huiji; J. Eshaku 穢積 [跡]

Huijiao 慧皎

huimen; J: *emon* 慧門

huimen shiliuzun; J: *emon jūrokuson* 慧門十六尊

Huiyu 慧昱

Huiyuan 慧遠

humo; J: *goma* 護摩

ikimi 寄木

Jianchusi 建初寺

Jianduan 鑑端

Jiangling 江陵

Jiangyan 將炎

Jiankang 建康

Jianwen 簡文

Jianye 建業

Jiaoyuan 教原

jiedao; J: *kaidō* 界道

jiejie; J: *kekkai* 結界

Jiemoboluomi; J: Katsumaharamitsu 羯磨波羅蜜

Jimon branch 寺門派

Jin'gang banruo boluomi jing; J: *Kongō hannya haramitsu kyō* 金剛般若波羅蜜經

Jin'gang boluomi; J: Kongōharamitsu 金剛波羅蜜

jin'gang chu; J: *kongōsho* 金剛杵

Jin'gang deng; J: Kongōtō 金剛燈

Jin'gang ding jing; J: *Kongōchōkyō* 金剛頂經

Jin'gang ding jing yizi ding lunwang yigui yinyi, J: *Kongōchō kyō ichiji chōrinnō giki ongi* 金剛頂經一字頂輪王儀軌音義

Jin'gang ding jing yizi ding lunwang yuqie yiqie shichu niansong chengfo yigui, J: *Kongōchō kyō ichiji chōrinnō yuga issai jisho nenju jōbutsu giki* 金剛頂經一字頂輪王瑜伽一切時處念誦成佛儀軌

Jin'gang ge; J: Kongōka 金剛歌

Jin'gang gou; J: Kongōkō 金剛鉤

Jin'gang hua; J: Kongōke 金剛華

jin'gang jie da mantuluo; J: *kongōkai daimandara* 金剛界大曼荼羅

Jin'gang ling; J: Kongōrei 金剛鈴

Jin'gang man; J: Kongōman 金剛鬘

jin'gang qiang; J: *kongōshō* 金剛牆

jin'gang ruyi; J: *kongō nyoi* 金剛如意

Jin'gang shaoxiang; J: Kongōshōkō 金剛燒香

jin'gang shenwang 金剛神王

Jin'gang shou, J: Kongōshu 金剛手

Jin'gang suo; J: Kongōsa 金剛鎖

Jin'gang suo; J: Kongōsaku 金剛索

Jin'gang tuxiang; J: Kongōzukō 金剛塗香

Jin'gang wu; J: Kongōbu 金剛舞

jin'gang xian; J: *kongōsen* 金剛線

Jin'gang xixi; J: Kongōkike 金剛嬉戲

Jin'gang yecha; J: Kongōyasha 金剛夜叉

Jin'gangzhi 金剛智

jing'ai; J: *keiai* 敬愛

Jingchuan county 涇川縣

Jingguang 景光

Jinghuan 景煥

Jingshansi 敬善寺

Jinguang ming jing 金光明經

Jingzhi Monastery 靜志寺

Jingzhongsi 淨眾寺

Jingzhou 涇州

Jinhua City 金華市

Jinling 金陵

Jinlun Shengshen Huangdi 金輪聖神皇帝

Jinlunwang foding yaolüe niansong fa; J: *Kinrinnō butchō yōryaku nenju hō* 金輪王佛頂
　　要略念誦法

Jisei jukai ki 自誓受戒記

jisei jukai 自誓受戒

jitai 自體

Jiufengchansi 鷲峰禪寺

Jizō 地藏

Jōdoji 淨土寺

jōjin'e 成身會

Jōraku'in 常樂院

juan 卷

jue; J: *ketsu* 橛

Juezhi 覺支

Junchali; J: Gundari 軍荼利

kadai 火大

Kagenji 家原寺

Kaibaosi 開寶寺

Kaifuhuawang; J: Kaifukeō 開敷華王

kaigen kuyō 開眼供養

kaiyan; J: *kaigen* 開眼

Kaiyuansi 開元寺

Kaizōji 海藏寺

kaji riki 加持力

Kakujō 覺盛

Kamunsa 感恩寺

kan 觀

Kang Senghui 康僧會

(Kanjin) Gakushōki 感身學正記

kannen 觀念

Kannon 觀音

Kano Motonobu 狩野元信

Kanshinji 觀心寺

karin 火輪

kaya 榧

kechi'en shūinjō 結緣手印狀

Kegon school 華嚴宗

keiaihō 敬愛法

Keizan Jōkin 塋山紹瑾

(kezoku) kechi'en 化俗結緣

King Jing 敬王

King Munmu 文武王

King of the state of Wuyue 吳越國王

King Sinmun 神文王

kirikane 截金

Kōdō 講堂

Kōen 康圓

Komatsudera 小松寺

Kondō 金堂

Konghuisi 空慧寺

kongō busshi 金剛佛子

Kongōkai Dainichi 金剛界大日

kongōkai mandara 金剛界曼荼羅

kongōkei 金剛形

Konomiya Jinja 胡宮神社

Konrenji 金蓮寺

kosatsu 古剎

Kōtokuji 光得寺

Kōyasan 高野山

kūdai 空大

Kūkai 空海

Kyōōgokokuji 教王護國寺

Lady Daoyou 莫姥道猷

Lantian county 蘭田縣

Leifengta 雷峰塔

Li Deyu 李德裕

Li Gonglin 李公麟

Li Heng 李亨

li 理

liangbu mantuluo; J: *ryōbu mandara* 兩部曼荼羅

lianhuabu yuan; J: *rengebu'in* 蓮華部院

Lindedian 麟德殿

ling; J: *rei* 靈

lingjiu; J: *reikyū* 靈柩

lingjun jiangjun 領軍將軍

Lingshan; J: Ryōzen 靈山

Lingshan bianxiang; J: *Ryōzen hensō* 靈山變相

lingwei; J: *reii* 靈位

lingxiang; J: *reizō* 靈像

lingyan; J: *reigen* 靈驗

lingzhang 靈帳

Lintong county 臨潼縣

Linzi 臨淄

Liquan county 禮泉縣

Liu Sahe 劉薩河

Liu Zairong 劉再榮

lizhi buer; J: *richi funi* 理智不二

longgong 龍宮

Longguangsi 龍光寺

Longmen 龍門

Longxingsi 龍興寺

Lü Guang 呂光

lun 輪

Lun fogu biao 論佛骨表

lunbao; J: *rinbō* 輪寶

lunwangzuo; J: *rinnōza* 輪王坐

Luoyang 洛陽

Luoyang qielanji 洛陽伽藍記

Mancheng county 滿城縣

Matou; J: Batō 馬頭

Matou Guanyin; J: Batō Kannon 馬頭觀音

Matsunoodera 松尾寺

Mengcun 孟村

Miaofa lianhua jing Shijia duobao rulai quanshen sheli baota; J: *Myōhō renge kyō Shaka tahō nyorai zenshin shari hōtō* 妙法蓮華經釋迦多寶如來全身舍利寶塔

Miaoshansi 妙善寺

mijiao; J: *mikkyō* 密教

mikan 秘龕

miken byakugōsō 眉間白毫相

Mile; J: Miroku 彌勒

Mimurodoji 三室戶寺

mingtang 明堂

mingwang; J: *myōō* 明王

Mirokudō 彌勒堂

mizong 密宗

Modengqie jing; J: *Matōga kyō* 摩登伽經

mofa 末法

momitō 粒塔

Monju Bosatsu 文殊菩薩

Mount Atago 愛宕山

Mount Beigu 北固山
Mount Jiuhua 九華山
Mount Wutai 五臺山
Mujaku Dōchū 無著道忠
Mujianlian; J: Mokkenren 目犍蓮
Murōji 室生寺
Murōzan oshari sōden engi 室生山御舍利相傳緣起
musō 無相
muzhiming 墓誌銘
Myōe 明慧
Najie 那竭
Nanhai jigui neifa zhuan 南海寄歸內法傳
nembutsu 念佛
nikkei 肉髻
Ningbo 寧波
Ningkang 寧康
nishiki fukuro 錦袋
nōnyō butsu 納入佛
Nyoirin Kannon 如意觀音
Onjōji 園城寺
oujiaping; J: *akabyō* 閼伽瓶
panguan 判官
Pengcheng 彭城
Pingyin county 平陰縣
Pishamen; J: Bishamon 毘沙門
Prince of Poyang 鄱陽世子
Pugui 普貴
Puti Liuzhi 菩提流志
Puti Xianna; J: Bodaisenna 菩提僊那
Putuoluojia 普陀落迦
Puxian; J: Fugen 普賢
　　Daizhao Gao Wenjin hua 待詔高文進畫
Qian Hongchu 錢弘俶
Qianshou Qianyan Guanyin; J: Senju Sengen Kannon 千手千眼觀音
qifo; J: *shichibutsu* 七佛
Qingdao 青島
Qinglongsi 青龍寺
Qingshan Monastery 慶山寺
Qingyang county 青陽縣
qinjin; J: *shinkin* 親近
quanshen sheli; J: *zenshin shari* 全身舍利
rengeyō 蓮華葉
Renwang hu guo banruo boluomiduo jing; J: *Ninnō gokoku hannya haramitta kyō* 仁王護
　　國般若波羅蜜多經
richi funi 理智不二
Rinjū hiketsu 臨終秘決

Riyansi 日嚴寺

rokudō 六道

Ruiguangsi 瑞光寺

Ruiwen yingwu mingde zhiren dasheng guangxiao huangdi 睿文英武明德至仁大聖廣
孝皇帝

rulai; J: *nyorai* 如來

Runzhou 潤州

ruyi baozhu; J: *nyoi hōju* 如意寶珠

ryōkai shuji mandara 兩界種子曼荼羅

Saga 嵯峨

Saichō 最澄

Saidaiji 西大寺

saishō 最勝

sammitsu kaji 三密加持

sanbao; J: *sanbō* 三寶

sange 散華

sangoku denrai 三國傳來

Sanjūsanten 三十三天

sankaku gorintō 三角五輪塔

sankakukei 三角形

sanmi; J: *sanmitsu* 三密

sanshen; J: *sanjin* 三身

saya butsu 鞘佛

Seiganji 誓願寺

Seiryōji 清凉寺

Seiryōji engi 清凉寺緣起

Sengche 僧澈

sengjia; J: *sōgya* 僧伽

seshen; J: *shikishin* 色身

Shahutuo village 沙呼沱村

Shaka zuizō 釋迦瑞像

Shakadō engi 釋迦堂緣起

Shandao; J: Zendō 善導

Shangfang shelita ji 上方舍利塔記

Shanwuwei 善無畏

Shaoqian 紹乾

Shaoxing 紹興

sheli; J: *shari* 舍利

Shende Monastery 神德寺

shengshen sheli; J: *shōjin shari* 生身舍利

shengu sheli; J: *shinkotsu shari* 身骨舍利

shentong miyu 深通密語

shenzuoguan 審作官

Shijia Rulai sheli baozhang 釋迦如來舍利寶帳

Shingon 真言

Shingonshū 真言宗

shinjō 心城

shippō 七寶

shishi 石室

Shitennōji 四天王寺

shiwuweiyin; J: semui'in 施無畏印

Shiyi 師益

shiyuanyin; J: segan'in 施願印

shizhong 侍中

Shō Kannon 聖觀音

shō'enkei 正圓形

Shōdai giki 攝大儀軌

shōhōkei 正方形

Shōmyōji 稱名寺

Shōrai mokuroku 請來目錄

Shōtoku Taishi 聖德太子

shūbutsu 摺佛

Shuiquansi 水泉寺

Shuiyue Guanyin; J: Suigetsu Kannon 水月觀音

shuji 種子

Shunjōbō Chōgen 俊乘房重源

Shunshō 春聖

si 寺

Sita ji 寺塔記

sitianwang; J: shitennō 四天王

sokushin jōbutsu 即身成佛

Sōmyō 宗明

Song gaoseng zhuan 宋高僧傳

Su E 蘇鶚

suidai 水大

suirin 水輪

suishō shariyōki 水晶舍利容器

Sun Quan 孫權

Suxidi jieluo jing; J: Soshitsuji kara kyō 蘇悉地羯羅經

Suzhou 蘇州

ta 塔

ta xia zhi shishi 塔下之石室

taicangjie da mantuluo; J: taizōkai daimandara 胎藏界大曼荼羅

tainai butsu 胎內佛

Taiqing wu nian jiu yue san shi ri fodizi Du Sengyi wei wang er Li Foshi jing zao Yuwang
 xiang gongyang 太清五年九月三十日佛弟子杜僧逸為亡兒李佛施敬造育王像供養

Taiqing 太清

Taizhou 台州

Taizōkai mandara 台藏界曼荼羅

Taizōkai shidai bunsho 胎藏界次第聞書

taizōkai shuji mandara 胎藏界種子曼荼羅

Tanmochen 曇摩讖

Tanyi 曇翼

teihatsu 剃髮

tian; J: *ten* 天

Tianguleiyin; J: Tenkuraion 天鼓雷音

Tianhou 天后

Tiantai ; J: Tendai 天台

tianwangtang 天王堂

tieta 鐵塔

Tōdaiji 東大寺

Tōji 東寺

tokushō 獨勝

Tōriten 忉利天

tōshin (*tōjin*) 等身

Tōshōdaiji 唐招提寺

Ugon 有嚴

Unkei 運慶

wagō 和合

Wan Shen 菀申

Wanfo pagoda 萬佛塔

Wanfosi 萬佛寺

Wang Hu 王虎

Wei Shou 魏收

Weishu 魏書

Wenshu; J: Monju 文殊

wensi fushi 文思副使

wensi shi 文思使

wensi yuan 文思院

Wu Shouzhen 吳守真

Wu 吳

Wubu xinguan; J: *Gobu shinkan* 五部心觀

Wuchang 武昌

wuda mingwang; J: *godai myoō* 五大明王

wuguling; J: *gokorei* 五鈷鈴

Wuliangshou; J: Muryōju 無量壽

Wunengsheng; J: Munōshō 無能勝

wuse jiedaoxian; J: *goshiki kaidōsen* 五色界道線

Wushushama; J: Usumasa 烏樞沙摩

wuzang liufu; J: *gozō roppu* 五臟六腑

wuzhi rulai; J: *gochi nyorai* 五智如來

xiang; J: *zō* 像

Xiangsanshi Mingwang; J: Gōzanze Myōō 降三世明王

Xiao Fan 蕭範

Xiao Hui 蕭恢

Xin Tangshu 新唐書

Xinfengzhen 新豐鎮

xingxiang; J: *gyōzō* 形像

xinshi 心室

xitan; J: *shittan* 悉曇

xiufa; J: *shuhō* 修法

xiyuren 西域人

xizai; J: *sokusai* 息災

xizaifa; J: *sokusaihō* 息災法

xuan 玄

Xuanzang 玄奘

xuepan; J: *keppan* 血判

Xukongcang, J: Kokūzō 虛空藏

Yakushi Nyorai 藥師如來

Yang Xuanzhi 楊銜之

Yangzhou 揚州

Yao county 耀縣

Yigong Zhangwen 益貢章聞

Yijing 義淨

Yijun county 宜君縣

Yingcong Chongzhensi sui zhenshen gongyang daoju ji enci jinyin qiwu baohan dengbing xin enci dao jinyin baoqi yiwuzhang 應從重真寺隨真身供養道具及恩賜金銀器物寶函等並新恩賜到金銀寶器衣物帳

yinggu 影骨

yingshen; J: *ōjin* 應身

yingxiang; J: *yōzō* 影像

Yiqie jing; J: *Issaikyō* 一切經

Yiqie Rulai xin mimi quanshen sheli baoqieyin tuoluoni; J: *Issai Nyorai shin himitsu zenshin shari hōkyōin darani* 一切如來心祕密全身舍利寶篋印陀羅尼

Yishan Yining 一山一寧

Yiwuzhang 衣物帳

Yixing 一行

Yiyinhui; J: *Ichiin'e* 一印會

Yizhou *cishi* 益州刺史

Yizhou zongguan zhuguo Zhaoguogong Zhao jing zao Ayuwang zao xiang yiqu 益州揔管柱國趙國公招敬造阿育王造像一軀

Yizhou 宜州

Yizi ding lunwang niansong yigui; J: *Ichiji chōrinnō nenju giki* 一字頂輪王念誦儀軌

Yizi ding lunwang yuqie guanxing yigui; J: *Ichiji chōrinnō yuga kangyō giki* 一字頂輪王瑜伽觀行儀軌

Yizi Jinlun [Foding]; J: Ichiji Kinrin [Butchō] 一字金輪佛頂

yō 影

yong tong wan guo 永通万國

Yongxi 雍熙

yosegi 寄木

Youtian wang; J: Udennō 優填王

Youtian wang xiang 優填王像

Yuanfeng 元豐

Yuanhe 元和

Yuezhou seng Zhili diao 越州僧知禮雕

Yufo gongde jing; J: *Yokubutsu kōtoku kyō* 浴佛功德涇

Yuwen Tai 宇文泰

Yuwen Zhao 宇文招

Yuzhi huiwen jisong; J: *Gyosei emon geju* 御製迴文偈頌

Zanning 贊寧

Zaoxiang liangdu jing 造像量度經

Zen'en 善圓

Zengchangtian; J: Zōchōten 增長天

Zenjitsu 善實

Zenkei 善慶

Zennenji 善然寺

Zenshun 善春

Zhang Cidai 張次戴

Zhang Jingyan 張淨眼

Zhang Yanjiao 張延皎

Zhang Yanxi 張延襲

Zhaojin 照金

Zhaoxuancao 昭玄曹

Zhaoxuansi 昭玄寺

zhen fogu 真佛骨

Zhenjiang 真江

zhenshen, J: *shinshin* 真身

Zhenshen sheli ta 真身舍利塔

Zhexi 浙西

Zhi Qian 支謙

zhi 帙

zhi 智

zhihui 智慧

Zhihuilun 智慧輪

Zhiloujiachen; J: Shirukasen 支婁迦讖

zhiquanyin; J: *chiken'in* 智拳印

Zhitan Ruixiang 植檀瑞像

Zhiying 智英

Zhong Datong 中大通

zhongtai bayeyuan; J: *chūtai hachiyōin* 中臺八葉院

zhu fofa genben zong hu Dapiluzhena 著佛法根本宗乎大毘盧遮那

Zhu Lüyan 竺律炎

Zhu Sengyi 柱僧逸

zhuan daxiao sanzang seng Zhihuilun 傳大孝三藏僧智慧輪

Zhuli 住力

Zifudian 滋福殿

zizun; J: *jizon* 自尊

zōnai nōnyūhin 像內納入品

Zuo fo xingxiang jing 作佛形像經

zuoguan 作官

NOTES

1

From Image to Icon

1 For modern scholarship on these aspects, see the stimulating discourse of Bernard Faure, *The Rhetoric of Immediacy: A Cultural Critique of Chan/Zen Buddhism* (Princeton: Princeton University Press, 1991), 148–78; Bernard Faure, *Visions of Power: Imagining Medieval Japanese Buddhism*, trans. Phyllis Brooks (Princeton: Princeton University Press, 1996), especially chapter 8: "The Ritual Body," 198–223, and chapter 10: "Iconic Imagination," 237–63; Bernard Faure, "The Buddhist Icon and the Modern Gaze," *Critical Inquiry* 24, no. 3 (Spring 1998): 768–813; Robert H. Sharf, "Prolegomenon to the Study of Japanese Buddhist Icons," in *Living Images: Japanese Buddhist Icons in Context*, ed. Robert H. Sharf and Elizabeth Horton Sharf (Stanford, CA: Stanford University Press, 2001), 1–18.

2 According to advanced Mahāyāna teachings and later *prajñāpāramitā* literature, images for worship and devotion may be made only of the "Retribution Body" (S: *sambhogakāya*; C: *baoshen*; J: *hōjin*) and the "Shadow Body" (S: *nirmāṇakāya*; C: *yingshen*; J: *ōjin*). The latter two bodies are also referred to as "Form Bodies" or "Color Bodies" (S: *rūpakāya*; C: *seshen*; J: *shikishin*).

3 Takakusu Junjirō and Watanabe Kaigyoku, eds., *Taishō shinshū daizōkyō: The Tripitaka in Chinese*. 100 vols. (Tōkyō: Taishō issaikyō kankōkai, 1924–1932; reprint, 1960); for the *Daoxing banruo jing*, see vol. 8, no. 224, 425a–78b.

4 Lewis R. Lancaster, "An Early Mahāyāna Sermon about the Body of the Buddha and the Making of Images," *Artibus Asiae*, vol. 36, no. 4 (1974): 289.

5 Rudolf G. Wagner, "Die Fragen Hui-yuans an Kumārajīva." Ph.D. diss., Ludwig-Maximilians-Universität München, 1969.

6 This passage is quoted from chapter 15 of Daoxuan's (596–667 CE) "Expanded Collection on Propagating the Light" (*Guang hongming ji*) of 664 (*Taishō shinshū daizōkyō*, vol. 52, no. 2103, 198b–c), in the translation of Alexander C. Soper, *Literary Evidence for Early Buddhist Art in China. Artibus Asiae*, Supplementum 19 (Ascona, 1959), 16. For the Chinese text, see also "Quotations and Technical Terms," 296:D.

7 *Kūkai: Major Works*, trans. Yoshito S. Hakeda (New York: Columbia University Press, 1972), 256.

8 Cf. Roger Goepper, "Der Priester Kūkai und die Kunst," in *Religion und Philosophie in Ostasien. Festschrift für Hans Steininger zum 65. Geburtstag*, ed. Gert Naundorf, Karl-Heinz Pohl, and Hans-Hermann Schmidt (Würzburg: Königshausen + Neumann, 1985), 223–32.

9 *Kūkai: Major Works*, 145–46; cf. also *Sources of the Japanese Tradition*, ed. Ryusaku Tsunoda, Wm. Theodore de Bary, Donald Keene (New York: Columbia University Press, 1958), 142. For Kūkai and his relation to art, see Kyōto Kokuritsu Hakubutsu-kan and Tōkyō Kokuritsu Hakubutsukan, eds., *Kōbō Daishi to mikkyō bijutsu: Kōbō Daishi and the Arts of Esoteric Buddhism* (Tōkyō: National Museum, 1983). Samuel Crowell Morse, "The Formation of the Plain-Wood Style and the Development of Japanese Buddhist Sculpture: 760–840." Ph.D. diss., Harvard University, 1985; see especially "Kūkai and the Appearance of the Shingon Style," 338.

10 Generally speaking, rituals were addressed to them to solicit the divinities' "loving protection" (C: *jing'ai*; J: *keiai*) and support in "stopping calamities" (C: *xizai*; J: *sokusai*) and receiving "well-being."

11 The word *benzun* can be traced back at least as far as the Northern Wei dynasty (386–534). Stronger emphasis on the intimate relationship between the devotee and the deity addressed in an icon is connoted by the word *zizun* (J: *jizon*), "Personal Honored One," defined in early exegetic medieval texts as "the venerated deity to which one's Self is clinging." We may assume that icons of this category were preferably set up on the private altar of a practitioner.

12 Its Sanskrit equivalents are *pratimā*, "proportioned in correspondence [with the real divinity]," *pratikṛti*, "made in accordance [with the real divinity]," or *saṃsthāna*, the "beautiful shape or form."

13 Michel Strickmann, ed., *Classical Asian Rituals and the Theory of Ritual* (Berlin and New York: Mouton de Gruyter, 1988).

14 Robert E. Morrell, *Early Kamakura Buddhism: A Minority Report* (Berkeley, CA: Asian Humanities Press, 1987), 60. For Myōe and his "Dream Diary," see George J. Tanabe Jr., *Myōe the Dreamkeeper: Fantasy and Knowledge in Early Kamakura Buddhism. Harvard East Asian Monograph*, no. 156 (Cambridge, MA: Harvard University Press, 1992).

15 Cf. Kurata Bunsaku, *Zōnai nōnyūhin* [Objects Deposited Inside Images], Nihon no bijutsu, no. 86 (Tōkyō: Shibundō, 1973); Bunkachō, ed., *Jūyō bunkazai* [Important Cultural Properties], special vols. I and II: *Zōnai nōnyūhin* (Tōkyō: Mainichi Shinbunsha, 1978); Nishikawa Kyōtarō, *Chinsō chōkoku* [Zen Portrait Sculpture], Nihon no bijutsu, no. 123 (Tōkyō: Shibundō, 1976); Hisashi Mōri, *Japanese Portrait Sculpture*, trans. W. Chië Ishibashi (Tōkyō, New York, and San Francisco: Kodansha International Ltd. and Shibundō, 1977), 26–46 (originally published as

Shōzō chōkoku, Nihon no bijutsu, no. 10, Tōkyō: Shibundō, 1967); Helmut Brinker and Hiroshi Kanazawa, *ZEN: Masters of Meditation in Images and Writings*, trans. Andreas Leisinger, Artibus Asiae Supplementum 40 (Zürich: Artibus Asiae, 1996), 83–97, 238–45 (originally published as *ZEN: Meister der Meditation in Bildern und Schriften* [Zürich: Museum Rietberg, 1993]), and the author's paper "The Iconic Body as Insight: Reflections of Buddhist Faith and Worship, Ritual and Relic in Japanese Medieval Sculpture" at the symposium *Object as Insight*, Amherst College (1996). For Chinese religious images of rather poor aesthetic quality with a variety of deposits, including handwritten "consecration certificates," see James Robson, *Inside Asian Images: An Exhibition of Religious Statuary from the Artasia Gallery Collection* (Ann Arbor: University of Michigan, Institute for the Humanities, 2007).

16 *Taishō shinshū daizōkyō*, vol. 21, no. 1419, 951a; for an English translation, see *Zaoxiang Liangdu Jing: The Buddhist Canon of Iconometry*, with supplement. A Tibetan-Chinese Translation from about 1742 by mGon-po-skyabs (Gömpojab), trans. and ann. Cai Jingfeng (Ulm: Fabri Verlag, 2000), 112. The formal Buddhist canon, known in Japan as *Issaikyō*, consisted of about five thousand separate scrolls. Around the mid-eighth century at least twenty-four complete sets of the *Issaikyō* were available, i.e., more than 120,000 scrolls must have been copied, with great expenditure of resources, labor, and patience. *Dhāraṇī* (J: *darani*) are invocatory formulas to concentrate the mind of the practitioner. These brief spells are often referred to as *shingon*, "true words," and the term is sometimes used indiscriminately for shorter *mantras*. Properly employed, *dhāraṇī* as well as *mantras* are believed to yield great benefit, since they are regarded as embodiments of Buddhist divinities and saints in sounds. The Sanskrit word *bīja*, in Japanese *shuji*, refers to individual letters or one-character incantations which represent and invoke mainly divinities of the Esoteric Buddhist pantheon.

17 Translation by Eugene Y. Wang, "Of the True Body: The Famen Monastery Relics and Corporeal Transformation in Tang Imperial Culture," in *Body and Face in Chinese Visual Culture*, ed. Wu Hung and Katherine R. Tsiang, Harvard East Asian Monographs 239 (Cambridge, MA: Harvard University Press, 2005), 82; see also James R. Ware, "Wei Shou on Buddhism," *T'oung Pao*, 2d ser., 30 (1933): 118–19.

18 *Taishō shinshū daizōkyō*, vol. 16, no. 663, 354a.

19 Ibid., no. 697, 799a. Bao Siwei came to Luoyang in 693 and headed several Buddhist monasteries of the capital until 706. Sprinkling water or tea on an image of the (infant) Buddha was an annual ceremony held on the traditional date of Śākyamuni's birthday on the eighth day of the fourth month. This ritual of "bathing the Buddha" commemorates the washing of the newborn child by gods (*nāgas*) immediately following the savior's birth. The ceremony is described in a number of canonical scriptures, the earliest Chinese sources dating from the late second or early third century CE; for more details, see Erik Zürcher, *The Buddhist Conquest of China: The Spread and Adaptation of Buddhism in Early Medieval China* (Leiden: E. J. Brill, 1959), vol. 2, 327n53.

20 *Taishō shinshū daizōkyō*, vol. 16, no. 698, 800a; see also Jan Fontein, "Relics and Reliquaries, Texts and Artefacts," in *Function and Meaning in Buddhist Art*, ed. K. R. van Kooij and H. van der Veere (proceedings of a seminar held at Leiden Uni-

versity, 21–24 October 1991) (Groningen: Egbert Forsten, 1995), 27. Yijing is said to have translated a total of 56 texts in 230 fascicles. He was highly respected by the pious Tang Empress Wu (r. 684–705) and was greeted by her in person at the Eastern Gate of Luoyang, when he returned to China in 695 after his twenty-four-year sojourn abroad in search of Buddhist scriptures.

21 *Taishō shinshū daizōkyō*, vol. 51, no. 2087, 920. On Xuanzang's life and work, see Alexander Leonhard Mayer and Klaus Röhrborn, eds., *Xuanzangs Leben und Werk*. Veröffentlichungen der Societas Uralo-Altaica, vol. 34 (Wiesbaden: Otto Harrassowitz, 1991–92).

22 *Taishō shinshū daizōkyō*, vol. 54, no. 2125, 226c; trans. Daniel Boucher, "Sūtra on the Merit of Bathing the Buddha," in *Religions of China in Practice*, ed. Donald S. Lopez Jr., Princeton Readings in Religions (Princeton: Princeton University Press, 1996), 61.

23 H. 96.4 cm; see Kurata, *Zōnai nōnyūhin*, figs. 19, 44–45; *Jūyō bunkazai: Zōnai nōnyūhin* I, 108, no. 123.

24 H. 99.4 cm; see Shimizu Mazumi, "Gozō roppu no aru Sōdai mokuzō Bosatsu hankazō" [The Five Intestines and the Six Organs of a Song Dynasty Wooden Bodhisattva Image in Semi-cross-legged Position], *Bukkyō geijutsu: Ars Buddhica*, no. 135 (March 1981): 49–60; Kamakura Kokuhōkan, ed., *Zōnai nōnyūhin: Kamakura o chūshin ni* (Kamakura: Kamakura Kokuhōkan, 1997), no. 12; Umezawa Megumi et al., eds., *Sōgen butsuga: Buddhist Paintings of Song and Yuan Dynasties*. The 40th anniversary special exhibition (Yokohama: Kanagawa Prefectural Museum of Cultural History, 2007), no. 2, 34, and 158. The authors of this exhibition catalogue date the "Seated Bosatsu" image to the Southern Song dynasty and give as height 100.1 cm.

25 The height of the Yakushi figure is 67.3 cm and that of the Buddha face is 18 cm; see *Zōnai nōnyūhin*, no. 3 and front cover.

26 The figure is 46 cm high, and the small sculpture inside is 17.5 cm; see ibid., no. 4.

27 Bernard Faure ("The Buddhist Icon and the Modern Gaze," 770) even thinks of the icon in this context as "a kind of tomb. A significant case is that of a Japanese stone statue of the Buddha Amida, in which was placed the mummy of a Buddhist monk."

28 Translation [with minor changes by the author] by Roger Goepper, "Some Thoughts on the Icon in Esoteric Buddhism of East Asia," in *Studia Sino-Mongolica*. Festschrift für Herbert Franke, ed. Wolfgang Bauer. Münchener Ostasiatische Studien, vol. 25 (Wiesbaden: Franz Steiner Verlag, 1980), 250. Kōyasan University Library, no. 416.3.14, 8–9; Goepper, "Icon and Ritual in Japanese Buddhism," in *Enlightenment Embodied: The Art of the Japanese Buddhist Sculptor (7th–14th Centuries)*, trans. and ed. Reiko Tomii and Kathleen M. Friello (New York: Japan Society, Inc., 1997), 73; on various aspects of "visualization," see Robert H. Sharf, "Visualization and Mandala in Shingon Buddhism," in *Living Images: Japanese Buddhist Icons in Context*, ed. Robert H. Sharf and Elizabeth Horton Sharf, pp. 151–97.

29 The statue is 160 cm high and the cavity in its back measures 28.3 x 13.6 cm. See Oku Takeo. S*eiryōji Shaka Nyorai zō* [The Shaka Nyorai Image at Seiryōji], Nihon no bijutsu, no. 513 (Tōkyō: Shibundō, 2009).

30 The document, written in ink on paper (height 17 cm, length 150 cm), is dated to 5 September 985. Cf. *Jūyō bunkazai*, special vol. II: *Zōnai nōnyūhin*, no. 56,1–2, 124; Kyōto Kokuritsu Hakubutsukan, ed., *Tokubetsu tenrankai: Shaka shinkō to Seiryōji*

[Special Exhibition of Śākyamuni Worship and Seiryō-ji Temple] (Kyōto: Kyōto National Museum, 1982), fig. 40-2, 91. For a translation, see Gregory Henderson and Leon Hurvitz, "The Buddha of Seiryōji: New Finds and New Theory," *Artibus Asiae* 19, no. 1 (1956): 49–55.

31 It is 32 cm high and 47 cm long; cf. Henderson and Hurvitz, "The Buddha of Seiryōji: New Finds and New Theory," pl. 8, 26, and for a translation of the text, see 45–47; Kurata, *Zōnai nōnyūhin*, fig. 52; Bunkachō, ed., *Jūyō bunkazai*, special vol. II: *Zōnai nōnyūhin*, no. 56, 13, 126; Kyōto Kokuritsu Hakubutsukan, ed., *Tokubetsu tenrankai: Shaka shinkō to Seiryō-ji*, cpl. 40, 33.

32 This document is written in ink on paper. The handscroll (h. 32.7 cm, l. 789 cm) has been preserved at Daikakuji; see Bunkazai Hogoi'inkai, ed., *Kokuhō—National Treasures of Japan*, vol. 4: *Kamakura jidai I—12th–14th Centuries* (Tōkyō: Mainichi Shinbunsha, 1966), no. 85.

33 Henderson and Hurvitz, "The Buddha of Seiryōji," 4–55; Kurata Bunsaku, "Kyōto Seiryōji no Shaka nyorai zō" [The Shaka Nyorai Image of Seiryōji in Kyōto], in *Butsuzō no mikata: gihō to hyōgen* [A View of Buddhist Images: Technique and Expression] (Tōkyō: Daiichi Hōki Shuppan, 1965), 248–56; Kurata, *Zōnai nōnyūhin*, 1, fig. 1, 19–27, figs. 39–43, 46–54, and 107; Mōri Hisashi, "Seiryōji Shaka zō: hensen kō" [The Seiryōji Shaka Image: Changes in Research], in *Nihon bukkyō chōkoku shi no kenkyū* [Studies in the History of Japanese Buddhist Sculpture] (Kyōto: Hōzōkan, 1970), 312–27 (originally published in *Bukkyō geijutsu*, no. 35 [1958]: 1–23); Kyōto Kokuritsu Hakubutsukan, ed., *Tokubetsu tenrankai: Shaka shinkō to Seiryōji*; Okada Ken, "Shaka Nyorai ryūzō—Zōnai nōnyūhin issai," [The Standing Shaka Nyorai Statue—All About the Cache Inside the Image], *Nihon no kokuhō—National Treasures of Japan*, no. 16 (8 June 1997): 6/165–6/167; id., "Sangoku denrai no Shaka zuizō" [The Auspicious Shaka Image Transmitted Across Three Countries], *Nihon no kokuhō—National Treasures of Japan*, no. 16 (8 June 1997): 6/167.

34 Amy McNair, in *Latter Days of the Law: Images of Chinese Buddhism, 850–1850*, ed. Marsha Weidner (Lawrence: Spencer Museum of Art, The University of Kansas, in association with University of Hawai'i Press, 1994), 225.

35 *Taishō shinshū daizōkyō*, vol. 16, no. 692, 788b-c; trans. Robert H. Sharf, "The Scripture on the Production of Buddha Images," in Lopez, *Religions of China in Practice*, 261–67.

36 The "Heaven of the Thirty-three [Gods of Hindu origin ruled by Indra]" (J: Sanjūsanten), is another name for the Trāyastriṃśa (J: Tōriten) at the summit of Mount Sumeru.

37 Sharf, "The Scripture on the Production of Buddha Images," 262; see also Faure, "The Buddhist Icon and the Modern Gaze," 782, quoting the story as transmitted by Huijiao (497–554) in his "Biographies of Eminent Monks" (C: *Gaoseng zhuan*); see *Taishō shinshū daizōkyō*, vol. 50, no. 2059, 860b. For a detailed account of this legend, see Soper, *Literary Evidence for Early Buddhist Art in China*, 259–65; Martha L. Carter, *The Mystery of the Udayana Buddha* (Naples: Istituto Universitario Orientale, 1990).

38 Faxian went to India in 399 and returned in 414. Xuanzang spent the years between 629 and 645 on his trip to India via Central Asia and Afghanistan.

39 Henderson and Hurvitz, "The Buddha of Seiryōji," 15.

40 The scrolls (h. 34.8 cm, l. of scroll two 1589 cm, of scroll three 1318.1 cm) were originally painted (in ink and color on paper) for Seiryōji and remain in the temple's collection.

41 We shall not discuss the dramatically different seated Udayana images, for example, those carved in great quantities between the Binyang courtyard and Jingshansi Grotto at Longmen from about 655 to 663. For further information and references, see Amy McNair, "The Fengxiansi Shrine and Longmen in the 670s," *The Museum of Far Eastern Antiquities, Stockholm, Bulletin*, no. 68 (1996): 331n26 and fig. 9. On the origin of these seated Buddha figures, McNair remarks: "Since the Longmen figures are all nearly identical in style and size (about 100 cm high), they likely replicate a single copy of some Gupta dynasty (320–647) statue of the Sarnath school that purported to be 'the King Udayana image.' Perhaps it was the copy the great pilgrim Xuanzang (600–64) brought back to Chang'an in 645." See also McNair's chapter "A Thousand Years after My *Nirvāṇa*, You Will Be Found in China," in her *Donors of Longmen: Faith, Politics, and Patronage in Medieval Chinese Buddhist Sculpture* (Honolulu: University of Hawai'i Press, 2007), 99.

42 Carter, *The Mystery of the Udayana Buddha*, 21.

43 McNair, *Donors of Longmen*, 101, fig. 5.6, 102.

44 H. 140.5 cm; see Laurence Sickman and Alexander Soper, *The Art and Architecture of China*. The Pelican History of Art (Harmondsworth, Baltimore, Mitcham: Penguin Books Ltd, 1956), pl. 30A, and 44; Benjamin Rowland, *The Evolution of the Buddha Image* (New York: Asia Society, 1963), no. 39; Jin Shen, *Zhongguo lidai jinian foxiang tudian* [Illustrated Chronological Compendium of Buddhist Images Throughout China's History] (Beijing: Wenwu chubanshe, 1994), no. 43, 65., and 449; James C. Y. Watt et al., *China: Dawn of a Golden Age, 200–750 A D* (New Haven and London: Yale University Press, 2004), no. 77, 168–69.

45 The statue is 53.5 cm high and has been preserved in the Agency for Cultural Affairs, Tōkyō, on deposit at the Kyūshū National Museum, Dazaifu.; see Izumishi Kuboso Kinen Bijutsukan, ed., *Chūgoku koshiki kondōbutsu to Chūō Tōnan Ajia no kondōbutsu* [Ancient Gilt Buddhist Bronzes from China and Gilt Buddhist Bronzes from Central and Southeast Asia] (Izumishi: Kuboso Kinen Bijutsukan, 1988), no. 53, 62; Jin, *Zhongguo lidai jinian foxiang tudian*, no. 10, 12–13, and 436–37; Matsubara Saburō, *Chūgoku bukkyō chōkoku shiron* [Historical Survey of Chinese Buddhist Sculpture] (Tōkyō: Yoshikawa kōbunkan, 1995), Zuhanhen [Plates] 1, pls. 23–24, and Honbunhen [Text], 245.

46 H. 11.5 cm; see Izumishi Kuboso Kinen Bijutsukan, ed., *Rokuchō jidai no kondōbutsu* [Gilt Buddhist Bronzes of the Six Dynasties] (Izumishi: Kuboso Kinen Bijutsukan, 1991) no. 38, 39.

47 H. 29.7 cm; see ibid., no. 46, 46; and Jin, *Zhongguo lidai jinian foxiang tudian*, no. 54, 82 and 453.

48 H. 40.2 cm; see Izumishi Kuboso Kinen Bijutsukan, *Rokuchō jidai no kondōbutsu*, no. 47, 47; Jin, *Zhongguo lidai jinian foxiang tudian*, no. 65, 97–98 and 457; Matsubara, *Chūgoku bukkyō chōkoku shiron*, Zuhanhen, vol. 1, no. 90, and Honbunhen [Text], 254.

49 Carter, *The Mystery of the Udayana Buddha*, 22.

50 H. 35.2 cm; see Jin, *Zhongguo lidai jinian foxiang tudian*, no. 27, 39–40 and 443; Hebei sheng bowuguan, ed., *Hebei sheng bowuguan wenwu jingpin ji* [Treasures from the Hebei Provincial Museum] (Beijing: Wenwu chubanshe, 1999), no. 108, 214; Matsubara, *Chūgoku bukkyō chōkoku shiron*, Zuhanhen, vol. 1, no. 35b, and Honbunhen [Text], 247; Watt, et al., *China: Dawn of a Golden Age, 200-750 AD*, no. 75, 166–67.

51 H. 10.5 cm; see Izumishi Kubosō Kinen Bijutsukan, ed., *Chūgoku koshiki kondōbutsu to Chūō Tōnan Ajia no kondōbutsu* [Ancient Gilt Buddhist Bronzes from China and Gilt Buddhist Bronzes from Central and Southeast Asia], no. 68, 78.

52 Alexander Soper, "South Chinese Influence on the Buddhist Art of the Six Dynasties Period," *The Museum of Far Eastern Antiquities, Stockholm, Bulletin*, no. 32 (1960): 93.

53 Soper, *Literary Evidence for Early Buddhist Art in China*, XIV.

54 *Taishō shinshū daizōkyō*, vol. 50, no. 2059, 355c–56a; trans. Alexander Soper, *Literary Evidence for Early Buddhist Art in China*, 23.

55 Soper, *Literary Evidence for Early Buddhist Art in China*, 28; Soper, "South Chinese Influence," 93–94.

56 *Taishō shinshū daizōkyō*, vol. 53, no. 2122, 392c; for a full translation of this passage, see Soper, *Literary Evidence for Early Buddhist Art in China*, 28–29.

57 Ibid.

58 The figure seems to have been supplied with a nonmatching head which was recently removed. The first sculptures were discovered at the Wanfosi site in 1882. Subsequent investigations in 1937, 1945–46, and 1953–54 brought to light a total of about 200 fragments. Tradition holds that the Wanfo Monastery was established shortly after the middle of the second century; under the Liang it was a nunnery, known as Anpusi, and under the Tang as "Pure Assembly Monastery" (C: Jingzhongsi); see Liu Zhiyuan and Liu Tingbi, eds., *Chengdu Wanfosi shike yishu* [The Art of Stone Sculpture from the 'Myriad Buddha Monastery' in Chengdu] (Beijing: Zhongguo gudian yishu chubanshe, 1958), pl. 9; Soper, "South Chinese Influence," pl. 11; Yuan Shuguang, "Sichuan sheng Bowuguan cang Wanfosi shike zaoxiang zhengli jianbao" [Bulletin on the Readjustment of the Wanfosi Stone Sculptures in the Museum of Sichuan Province], *Wenwu*, no. 10 (2002): 21–23, and Xiaoneng Yang, *New Perspectives on China's Past: Chinese Archaeology in the Twentieth Century*, vol. 1: *Cultures and Civilizations Reconstructed* (New Haven, CT: Yale University Press, and the Nelson-Atkins Museum, Kansas City, 2004), fig. 21-6, 388.

59 Liu Zhiyuan and Liu Tingbi, eds., *Chengdu Wanfosi shike yishu*, vol. 4, no. 6; see also Soper, "South Chinese Influence," 92, and Yuan Shuguang, *Wenwu*, no. 10 (2001): 20, fig. 2 and 23.

60 Tōkyō Kokuritsu Hakubutsukan, Asahi Shinbun, ed., *Chūgoku kokuhō ten — Treasures of Ancient China* (Tōykō: Tōkyō National Museum and Asahi Shimbun, 2000), no. 114, 175; Yuan Shuguang, *Wenwu*, no. 10 (2001): pl. 7, 22; Yang, *New Perspectives on China's Past*, vol. 1: *Cultures and Civilizations Reconstructed*, fig. 21-7, 388.

61 Angela F. Howard, in Watt et al., *China: Dawn of a Golden Age, 200-750 AD*, 227–28.

62 Tōkyō Kokuritsu Hakubutsukan, ed., *Chūgoku kokuhō ten — Treasures of Ancient*

China, 2000, no. 113, 174, Yuan Shuguang, *Wenwu*, no. 10 (2001): pl. 8, 22, and Yang, *New Perspectives on China's Past*, vol. 2: *Major Archaeological Discoveries in Twentieth-Century China*, no. 106, 337.

63 The Archaeological Team of Chengdu Municipality and the Institute of Archaeology of Chengdu, "Chengdushi Xi'anlu Nanzhao shike zaoxiang qingli jianbao" [Brief Survey on the Stone Sculptures of the Southern Dynasties Unearthed at Xi'an Road in Chengdu City], *Wenwu*, no. 11 (1998): 4–20, cpls. inner title page, and 1–4; Watt et al., *China: Dawn of a Golden Age, 200–750 A D*, no. 128, 227–29, and Yang, *New Perspectives on China's Past*, vol. 1: *Cultures and Civilizations Reconstructed*, fig. 21-8a-c, 390–91.

64 *Wenwu*, no. 11 (1998): cpl. 2, 7–8, figs. 11 and 14. The donor's name is transcribed here as Zhu Sengyi. *Sekai bijutsu daizenshū—New History of World Art*: Tōyōhen 3: Sangoku—Nanbokuchō, ed. Sofukawa Hiroshi and Okada Ken (Tōkyō: Shogakukan, 2000), cpl. 248, 262 and 456; Lukas Nickel, ed., *The Return of the Buddha: Buddhist Sculptures of the 6th Century from Qingzhou, China* (Zürich: Museum Rietberg, 2002), originally published as *Die Rückkehr des Buddha: Chinesische Skulpturen des 6. Jahrhunderts: Der Tempelfund von Qingzhou* (Zürich: Museum Rietberg, 2001), fig. 59, 84; Watt et al., *China: Dawn of a Golden Age, 200–750 A D*, no. 128, 227–29, and Yang, *New Perspectives on China's Past,* vol. 1: *Cultures and Civilizations Reconstructed*, fig. 21-8a-c, 390–91.

65 The statue (H1:4) is 48.5 cm high. I shall leave aside speculations on the possible relationship between these Southern dynasties sculptures discovered in Sichuan province and the hundreds of superb contemporaneous Buddhist sculptures unearthed in 1996 from a cache at the ancient temple site of Longxingsi in northeastern Shandong, nor shall I attempt to trace possible avenues of stylistic derivations from Central, South, and Southeast Asian ancestors; for these aspects, see Su Bai, "Sculpture of the Northern Qi Dynasty and its Stylistic Prototypes," in Nickel, *The Return of the Buddha,* 81–90, and *Die Rückkehr des Buddha*, 81–90.

66 Liu Zhiyuan and Liu Tingbi, eds., *Chengdu Wanfosi shike yishu*, no. 8; Yoshimura Rei, "Seito Manbutsuji shi shutsudo butsuzō to Kenkō bukkyō—Ryō chūdaitō gannen mei no Indo shiki butsuzō ni tsuite" [Jiankang Buddhism and the Buddhist Images Unearthed from the Ruins of Wanfosi—On the Indian Style of the Buddha Image with the Inscription Dated First Year Zhong Datong of the Liang Dynasty], *Bukkyō geijutsu—Ars Buddhica*, no. 240 (September 1998): 33–50; Tōkyō Kokuritsu Hakubutsukan, ed., *Chūgoku kokuhō ten—Treasures of Ancient China*, 2000, no. 115, 176–77; Yuan Shuguang, *Wenwu*, no. 10 (2001): 19–21, figs. 1 and 4; Watt et al., *China: Dawn of a Golden Age, 200–750 A D*, no. 123, 218–19.

67 Angela F. Howard in Watt et al., *China: Dawn of a Golden Age, 200–750 A D*, 218.

68 The second part of the inscription reads in Angela Howard's translation as follows: "With this merit, they hope that seven past generations can be born in the Pure Land and behold the true face of the Buddha and achieve perfection in shining wisdom. They hope that Jingguang and his mother, as well as all their relatives, will live one hundred years and their good karma will be extended far into the future. That they will be saved from the three obstacles and forever removed from evil. That life after life, generation after generation, mother and son will be reunited to learn the Dharma extensively. And that together with all sentient beings, they

will attain the fruits of Buddhahood without fail." See Watt, et al., *China: Dawn of a Golden Age, 200-750 A D,* 218; for reproductions and varying transcriptions and interpretations of the inscription, see Yoshimura, *Bukkyō geijutsu—Ars Buddhica,* no. 240 (September 1998), 34; Tōkyō Kokuritsu Hakubutsukan, ed., *Chūgoku kokuhō ten—Treasures of Ancient China,* 2000, 291–92; Yuan Shuguang, *Wenwu,* no. 10 (2001): fig. 1, 19–20.

69 H. 270 cm; see Dieter Kuhn, ed., *Chinas Goldenes Zeitalter: Die Tang-Dynastie (618-907 n. Chr.) und das kulturelle Erbe der Seidenstrasse* (Heidelberg: Edition Braus, 1993), no. 100, 260.

70 H. 169 cm; see Kuhn, ed., *Chinas Goldenes Zeitalter,* no. 99, 260; Matsubara, *Chūgoku bukkyō chōkoku shiron,* Zuhanhen, vol. 3, no. 608–609a/b, and Honbunhen [Text], 321.

71 The sculpture is 79 cm high and now kept at the Forest of Stelae Museum, Xi'an; see Tōkyō Kokuritsu Hakubutsukan, ed., *Kyūtei no eiga: Tō no jotei Soku Tenmukō to sono jidai ten—The Glory of the Court: Tang Dynasty Empress Wu and Her Times* (Tōkyō, Kōbe, Fukuoka, Nagoya: NHK, 1998), no. 18, 43.

72 H. 145 cm; Matsubara, *Chūgoku bukkyō chōkoku shiron,* Zuhanhen, vol. 3, no. 679–680a/b, and Honbunhen [Text], 329.

73 James O. Caswell, *Written and Unwritten: Buddhist Caves at Yungang* (Vancouver: UBC Press, 1988), 147, n. 2.

74 See Rowland, *The Evolution of the Buddha Image,* nos. 49 and 50.

75 Weidner, *Latter Days of the Law,* no. 1, 221–25.

76 136 x 77 cm; see Weidner, *Latter Days of the Law,* no. 1, 221–25.

77 Translation by Amy McNair, in Weidner, *Latter Days of the Law,* no. 1, 221–24.

78 Wooden statues of this type have been preserved at Mimurodoji, Kyōto, probably 1098 (h. 154 cm); Daienji, Tōkyō, dated to 1193 (h. 163.9 cm); Byōdōji, Kyōto, dated to 1213 (h. 76.7 cm); Jōraku'in, Kyōto, first half 13th century (h. 97 cm); Saidaiji, Nara, dated to 1249 (h. 167 cm); Tōshōdaiji, Nara, dated to 1258 (h. 166.6 cm); Hōzōji, Ochi county, Ehime prefecture, dated to 1268 (h. 163.6 cm); Nara National Museum, dated to 1273 (h. 78.8 cm); Gokurakuji, Kamakura, dated to 1297 (h. 158.5 cm); Shōmyōji, Kamakura, dated to 1308 (h. 160.6 cm); Daikōzenji, Fukuoka, first half of the 14th century (h. 170 cm). See Ikawa Kazuko, "Kantō no Seiryōji shiki Shaka zō" [Shaka Images in the Seiryōji style from the Kantō Region], *Bijutsu kenkyū,* no. 237 (1964), 23–35; Bunkachō, ed., *Jūyō bunkazai* [Important Cultural Properties], vol. 1: *Chōkoku I* [Sculpture I] (Tōkyō: Mainichi Shinbunsha, 1972), nos. 60–78, 43–45; Shimizu Zenzō, "Seiryōji shiki Shaka zō," *Nihon bijutsu kōgei,* no. 440 (1975); Nara Kokuritsu Hakubutsukan, ed., *Nihon bukkyō bijutsu no genryū—Sources of Japanese Buddhist Art* (Nara: National Museum, Special Exhibition, 1978), nos. 94–97, 95–98; Ikawa Kazuko, "Ehime no Seiryōji shiki Shaka Nyorai zō" [Shaka Nyorai Images in the Seiryōji Style from Ehime Prefecture], *Bijutsu kenkyū,* no. 330 (1984), 37–42; Donald F. McCallum, "The Saidaiji Lineage of the Seiryōji Shaka Tradition," *Archives of Asian Art* 49 (1996): figs. 2–8; Fukuoka shi Bijutsukan, ed., *Satori no bi* [The Beauty of Enlightenment] (Fukuoka: Fukuoka Municipal Art Museum, Special Exhibition, 2003), no. 62, 95.

79 McCallum, "The Saidaiji Lineage of the Seiryōji Shaka Tradition," 54.

80 Diam. 11.4 cm; see Sawa Ryūken and Hamada Takashi, eds., *Mikkyō bijutsu tai-*

kan [A Survey of Esoteric Buddhist Art], vol. 2: *Nyorai—Kannon* [Tathāgata—Avalokiteśvara] (Tōkyō: Asahi Shinbunsha, 1984), vol. 2, pl. 176, 168, 245; Nara Kokuritsu Hakubutsukan, ed., *Tō Ajia no hotoke tachi; Buddhist Images of East Asia* (Nara: National Museum, Special Exhibition, 1996), no. 63, 64, 248.

81 The islet was called Putuoluojia or Butuoluojia (also Budaluojia) in Chinese transliteration.

82 Thomas Lawton, *Chinese Figure Painting*. Freer Gallery of Art: Fiftieth Anniversary Exhibition (Washington, DC: Smithsonian Institution, 1973), no. 16, 88–90.

83 H. 58.5 cm, w. 56.3 cm; Roderick Whitfield, *The Art of Central Asia*. The Stein Collection in the British Museum (Tōkyō and New York: Kodansha, 1982), vol. 1: *Paintings from Dunhuang I*, figs. 50–52.

84 *Taishō shinshū daizōkyō*, vol. 20, no. 1097, 421b–32a; for a partial translation of this scripture by Charles D. Orzech, see Victor H. Mair, ed., *The Columbia Anthology of Traditional Chinese Literature* (New York: Columbia University Press, 1994), 116–20. Amoghapāśa, the "Unfailing Lasso," is a manifestation of Avalokiteśvara. Bounding the central image and its spiral invocation of the Dunhuang maṇḍala is is a kind of chain, which may represent the bodhisattva's lasso or lifeline for saving those in danger.

85 H. 60 cm, w. 33 cm; Sawa and Hamada, *Mikkyō bijutsu taikan*, vol. 2, pl. 177, 168 and 245.

86 H. 61.4 cm, w. 29.9 cm. An identical imprint was discovered among the deposits inside the Shōtoku Taishi statue of Enjōji, Nara, dated to 1309; see Sawa and Hamada, *Mikkyō bijutsu taikan*, vol. 2, pl. 158, 151, 242; Uchida Keiichi, "Gangōji no bukkyō hanga ni tsuite no isshiron" [A Preliminary Essay on Buddhist Prints at Gangōji], *Kobijutsu*, no. 102 (May 1992): 70–80, pl. 6.

87 Nara Kokuritsu Hakubutsukan, ed., *Tō Ajia no hotoke tachi: Buddhist Images of East Asia*, no. 196, 202 and 280.

88 Roderick Whitfield, *The Art of Central Asia*, vol. 2: *Paintings from Dunhuang II*, fig. 144.

89 Among the deposits recovered from the Jizō statue of Denkōji in Nara, dated to 1228, and from the Jizō figure by Kōen, dated to 1249, in the Museum für Ostasiatische Kunst, Köln, was a twelfth-century Chinese printed book of the "Lotus Sūtra;" see Roger Goepper, "An Early Work by Kōen in Cologne," *Asiatische Studien/Etudes Asiatiques* 37, no. 2 (1983): figs. 15–16; Nara Kokuritsu Hakubutsukan, *Tō Ajia no hotoke tachi—Buddhist Images of East Asia*, no. 197, 202 and 280–81.

90 Six of the scrolls are in the Museum of Jimo county and one is in the Museum of Jiao county, both in Shandong province; see *Wenwu*, no. 8 (1988): cpls. 1–2, and pls. 6–7.

91 The term *Daizō kyō* is synonymous with *Issai kyō*, which comprises three "baskets," all the sūtras, precepts, and commentaries.

92 Kōgen Mizuno, *Buddhist Sutras: Origin, Development, Transmission* (Tōkyō: Kōsei, 1982), 165, 173.

93 Nara Kokuritsu Hakubutsukan, *Tō Ajia no hotoke tachi*, nos. 133–36, 125 and 262–63.

94 Max Loehr, *Chinese Landscape Woodcuts from an Imperial Commentary to the Tenth-Century Printed Edition of the Buddhist Canon* (Cambridge, MA: The Belknap Press of Harvard University Press, 1968), 12.

95 For a translation of the "Detailed Record of the Objects offered when the Five

Innards were deposited in the Sacred Figure," see Henderson and Hurvitz, "The Buddha of Seiryōji," 47–49, cf. also pl. 7, 23; Kurata, *Zōnai nōnyūhin*, pl. 1; Bunkachō, ed., *Jūyō bunkazai*, special vol. II: *Zōnai nōnyūhin*, cpl. 10, and no. 56, 124–27; Ishihara Akira, "Seiryōji Shaka ryūzō nōnyū no naizō mokei" [The Models of Intestines Installed Inside the Statue of Shaka Nyorai, Seiryōji], *Museum*, no. 289 (April 1975): 15–20; *Museum*, no. 293 (August 1975): 27–34; Okada, "Shaka Nyorai ryūzō—Zōnai nōnyūhin issai," no. 6: 165.

96 Nara Kokuritsu Hakubutsukan, ed., *Nihon bukkyō bijutsu no genryū*, no. 95, 96; *Enlightenment Embodied*, no. 21, 122–23.

97 McCallum, "The Saidaiji Lineage of the Seiryōji Shaka Tradition," 51–67, figs. 1 and 4; Kurata, *Zōnai nōnyūhin*, 36–38, pls. 23–24 and 76–81; Nara Rokudaiji Taikan Kankōkai, ed., *Saidaiji*, Nara Rokudaiji taikan [A Survey of the Six Great Temples of Nara], vol. 14 (Tōkyō: Iwanami Shoten, 1973) (hereafter referred to as *Saidaiji*, Nara Rokudaiji taikan), pls. 8–9, 40–45, 34–38, text pls. 1:1, 2:1–5, and 18:71; Ito Nobuo, ed., *Saidaiji to Nara no koji* [Saidaiji and the Ancient Temples of Nara], Nihon koji bijutsu zenshū [Compilation of Art in Ancient Temples of Japan], vol. 6 (Tōkyō: Shueisha, 1983), pl. 14, 109, fig. 40, and 127; Nara Kokuritsu Hakubutsukan, ed., *Kōshō Bosatsu Eizon nanahyaku nen onki kinen: Nara ten: Shingon Risshū ichimon no hihō kōkai* [The Seven Hundredth Death Anniversary of Eizon, the Bodhisattva Kōshō—Exhibition of the Saidaiji, Nara: Hidden Treasures Presented to the Public from the Heritage of the Shingon Ritsu School] (Tōkyō: Nihon Keizai Shinbunsha, 1991) (hereafter referred to as *Nara Saidaiji ten*), no. 30, 66–69 and 172; see also n. 78.

98 Zenkei and Zen'en (act. 1221–1247), who upon completion signed Eizon's personal Aizen Myōō icon at Saidaiji in 1247, may be different names for one sculptor who changed his name in the middle of his career, Zen'en being the earlier name and Zenkei the later; see Kaneko Hiroaki, *Saidaiji*, Nihon no koji bijutsu, vol. 10 (Tōkyō: Hoikusha, 1987), 151–54 and 157; Tanabe Saburōsuke, "Zen'en, Zenkei to sono jidai" [Zen'en and Zenkei and Their Time], in *Saidaiji to Nara no koji*; Nihon koji bijutsu zenshū, vol. 6, 106–9; see also Paul Groner, "Icons and Relics in Eison's Religious Activities," in *Living Images: Japanese Buddhist Icons in Context*, ed. Robert H. Sharf and Elizabeth Horton Sharf, 114–50.

99 *Saidaiji*, Nara Rokudaiji taikan, vol. 14, text pls. 1:1 and 18:71; Bunkachō, ed., *Jūyō bunkazai*, special vol. II: *Zōnai nōnyūhin*, 44–48; *Nara Saidaiji ten*, no. 30, 68–69.

100 *Saidaiji*, Nara Rokudaiji taikan, vol. 14, 34, and 136.

101 McCallum, "The Saidaiji Lineage of the Seiryōji Shaka Tradition," 57.

102 Eizon's own personal Aizen Myōō icon is a polychromed wooden sculpture (h. 31.8 cm) with several sacred objects deposited in its hollow interior. The seated Aizen image was made by Zen'en in 1247. On the eighteenth day of the eighth month of that year it was consecrated and enshrined as a secret *honzon* at the Aizendō of Saidaiji. See *Saidaiji*, Nara Rokudaiji taikan, vol. 14, pls. 10–11 and 46–49, 38–40, text pls. 1:2–4, 5:6–9; *Saidaiji to Nara no koji*; Nihon koji bijutsu zenshū, vol. 6, pls. 15 and 19, 127; *Nara Saidaiji ten*, no. 38, 80–81 and 174. For a detailed analysis of this "Bright King [of Esoteric Wisdom]" (S: *vidyārāja*), see Roger Goepper, *Aizenmyōō: The Esoteric King of Lust. An Iconological Study*. Artibus Asiae Supplementum 39 (Zürich: Artibus Asiae, 1993).

103 With Monju Bosatsu as patron divinity, Eizon and some of his confreres established hostels for the homeless and sick. They held services for the sake of the souls of prisoners and for this purpose had Monju images installed in the two prisons of Nara.

104 Paul B. Watt, "Eison and the Shingon Vinaya Sect," in *Religions of Japan in Practice*, ed. George J. Tanabe Jr., Princeton Readings in Religions (Princeton: Princeton University Press, 1999), 89–97.

105 Michael R. Cunningham, *Buddhist Treasures from Nara* (Cleveland: The Cleveland Museum of Art, 1998), no. 32, 104–5.

106 H. 113 cm, w. 53.2 cm; cf. Okada, "Shaka Nyorai ryūzō—Zōnai nōnyūhin issai," 6/169.

107 Kobayashi Takeshi, "Saidaiji Eizon zō ni tsuite" [On the Eizon Portrait at Saidaiji], *Bukkyō geijutsu*, no. 28 (1956), 30–37. Restoration work and thorough investigation of the sculpture and its hidden contents was begun in 1963 by the Nara National Research Institute of Cultural Properties; see *Saidaiji*, Nara Rokudaiji taikan, vol. 14, pls. 12–13 and 50–53, 41–46, text pls. 2:10–11, 7–11:16–37, 18:67 and 70, figs. 16–18; Kurata, *Zōnai nōnyūhin*, 39–42, pls. 82–84; Bunkachō, ed., *Jūyō bunkazai*, special vol. II: *Zōnai nōnyūhin*, 58–74, no. 6, 1–116; *Nara Saidaiji ten*, no. 1, 24–29. For Eizon's activities at Saidaiji, see Kaneko, *Saidaiji*, Nihon no koji bijutsu, vol. 10, 74–136. For basic biographical information and research on Eizon's thought and career, see the excellent article by Donald F. McCallum, "The Saidaiji Lineage of the Seiryōji Shaka Tradition," 55, and the studies mentioned there in n. 22, 66; Helmut Brinker, "Facing the Unseen: On the Interior Adornment of Eizon's Iconic Body," *Archives of Asian Art* 50 (1997–98): 42–61.

108 Prior to his "self-ordination" together with his confreres Ensei (1180–1241), Ugon (1186–1275), and Kakujō (1194–1249) on the first day of the ninth month in 1236, Eizon had an auspicious dream. But it was only on the thirteenth day of the ninth month in 1245 that his self-assured ordination was divinely recognized by yet another vision, in which the Bodhisattva Monju transmitted to him the Tantric unction ritual (S: *abhiṣeka*). See Faure, *Visions of Power*, 122.

109 On the sculptor Zenshun, see Kobayashi Takeshi, "Busshi Zen'en, Zenkei, Zenshun" [The Buddhist Master (Sculptors) Zen'en, Zenkei, and Zenshun], *Bukkyō geijutsu*, no. 31 (1957), 67–76, in particular 73–76; Tanabe Saburōsuke, "Zenshun to sono jidai" [Zenshun and His Time], in *Saidaiji to Nara no koji*, Nihon koji bijutsu zenshū, vol. 6, 109–12.

110 See *Saidaiji*, Nara Rokudaiji taikan, vol. 14, 42, fig. 16: left, and 46, n. 3; *Saidaiji to Nara no koji*; Nihon koji bijutsu zenshū, vol. 6, fig. 41, 109.

111 The Indian monk Bodhisena (C: Puti Xianna; J: Bodaisenna, 704–760) is known to have taught writing *Siddhaṃ* in Nara, and Kūkai (774–835), who had learned and mastered this script during his sojourn in Chang'an, wrote a short explanatory "Commentary on Sanskrit and Siddham Letters," entitled *Bonji shittan jibo hei shakugi*; see *Taishō shinshū daizōkyō*, vol. 84, no. 2701, 361–64.

112 See *Saidaiji*, Nara Rokudaiji taikan, vol. 14, 43, figs. 17–18; Bunkachō, ed., *Jūyō bunkazai*, special vol. II: *Zōnai nōnyūhin*, vol. 74, no. 6,116.

113 *Zenrin shōkisen* [Basket of Articles from the Zen Tradition], completed 1741, ed. Shibata Otomatsu (Tōkyō: Seishin shobō, 1963), 163; cf. Brinker and Kanazawa, *ZEN—Masters of Meditation in Images and Writings*, 85.

114 *Nara Saidaiji ten*, no. 2, 30; Sherman E. Lee, *Reflections of Reality in Japanese Art* (Cleveland: The Cleveland Museum of Art, 1983), no. 73, 120 and 254.

115 Translation [with minor changes by the author] after Henderson and Hurvitz, "The Buddha of Seiryōji," 48–49; for the engraved silver *ūrṇā*, see also 11, pl. 6. For the minor emendatory changes of the translation, cf. McCallum: "The Saidaiji Lineage of the Seiryōji Shaka Tradition," 54 and 66n14.

116 Brinker, "Facing the Unseen," 55, fig. 21.

2

Mysteries of Buddha Relics and Esoteric Divinities

...

1 Charles O. Hucker, *A Dictionary of Official Titles in Imperial China* (Stanford, CA: Stanford University Press, 1985), no. 285, 116–17, and no. 1656, 196; Stanley Weinstein, *Buddhism under the T'ang* (New York: Cambridge University Press, 1987), 9–10.

2 Takakusu Junjirō and Watanabe Kaigyoku, eds., *Taishō shinshū daizōkyō: The Tripiṭaka in Chinese*, 100 vols. (Tōkyō: Taishō issaikyō kankōkai, 1924–1932; new printing, 1960); for the *Modengqie jing*, see vol. 21, no. 1300, 399c–410b. This scripture in two fascicles sets forth the story of an outcaste girl, a Mātaṅgī, who was converted to Buddhism. It expounds the equality of the four castes and also elaborates on astronomical ceremonies as well as other Esoteric rituals.

3 Śubhakarasiṃha arrived in Chang'an in 716 with a number of Sanskrit texts. The following year, he received assistance from Yixing in translating and commenting on some of the fundamental Esoteric Buddhist scriptures. By the time of his death Śubhakarasiṃha had translated no fewer than twenty-one Esoteric scriptures.

4 Amoghavajra was the son of an Indian father and a Sogdian mother. Born in Central Asia, he came to China in 714, then nine years of age. Five years later, the boy became the disciple of Vajrabodhi, who just had arrived at Chang'an. Amoghavajra became known by his Chinese religious name, Bukong; from the account of his life he should be regarded primarily as a Chinese Esoteric monk. For the origins, introduction, and spread of Esoteric Buddhism in China, see Charles D. Orzech, "Seeing Chen-yen Buddhism: Traditional Scholarship and the Vajrayāna in China," *History of Religions* 29, no. 2 (November 1989): 87–114; Orzech, "The Legend of the Iron Stūpa," in Lopez, *Buddhism in Practice*, 314–17; Orzech, *Politics and Transcendent Wisdom: The Scripture for Humane Kings in the Creation of Chinese Buddhism* (University Park, PA: The Pennsylvania State University Press, 1998).

5 David L. Gardiner, "Kūkai and the Beginnings of Shingon Buddhism in Japan," Ph.D. diss., Stanford University, 1995.

6 Jinhua Chen, "Sarira and Scepter: Empress Wu's Political Use of Buddhist Relics," *Journal of the International Association of Buddhist Studies* 25, nos. 1–2 (2002): 33–150.

7 This ritual of sprinkling water on the head of a devotee is based on the enthronement ceremony of Indian monarchs. During the royal consecration, water from the Four Seas was sprinkled on the head of the new ruler.

8 See Edwin O. Reischauer, *Ennin's Diary: The Record of a Pilgrimage to China in Search of the Law* (New York: Ronald Press, 1955), 294.

9 *Zhi* and *hui* (J: *chi'e*) are often used synonymously. This binomial keyword denotes the operation of the mind to capture and then realize the true nature of reality. *Zhi* is the mental functioning derived from *hui*; *zhi* grasps and understands the actual world of discrimination, *hui* penetrates to the ultimate truth and thus leads to nirvāṇa.

10 H. 19.8 cm, weight 695 g. See Archaeological Institute of Shaanxi Province and Famensi Museum, ed., *Fomen mibao da Tang yizhen: Shaanxi Fufeng Famensi digong* [Hidden Buddhist Treasures of the Great Tang Dynasty: The "Underground Palace" of the Famensi in Fufeng, Shaanxi], vol. 10, *Zhongguo kaogu wenwu zhi mei* (Beijing: Wenwu chubanshe, 1994), pl. 25, 112 and 160; Wu Limin and Han Jinke, *Famensi digong Tang mi mantuluo zhi yanjiu* [Studies on the Secret Maṇḍalas of the Tang Dynasty from the Underground Palace of the Famensi] (Hong Kong: Zhongguo Fojiao wenhua chuban youxian gongsi, 1998), 433.

11 Cheng Xuehua, "Tang tie jinhuacai shikezao xiang" [Tang Gilt and Polychrome Stone Statuary], *Wenwu*, no. 7 (1961): 63, figs. 1–11; Helmut Brinker and Roger Goepper, *Kunstschätze aus China. 5000 v. Chr. bis 900 n. Chr. Neuere archäologische Funde aus der Volksrepublik China* (Zürich: Kunsthaus Zürich, 1981), nos. 45–47, 212–22; Matsubara Saburō, *Chūgoku bukkyō chōkoku shiron* [Historical Survey of Chinese Buddhist Sculpture] (Tōkyō: Yoshikawa Kōbunkan, 1995), Zuhanhen [Plates] 3, pls. 744–46, 748–51, 754–55, and Honbunhen [Text], 334–35; Howard Rogers, ed., *China: 5,000 Years, Innovation and Transformation in the Arts*, selected by Sherman Lee (New York: The Solomon R. Guggenheim Museum, 1998), nos. 166, 170–72; Tōkyō Kokuritsu Hakubutsukan, ed., *Kyūtei no eiga: Tō no jotei Soku Tenmukō to sono jidai ten* [The Glory of the Court: Tang Dynasty Empress Wu and Her Times] (Tōkyō: NHK, 1998), nos. 20–23, 46–50.

12 Cf. n. 144; see Hamada Takashi, *Zuzō* [Iconographic Drawings], Nihon no bijutsu, no. 55 (Tōkyō: Shibundō, 1970), 24–25, pl. 32, 92–93, pl. 126; Sawa Ryūken and Hamada Takashi, eds., *Mikkyō bijutsu taikan* [A Survey of Esoteric Buddhist Art], vol. 1, *Ryōkai mandara* [Maṇḍala of the Two Worlds] (Tōkyō: Asahi Shinbunsha, 1983), no. 26, 141–48, 236–37; Elizabeth ten Grotenhuis, *Japanese Mandalas: Representations of Sacred Geography* (Honolulu: University of Hawai'i Press, 1999), 47–48; *Nihon kokuhōten: National Treasures of Japan* (Tōkyō: Tōkyō National Museum, 2000), no. 3, 20–21.

13 See the translation by Alexander C. Soper, "A Vacation Glimpse of the T'ang Temples of Ch'ang-an: The *Ssu-t'a Chi* by Tuan Ch'eng-shih," *Artibus Asiae* 23, no. 1 (1960): 22–23. *Taishō shinshū daizōkyō*, vol. 51, no. 2093, 1022b–1024a, gives only an abridged version of the text.

14 On the Shingon fire sacrifice in Japan, see Richard Karl Payne, *The Tantric Ritual of Japan: Feeding the Gods — The Shingon Fire Ritual.* Sata-Pitaka Series, vol. 365 (New Dehli, India: Aditya Prakashan, 1991).

15 Weinstein, *Buddhism under the T'ang*, 59.

16 *Taishō shinshū daizōkyō*, vol. 18, no. 848, 1a–55a.

17 On the *gorintō* and the correlation of sets of five, see James H. Sanford, "Wind, Waters, Stupas, Mandalas: Fetal Buddhahood in Shingon," *Japanese Journal of Religious Studies* 24, nos. 1–2 (Spring 1997): 17–21.

18 The *Rinjū hiketsu* from Shōmyōji has been preserved at the Kanagawa Kenritsu Kanazawa Bunko in Yokohama. See Sawa Ryūken and Hamada Takashi, *Mikkyō bijutsu taikan*, vol. 3, *Bosatsu—Myōō* [Bodhisattvas—Vidyārājas] (Tōkyō: Asahi Shinbunsha, 1984), 176 and fig. 6; and Helmut Brinker, "Facing the Unseen: On the Interior Adornment of Eizon's Iconic Body," *Archives of Asian Art* 50 (1997–1998): fig. 3, 45.

19 *Taishō shinshū daizōkyō*, vol. 18, no. 850, 83c–84a. *Shōdai giki*, "Manual of Ritual Rules to Hold Up the Great [Radiance of Illumination]," is the Japanese abbreviation of an extremely long 36-character title. The text is thought to have been translated into Chinese by Śubhakarasiṃha, known to the Japanese as Zenmui.

20 Roger Goepper, "Some Thoughts on the Icon in Esoteric Buddhism of East Asia," in *Studia Sino-Mongolica*, ed. Wolfgang Bauer. Festschrift für Herbert Franke. Münchener Ostasiatische Studien, vol. 25 (Wiesbaden: Franz Steiner Verlag GmbH, 1980), 252.

21 The reliquary measures 38.7 cm in height; Nara Kokuritsu Hakubutsukan, ed., *Busshari no shōgon—The Worship of the Buddha's Relics and the Art of Reliquary* (Tōkyō: Dōhōsha, 1983), pl. 53, and 320, fig. 14; Kawada Sadamu, *Busshari to kyō no shōgon* [The Adornment of Buddhist Reliquaries and Sūtra Scrolls], Nihon no bijutsu, no. 280 (Tōkyō: Shibundō, 1989), 44, fig. 63; Nara Kokuritsu Hakubutsukan, ed., *Busshari to hōju: Shaka wo shitau kokoro* [Ultimate Sanctuaries: The Aesthetics of Buddhist Relic Worship] (Nara: Nara National Museum, 2001), no. 95, 118. The enormously influential abbot Chōgen is known especially as untiring fund-raiser for the restoration work on Tōdaiji in Nara; for Chōgen and his relic veneration, see Brian D. Ruppert, *Jewel in the Ashes: Buddha Relics and Power in Early Medieval Japan* (Cambridge, MA: Harvard University Press, 2000), 177–88; John M. Rosenfield, *Portraits of Chōgen: The Transformation of Buddhist Art in Early Medieval Japan*, Japanese Visual Culture 1 (Leiden: Brill, 2011), 185–89.

22 The reliquary is 38.5 cm high; Nara Kokuritsu Hakubutsukan, *Busshari no shōgon*, pl. 54, and 320–21; Kawada, *Busshari to kyō no shōgon*, 44, fig. 64; Nara Kokuritsu Hakubutsukan, *Busshari to hōju*, no. 97, 121.

23 Mimi Yiengpruksawan, "In My Image: The Ichiji Kinrin Statue at Chūsonji," *Monumenta Nipponica. Studies in Japanese Culture* 46, no. 1–4 (1991): 333.

24 *Taishō shinshū daizōkyō*, vol. 19, no. 948, 189a–90b.

25 Ibid., no. 954, 307c–10c.

26 Ibid., no. 955, 313b–15c.

27 Ibid., no. 957, 320b–27a.

28 Ibid., no. 958, 327a–c.

29 Mimi Hall Yiengpruksawan, *Hiraizumi: Buddhist Art and Regional Politics in Twelfth-Century Japan* (Cambridge, MA: Harvard University Press, 1998), 179.

30 Ulrich H. R. Mammitzsch, *Evolution of the Garbhadhātu Maṇḍala* (New Dehli: International Academy of Indian Culture and Aditya Prakashan, 1991).

31 On the concept of *hibutsu*, see Sherry Fowler, "Hibutsu: Secret Buddhist Images of Japan," *Journal of Asian Culture* 15 (1991–92): 137–61.

32 The sculpture is 76 cm high. For detailed information, see the excellent article by Mimi Yiengpruksawan, "In My Image," 329–47, and Yiengpruksawan, *Hiraizumi*, 177–83.

33 Yiengpruksawan, *Hiraizumi*, 182.

34 The monastery name Bannaji refers, with its sounds *ban* and *a*, to the "seed syllables" of Mahāvairocana in his Taizōkai and Kongōkai forms. For detailed information on this image, see Kaneko Hiroaki, *Unkei: Kaikei*, Meihō Nihon no bijutsu, vol. 13 (Tōkyō: Shogakkan, 1991), 50, 63–64, and pl. 28; Yamamoto Tsutomu, *Dainichi Nyorai zō* [Images of Dainichi Nyorai], Nihon no bijutsu, no. 374 (Tōkyō: Shibundō, 1997), 55–60, cpl. 14, pls. 86–89; Maruyama Shiro et al., "Report on CT-Scanned Images of the Seated Dainichi Nyorai Statue of Kōtokuji Temple," *Museum*, no. 621 (August 2009): 5–27.

35 The image is only 32.1 cm high, the shrine 83.7 cm.

36 Roger Goepper, *Aizen-Myōō: The Esoteric King of Lust, An Iconological Study*. Artibus Asiae Supplementum 39 (Zürich: Museum Rietberg, 1993).

37 Roger Goepper, "The Four Kinds of Rites at the Altar: Paragraph Six of the Hizō-ki," in *Das andere China*. Festschrift für Wolfgang Bauer zum 65. Geburtstag, ed. Helwig Schmidt-Glintzer. Wolfenbütteler Forschungen, Band 62 (Wiesbaden: Harrassowitz, 1995), 197.

38 Roger Goepper, *Shingon: Die Kunst des Geheimen Buddhismus in Japan* (Köln: Museum für Ostasiatische Kunst, 1988), no. 3, 72–73.

39 The Museum of Fine Arts owns a late Heian-period Ichiji Kinrin painting and another version of the same subject datable to the thirteenth century; see John M. Rosenfield and Elizabeth ten Grotenhuis, *Journey of the Three Jewels: Japanese Buddhist Paintings from Western Collections* (New York: The Asia Society, 1979), no. 15, 79; *Asiatic Art in the Museum of Fine Arts Boston* (Boston: Museum of Fine Arts, 1982), no. 13, 29; Sawa and Hamada, *Mikkyō bijutsu taikan*, vol. 2, no. 28, 34 and 210.

40 For further information, see Roger Goepper, "Kekkai: Notes on a Shingon Ceremony and Its Connections with Art," in *Nihon ni okeru bukkyō bijutsu no juyō to tenkai* [Formation and Development of Buddhist Art in Japan] (Nara: Nara National Museum, 1979), 41–58.

41 For the usage of *maṇḍala*s in Shingon Buddhism, see David L. Gardiner, "Mandala, Mandala on the Wall: Variations of Usage in the Shingon School," *Journal of the International Association of Buddhist Studies* 19, no. 2 (1996): 245–79, and Sharf, "Visualization and Mandala in Shingon Buddhism," 151–97.

42 For details, see ten Grotenhuis, *Japanese Mandalas*, 100.

43 Goepper, *Shingon*, no. 35, 158–59; Michael R. Cunningham, *Buddhist Treasures from Nara* (Cleveland: The Cleveland Museum of Art, 1998), no. 42, 132–33; see also Hisatoya Ishida, *Esoteric Buddhist Painting*, trans. and adapted by E. Dale Saunders. Japanese Arts Library 15 (Tōkyō and New York: Kodansha International Ltd. and Shibundō, 1987), 52.

44 Goepper, "The Four Kinds of Rites at the Altar," 188.

45 Ten Grotenhuis, *Japanese Mandalas*, 102.

46 Ibid.

47 *Taishō shinshū daizōkyō*, vol. 8, no. 246, 834a–45a. For a concise introduction and translation of some of the most distinctive parts, see Charles Orzech, "The Scripture on Perfect Wisdom for Humane Kings Who Wish to Protect Their States," in Lopez, *Religions of China in Practice*, 372–80; Orzech, *Politics and Transcendent Wisdom*.

ō

48 Orzech, "The Scripture on Perfect Wisdom for Humane Kings," 372–73, 377.

49 Ibid., 373.

50 On the early history and mysteries of Aśokan relics, see Erik Zürcher, *The Buddhist Conquest of China. The Spread and Adaptation of Buddhism in Early Medieval China* (Leiden: E. J. Brill, 1959), vol. 1, 277–80; Ruppert, *Jewel in the Ashes*, 16–24.

51 For "Buddha Relics as Objects of Contention: Wish-Fulfilling Jewel Worship and the Genealogy of Relic Theft," see Ruppert, *Jewel in the Ashes*, 142–91.

52 *Taishō shinshū daizōkyō*, vol. 53, no. 2122, 598b–605a

53 Ibid., 598c.

54 Ibid., vol. 19, no. 961, 332c; Ruppert, *Jewel in the Ashes*, 286. That Esoteric scripture with the lengthy title *Ruyi baozhu zhuanlun mimi xianshen chengfo jinlun zhouwang jing* (J: *Nyoi hōju tenrin himitsu genshin jōbutsu kinrin juō kyō*) is said to have been translated by Bukong, but in fact may be a mid-tenth-century Japanese apocryphon.

55 *Taishō shinshū daizōkyō*, vol. 25, no. 1509, 134a; trans. Étienne Lamotte, *Le Traité de la Grande Vertu de Sagesse de Nāgārjuna* (Mahāprajñāpāramitāśāstra) (Louvain-la-Neuve: Institut Orientaliste, 1944–80), vol. 1, 600.

56 *Kōbō Daishi zenshū*, ed. Mikkyō bunka kenkyūjo (Mount Kōya: Mikkyō bunka kenkyūjo, 1970–77), vol. 2, no. 44, 24; Ruppert, *Jewel in the Ashes*, 293. By quoting the above passage from the *Dazhidulun*, the Shingon priest Kakuzen (1143–ca. 1213) elaborates this concept of mystic transformation of relics into jewels in section 18 of his massive compendium *Kakuzen shō* by claiming that "the relics of the Buddhas of old metamorphose into wish-fulfilling jewels. Wish-fulfilling jewels metamorphose into rice." See Ruppert, *Jewel in the Ashes*, 293. The *Dazhidulun*, a huge commentary on the *Mahāprajñāpāramitā sūtra* translated by Kumārajīva (344–409 [or 413] CE) in 402–405, actually never claims "that Buddha relics are grains of rice or that they transmute into rice; Kakuzen or those works on which he based his compilation seem to have drawn on the native tradition dating to Kūkai—and perhaps other continental works—to make the claim." Ibid., 288.

57 *Taishō shinshū daizōkyō*, vol. 82, no. 2585, 361c; see Bernard Faure, "Now You See It, Now You Don't: Relics and Regalia in Japanese Buddhism." Paper, AAR Panel, New Orleans (November 1996), 19–20; Faure, *Visions of Power: Imagining Medieval Japanese Buddhism*, trans. Phyllis Brooks (Princeton: Princeton University Press, 1996), 161–62. For further information on Keizan Jōkin and his writings, see William M. Bodiford, "Keizan's Dream History," in George J. Tanabe Jr., ed., *Religions of Japan in Practice*. Princeton Readings in Religions (Princeton: Princeton University Press, 1999), 501–22.

58 Faure, "Now You See It, Now You Don't," 1. For general information on relics and reliquaries in Asian Buddhism and its art, see Gregory Schopen, *Bones, Stones, and Buddhist Monks: Collected Papers on the Archaeology, Epigraphy, and Texts of Monastic Buddhism in India* (Honolulu: University of Hawai'i Press, 1997); Kayamoto Kamejirō, "Nissen jōdai jiin no shari shōgongu ni tsuite" [On the Glorification of Relics in Ancient Temples of Japan and Korea], *Bukkyō geijutsu: Ars Buddhica*, no. 33 (1958): 58–59; Ishida Mosaku, *Tō. Tōba, sutsūpa* [Pagoda. Pagodas and Stūpas], Nihon no bijutsu, no. 77 (Tōkyō: Shibundō, 1972); Nara Kokuritsu Hakubutsukan, *Busshari no shōgon*; Kawada, *Busshari to kyō no shōgon*; Suzuki

Kakichi, "Busshari mainō" [Burial of Buddha Relics], *Asuka shiryōkan zuroku*, no. 21 (Asuka: Asuka Shiryōkan, 1989); Bernard Faure, *The Rhetoric of Immediacy: A Cultural Critique of Chan/Zen Buddhism* (Princeton: Princeton University Press, 1991), 132–47; Faure, *Visions of Power: Imagining Medieval Japanese Buddhism*, 158–67; *Bukkyō geijutsu: Ars Buddhica*, no. 188 (January 1990), Special Issue: *Shari yōki no mondaiten: Controversial Points of Śarīra Container Contents*; J. Edward Kidder Jr., "*Busshari* and *Fukuzō*: Buddhist Relics and Hidden Repositories of Hōryūji," *Japanese Journal of Religious Studies* 19, nos. 2–3 (June–September 1992): 217–44; Jan Fontein, "Relics and Reliquaries, Texts and Artefacts," in *Function and Meaning in Buddhist Art*. Proceedings of a Seminar Held at Leiden University, 21–24 October 1991, ed. K. R. van Kooij and H. van der Veere (Groningen: Egbert Forsten, 1995), 21–31; Ruppert, *Jewel in the Ashes*; Kang Woo-bang, "Buddhistische Reliquien und Reliquienbehälter in Korea," in *Korea: Die Alten Königreiche* (Zürich: Museum Rietberg, 2000), 37–45; Nara Kokuritsu Hakubutsukan, *Busshari to hōju*.

59 Nakamura Harutoshi, "Murōji Mirokudō hakken no momitō" [The Discovery of "Rice-Grain Pagodas" in the Maitreya Hall of Murōji], *Yamato bunka kenkyū* 1, no. 2 (1953): 61; Gangōji bukkyō minzoku shiryō kenkyūjo, *Murōji momitō no kenkyū* [Studies of the "Rice-Grain Pagodas" of Murōji] (Tōkyō: Chūō kōron bijutsu shuppansha, 1976), 56; Sherry Fowler, "In Search of the Dragon: Mt. Murō's Sacred Topography," *Japanese Journal of Religious Studies* 24, nos. 1–2 (Spring 1997): fig. 3, 151–54 : "It is quite possible that the original number of stūpas offered at the Mirokudō was 84,000, with a loss of over half. . . . The number 84,000 became standard in imitation of the offering said to have been made by King Aśoka in India in the third century BCE (153)." Fowler, *Murōji: Rearranging Art and History at a Japanese Buddhist Temple* (Honolulu: University of Hawai'i Press, 2005), 27, fig. 1.9. For cpl. of the *momitō*, see Tanaka Sumie et al., *Murōji*; Koji junrei, Nara, vol. 10 (Tōkyō: Tankōsha, 1979), fig. 76.

60 The Murōji Mirokudō pagodas are ca. 9 cm high including the finial, which measures ca. 5 cm; for Chinese prototypes, see Luo Zhewen, *Ancient Pagodas in China* (Beijing: Foreign Language Press, 1994), 290–97: "Box-Shaped Pagodas for Keeping Buddhist Sūtras"; for medieval Japanese reliquaries of this particular shape, see Nara Kokuritsu Hakubutsukan, *Busshari no shōgon*, 326–27 and pls. 77–83.

61 Washizuka Hiromitsu, *Murōji*, Nihon no koji bijutsu [Art in Ancient Temples of Japan], vol. 13 (Ōsaka: Hoikusha, 1991), 128; for this Esoteric text, see *Taishō shinshū daizōkyō*, vol. 19, no. 1022, 710a–12b. The scripture states by invoking the powerful *hōkyōin darani* one can deliver ancestors and other people even from the torments of hell to paradisiacal rebirth. It is also effective in removing all kinds of sufferings, restoring the sick, and redeeming poverty.

62 Rupert, *Jewel in the Ashes*, 456n62; Rosenfield, *Portraits of Chōgun*, 236.

63 Cf. Marinus Willem de Visser, "The Bodhisattva Ti-tsang (Jizō) in China and Japan," *Ostasiatische Zeitschrift* 2 (1913–14): 179–98, 266–305, 393–401; 3 (1914–15): 61–92, 209–42; Manabe Kōsai, *Jizō Bosatsu no kenkyū* [A Study of the Bodhisattva Jizō] (Kyōto: Sanmitsudō shoten, 1960); Yoshiko Kurata Dykstra, "Jizō, the Most Merciful: Tales from 'Jizō Bosatsu Reigenki'," *Monumenta Nipponica, Studies in Japanese Culture* 33, no. 2 (Summer 1978): 179–200; Roger Goepper, "An Early Work by Kōen in Cologne," *Asiatische Studien/Études Asiatiques* 37, no. 2 (1983): 67–102;

Goepper, *Die Seele des Jizō: Weihegaben im Inneren einer buddhistischen Statue*, Kleine Monographien 3 (Köln: Museum für Ostasiatische Kunst, 1984); Matsushima Ken, *Jizō Bosatsu zō* [Images of the Bodhisattva Jizō], Nihon no bijutsu, no. 239 (Tōkyō: Shibundō, 1986).

64 John M. Rosenfield and Shūjirō Shimada, *Traditions of Japanese Art: Selections from the Kimiko and John Powers Collection* (Cambridge, MA: Fogg Art Museum, Harvard University, 1970), no. 37, 95–97.

65 *Taishō shinshū daizōkyō*, vol. 19, no. 1022, 712a–b.

66 Rosenfield and Shimada, *Traditions of Japanese Art*, 97.

67 The *Gaoseng zhuan* is a compilation of 257 biographies in 13 fascicles; *Taishō shinshū daizōkyō*, vol. 50, no. 2059, 322c–423a; for Kang Senghui's biography, see 325a–326b. Translation [with minor changes by the author] by Alexander C. Soper, *Literary Evidence for Early Buddhist Art in China*. Artibus Asiae Supplementum 19 (Ascona: Artibus Asiae, 1959), 5–6. The relic miracle was also included by Daoshi in his extensive "Grove of Jewels from the Dharma Garden" of 668 (*Taishō shinshū daizōkyō*, vol. 53, no. 2122, 600c); see also Zürcher, *The Buddhist Conquest of China*, 278 (2), and Wang, "Of the True Body: The Famen Monastery Relics and Corporeal Transformation in Tang Imperial Culture," in *Body and Face in Chinese Visual Culture*, ed. Wu Hung and Katherine R. Tsiang, 79–118 (Cambridge, MA: Harvard University Press, 2005), 84.

68 Yi-t'ung Wang, trans., *A Record of Buddhist Monasteries in Lo-yang by Yang Hsüan-chih* (Princeton: Princeton University Press, 1984), 179.

69 Wang, *A Record of Buddhist Monasteries*, 244 and note 203.

70 Soper, *Literary Evidence for Early Buddhist Art in China*, 8; for Huida's biography see *Taishō shinshū daizōkyō*, vol. 50, no. 2059, 409b–10a.

71 Soper, *Literary Evidence for Early Buddhist Art in China*, 8–9 and 75 (*Liangshu* entry 14); see also Zürcher, *The Buddhist Conquest of China*, 279 (6); Fontein, "Relics and Reliquaries, Texts and Artefacts," 23; Wang, "Of the True Body," 84.

72 Luo Zhewen, *Ancient Pagodas in China*, 290, 292 fig.; Katherine R. Tsiang, "Miraculous Flying Stupas in Qingzhou Sculpture," *Orientations* 31, no. 10 (December 2000): 52, fig. 11.

73 Suzhou shi wenguan hui, Suzhou bowuguan [Suzhou Municipal Cultural Centre Committee, Suzhou Museum], "Suzhou shi Ruiguangsi ta faxian—pi Wudai, Bei Song wenwu" [Discoveries in the Ruiguangsi Pagoda at Suzhou City: Comments on the Cultural Relics of the Five Dynasties and the Northern Song], *Wenwu*, no. 11 (1979): 30, fig. 19; Tōkyō Kokuritsu Hakubutsukan, Asahi Shinbun, ed., *Chūgoku kokuhō ten* [Treasures of Ancient China] (Tōkyō: Exhibition Tōkyō National Museum, 2004), no. 146, 178.

74 Nara Kokuritsu Hakubutsukan, ed., *Bukkyō bijutsu* [Buddhist Art] (Nara: National Museum, Special Exhibition: Kyūshū 1—Fukuoka, 1976), no. 68, 132, 245; Nara Kokuritsu Hakubutsukan, ed., *Nihon bukkyō bijutsu no genryū: Sources of Japanese Buddhist Art* (Nara: Nara National Museum, Special Exhibition, 1978), no. 13, 165 and 361; Rosenfield, *Portraits of Chōgun*, 188–89.

75 *Jinhua Wanfota chutu wenwu* [Cultural Relics Excavated from the "Myriad Buddha Pagoda" at Jinhua] (Beijing, 1958); Tōkyō Kokuritsu Hakubutsukan, Asahi Shinbun, *Chūgoku kokuhō ten*, 2004, no. 144, 176.

76 Zhejiang sheng wenwu kaogu yanjiusuo [Institute of Archaeology and Cultural Relics of Zhejiang Province], "Hangzhou Leifengta wudai digong fajue jianbao" [Bulletin on the Excavation of the "Thunder Peak Pagoda's" Underground Palace of the Five Dynasties in Hangzhou], *Wenwu*, no. 5 (2002): 4–32, cpls. cover and 20–21; 13–18, fig. 16–18.

77 Luo Zhewen, *Ancient Pagodas in China*, 291 and 294 fig.

78 Gongxian wenhua guan [Gongxian Cultural Centre], "Henan Gongxian faxian: Pi Han dai tongqi" [Discoveries at Gongxian, Henan: Comments on the Bronze Objects of the Han Dynasty], *Kaogu*, no. 2 (1974): pl. 9:4, and 124, fig. 3.

79 Tsiang, "Miraculous Flying Stupas in Qingzhou Sculpture," 46.

80 Ibid., 45–50, figs. 1–2, 4–7; see also Nickel, *The Return of the Buddha: Buddhist Sculptures of the 6th Century from Qingzhou, China* (Zürich: Museum Rietberg, 2001), nos. 5–6, 126–32.

81 For pertinent examples of the "miraculous flying stupas" in Buddhist sculpture from Hebei (dated 550 and 570), see Tōkyō Kokuritsu Hakubutsukan, Asahi Shinbun, *Chūgoku kokuhō ten,* 2000, no. 136, 204; no. 138, 206.

82 For some earlier examples from the Xi'an Road site in Chengdu City (dated 530 and 545), see Archaeological Team of Chengdu Municipality and the Institute of Archaeology of Chengdu, *Wenwu*, no. 11 (1998): 12, fig. 10, clp. 1:1 and 1:3; Watt et al., *China: Dawn of a Golden Age, 200–750 AD*, no. 127, 226.

83 Tōkyō Kokuritsu Hakubutsukan, Asahi Shinbun, *Chūgoku kokuhō ten,* 2000, no. 119, 182–84.

84 Tsiang, "Miraculous Flying Stupas in Qingzhou Sculpture," 51.

85 Idemitsu Museum of Arts, ed., *Chika kyūden no ihō* [Treasures from the Underground Palaces; *Chūgoku Kanhokushō Teishū Hokusō tōki shutsudo bunbutsu ten* [Excavated Treasures from Northern Song Pagodas, Dingzhou, Hebei Province, China] (Tōkyō: Idemitsu Bijutsukan, 1997), 31, fig. 25.

86 *Jiangsu chutu wenwu xuanji* [Selected Relics Unearthed from Jiangsu Province] (Beijing: Wenwu chubanshe, 1963), pls. 159–65; François Louis, *Die Goldschmiede der Tang- und Song-Zeit: Archäologische, sozial- und wirtschaftsgeschichtliche Materialien zur Goldschmiedekunst Chinas vor 1279*. Schweizer Asiatische Studien, Monographie, vol. 32 (Berlin, New York: Peter Lang, 1999), 127, 304, and figs. 39–42; Tōkyō Kokuritsu Hakubutsukan, Asahi Shinbun, *Chūgoku kokuhō ten* (2004), nos. 139–41, 173; on Changgansi, see ibid., Koizumi Toshihide, "Chūgoku bukkyō bijutsu shi ni miru Ashiyoka ō shinkō" [The King Aśoka Belief as Reflected in the History of Chinese Buddhist Art], 241.

87 Tōkyō Kokuritsu Hakubutsukan, Asahi Shinbun, *Chūgoku kokuhō ten,* 2004, nos. 142–43, 175.

88 Soper, *Literary Evidence for Early Buddhist Art in China*, 75.

89 *Ji shenzhou sanbao gantong lu* [Catalogue of Salvific Influences of the Three Jewels on the Divine Continent] of 664 (*Taishō shinshū daizōkyō*, vol. 52, no. 2106, 405b–406a).

90 Soper, *Literary Evidence for Early Buddhist Art in China*, 8n8.

91 See Daoshi's chapter 40 on "relics" in his *Fayuan zhulin* (*Taishō shinshū daizōkyō*, vol. 53, no. 2122, 601c–602a).

92 Arthur F. Wright, *The Sui Dynasty* (New York: Alfred A. Knopf, Inc., 1978), 135.

93 See Daoshi's chapter 40 on "relics" in his *Fayuan zhulin* (*Taishō shinshū daizōkyō*, vol. 53, no. 2122, 601c–602a).

94 Wright, *The Sui Dynasty*, 136.

95 The stone casket measures 119 cm in height and 103 cm in width; the bronze case is 15 cm high, the gilt-bronze casket 8 cm, and the small green glass bottle for the *śarīra* 5.8 cm. Among the pious offerings nearby were a flat round bronze box (h. 5.2 cm, diam. 7.9 cm) with hairpins, three Sassanian silver coins, twenty-seven *wuzhu* copper coins of the Sui dynasty, one ring of jade, one of gold, and nine of silver; see Zhu Jieyuan and Qin Bo, "Shaanxi Chang'an he Yaoxian faxian de Bosi Sashan chao yinbi" [Persian Sassanian Silver Coins Discovered at Chang'an and Yaoxian, Shaanxi], *Kaogu*, no. 2 (1974): 126–32, and pl. 10.

96 Brinker and Goepper, *Kunstschätze aus China*, no. 44, 208–12; Rogers, *China: 5,000 Years*, no. 160.

97 The outer casket weighs 5,200 kg and measures 135 cm in height and 134 cm in width; the inner casket weighs 1,600 kg and is 97 cm high and 83 cm wide. Three hundred and sixty *wuzhu* copper coins of the Sui dynasty and one Northern Zhou (557–581) coin with the four-character motto *yong tong wan guo* ("Perpetual Circulation in Ten Thousand Countries") were found inside the inner casket; see Qiu Yuding and Yang Shujie, "Shandong Pingyin faxian Da Sui Huangdi sheli baota shihan" [Sui Imperial Reliquary Treasure Pagoda Stone Casket Discovered in Pingyin, Shandong], *Kaogu*, no. 4 (1986): 375.

98 The reliquary is 19.5 cm high, 23.3 cm long, and 22.8 cm wide; it weighs 8 kg; see *Wenwu*, no. 8 (1972): 39–51, pl. 7:5; Tōkyō Kokuritsu Hakubutsukan, Kyōto Kokuritsu Hakubutsukan et al., eds., *Chūka Jinmin Kyōwakoku shutsudo bunbutsu ten* [Archaeological Treasures Excavated in the People's Republic of China] (Tōkyō: Asahi Shinbunsha, 1973), no. 203; *Chika kyūden no ihō* [Treasures from the Underground Palaces], no. 1 (5 color plates).

99 *Chika kyūden no ihō*, 30 and figs. 13–25.

100 H. 32 cm; see Dieter Kuhn, ed., *Chinas Goldenes Zeitalter* (Heidelberg: Edition Braus, 1993), no. 94, 253; Fontein, "Relics and Reliquaries, Texts and Artefacts," figs. 2a–3b; *Kyūtei no eiga: Tō no jotei Soku Tenmukō to sono jidai ten* [The Glory of the Court: Tang Dynasty Empress Wu and Her Times], no. 34, 66–68.

101 Weinstein, *Buddhism under the T'ang*, 43; Weinstein, "Imperial Patronage in the Formation of T'ang Buddhism," in *Perspectives on the T'ang*, ed. Arthur F. Wright and Denis Twitchett (New Haven and London: Yale University Press, 1973), 298n106.

102 Weinstein: *Buddhism under the T'ang*, 43 and 164n25.

103 H. 42.5 cm, l. 50.5 cm, w. 49.5 cm, weight 237 kg. The Dayunsi of Jingzhou is now called "Fountainhead Monastery" (C: Shuiquansi); see "Gansu Sheng Jingchuan Xian chutu de Tang dai sheli shihan" [A Tang Stone Relic Casket Unearthed at Jingchuan County in Gansu Province], *Wenwu*, no. 3 (1966): 8–15, 47, pl. 4; Tōkyō Kokuritsu Hakubutsukan et al., eds., *Chūka Jinmin Kyōwakoku Shiruku Rōdo bunbutsu ten: The Exhibition of Ancient Art Treasures of the People's Republic of China. Archaeological Finds of the Han to Tang Dynasty Unearthed at Sites along the Silk Road* (Tōkyō: Tōkyō National Museum, 1979), 139, 164, pls. 76–80; Yang Boda, *Jin yin boli falang qi* [Gold, Silver, Glass, Enamel], *Zhongguo meishu quanji, gongyi meishu bian*

[Survey of Chinese Art, Applied Arts], vol. 10 (Beijing: Renmin meishu chubanshe, 1987), 22, pls. 78–80; Nara Kokuritsu Hakubutsukan, *Busshari no shōgon*, 275, pl. 8a–b; Kawada, *Busshari to kyō no shōgon*, pl. 37; Chen, "Sarira and Scepter: Empress Wu's Political Use of Buddhist Relics," 70.

104 When Wu Zhao ascended the throne in 690, she proclaimed a new dynasty and named it, in nostalgic retrospection of glorious antiquity, Da Zhou [Great Zhou].

105 Lintong Xian Bowuguan, "Lintong Tang Qingshansi shelita ji jingshi qingliji" [Excavation of the Crypt Under the Reliquary Pagoda of the Tang Dynasty Qingshan Monastery in Lintong], *Wenbo*, no. 5 (1985): 16–25; Wang Ling, "Rare Buddhist Relics Unearthed in China," *Oriental Art* 33, no. 2 (Summer 1987): 208–11; Kuhn, *Chinas Goldenes Zeitalter*, nos. 91–93, 244–53; *Kyūtei no eiga: Tō no jotei Soku Tenmukō to sono jidai ten* [The Glory of the Court: Tang Dynasty Empress Wu and Her Times], nos. 35–44, 69–83.

106 H. 109 cm. The miniature green-glass bottles for the *śarīra* are 4.5 cm high; the golden coffin measures 6.5–9.5 cm in height, 14 cm in length, and 4.5–7.4 cm in width; the silver coffin is 10–14.5 cm high, 21 cm long, and 7–14.5 cm wide; the Sumeru shaped gilt-bronze base is 12 cm high, 23.4 cm long, and 17 cm wide; see *Kyūtei no eiga: Tō no jotei Soku Tenmukō to sono jidai ten* [The Glory of the Court: Tang Dynasty Empress Wu and Her Times], no. 37, 74–76.

107 The total height of stele and pedestal is 92 cm; the stele is 54 cm wide, the pedestal measures 54 x 34 cm; see *Kyūtei no eiga: Tō no jotei Soku Tenmukō to sono jidai ten* [The Glory of the Court: Tang Dynasty Empress Wu and Her Times], no. 35, 69–71.

108 Kuknip Chung'ang Pangmulkwan — The National Museum of Korea, ed., *Pulsari chang'om — The Art of Sarira Reliquary* (Seoul: The National Museum of Korea, 1991), no. 5, 19; *Korea: Die Alten Königreiche* (Zürich: Museum Rietberg, 2000), no. 49, 243–47.

109 Tongdosa Songbo Pangmulkwan, ed., *Pulsari shin'anggwa ku chang'om* [The Adornment of Buddhist Relics and the Faith in Relics], special exhibition cat. no. 10 (Yangsan: Tongdosa Museum, 2000), no. 4, 17–23, 110–11.

110 The outer caskets of the two reliquaries are 27 and 28 cm high and 19 cm wide; the rock crystal phials are 3.7 and 4.7 cm high, and the figures of the monks and guardians measure between 2 and 3.8 cm in height.

111 Alexander C. Soper, *The Evolution of Buddhist Architecture in Japan*. Princeton Monographs in Art and Archaeology XXII (Princeton and London: Princeton University Press, 1942), 5.

112 H. 22.6 cm, l. 35–36 cm. The cover is missing, but was most likely a stone lid with bevelled edges and bas-relief decoration and/or an inscription similar to a somewhat larger and complete reliquary of the early Tang that was discovered in 1990 on the precincts of the Kaiyuansi in Zhengding, Hebei province. See Liu Youheng and Nie Lianshun, "Hebei Zhengding Kaiyuansi fajxian chu Tang digong" [An Early Tang Dynasty Underground Chamber Discovered at the Kaiyuan Monastery, Zhengding, Hebei], *Wenwu*, no. 6 (1995): 63–68, cover pl. and cpls. facing 17.

113 Fine *ghaṇṭā* may be found in the Tōkyō National Museum; Nara National Museum; Fujita Art Museum, Ōsaka; Shōchi'in, Wakayama; Iyadanidera, Kagawa; Saikokuji, Hiroshima; and Kongōbuji, Wakayama. See Sawa Ryūken and Hamada Takashi, eds., *Mikkyō bijutsu taikan*, vol. 4: Ten—*Hōgu*—*Soshi* [Gods—Ritual Imple-

ments—Patriarchs] (Tōkyō: Asahi Shinbunsha, 1984), nos. 138–41, 112–13; Goepper, *Shingon: Die Kunst des Geheimen Buddhismus in Japan*, no. 73, 260–61; Nara Kokuritsu Hakubutsukan, ed., *Tō Ajia no hotoke tachi – Buddhist Images of East Asia* (Nara: National Museum, Special Exhibition, 1996), nos. 84–91, 88–92, 252.

114 For excellent introductions into the world of the Buddhist *maṇḍala*, see ten Grotenhuis, *Japanese Mandalas*, and Sharf, "Visualization and Mandala in Shingon Buddhism," 151–97.

115 H. 16.6 cm, l. 17.5 cm. The Famensi is located about 110 km west of Xi'an. The precious relic deposits of the Tang dynasty were concealed in the crypt hidden below the monastery's sixteenth-century brick pagoda. The Ming-period octagonal pagoda collapsed in 1981 and allowed the investigation of its "underground palace" six years later. See Shaanxi sheng Famensi kaogu dui [Archaeological Team of Famensi, Shaanxi Province], "Fufeng Famensi ta Tangdai digong fajue jianbao" [Bulletin on the Excavation of the Famensi Pagoda's Tang Dynasty Underground Palace in Fufeng], *Wenwu*, no. 10 (1988): 1–56; Shi Xingbang, ed., *Famensi digong zhenbao—Precious Cultural Relics in the Crypt of Famen Temple* (Xi'an: Renmin meishu chubanshe, 1988); Zhu Qixin, "Buddhist Treasures from Famensi: The Recent Excavation of a Tang Underground Palace," *Orientations* 21, no. 5 (May 1990): 77–83; Roderick Whitfield, "The Significance of the Famensi Deposit," *Orientations* 21, no. 5 (May 1990): 84–85; Whitfield, "Esoteric Buddhist Elements in the Famensi Reliquary Deposit," *Asiatische Studien/Études Asiatiques* 64, no. 2 (1990): 247–66; Bai Ming and Zhang Tianjie, *Famen Temple and Pagoda* (Xi'an: Shaanxi Teacher's University Press, 1990); Han Jinke, "Famensi yu Famensi wenhua" [The Famensi and Famensi Culture], *Wenbo*, no. 4 (1993): 1–12; Han Wei, "Shaanxi Fufeng Famensi Tangdai digong kaogu dashiji" [A Chronicle of Major Events in the Archaeological Research on the Tang Dynasty Underground Palace at Famensi in Fufeng, Shaanxi Province], *Wenbo*, no. 4 (1993): 100–12; Patricia Eichenbaum Karetzky, "Esoteric Buddhism and the Famensi Finds," *Archives of Asian Art* 47 (1994): 78–83; Alexander Koch, "Der Goldschatzfund des Famensi. Prunk und Pietät im chinesischen Buddhismus der Tang-Zeit," *Jahrbuch des Römisch-Germanischen Zentralmuseums Mainz*, 42. Jahrgang, 1995, 403–542; Kegasawa Yasunori, "Shilun Famensi chutu de Tangdai wenwu yu yiwuzhang" [A Preliminary Essay on the Cultural Relics of the Tang Dynasty and the Inventory from Famensi], *Wenbo*, no. 1 (1996): 58–85; Pei Jianping, *Famensi fojiao wenhua qiji: Sheli, baota, digong* [The Wonders of Buddhist Culture from Famensi: Relics, Treasure Pagodas, Underground Palace] (Chengdu: Sichuan jiaoyu chubanshe, 1996); Louis, *Die Goldschmiede der Tang- und Song-Zeit*, 140–61; I-mann Lai, "Relics, the Sovereign and Esoteric Buddhism in Ninth-Century China: The Deposits from the Famen Monastery," Ph.D. diss., University of London, 2005.

 For good reproductions and introduction, see *Fomen mibao da Tang yizhen*, 109, pl. 17: left, 110, 144–46, 158. For detailed studies of the reliquary, see Han Wei, "Famensi Tangdai jin'gangjie da mantuluo chengshenhui zaoxiang baohan kaoshi" [A Study of the "Assembly of Perfected Bodies" in the "Diamond World *Mandala*" Representation on a Tang-Period Reliquary of the Famensi], *Wenwu*, no. 8 (1992): 41–54; Luo Zhao, "Lüeshu Famensi ta digong zangpin de zongjiao neihan" [On the Religious Meaning of the Treasures from the Underground Palace of the Famensi

Pagoda], *Wenwu*, no. 6 (1995): 53–62; Wu Limin and Han Jinke, *Famensi digong Tang mi mantuluo zhi yanjiu*, 134–267.

116 The Assembly of Perfected Bodies corresponds to the Court of the Central Dais Eight Petals in the *maṇḍala* of the Matrix, or Womb, World [of Great Compassion].

117 See Goepper, "Kekkai: Notes on a Shingon Ceremony and Its Connections with Art," 42; Goepper, "Das Kultbild im Ritus des esoterischen Buddhismus Japans," in *Rheinisch-Westfälische Akademie der Wissenschaften. Vorträge* G 264 (Opladen: Westdeutscher Verlag, 1983), 17.

118 *Taishō shinshū daizōkyō*, vol. 18, no. 893, 603a–92a.

119 See Wu Limin and Han Jinke, *Famensi digong Tang mi mantuluo zhi yanjiu*, 238.

120 Ibid., 254.

121 H. 7 cm, l. 10.5 cm; see *Fomen mibao da Tang yizhen*, 107 and pl. 19.

122 H. 4.8 cm, l. 6.5 cm; see ibid., 107 and pl. 18; Wu Limin and Han Jinke, *Famensi digong Tang mi mantuluo zhi yanjiu*, 136–37.

123 See *Fomen mibao da Tang yizhen*, 108–10 and pls. 4–15; Wu Limin and Han Jinke, *Famensi digong Tang mi mantuluo zhi yanjiu*, 336–412.

124 H. 23.5 cm, l. 20 cm; see *Fomen mibao da Tang yizhen*, pls. 5–7, 108:left, 125, 147–49.

125 H. 19.3 cm, l. 17.5 cm; see *Fomen mibao da Tang yizhen*, pl. 8.

126 H. 16.2 cm, l. 14.5 cm; see ibid., pl. 9; Wu Limin and Han Jinke, *Famensi digong Tang mi mantuluo zhi yanjiu,* 394–405.

127 H. 13.5 cm, l. 13 cm; see *Fomen mibao da Tang yizhen*, pls. 10–11 and 108:right, 142–43; Wu Limin and Han Jinke, *Famensi digong Tang mi mantuluo zhi yanjiu*, 340–93.

128 The *Ruyilun tuoluoni jing* (J: *Nyoirin darani kyō*) was translated into Chinese by Bodhiruci (C: Puti Liuzhi, d. 727), who arrived in Chang'an in 693 and was installed at Foshoujisi, the "Monastery of the Buddha's Prophecy." He translated fifty-three scriptures and was honored by the assistance of Emperor Zhongzong (r. 705–710) in one of his projects of the year 706; see *Taishō shinshū daizōkyō*, no. 1080, vol. 20, 188b–196b, and ibid., nos. 1081–83, 196b–202b. See also Sherry Fowler, "Nyoirin Kannon: Stylistic Evolution of Sculptural Images," *Orientations* 20, no. 12 (December 1989): 58–65.

129 Tonkō bunbutsu kenkyūjo [Dunhuang Research Institute], ed., *Tonkō Bakkōkutsu* [The Mogao Caves at Dunhuang]. Chūgoku sekkutsu [Chinese Cave Temples] (Tōkyō: Heibonsha/Bunbutsu shuppansha, 1982), vol. 4, pls. 167–68.

130 H. 222.5 cm, w. 167 cm; see Roderick Whitfield, *The Art of Central Asia: The Stein Collection in the British Museum* (Tōkyō, New York: Kodansha, 1982), vol. 1: *Paintings from Dunhuang I*, pls. 18:1, 18:4, 18:6.

131 Whitfield, *The Art of Central Asia*, vol. 1, 313 and pl. 16.

132 H. 140 cm, w. 125 cm; see ibid., figs. 68–70.

133 H. 111 cm, w. 74.5 cm; see ibid., vol. 2, pl. 5.

134 The mirror has a diameter of 17.8 cm; see Sawa Ryūken and Hamada Takashi, eds., *Mikkyō bijutsu taikan*, vol. 2: *Nyorai—Kannon* [Tathāgata—Avalokiteśvara] (Tōkyō: Asahi Shinbunsha, 1984), no. 164, 156.

135 H. 17.9 cm; see Inoue Kazutoshi, *Nyoirin Kannon zō—Batō Kannon zō* [Images of Nyoirin and Batō Kannon], Nihon no bijutsu, no. 312 (Tōkyō: Shibundō, 1992), 22, pl. 20.

136 H. 17.9 cm; see Sawa and Hamada, *Mikkyō bijutsu taikan*, vol. 2, no. 165, 157; Inoue, *Nyoirin Kannon zō—Batō Kannon zō*, cpl. 1.

137 8.4 x 7.6 cm, thickness 1.4 cm; see Sawa and Hamada, *Mikkyō bijutsu taikan*, vol. 2, no. 163, 156; Inoue, *Nyoirin Kannon zō—Batō Kannon zō*, 22, cpl. 21.

138 H. 108.8 cm; see Sawa and Hamada, *Mikkyō bijutsu taikan*, vol. 2, no. 166, 158; Inoue, *Nyoirin Kannon zō—Batō Kannon zō*, cpl. 3.

139 H. 94.9 cm; see Goepper, *Shingon: Die Kunst des Geheimen Buddhismus in Japan*, no. 7, 82; Inoue, *Nyoirin Kannon zō—Batō Kannon zō*, cpl. 4; Cunningham, *Buddhist Treasures from Nara*, no. 26, 92–93.

140 H. 49.6 cm; see Sawa and Hamada, *Mikkyō bijutsu taikan*, vol. 2, no. 169, 161; Inoue, *Nyoirin Kannon zō—Batō Kannon zō*, 31, pl. 35.

141 Hanging scroll, ink, color, gold pigment, and cut gold foil on silk, 98.5 x 44.5 cm; see Sawa and Hamada, *Mikkyō bijutsu taikan*, vol. 2, no. 150,144; Inoue, *Nyoirin Kannon zō—Batō Kannon zō*, cpl. 8.

142 Hanging scroll, ink, color, gold pigment, and cut gold foil on silk, 101.7 x 41.6 cm; see Sawa and Hamada, *Mikkyō bijutsu taikan*, vol. 2, no. 154, 148; Cunningham, *Buddhist Treasures from Nara*, no. 49, 146–47.

143 Hanging scroll, ink, color, gold pigment, and gold foil on silk, 102.5 x 54.3 cm; see Sawa and Hamada, *Mikkyō bijutsu taikan,* vol. 2, no. 155, 149; Inoue, *Nyoirin Kannon zō—Batō Kannon zō*, 49, pl. 72.

144 See note 12. The iconographic handscroll is 29.9 cm high and 1808.9 cm long.

145 Wang, "Of the True Body," 105 and 107.

146 The finger-bone is 4.03 cm high. The golden miniature stūpa has a length of 4.8 cm at the base and a height of 7.1 cm; see *Fomen mibao da Tang yizhen*, pls. 3, 15; Wu Limin and Han Jinke, *Famensi digong Tang mi mantuluo zhi yanjiu*, 68–69.

147 *Taishō shinshū daizōkyō*, vol. 52, no. 2106, 407b.

148 H. 68 cm, w. 113 cm; see *Fomen mibao da Tang yizhen*, 95–96; Wu Limin and Han Jinke, *Famensi digong Tang mi mantuluo zhi yanjiu* , 44–49. For a German translation of the inventory, see Louis, *Die Goldschmiede der Tang- und Song-Zeit*, 143–50.

149 See Wu Limin and Han Jinke, *Famensi digong Tang mi mantuluo zhi yanjiu*, 68–78.

150 In 601 Sui Emperor Wen celebrated his sixtieth birthday at the Daxingshansi with the simultaneous enshrinement of Buddha relics in twenty-eight prefectural capitals. Nearly three centuries later, relics were still a significant concern of the monks of Daxingshansi.

151 H. 48 cm, w. 113 cm. The title of this memorial is usually abbreviated to *Zhenshen zhiwen*, "Memorial of the True Body"; see Wu Limin and Han Jinke, *Famensi digong Tang mi mantuluo zhi yanjiu*, 40–43.

152 H. 160 cm; see *Fomen mibao da Tang yizhen*, 106; Wu Limin and Han Jinke, *Famensi digong Tang mi mantuluo zhi yanjiu*, 31–34.

153 Weinstein, *Buddhism under the T'ang*, 103.

154 Stephen Owen, ed. and trans., *An Anthology of Chinese Literature: Beginnings to 1911* (New York: W. W. Norton & Company, 1996), 598–600; for other translations into English and commentaries, see Homer H. Dubs, "Han Yü and the Buddha's Relic: An Episode in Medieval Chinese Religion," *Review of Religion*, no. 11 (November 1946): 5–17; James R. Hightower, in Reischauer, *Ennin's Travels in T'ang China*, 223–24, and in Weinstein, *Buddhism under the T'ang*, 104.

155 The name of this Chan monk is unclear. He is sometimes referred to as "Master Yi," Shiyi.

156 H. 13.5 cm, weight 1099 g; *Fomen mibao da Tang yizhen*, pl. 24; Wu Limin and Han Jinke, *Famensi digong Tang mi mantuluo zhi yanjiu*, 435; Louis, *Die Goldschmiede der Tang- und Song-Zeit*, fig. 53, 312; for a German translation of the inscription, see ibid., 136.

157 H. 27.2 cm, weight 2030.5 g; *Fomen mibao da Tang yizhen*, pl. 23; Louis, *Die Goldschmiede der Tang- und Song-Zeit*, fig. 52, 312; for a German translation of the inscription, see ibid., 135–36.

158 The name of this "Crafts Institute for Ornamentation" emphasizes the elitist status with reference to literary and artistic excellence. The *wensi yuan* was a group of specialized workshops within the palace. It received commissions for the production of fine jewelry, gold and silver ware, brocades, and other luxury goods for use by the imperial household and high officials. This eunuch-staffed workshop was headed by a eunuch commissioner (*wensi shi*), a vice commissioner (*wensi fushi*), and assisted by "decision making officials" (*panguan*), and "production supervisors" (*zuoguan* or *shenzuoguan*). See Lu Zhaoyin, "Guanyu Famensi digong jinyinqi de ruogan wenti" [Some Questions Concerning the Gold and Silver Objects from the Underground Palace of the Famen Monastery], *Kaogu*, no. 7 (1990): 638–43; Louis, *Die Goldschmiede der Tang- und Song-Zeit*, 129.

159 His name is sometimes read Chengyi.

160 Weinstein, *Buddhism under the T'ang*, 146.

161 Ibid.

162 For a full English translation see Kenneth K. S. Ch'en, *Buddhism in China: A Historical Survey* (Princeton: Princeton University Press, 1964), 280–82; Wang, "Of the True Body," 94–95.

163 L. 11.2 cm, w. 8.4 cm; see Koch, *Der Goldschatzfund des Famensi*, 464–65, fig. 27, and pl. 124; Wu Limin and Han Jinke, *Famensi digong Tang mi mantuluo zhi yanjiu*, 276.

164 Guanyin is the most important benign manifestation of Amitābha, the Buddha of Infinite Light.

165 *Ruiwen yingwu mingde zhiren dasheng guangxiao huangdi* is a respectful honorary title of Emperor Yizong.

166 For English translations, see also Ma Zishu et al., eds., *National Treasures—Gems of China's Cultural Relics* (Hong Kong: Hong Kong Museum of Art, 1997), no. 86, 226; Lai, *Relics, the Sovereign and Esoteric Buddhism in Ninth-Century China: The Deposits from the Famen Monastery*, 183–84; for German translations, see Koch, "Der Goldschatzfund des Famensi: Prunk und Pietät im chinesischen Buddhismus der Tang-Zeit," 464; Louis, *Die Goldschmiede der Tang- und Song-Zeit*, 151–52.

167 Originally more than 460 pearls were draped in chains around the bodhisattva's head and body.

168 The figure is 22.3 cm high and weighs 894.8 g. Together with its lotus throne the sculpture has a height of 41.7 cm and a total weight of 1982.1 g. The unique work underwent thorough restoration and conservation by experts of the Römisch-Germanische Zentralmuseum Mainz in collaboration with the Archaeological Institute of Shaanxi Province in Xi'an; see Koch, *Der Goldschatzfund des Famensi*,

455–72, cpl. XI, pls. 115–24; *Fomen mibao da Tang yizhen*, pl. 2; Wu Limin and Han Jinke, *Famensi digong Tang mi mantuluo zhi yanjiu*, 270–333.

169 *Taishō shinshū daizōkyō*, vol. 19, no. 965, 339a–42b.

170 Ten Grotenhuis, *Japanese Mandalas*, 34.

171 H. 55–56.5 cm; see *Fomen mibao da Tang yizhen*, 125 and pls. 33–34; Koch, *Der Goldschatzfund des Famensi*, nos. 2–4, 96.

172 Four faintly visible lines intersecting in the center and forming a kind of grid were finely incised to secure accurate arrangement and placement of the five characters.

173 *Taishō shinshū daizōkyō*, vol. 50, no. 2061, 723a.

174 Ibid.

175 Siddhaṃ literally means "success." For detailed information, see Robert Hans van Gulik, *Siddham: An Essay on the History of Sanskrit Studies in China and Japan*, Sarasvati-Vihara Series, ed. Raghu Vira, vol. 36 (Nagpur [India], 1956; repr. Sata-Pitaka Series, Indo-Asian Literatures, vol. 247, New Dehli, 1980).

176 Yiengpruksawan, "In My Image," 334.

BIBLIOGRAPHY

Primary Sources

..

Bukong juansuo tuoloni zizai wang zhou jing (J: *Fukūkenjaku darani jizai ōshi kyō* 不空絹索陀羅尼自在王咒經) [Scripture of the Amoghapāsa Dhāraṇī, the Sovereign Lord of Spells]. *Taishō shinshū daizōkyō* 20, no. 1097.

Da Tang xiyuji (J: *Daitō saiiki ki* 大唐西域記) [Record of the Western Regions of the Great Tang (Dynasty)], completed by Xuanzang (J: Genjō 玄奘, 600–64) in 646. *Taishō shinshū daizōkyō* 51, no. 2087.

Damiao jin'gang jing (J: *Daimyō kongō kyō* 大妙金剛經) [Scripture of the Great Mystery and the Diamond Scepter], translated by Dharmaksena (C: Damoqina 達磨栖那) in 838. *Taishō shinshū daizōkyō* 19, no. 965.

Daoxing banruo jing (J: *Dōgyō hannya kyō* 道行般若經) [Practice of the Way of Perfect Wisdom Scripture], allegedly completed by Lokaksema (C: Zhiloujiachan; J: Shirukasen支婁迦讖) in 179 CE. *Taishō shinshū daizōkyō* 8, no. 224.

Dari jing (J: *Dainichi kyō* 大日經) [Scripture of the Great Illuminator], translated by Subhakarasimha (C: Shanwuwei; J: Zenmui 善無畏, 637–735) in 724 with Yixing 一行 (683–727) serving as a copyist and commentator. *Taishō shinshū daizōkyō* 18, no. 848.

Dazhidulun (J: *Daichidoron* 大智度論) [Treatise on the Great Perfection of Wisdom], traditionally attributed to Nāgārjuna (C: Longshu; J: Ryūjū 龍樹, ca. 150–ca. 250 CE). *Taishō shinshū daizōkyō* 25, no. 1509.

Denkōroku 傳光錄 [Record of the Transmission of the Light], by Keizan Jōkin 瑩山紹瑾 (1264–1325). *Taishō shinshū daizōkyō* 82, no. 2585.

Dhātukāraṇḍa mudrā dhāraṇī (C: baoqieyin tuoluoni; J: *hōkyōin darani* 寶篋印陀羅尼) [Treasure-Casket Seal Dhāraṇī]. *Taishō shinshū daizōkyō* 19, no. 1022.

Fayuan zhulin (J: *Hōon jurin* 法苑珠林) [A Grove of Jewels from the Dharma Garden], by Daoshi (J: Dōsei 道世) in 668. *Taishō shinshū daizōkyō* 53, no. 2122.

Foshuo yuxiang gongde jing (J: *Bussetsu yokuzō kōtoku kyō* 佛說浴像功德涇) [Buddha's Discourse on the Scripture of Merit and Virtue of Sprinkling [Water] on Sacred Icons], translated ca. 700 by Ratnacinta (Manicinta, C: Bao Siwei 寶思惟). *Taishō shinshū daizōkyō* 16, no. 697.

Gaoseng zhuan (J: *Kōsōden* 高僧傳) [Biographies of Eminent Monks], by Huijiao 慧皎 (497–554) in 519, *Taishō shinshū daizōkyō* 50, no. 2059.

Guang hongming ji (J: *Kōgumyō shū* 廣弘明集) [Expanded Collection on Propagating the Light] of 664, by Daoxuan (J: Dōsen, 596–667 CE). *Taishō shinshū daizōkyō* 52, no. 2103.

Hizōki 秘藏記 [Account of the Secret Treasury], traditionally considered to be Kūkai's recorded memories of the oral instructions given by his Chinese teacher Huiguo 惠果 (746–805). Kōyasan University Library, no. 416.3.14.

Ji shenzhou sanbao gantong lu 集神州三寶感通錄 [Catalogue of Salvific Influences of the Three Jewels on the Divine Continent], by Daoxuan 道宣 (596–667) in 664. *Taishō shinshū daizōkyō* 52, no. 2106.

Jin'gang ding jing yizi ding lunwang yigui yinyi (J: *Kongōchō kyō ichiji chōrinnō giki ongi* 金剛頂經一字頂輪王儀軌音義) [The Recital Regulations and Manual of Rituals for the Single-Word Supreme Wheel King of the Diamond Supreme Sūtra]. *Taishō shinshū daizōkyō* 19, no. 958.

Jin'gang ding jing yizi ding lunwang yuqie yiqie shichu niansong chengfo yigui (J: *Kongōchō kyō ichiji chōrinnō yuga issai jisho nenju giki* 金剛頂經一字頂輪王瑜伽一切時處念誦成佛儀軌) [The Manual of Rituals for the Mystic Unity with the Single-Word Supreme Wheel King of the Diamond Supreme Sūtra by Proper Conduct and Invocation of All the Scriptures and the Attainment of Buddhahood]. *Taishō shinshū daizōkyō* 19, no. 957.

Jinlunwang foding yaolue niansong fa (J: *Kinrinnō butchō yōryaku nenju hō* 金輪王佛頂要略念誦法) [The Rules for an Abriged Invocation of the Golden Wheel King of the Buddha's Cranial Protuberance]. *Taishō shinshū daizōkyō* 19, no. 948.

Luoyang qielanji 洛陽伽藍記 [Record of Buddhist Monasteries in Luoyang], completed by Yang Xuanzhi 楊衒之 about 547.

Mātaṅgī sūtra (C: *Modengqie jing*; J: *Matōga kyō* 摩登伽經), first translated by An Shigao (J: Anseikō 安世高, act. 2nd cent. CE); third translation in 230 CE by Zhu Luyan (J: Jikuritsuen 竺律炎), or Jiangyan (J: Shō'en 將炎) in collaboration with Zhi Qian (J: Shiken 支謙, act. 223–253). *Taishō shinshū daizōkyō* 21, no. 1300.

Nanhai jigui neifa zhuan 南海寄歸內法傳 [Account of Buddhism Sent Home from the Southern Sea], completed by Yijing 義淨 (635–713) in 691. *Taishō shinshū daizōkyō* 54, no. 2125.

Renwang hu guo banruo boluomiduo jing (J: *Ninnō gokoku hannya haramitta kyō* 仁王護國般若波羅蜜多經) [Scripture on Perfect Wisdom (S: Prajñāpāramitā) for Humane Kings Who Wish to Protect Their States], translated by Amoghavajra (C: Bukong, J: Fukū 不空, 705–774) in 765–66. *Taishō shinshū daizōkyō* 8, no. 246.

Ruyi baozhu zhuanlun mimi xianshen chengfo jinlun zhouwang jing (J: *Nyoi hōju tenrin himitsu genshin jōbutsu kinrin juō kyō* 如意寶珠轉輪秘密現身成佛金輪咒王涇) [Scripture of the Golden-Wheel Dhāraṇī King's Secret Transformation into a Buddha

in This Body Through Turning the Wheel of the Wish-Fulfilling Jewel], purportedly
translated by Amoghavajra (C: Bukong, J: Fukū 不空, 705–774), but in fact may be a
mid-tenth-century Japanese apocryphon. *Taishō shinshū daizōkyō* 19, no. 961.

Ruyilun tuoluoni jing (J: *Nyoirin darani kyō* 如意輪陀羅尼經) [Scripture of the Dhāraṇī
of the Talismanic Wheel Avalokitesvara], translated by Bodhiruci (C: Puti Liuzhi, J:
Bodairushi 菩提流志, d. 727). *Taishō shinshū daizōkyō* 20, no. 1080.

Seiryōji engi 清凉寺緣起, Muromachi period.

Shōdai giki 攝大儀軌 [Manual of Ritual Rules to Hold Up the Great (Radiance of
Illumination)]. *Taishō shinshū daizōkyō* 18, no. 850.

Sita ji 寺塔記 [Notes on Temples and Pagodas], published in 853 by Duan Chengshi 段
成式 (d. 863). *Taishō shinshū daizōkyō* 51, no. 2093.

Song gaoseng zhuan (J: *Sōkōsōden* 宋高僧傳) [Song Biographies of Eminent Monks],
compiled by Zanning 贊寧 (919–1001) between 982 and 988. *Taishō shinshū daizōkyō*
50, no. 2061.

Susiddhikara sūtra (C: *Suxidi jieluo jing*; J: *Soshitsuji kara kyō* 蘇悉地羯羅經) [Scripture
on the Act of Perfection], translated by Subhakarasimha (C: Shanwuwei, J: Zenmui
善無畏, 637–735) in 724. *Taishō shinshū daizōkyō* 18, no. 893.

Suvarnaprabhāsa sūtra (C: *Jinguang ming jing* 金光明經) [Scripture of the Golden
Light], translated during the Northern Liang dynasty (397–439) by Dharmaksema (C:
Tanmochen 曇摩讖, 385–433). *Taishō shinshū daizōkyō* 16, no. 663.

Takakusu Junjirō and Watanabe Kaigyoku, eds. *Taishō shinshū daizōkyō: The Tripitaka in
Chinese.* 100 vols. Tōkyō: Taishō issaikyō kankōkai, 1924–32; new printing, 1960.

Yizi ding lunwang niansong yigui (J: *Ichiji chōrinnō nenju giki* 一字頂輪王念誦儀軌)
[The Manual of Rituals for Invoking the Single-Word Supreme Wheel King]. *Taishō
shinshū daizōkyō* 19, no. 954.

Yizi ding lunwang yuqie guanxing yigui (J: *Ichiji chōrinnō yuga kangyō giki* 一字頂輪王
瑜伽觀行儀軌) [The Manual of Rituals for Meditation on the Mystic Unity with the
Single-Word Supreme Wheel King]. *Taishō shinshū daizōkyō* 19, no. 955.

Yufo gongde jing (J: *Yokubutsu kōtoku kyō* 浴佛功德涇) [The Scripture of Merit and
Virtue of Sprinkling (Water on Sacred Icons)], allegedly translated by Yijing 義淨
(635–713). *Taishō shinshū daizōkyō* 16, no. 698.

Zaoxiang liangdu jing 造像量度經 [Scripture of Measurements for Making Buddhist
Images], translated and annotated by Gongbu Chabu 工布查布 in 1742. *Taishō
shinshū daizōkyō* 21, no. 1419.

Zenrin shōkisen 禪林象器箋 [Basket of Articles from the Zen Tradition], by Mujaku
Dōchū 無著道忠 (1653–1744), completed 1741, edited by Shibata Otomatsu. Tōkyō:
Seishin shobō, 1963.

Zuo fo xingxiang jing 作佛形像經 [Scripture on the Production of Buddha Images].
Taishō shinshū daizōkyō 16, no. 692.

Secondary Works in
Chinese, Japanese, and Korean

Archaeological Institute of Shaanxi Province and Famensi Museum, ed. *Fomen mibao
da Tang yizhen. Shaanxi Fufeng Famensi digong* [Hidden Buddhist Treasures of the

Great Tang Dynasty. The "Underground Palace" of the Famensi in Fufeng, Shaanxi], *Zhongguo kaogu wenwu zhi mei*, vol. 10. Beijing: Wenwu chubanshe, 1994.

Archaeological Team of Chengdu Municipality and the Institute of Archaeology of Chengdu. "Chengdushi Xi'anlu Nanzhao shike zaoxiang qingli jianbao" [Brief Survey on the Stone Sculptures of the Southern Dynasties Unearthed at Xi'an Road in Chengdu City]," *Wenwu*, no. 11 (1998): 4–20.

Bukkyō geijutsu—Ars Buddhica, no. 188 (January 1990), Special Issue: *Shari yōki no mondaiten—Controversial Points of Sarīra Container Contents*.

Bunkachō, ed. *Jūyō bunkazai* [Important Cultural Properties], special vols. I and II: *Zōnai nōnyūhin*. Tōkyō: Mainichi Shinbunsha, 1978.

Bunkazai Hogoi'inkai, ed. *Kokuhō—National Treasures of Japan*, vol. 4: Kamakura jidai I—12th–14th centuries. Tōkyō: Mainichi Shinbunsha, 1966.

Cheng Xuehua. "Tang tie jinhuacai shikezao xiang" [Tang Gilt and Polychrome Stone Statuary], *Wenwu*, no. 7 (1961): 61–63.

Fukuoka shi Bijutsukan, ed. *Satori no bi* [The Beauty of Enlightenment]. Fukuoka: Fukuoka Municipal Art Museum, Special Exhibition, 2003.

Gangōji bukkyō minzoku shiryō kenkyūjo. *Murōji momitō no kenkyū* [Studies of the 'Rice-Grain Pagodas' of Murōji]. Tōkyō: Chūō kōron bijutsu shuppansha, 1976.

Gansu sheng wenwu gongzuodui [Cultural Relics Team of Gansu Province]. "Gansu sheng Jingchuan xian chutu de Tangdai sheli shihan" [A Tang Period Stone Relic Casket Unearthed at Jingchuan County in Gansu Province], *Wenwu*, no. 3 (1966): 8–15.

Gongxian wenhua guan [Gongxian Cultural Centre]. "Henan Gongxian faxian—pi Han dai tongqi" [Discoveries at Gonxian, Henan—Comments on the Bronze Objects of the Han Dynasty], *Kaogu*, no. 2 (1974): 123–25.

Hamada Takashi. *Zuzō* [Iconographic Drawings], Nihon no bijutsu, no. 55. Tōkyō: Shibundō, 1970.

Han Jinke. "Famensi yu Famensi wenhua" [The Famensi and Famensi Culture], *Wenbo*, no. 4 (1993): 1–12.

Han Wei. "Famensi Tangdai jin'gangjie da mantuluo chengshenhui zaoxiang baohan kaoshi" [A Study of the "Assembly of Perfected Bodies" in the "Diamond World *mandala*" Representation on a Tang-Period Reliquary of the Famensi], *Wenwu*, no. 8 (1992): 41–54.

———. "Shaanxi Fufeng Famensi Tangdai digong kaogu dashiji" [A Chronicle of Major Events in the Archaeological Research on the Tang Dynasty Underground Palace at Famensi in Fufeng, Shaanxi Province], *Wenbo*, no. 4 (1993): 100–112.

Hebei sheng bowuguan, ed. *Hebei sheng bowuguan wenwu jingpin ji* [Treasures from the Hebei Provincial Museum]. Beijing: Wenwu chubanshe, 1999.

Idemitsu Museum of Arts, ed. *Chika kyūden no ihō—Treasures from the Underground Palaces*. Chūgoku Kanhokushō Teishū Hokusō tōki shutsudo bunbutsu ten—Excavated Treasures from Northern Song Pagodas, Dingzhou, Hebei Province, China. Tōkyō: Idemitsu Bijutsukan, 1997.

Ikawa Kazuko. "Kantō no Seiryōji shiki Shaka zō" [Shaka Images in the Seiryōji style from the Kantō Region], *Bijutsu kenkyū*, no. 237 (1964): 23–35.

Ikawa Kazuko. "Ehime no Seiryōji shiki Shaka Nyorai zō" [Shaka Nyorai Images in the Seiryōji Style from Ehime Prefecture], *Bijutsu kenkyū*, no. 330 (1984): 37–42.

Inoue Kazutoshi. *Nyoirin Kannon zō—Batō Kannon zō* [Images of Nyoirin and Batō Kannon], Nihon no bijutsu, no. 312. Tōkyō: Shibundō, 1992.

Ishida Mosaku. *Tō: Tōba, Sutsūpa* [Pagoda: Pagodas and Stūpas], Nihon no bijutsu, no. 77. Tōkyō: Shibundō, 1972.

Ishihara Akira. "Seiryōji Shaka ryūzō nōnyū no naizō mokei" [The Models of Intestines Installed Inside the Statue of Shaka Nyorai, Seiryōji], *Museum*, no. 289 (April 1975): 15–20; no. 293 (August 1975): 27–34.

Ito Nobuo, ed. *Saidaiji to Nara no koji* [Saidaiji and the Ancient Temples of Nara], Nihon koji bijutsu zenshū [Compilation of Art in Ancient Temples of Japan], vol. 6. Tōkyō: Shueisha, 1983.

Izumishi Kubosō Kinen Bijutsukan, ed. *Chūgoku koshiki kondōbutsu to Chūō Tōnan Ajia no kondōbutsu* [Ancient Gilt Buddhist Bronzes from China and Gilt Buddhist Bronzes from Central and Southeast Asia]. Izumishi: Kubosō Kinen Bijutsukan, 1988.

———. *Rokuchō jidai no kondōbutsu* [Gilt Buddhist Bronzes of the Six Dynasties]. Izumishi: Kubosō Kinen Bijutsukan, 1991.

Jiangsu chutu wenwu xuanji [Selected Relics Unearthed from Jiangsu Province]. Beijing: Wenwu chubanshe, 1963.

Jin Shen. *Zhongguo lidai jinian foxiang tudian* [Illustrated Chronological Compendium of Buddhist Images Throughout China's History]. Beijing: Wenwu chubanshe, 1994.

Jinhua Wanfota chutu wenwu [Cultural Relics Excavated from the "Myriad Buddha Pagoda" at Jinhua]. Beijing: Wenwu chubanshe, 1958.

Kamakura Kokuhōkan, ed. *Zōnai nōnyūhin: Kamakura o chūshin ni* [Objects Deposited Inside Images: In the Heart of Kamakura]. Kamakura: Kamakura Kokuhōkan, 1997.

Kaneko Hiroaki. *Saidaiji*, Nihon no koji bijutsu [Art in Ancient Temples of Japan], vol. 10, 151–54. Tōkyō: Hoikusha, 1987.

Kaneko Hiroaki. *Unkei—Kaikei*, Meihō Nihon no bijutsu, vol. 13. Tōkyō: Shogakkan, 1991.

Kawada Sadamu. *Busshari to kyō no shōgon* [The Adornment of Buddhist Reliquaries and Sūtra Scrolls], Nihon no bijutsu, no. 280. Tōkyō: Shibundō, 1989.

Kayamoto Kamejirō. "Nissen jōdai jiin no shari shōgongu ni tsuite" [On the Glorification of Relics in Ancient Temples of Japan and Korea], *Bukkyō geijutsu—Ars Buddhica*, no. 33 (1958): 58–59.

Kegasawa Yasunori. "Shilun Famensi chutu de Tangdai wenwu yu yiwuzhang" [A Preliminary Essay on the Cultural Relics of the Tang Dynasty and the Inventory from Famensi], *Wenbo*, no. 1 (1996): 58–85.

Kobayashi Takeshi. "Saidaiji Eizon zō ni tsuite" [On the Eizon Portrait at Saidaiji], *Bukkyō geijutsu*, no. 28 (1956): 30–37.

———. "Busshi Zen'en, Zenkei, Zenshun" [The Buddhist Master (Sculptors) Zen'en, Zenkei, and Zenshun], *Bukkyō geijutsu*, no. 31 (1957): 67–76.

Kōbō Daishi zenshū [The Complete Works of Kōbō Daishi], edited by Mikkyō bunka kenkyūjo. Mount Kōya: Mikkyō bunka kenkyūjo, 1970–77.

Koizumi Yoshihide. "Chūgoku bukkyō bijutsu shi ni miru Ashiyoka ō shinkō" [The King Asoka Belief as Reflected in the History of Chinese Buddhist Art], in Tōkyō Kokuritsu Hakubutsukan, Asahi Shinbun, ed., *Chūgoku kokuhō ten—Treasures of Ancient China*, 240–48. Tōkyō: Tōkyō National Museum, Asahi Shinbun 2004.

Kuknip Chung'ang Pangmulkwan—The National Museum of Korea, ed. *Pulsari chang'om—The Art of Sarira Reliquary*. Seoul: The National Museum of Korea, 1991.

Kurata Bunsaku. "Kyōto Seiryōji no Shaka nyorai zō" [The Shaka Nyorai Image of
 Seiryōji in Kyōto], in *Butsuzō no mikata: gihō to hyōgen* [A View of Buddhist Images:
 Technique and Expression], 248–56. Tōkyō: Daiichi Hōki Shuppan, 1965.

———. *Zōnai nōnyūhin* [Objects Deposited Inside Images], Nihon no bijutsu, no. 86.
 Tōkyō: Shibundō, 1973.

Kyōto Kokuritsu Hakubutsukan and Tōkyō Kokuritsu Hakubutsukan, eds. *Kōbō Daishi
 to mikkyō bijutsu—Kōbō Daishi and the Arts of Esoteric Buddhism*. Tōkyō: Tōkyō
 National Museum, 1983.

Kyōto Kokuritsu Hakubutsukan, ed. *Tokubetsu tenrankai: Shaka shinkō to Seiryōji*
 [Special Exhibition of Sākyamuni Worship and Seiryō-ji Temple]. Kyōto: Kyōto
 National Museum, 1982.

———. *Kūkai to Mikkyō no katachi—Priest Kūkai and Formative Arts of Esoteric
 Buddhism*, The Ueno Memorial Foundation for the Study of Buddhist Art Report, no.
 31. Kyōto: Kyōto National Museum, 2004.

Lintong Xian Bowuguan. "Lintong Tang Qingshansi shelita ji jingshi qingliji"
 [Excavation of the Crypt Under the Reliquary Pagoda of the Tang Dynasty Qingshan
 Monastery in Lintong], *Wenbo*, no. 5 (1985): 16–25.

Liu Youheng and Nie Lianshun. "Hebei Zhengding Kaiyuansi fajxian chu Tang
 digong," [An Early Tang Dynasty Undergrond Chamber Discovered at the Kaiyuan
 Monastery, Zhengding, Hebei], *Wenwu*, no. 6 (1995): 63–68.

Liu Zhiyuan and Liu Tingbi, eds. *Chengdu Wanfosi shike yishu* [The Art of Stone
 Sculpture from the "Myriad Buddha Monastery" in Chengdu]. Beijing: Zhongguo
 gudian yishu chubanshe, 1958.

Lu Zhaoyin. "Guanyu Famensi digong jinyinqi de ruogan wenti" [Some Questions
 Concerning the Gold and Silver Objects from the Underground Palace of the Famen
 Monastery], *Kaogu*, no. 7 (1990): 638–43.

Luo Zhao. "Lüeshu Famensi ta digong zangpin de zongjiao neihan" [On the Religious
 Meaning of the Treasures from the Underground Palace of the Famensi Pagoda],
 Wenwu, no. 6 (1995): 53–62.

Manabe Kōsai. *Jizō Bosatsu no kenkyū* [A Study of the Bodhisattva Jizō]. Kyōto:
 Sanmitsudō shoten, 1960.

Maruyama Shirō, et al. "Kōtokuji Dainichi Nyorai zazō no Xsen conbiyu—dansō satsuei
 (CT) chōsa hōkoku—Report on CT-Scanned Images of the Seated
 Dainichi Nyorai Statue of Kōtokuji Temple," *Museum*, no. 621 (August 2009), 5–27.

Matsubara Saburō. *Chūgoku bukkyō chōkoku shiron* [Historical Survey of Chinese
 Buddhist Sculpture]. Tōkyō: Yoshikawa Kōbunkan, 1995.

Matsushima Ken. *Jizō Bosatsu zō* [Images of the Bodhisattva Jizō], Nihon no bijutsu, no.
 239. Tōkyō: Shibundō, 1986.

Mōri Hisashi. "Seiryōji Shaka zō: hensen kō" [The Seiryōji Shaka Image: Changes in
 Research], in *Nihon bukkyō chōkoku shi no kenkyū* [Studies in the History of Japanese
 Buddhist Sculpture], 312–27. Kyōto: Hōzōkan, 1970 (originally published in *Bukkyō
 geijutsu*, no. 35 [1958]: 1–23).

Nakamura Harutoshi. "Murōji Mirokudō hakken no momitō" [The Discovery of "Rice-
 Grain Pagodas" in the Maitreya Hall of Murōji], *Yamato bunka kenkyū*, vol. 1, no. 2
 (1953).

Nara Kokuritsu Hakubutsukan, ed. *Bukkyō bijutsu* [Buddhist Art]. Nara: National Museum, Special Exhibition: Kyūshū 1—Fukuoka, 1976.

———. *Nihon bukkyō bijutsu no genryū—Sources of Japanese Buddhist Art*. Nara: Nara National Museum, Special Exhibition, 1978.

———. *Busshari no shōgon—The Worship of the Buddha's Relics and the Art of Reliquary*. Tōkyō: Dōhōsha, 1983.

———. *Kōshō Bosatsu Eizon nanahyaku nen onki kinen—Nara Saidaiji ten: Shingon Risshū ichimon no hihō kōkai* [The Seven Hundredth Death Anniversary of Eizon, the Bodhisattva Kōshō—Exhibition of the Saidaiji, Nara: Hidden Treasures Presented to the Public from the Heritage of the Shingon Ritsu School]. Tōkyō: Nihon Keizai Shinbunsha, 1991.

———. *Tō Ajia no hotoke tachi—Buddhist Images of East Asia*. Nara: Nara National Museum, Special Exhibition, 1996.

———. *Busshari to hōju: Shaka o shitau kokoro—Ultimate Sanctuaries: The Aesthetics of Buddhist Relic Worship*. Nara: Nara National Museum, 2001.

———. *Seichi Neiha: Nihon Bukkyō 1300 nen no genryū—Sacred Ningbo: Gateway to 1300 Years of Japanese Buddhism*. Nara: Nara National Museum, 2009.

Nara Rokudaiji Taikan Kankōkai, ed. *Saidaiji*, Nara Rokudaiji taikan [A Survey of the Six Great Temples of Nara], vol. 14. Tōkyō: Iwanami Shoten, 1973.

National Museum of Korea, ed. *Pulsari chang'om—The Art of Sarira Reliquary*. Seoul: The National Museum of Korea, 1991.

Nihon kokuhōten—National Treasures of Japan. Tōkyō: Tōkyō National Museum, 2000.

Nishikawa Kyōtarō. *Chinsō chōkoku* [Zen Portrait Sculpture], Nihon no bijutsu, no. 123. Tōkyō: Shibundō, 1976.

Okada Ken. "Sangoku denrai no Shaka zuizō" [The Auspicious Shaka Image Transmitted Across Three Countries], *Nihon no kokuhō—National Treasures of Japan* 6, no. 16 (8 June 1997): 167–169.

———. "Shaka Nyorai ryūzō—Zōnai nōnyūhin issai," [The Standing Shaka Nyorai Statue—All About the Cache Inside the Image], *Nihon no kokuhō—National Treasures of Japan* 6, no. 16 (8 June 1997): 165–167.

Oku Takeo. *Seiryōji Shaka Nyorai zō* [The Shaka Nyorai Image at Seiryōji], Nihon no bijutsu, no. 513. Tōkyō: Shibundō, 2009.

Pei Jianping. *Famensi fojiao wenhua qiji: Sheli, baota, digong* [The Wonders of Buddhist Culture from Famensi: Relics, Treasure Pagodas, Underground Palace]. Chengdu: Sichuan jiaoyu chubanshe, 1996.

Qiu Yuding and Yang Shujie. "Shandong Pingyin faxian Da Sui Huangdi sheli baota shihan" [Sui Imperial Reliquary Treasure Pagoda Stone Casket Discovered in Pingyin, Shandong], *Kaogu*, no. 4 (1986): 375.

Sawa Ryūken and Hamada Takashi, eds. *Mikkyō bijutsu taikan* [A Survey of Esoteric Buddhist Art], vol. 1: *Ryōkai mandara* [Mandala of the Two Worlds]. Tōkyō: Asahi Shinbunsha, 1983.

Sawa Ryūken and Hamada Takashi, eds. *Mikkyō bijutsu taikan* [A Survey of Esoteric Buddhist Art], vol. 2: *Nyorai—Kannon* [Tathāgata—Avalokitesvara]. Tōkyō: Asahi Shinbunsha, 1984.

Sawa Ryūken and Hamada Takashi, eds. *Mikkyō bijutsu taikan* [A Survey of Esoteric

Buddhist Art], vol. 3: *Bosatsu—Myōō* [Bodhisattvas—Vidyārājas]. Tōkyō: Asahi Shinbunsha, 1984.

Sawa Ryūken and Hamada Takashi, eds. *Mikkyō bijutsu taikan* [A Survey of Esoteric Buddhist Art], vol. 4: *Ten—Hōgu—Soshi* [Gods—Ritual Implements—Patriarchs]. Tōkyō: Asahi Shinbunsha, 1984.

Shaanxi sheng Famensi kaogu dui [Archaeological Team of Famensi, Shaanxi Province]. "Fufeng Famensi ta Tangdai digong fajue jianbao" [Bulletin on the Excavation of the Famensi Pagoda's Tang Dynasty Underground Palace in Fufeng], *Wenwu*, no. 10 (1988): 1–56.

Shen Hsueh-man. "Liao yu Bei Song shelita nei cang jing zhi yanjiu" [Liao and Northern Song Deposits of the Buddha's Spiritual Relics], *Taida Journal of Art History*, no. 12 (March 2002): 169–212.

Shi Xingbang, ed. *Famensi digong zhenbao—Precious Cultural Relics in the Crypt of Famen Temple*. Xi'an: Renmin meishu chubanshe, 1988.

Shimizu Mazumi. "Gozō roppu no aru Sōdai mokuzō Bosatsu hankazō" [The Five Intestines and the Six Organs of a Song Dynasty Wooden Bodhisattva Image in Semi-cross-legged Position], *Bukkyō geijutsu—Ars Buddhica*, no. 135 (March 1981): 49–60.

Shimizu Zenzō. "Seiryōji shiki Shaka zō" [The Style of the Seiryōji Shaka], *Nihon bijutsu kōgei* [Japanese Applied Arts], no. 440 (1975).

Sofukawa Hiroshi and Okada Ken, eds. *Sekai bijutsu daizenshū—New History of World Art*: Tōyōhen 3: Sangoku—Nanbokuchō. Tōkyō: Shogakukan, 2000.

Suzuki Kakichi. "Busshari mainō" [Burial of Buddha Relics], *Asuka shiryōkan zuroku*, no. 21. Asuka: Asuka Shiryōkan, 1989.

Suzhou shi wenguan hui, Suzhou bowuguan [Suzhou Municipal Cultural Centre Committee and Suzhou Museum]. "Suzhou shi Ruiguangsi ta faxian—pi Wudai, Bei Song wenwu" [Discoveries in the Ruiguangsi Pagoda at Suzhou City—Comments on the Cultural Relics of the Five Dynasties and the Northern Song], *Wenwu*, no. 11 (1979): 21–31, pls. 3–7.

Tanabe Saburōsuke. "Zen'en, Zenkei to sono jidai" [Zen'en and Zenkei and Their Time], in *Saidaiji to Nara no koji*, Nihon koji bijutsu zenshū, vol. 6, 106–9.

Tanaka Sumie, et al. *Murōji*, Koji junrei, Nara, vol. 10. Tōkyō: Tankōsha, 1979.

Tōkyō Kokuritsu Hakubutsukan, ed. *Kyūtei no eiga: Tō no jotei Soku Tenmukō to sono jidai ten—The Glory of the Court: Tang Dynasty Empress Wu and Her Times*. Tōkyō, Kōbe, Fukuoka, Nagoya: NHK, 1998.

———. *Chūgoku kokuhō ten—Treasures of Ancient China*. Tōykō: Tōkyō National Museum, Asahi Shimbun, 2000.

———. *Chūgoku kokuhō ten—Treasures of Ancient China*. Tōkyō: Tōkyō National Museum, Asahi Shinbun, 2004, especially section 4: Busshari no shinkō—The Worship of Buddhist Relics (Tang, Five Dynasties and Ten States, Northern Song), nos. 138–164: 171–95, 278–79.

Tōkyō Kokuritsu Hakubutsukan et al., eds. *Chūka Jinmin Kyōwakoku Shiruku Rōdo bunbutsu ten—The Exhibition of Ancient Art Treasures of the People's Republic of China. Archaeological Finds of the Han to Tang Dynasty Unearthed at Sites along the Silk Road*. Tōkyō: Tōkyō National Museum, 1979.

Tōkyō Kokuritsu Hakubutsukan, Kyōto Kokuritsu Hakubutsukan, et al. eds. *Chūka*

Jinmin Kyōwakoku shutsudo bunbutsu ten—Archaeological Treasures Excavated in the People's Republic of China. Tōkyō: Asahi Shinbun, 1973.

Tongdosa Songbo Pangmulkwan, ed. *Pulsari shin'anggwa ku chang'om* [The Adornment of Buddhist Relics and the Faith in Relics], special exhibition catalogue no. 10. Yangsan: Tongdosa Museum, 2000.

Tonkō bunbutsu kenkyūjo [Dunhuang Research Institute], ed. *Tonkō Bakkōkutsu* [The Mogao Caves at Dunhuang], Chūgoku sekkutsu [Chinese Cave Temples], vol. 4. Tōkyō: Heibonsha/Bunbutsu shuppansha, 1982.

Uchida Keiichi. "Gangōji no bukkyō hanga ni tsuite no isshiron" [A Preliminary Essay on Buddhist Prints at Gangōji], *Kobijutsu*, no. 102 (May 1992): 70–80.

Umezawa Megumi et al., eds. *Sōgen butsuga—Buddhist Paintings of Song and Yuan Dynasties*. The 40th anniversary special exhibition. Yokohama: Kanagawa Prefectural Museum of Cultural History, 2007.

Washizuka Hiromitsu. *Murōji*, Nihon no koji bijutsu [Art in Ancient Temples of Japan], vol. 13. Ōsaka: Hoikusha, 1991.

Wu Limin and Han Jinke. *Famensi digong Tang mi mantuluo zhi yanjiu* [Studies on the Secret Mandalas of the Tang Dynasty from the Underground Palace of the Famensi], 134–267. Hong Kong: Zhongguo Fojiao wenhua chuban youxian gongsi, 1998.

Yamamoto Tsutomu. *Dainichi Nyorai zō* [Images of Dainichi Nyorai], Nihon no bijutsu, no. 374. Tōkyō: Shibundō, 1997.

Yang Boda. *Jin yin boli falang qi* [Gold, Silver, Glass, Enamel], Zhongguo meishu quanji, gongyi meishu bian [Survey of Chinese Art, Applied Arts], vol. 10. Beijing: Wenwu chubanshe, 1987.

Yoshimura Rei. "Seito Manbutsuji shi shutsudo butsuzō to Kenkō bukkyō: Ryō chūdaitō gannen mei no Indo shiki butsuzō ni tsuite" [Jiankang Buddhism and the Buddhist Images Unearthed from the Ruins of Wanfosi: On the Indian Style of the Buddha Image with the Inscription Dated First Year Zhong Datong of the Liang Dynasty], *Bukkyō geijutsu—Ars Buddhica*, no. 240 (September 1998): 33–50.

Yuan Shuguang. "Sichuan sheng Bowuguan cang Wanfosi shike zaoxiang zhengli jianbao" [Bulletin on the Readjustment of the Wanfosi Stone Sculptures in the Museum of Sichuan Province], *Wenwu*, no. 10 (2001): 19–38.

Zhejiang sheng wenwu kaogu yanjiusuo [Institute of Archaeology and Cultural Relics of Zhejiang Province]. "Hangzhou Leifengta wudai digong fajue jianbao" [Bulletin on the Excavation of the "Thunder Peak Pagoda's" Underground Palace of the Five Dynasties in Hangzhou], *Wenwu*, no. 5 (2002): 4–32.

Zhu Jieyuan and Qin Bo. "Shaanxi Chang'an he Yaoxian faxian de Bosi Sashan chao yinbi" [Persian Sassanian Silver Coins Discovered at Chang'an and Yao Xian, Shaanxi], *Kaogu*, no. 2 (1974): 126–32.

Works in
Western Languages

Abe, Stanley K. "Art and Practice in a Fifth-Century Chinese Buddhist Cave Temple," *Ars Orientalis* 20 (1991): 1–31.

———. *Ordinary Images*. Chicago and London: University of Chicago Press, 2002.

Asiatic Art in the Museum of Fine Arts Boston. Boston: Museum of Fine Arts, 1982.

Bai Ming and Zhang Tianjie. *Famen Temple and Pagoda*. Xi'an: Shaanxi Teacher's University Press, 1990.

Barrett, T. H. "Stūpa, Sūtra, and Sarīra in China, c. 656–706 C E," *Buddhist Studies Review* 18, no. 1 (2001): 1–64.

Bodiford, William M. "Keizan's Dream History," in *Religions of Japan in Practice*, edited by George J. Tanabe Jr., 501–22. Princeton Readings in Religions. Princeton: Princeton University Press, 1999.

Bogel, Cynthea J. *With a Single Glance: Buddhist Icon and Early Mikkyō Vision*. Seattle: University of Washington Press, 2009.

Boucher, Daniel. "Sūtra on the Merit of Bathing the Buddha," in *Religions of China in Practice*, edited by Donald S. Lopez Jr., 59–68. Princeton Readings in Religions. Princeton: Princeton University Press, 1996.

Brinker, Helmut. "Facing the Unseen: On the Interior Adornment of Eizon's Iconic Body," *Archives of Asian Art* 50 (1997–98): 42–61.

Brinker, Helmut, and Roger Goepper. *Kunstschätze aus China, 5000 v.Chr. bis 900 n.Chr. Neuere archäologische Funde aus der Volksrepublik China*. Zürich: Kunsthaus Zürich, 1981.

Brinker, Helmut, and Kanazawa Hiroshi. *ZEN: Masters of Meditation in Images and Writings*, translated by Andreas Leisinger. Artibus Asiae Supplementum 40. Zürich: Artibus Asiae, 1996 (originally published as *ZEN: Meister der Meditation in Bildern und Schriften* [Zürich: Museum Rietberg, 1993]).

Cai Jingfeng, trans. and ann. *Zaoxiang Liangdu Jing: The Buddhist Canon of Iconometry*, with supplement. A Tibetan-Chinese translation from about 1742 by mGon-po-skyabs. Gömpojab. Ulm: Fabri Verlag, 2000.

Carter, Martha L. *The Mystery of the Udayana Buddha*. Naples: Istituto Universitario Orientale, 1990.

Caswell, James O. *Written and Unwritten: Buddhist Caves at Yungang*. Vancouver: UBC Press, 1988.

Chen, Jinhua. "Sarira and Scepter: Empress Wu's Political Use of Buddhist Relics," *Journal of the International Association of Buddhist Studies* 25, nos. 1–2 (2002): 33–150.

Ch'en, Kenneth K. S. *Buddhism in China: A Historical Survey*. Princeton: Princeton University Press, 1964.

Cunningham, Michael R. *Buddhist Treasures from Nara*. Cleveland: The Cleveland Museum of Art, 1998.

Davis, Richard H. *Images, Miracles, and Authority in Asian Religious Traditions*. Boulder, CO: Westview Press, 1998..

de Visser, Marinus Willem. "The Bodhisattva Ti-tsang (Jizō) in China and Japan," *Ostasiatische Zeitschrift* 2 (1913/14): 179–98, 266–305, 393–401; and 3 (1914/15): 61–92, 209–42.

Dubs, Homer H. "Han Yü and the Buddha's Relic: An Episode in Medieval Chinese Religion," *Review of Religion*, no. 11 (November 1946): 5–17.

Eichenbaum Karetzky, Patricia. "Esoteric Buddhism and the Famensi Finds," *Archives of Asian Art* 47 (1994): 78–83.

Faure, Bernard. *The Rhetoric of Immediacy: A Cultural Critique of Chan/Zen Buddhism*. Princeton: Princeton University Press, 1991.

————. "Now You See It, Now You Don't: Relics and Regalia in Japanese Buddhism." Paper presented at the AAR meeting, New Orleans, November 1996a.

————. *Visions of Power: Imagining Medieval Japanese Buddhism*, translated by Phyllis Brooks. Princeton: Princeton University Press, 1996b.

————. "The Buddhist Icon and the Modern Gaze," *Critical Inquiry* 24, no. 3 (Spring 1998): 768–813.

Fong, Wen C. "The 'Han-Tang Miracle': Making Chinese Sculpture Art History," in *Zürich Studies in the History of Art, Georges Bloch Annual* 13/14 (2006/07): 151–85. Zürich: University of Zürich, Institute of Art History, 2009.

Fontein, Jan. "Relics and reliquaries, texts and artefacts," in *Function and Meaning in Buddhist Art*. Proceedings of a Seminar Held at Leiden University, 21–24 October 1991, edited by K. R. van Kooij and H. van der Veere, 21–31. Groningen: Egbert Forsten, 1995.

Fowler, Sherry D. "Nyoirin Kannon: Stylistic Evolution of Sculptural Images," *Orientations* 20, no. 12 (December 1989): 58–65.

————. "Hibutsu: Secret Buddhist Images of Japan," *Journal of Asian Culture* 15 (1991–1992): 137–61.

————. "In Search of the Dragon: Mt. Murō's Sacred Topography," *Japanese Journal of Religious Studies* 24, nos. 1–2 (Spring 1997): 151–54 and fig. 3.

————. *Murōji: Rearranging Art and History at a Japanese Buddhist Temple.* Honolulu: University of Hawai'i Press, 2005.

Gardiner, David L. "Kūkai and the Beginnings of Shingon Buddhism in Japan," Ph.D. diss., Stanford University, 1995.

————. "Mandala, Mandala on the Wall: Variations of Usage in the Shingon School," *Journal of the International Association of Buddhist Studies* 19, no. 2 (1996): 245–79.

Gimello, Robert M. "Icon and Incantation: The Goddess Zhunti and the Role of Images in the Occult Buddhism of China," in *Images in Asian Religions: Texts and Contexts*, edited by Phyllis Granoff and Koichi Shinohara, 225–56. Vancouver and Toronto: UBC Press, 2004.

Goepper, Roger. "Kekkai: Notes on a Shingon Ceremony and Its Connections with Art," in *Nihon ni okeru bukkyō bijutsu no juyō to tenkai* [Formation and Development of Buddhist Art in Japan], 41–58. Nara: Nara National Museum, 1979.

————. "Some Thoughts on the Icon in Esoteric Buddhism of East Asia," in *Studia Sino-Mongolica* 25: 245–54. (Festschrift für Herbert Franke, edited by Wolfgang Bauer.) Münchener Ostasiatische Studien. Wiesbaden: Franz Steiner Verlag GmbH, 1980.

————. "An Early Work by Kōen in Cologne," *Asiatische Studien/Études Asiatiques* 37, no. 2 (1983): 67–102.

————. "Das Kultbild im Ritus des esoterischen Buddhismus Japans," in *Rheinisch-Westfälische Akademie der Wissenschaften*. Vorträge G 264. Opladen: Westdeutscher Verlag, 1983.

————. *Die Seele des Jizō: Weihegaben im Inneren einer buddhistischen Statue.* Kleine Monographien 3. Köln: Museum für Ostasiatische Kunst, 1984.

————. "Der Priester Kūkai und die Kunst," in *Religion und Philosophie in Ostasien*. Festschrift für Hans Steininger zum 65. Geburtstag, edited by Gert Naundorf, Karl-Heinz Pohl, and Hans-Hermann Schmidt, 223–32. Würzburg: Königshausen + Neumann, 1985.

————. *Shingon: Die Kunst des Geheimen Buddhismus in Japan*. Köln: Museum für Ostasiatische Kunst, 1988.

————. *Aizen-Myōō: The Esoteric King of Lust*. An Iconological Study. Artibus Asiae Supplementum 39. Zürich: Museum Rietberg, 1993.

————. "The Four Kinds of Rites at the Altar. Paragraph Six of the Hizō-ki," in *Das andere China*. Festschrift für Wolfgang Bauer zum 65. Geburtstag, edited by Helwig Schmidt-Glintzer, 183–208 Wolfenbütteler Forschungen, Band 62. Wiesbaden: Harrassowitz, 1995.

————. "Icon and Ritual in Japanese Buddhism," in *Enlightenment Embodied: The Art of the Japanese Buddhist Sculptor (7th–14th Centuries)*, translated and edited by Reiko Tomii and Kathleen M. Friello, 73–78. New York: Japan Society, Inc., 1997.

Groner, Paul. "Icons and Relics in Eison's Religious Activities," in *Living Images: Japanese Buddhist Icons in Context*. Asian Religions and Cultures, edited by Robert H. Sharf and Elizabeth Horton Sharf, 114–50. Stanford: Stanford University Press, 2001.

Granoff, Phyllis, and Koichi Shinohara, eds. *Images in Asian Religions: Texts and Contexts*. Vancouver and Toronto: UBC Press, 2004.

Henderson, Gregory, and Leon Hurvitz. "The Buddha of Seiryōji: New Finds and New Theory," *Artibus Asiae* 19, no. 1 (1956): 4–55.

Hucker, Charles O. *A Dictionary of Official Titles in Imperial China*. Stanford: Stanford University Press, 1985.

Ishida Hisatoya. *Esoteric Buddhist Painting*, translated and adapted by E. Dale Saunders, Japanese Arts Library 15. Tōkyō and New York: Kodansha International Ltd. and Shibundō, 1987.

Kang Woo-bang. "Buddhistische Reliquien und Reliquienbehälter in Korea," in *Korea: Die Alten Königreiche*. Zürich: Museum Rietberg, 2000.

Keightley, David N. "Art, Ancestors, and the Origins of Writing in China," *Representations* 56 (Fall 1996): 68–95.

Kidder, J. Edward, Jr. "*Busshari* and *Fukuzō*: Buddhist Relics and Hidden Repositories of Hōryūji," *Japanese Journal of Religious Studies* 19, nos. 2–3 (June–September 1992): 217–44.

Koch, Alexander. "Der Goldschatzfund des Famensi: Prunk und Pietät im chinesischen Buddhismus der Tang-Zeit," in *Jahrbuch des Römisch-Germanischen Zentralmuseums Mainz* 42 (1995): 403–542.

Korea: Die Alten Königreiche. Zürich: Museum Rietberg, 2000.

Kuhn, Dieter, ed. *Chinas Goldenes Zeitalter: Die Tang-Dynastie (618–907 n. Chr.) und das kulturelle Erbe der Seidenstrasse*. Heidelberg: Edition Braus, 1993.

Kūkai: Major Works. Translated, with an Account of His Life and a Study of His Thought, by Yoshito S. Hakeda. New York: Columbia University Press, 1972.

Kurata Dykstra, Yoshiko. "Jizō, the Most Merciful: Tales from 'Jizō Bosatsu Reigenki,'" *Monumenta Nipponica, Studies in Japanese Culture* 33, no. 2 (Summer 1978): 179–200.

Lai, I-mann. "Relics, the Sovereign and Esoteric Buddhism in Ninth-Century China: The Deposits from the Famen Monastery," Ph.D., diss., University of London, 2005.

Lamotte, Étienne, trans. *Le Traité de la Grande Vertu de Sagesse de Nāgārjuna* (Mahāprajñāpāramitāśāstra). Louvain-la-Neuve: Institut Orientaliste, 1944–80.

Lancaster, Lewis R. "An Early Mahāyāna Sermon about the Body of the Buddha and the Making of Images," *Artibus Asiae* 36, no. 4 (1974): 287–91.

Lawton, Thomas. *Chinese Figure Painting*. Freer Gallery of Art: Fiftieth Anniversary Exhibition. Washington, DC: Smithsonian Institution, 1973.

Lee, Sherman E. *Reflections of Reality in Japanese Art*. Cleveland: The Cleveland Museum of Art, 1983.

Leidy, Denise Patry. *The Art of Buddhism: An Introduction to Its History and Meaning*. Boston and London: Shambhala, 2008.

Loehr, Max. *Chinese Landscape Woodcuts from an Imperial Commentary to the Tenth-Century Printed Edition of the Buddhist Canon*. Cambridge, MA: The Belknap Press of Harvard University Press, 1968.

Louis, François. *Die Goldschmiede der Tang- und Song-Zeit: Archäologische, sozial- und wirtschaftsgeschichtliche Materialien zur Goldschmiedekunst Chinas vor 1279*, Schweizer Asiatische Studien, Monographie 32. Berlin and New York: Peter Lang, 1999.

Luo Zhewen. *Ancient Pagodas in China*. Beijing: Foreign Language Press, 1994.

Ma Zishu et al., eds., *National Treasures: Gems of China's Cultural Relics*. Hong Kong: Hong Kong Museum of Art, 1997.

Mair, Victor H., ed. *The Columbia Anthology of Traditional Chinese Literature*. New York: Columbia University Press, 1994.

Mammitzsch, Ulrich H. R. *Evolution of the Garbhadhātu Mandala*. New Dehli: International Academy of Indian Culture and Aditya Prakashan, 1991.

Mayer, Alexander Leonhard, and Klaus Röhrborn, eds. *Xuanzangs Leben und Werk*. Veröffentlichungen der Societas Uralo-Altaica, vol. 34. Wiesbaden: Otto Harrassowitz, 1991–92.

McCallum, Donald F. "The Saidaiji Lineage of the Seiryōji Shaka Tradition," *Archives of Asian Art* 49 (1996): 51–67.

McNair, Amy. "The Fengxiansi Shrine and Longmen in the 670s," *The Museum of Far Eastern Antiquities, Stockholm, Bulletin* no. 68 (1996): 325–92.

———. *Donors of Longmen: Faith, Politics, and Patronage in Medieval Chinese Buddhist Sculpture*. Honolulu: University of Hawai'i Press, 2007.

Mizuno Kōgen. *Buddhist Sutras: Origin, Development, Transmission*. Tōkyō: Kōsei, 1982.

Mori, Hisashi. *Japanese Portrait Sculpture*, translated and adapted by W. Chië Ishibashi. Tōkyō and New York: Kodansha International Ltd. and Shibundō, 1977 (originally published as *Shōzō chōkoku*, Nihon no bijutsu, no. 10 [Tōkyō: Shibundō, 1967]).

Morrell, Robert E. *Early Kamakura Buddhism: A Minority Report*. Berkeley, CA: Asian Humanities Press, 1987.

Morse, Samuel Crowell. "The Formation of the Plain-Wood Style and the Development of Japanese Buddhist Sculpture: 760-840." Ph.D. diss., Harvard University, 1985.

Morse, Samuel C. "Animating the Image: Buddhist Portrait Sculpture of the Kamakura Period," *Orientations* 35, no. 1 (January/February 2004): 22–30.

Nickel, Lukas, ed. *The Return of the Buddha: Buddhist Sculptures of the 6th Century from Qingzhou, China*, translated by Andreas Leisinger. Zürich: Museum Rietberg, 2002 (originally published as *Die Rückkehr des Buddha: Chinesische Skulpturen des 6. Jahrhunderts—Der Tempelfund von Qingzhou* [Zürich: Museum Rietberg, 2001]).

Nishimura Morse, Anne, and Samuel Crowell Morse. *Object as Insight: Japanese Buddhist Art and Ritual*. Katonah, N.Y.: Katonah Museum of Art, 1995.

Orzech, Charles D. "Seeing Chen-yen Buddhism: Traditional Scholarship and the Vajrayāna in China," *History of Religions* 29, no. 2 (November 1989): 87–114.

———. "The Legend of the Iron Stūpa," in *Buddhism in Practice*, edited by Donald S. Lopez, Jr., 314–17. Princeton Readings in Religions. Princeton: Princeton University Press, 1995.

———. "The Scripture on Perfect Wisdom for Humane Kings Who Wish to Protect Their States," in Donald S. Lopez, Jr., *Religions of China in Practice*. Princeton Readings in Religions, edited by Donald S. Lopez, Jr., 372–80. Princeton: Princeton University Press, 1996.

———. *Politics and Transcendent Wisdom: The* Scripture for Humane Kings *in the Creation of Chinese Buddhism*. University Park: Pennsylvania State University Press, 1998.

Owen, Stephen, ed. and trans. *An Anthology of Chinese Literature: Beginnings to 1911* New York and London: W. W. Norton & Company, 1996.

Payne, Richard Karl. *The Tantric Ritual of Japan: Feeding the Gods. The Shingon Fire Ritual*. Sata-Pitaka Series, vol. 365. New Dehli: Aditya Prakashan, 1991.

Reischauer, Edwin O. *Ennin's Travels in T'ang China*. New York: The Ronald Press Company, 1955a.

———. *Ennin's Diary: The Record of a Pilgrimage to China in Search of the Law*. New York: The Ronald Press, 1955b.

Robson, James. *Inside Asian Images: An Exhibition of Religious Statuary from the Artasia Gallery Collection*. Ann Arbor: University of Michigan, Institute for the Humanities, 2007.

Rogers, Howard, ed. *China: 5,000 Years. Innovation and Transformation in the Arts*, selected by Sherman Lee. New York: The Solomon R. Guggenheim Museum, 1998.

Rosenfield, John M. *Portraits of Chōgen: The Transformation of Buddhist Art in Early Medieval Japan*. Japanese Visual Culture 1. Leiden: Brill, 2011.

Rosenfield, John M., and Elizabeth ten Grotenhuis. *Journey of the Three Jewels: Japanese Buddhist Paintings from Western Collections*. New York: The Asia Society, 1979.

Rosenfield, John M., and Shūjirō Shimada. *Traditions of Japanese Art: Selections from the Kimiko and John Powers Collection*. Cambridge, MA: Fogg Art Museum, Harvard University, 1970.

Rowland, Benjamin. *The Evolution of the Buddha Image*. New York: Asia Society, 1963.

Ruppert, Brian D. *Jewel in the Ashes: Buddha Relics and Power in Early Medieval Japan* Cambridge, MA: Harvard University Press, 2000.

Sanford, James H. "Wind, Waters, Stupas, Mandalas: Fetal Buddhahood in Shingon," *Japanese Journal of Religious Studies* 24, nos. 1–2 (Spring 1997): 17–21.

Schopen, Gregory. *Bones, Stones, and Buddhist Monks*. Collected Papers on the Archaeology, Epigraphy, and Texts of Monastic Buddhism in India. Honolulu: University of Hawai'i Press, 1997.

Sharf, Robert H., trans. "The Scripture on the Production of Buddha Images," in *Religions of China in Practice*, edited by Donald S. Lopez, Jr., 261–67. Princeton Readings in Religions. Princeton: Princeton University Press, 1996.

Sharf, Robert H. "On the Allure of Buddhist Relics," *Representations* 66 (Spring 1999): 75–99.

———. "Prolegomenon to the Study of Japanese Buddhist Icons," in *Living Images: Japanese Buddhist Icons in Context*, edited by Robert H. Sharf and Elizabeth Horton Sharf, 1–18. Asian Religions and Cultures. Stanford: Stanford University Press, 2001.

———. "Visualization and Mandala in Shingon Buddhism," in *Living Images: Japanese Buddhist Icons in Context*, edited by Robert H. Sharf and Elizabeth Horton Sharf, 151–97. Asian Religions and Cultures. Stanford: Stanford University Press, 2001.

———. *Coming to Terms with Chinese Buddhism: A Reading of the* Treasure Store Treatise. Studies in East Asian Buddhism 14. Honolulu: University of Hawaiʻi Press, 2002; pbk. edition 2005.

Sharf, Robert H., and Elizabeth Horton Sharf, eds. *Living Images: Japanese Buddhist Icons in Context*. Asian Religions and Cultures. Stanford: Stanford University Press, 2001.

Shen Hsueh-man. "Liao and Northern Song Deposits of the Buddha's Spiritual Relics," *Taida Journal of Art History*, no. 12 (March 2002): 169–212.

———. "Pictorial Representations of the Buddha's nirvāṇa in Chinese Relic Deposits," *East Asia Journal: Studies in Material Culture* 1, no. 1 (2003): 25–48.

Sickman, Laurence, and Alexander Soper. *The Art and Architecture of China*. The Pelican History of Art. Harmondsworth, UK: Penguin Books Ltd, 1956.

Soper, Alexander C. *The Evolution of Buddhist Architecture in Japan*. Princeton Monographs in Art and Archaeology 22. Princeton: Princeton University Press, 1942.

———. *Literary Evidence for Early Buddhist Art in China*. Artibus Asiae Supplementum 19. Ascona: Artibus Asiae, 1959.

———. "A Vacation Glimpse of the T'ang Temples of Ch'ang-an: The *Ssu-t'a Chi* by Tuan Ch'eng-shih," *Artibus Asiae* 23, no. 1 (1960): 15–40.

———. "South Chinese Influence on the Buddhist Art of the Six Dynasties Period," *The Museum of Far Eastern Antiquities, Stockholm, Bulletin* 32 (1960): 47–112.

Sources of the Japanese Tradition, compiled by Ryusaku Tsunoda, Wm. Theodore de Bary, and Donald Keene. New York: Columbia University Press, 1958.

Strickmann, Michel. "The *Consecration Sūtra*: A Buddhist Book of Spells," in *Chinese Buddhist Apocrypha*, edited by Robert E. Buswell Jr., 75–118. Honolulu: University of Hawaiʻi Press, 1990.

Strickmann, Michel, ed. *Classical Asian Rituals and the Theory of Ritual*. Berlin and New York: Mouton de Gruyter, 1988.

Tanabe, George J., Jr. *Myōe the Dreamkeeper: Fantasy and Knowledge in Early Kamakura Buddhism*. Harvard East Asian Monograph, no. 156. Cambridge, MA: Harvard University Press, 1992.

ten Grotenhuis, Elizabeth, *Japanese Mandalas: Representations of Sacred Geography*. Honolulu: University of Hawaiʻi Press, 1999.

Tomii, Reiko, and Kathleen M. Friello, trans. and eds. *Enlightenment Embodied: The Art of the Japanese Buddhist Sculptor (7th–14th Centuries)*. New York: Japan Society, Inc., 1997.

Tsiang, Katherine R. "Miraculous Flying Stupas in Qingzhou Sculpture," *Orientations* 31, no. 10 (December 2000): 45–53.

———. "Embodiments of Buddhist Texts in Early Medieval Chinese Visual Culture," in *Body and Face in Chinese Visual Culture*, edited by Wu Hung and Katherine R. Tsiang, 49–78. Harvard East Asian Monographs 239. Cambridge, MA: Harvard University Press, 2005.

van Gulik, Robert Hans. *Siddham: An Essay on the History of Sanskrit Studies in China and Japan, in* Sarasvati-Vihara Series, edited by Raghu Vira, vol. 36. Nagpur, India, 1956 (repr. Sata-Pitaka Series, Indo-Asian Literatures, vol. 247, New Dehli, 1980).

Wagner, Rudolf G. "Die Fragen Hui-yuans an Kumārajīva." Ph.D. diss., Ludwig-Maximilians-Universität, München, 1969.

Wang, Eugene. *Shaping the Lotus Sutra: Buddhist Visual Culture in Medieval China* Seattle: University of Washington Press, 2005.

Wang, Eugene Y. "Of the True Body: The Famen Monastery Relics and Corporeal Transformation in Tang Imperial Culture," in *Body and Face in Chinese Visual Culture*, edited by Wu Hung and Katherine R. Tsiang, 79–118. Harvard East Asian Monographs 239. Cambridge, MA: Harvard University Press, 2005.

Wang Ling. "Rare Buddhist Relics Unearthed in China," *Oriental Art* 33, no. 2 (Summer 1987): 208–11.

Wang, Yi-t'ung, trans. *A Record of Buddhist Monasteries in Lo-yang by Yang Hsüan-chih*. Princeton: Princeton University Press, 1984.

Ware, James R. "Wei Shou on Buddhism," *T'oung Pao* (2d ser.), 30 (1933): 118–19.

Washizuka Hiromitsu, Park Youngbok, et al. *Transmitting the Forms of Divinity: Early Buddhist Art from Korea and Japan*. New York: Japan Society, Inc., 2003.

Watt, James C. Y., et al. *China: Dawn of a Golden Age, 200–750 AD.* Catalogue of an exhibition held at the Metropolitan Museum of Art, New York. New Haven, CT: Yale University Press, 2004.

Watt, Paul B. "Eison and the Shingon Vinaya Sect," in *Religions of Japan in Practice*, edited by George J. Tanabe Jr., 89–97. Princeton Readings in Religions. Princeton: Princeton University Press, 1999.

Weidner, Marsha, ed. *Latter Days of the Law: Images of Chinese Buddhism, 850–1850*. Lawrence, KS.: Spencer Museum of Art, The University of Kansas, in association with University of Hawai'i Press, 1994.

Weinstein, Stanley. "Imperial Patronage in the Formation of T'ang Buddhism," in *Perspectives on the T'ang*, edited by Arthur F. Wright and Denis Twitchett, 265–306. New Haven, CT: Yale University Press, 1973.

———. *Buddhism under the T'ang*. New York: Cambridge University Press, 1987.

Whitfield, Roderick. *The Art of Central Asia*. The Stein Collection in the British Museum. Tōkyō and New York: Kodansha, 1982.

———. "Esoteric Buddhist Elements in the Famensi Reliquary Deposit," *Asiatische Studien/Études Asiatiques* 44, no. 2 (1990): 247–66.

———. "The Significance of the Famensi Deposit," *Orientations* 21, no. 5 (May 1990): 84–85.

Wright, Arthur F. *The Sui Dynasty*. New York: Alfred A. Knopf, Inc., 1978.

Yang Xiaoneng. *New Perspectives on China's Past: Chinese Archaeology in the Twentieth Century*, vol. 1: Cultures and Civilizations Reconstructed; vol. 2: Major Archaeological Discoveries in Twentieth-Century China. New Haven, CT: Yale University Press; Kansas City: Nelson-Atkins Museum, 2004.

Yiengpruksawan, Mimi Hall. *Hiraizumi: Buddhist Art and Regional Politics in Twelfth-Century Japan*. Cambridge, MA: Harvard University Press, 1998.

———. "In My Image: The Ichiji Kinrin Statue at Chūsonji," *Monumenta Nipponica* (Studies in Japanese Culture), 46, no. 1–4 (1991): 329–47.

Zhu Qixin. "Buddhist Treasures from Famensi: The Recent Excavation of a Tang Underground Palace," *Orientations* 21, no. 5 (May 1990): 77–83.

Zürcher, Erik. *The Buddhist Conquest of China: The Spread and Adaptation of Buddhism in Early Medieval China*. Leiden: E. J. Brill, 1959.

INDEX

Page numbers in italic type indicate illustrations and those followed by "n" refer to endnotes; "cmssn" stands for "commissioned by."